BLOOM
WHERE
YOU ARE
PLANTED

BLOOM
WHERE

50 Conversations with

BEKA SHANE DENTER

YOU ARE PLANTED

Inspiring British Columbians

Heritage House Publishing Company Ltd.
heritagehouse.ca

Cataloguing information available from Library and Archives Canada
978-1-77203-429-5 (hardcover)
978-1-77203-430-1 (e-book)

Edited by Renée Layberry
Cover and interior design by Setareh Ashrafologhalai

The interior of this book was produced on FSC®-certified, acid-free paper, processed chlorine free, and printed with vegetable-based inks.

Heritage House gratefully acknowledges that the land on which we live and work is within the traditional territories of the Lkwungen (Esquimalt and Songhees), Malahat, Pacheedaht, Scia'new, T'Sou-ke, and W̱SÁNEĆ (Pauquachin, Tsartlip, Tsawout, Tseycum) Peoples.

We acknowledge the financial support of the Government of Canada through the Canada Book Fund (CBF) and the Canada Council for the Arts, and the Province of British Columbia through the British Columbia Arts Council and the Book Publishing Tax Credit.

26 25 24 23 22 1 2 3 4 5
Printed in China

Cover images

(clockwise from top left):

Erin Brillon (Photography by Kimberly Kufaas @Westcoastlife)

Myriam Steinberg (Photography by Diane Smithers)

Emma Smith (Photography by Sean Lande)

Alissa Hansen (Photography by Lauren Cryder)

Laïla Bédard-Potvin (Photography by Christi Kyprianou)

Athena Bax (Photography by Gaetano Fasciana)

Livona Ellis (Photography by Carson Gallagher)

Veerpal Sidhu (Photography by Ally Matos)

Emily Scholes (Photography by Sarah Stein, Fragment of Light Photography)

Lydia Okello (Photography by Vestige Story, shot by Aileen Lee)

Katherine Schlattman (Photography by Kelly Heurtier)

Erika Mitsuhashi (Tender Engine Performance, at vivo Media Arts Centre, 2019. Photography by Cara Tench)

Corrine Hunt (Photography by Sandra Bars)

Andrea Helleman (Photography by Anastasia Chomlack)

Alice de Crom (Photography by The Godard's Photography)

Kezia Nathe (Photography by Krystal Calver)

For Cali and Elle, my two inspirations.

For Christian, my rock.

*And for my mom, Ruth Michelle:
Here is the book you always said was
in my heart. From me, to you. I love
you as big as the universe.*

Contents

My hope for this book is that it will inspire.

Introduction

FROM A VERY YOUNG AGE, I went to galleries, art shows, dance performances, and music festivals. Mine was a colourful and creative childhood. I'm forever grateful to my mom for sharing with me her passion for all things artistic and teaching me that art is important. Art has the capacity to move, inspire, inform, heal, and unite us—in mind, body, and soul.

My mom also conveyed to me that it was imperative to do what you love because inevitably that would bring about success in the form of personal fulfillment. My mom knew what she was talking about because she had put aside her own passion for teaching to support the two of us. As a single parent, she felt it was her role to provide and have me want for nothing. We shopped at second-hand stores. We travelled extensively and ate mostly organic. I was enrolled in dance classes and tennis lessons. She left teaching and took a job with the federal government, which gave us financial security, healthcare, and the opportunity for adventure. Her new profession proved to be interesting as she took on positions that fulfilled her in a different way. But I always wondered what life would have been like had she continued to follow her dream of teaching drama.

I was raised to believe that women can achieve success in whichever form they desire—the arts, athletics, academics, business, and beyond. As I moved from childhood into young adulthood and started to travel the world, I was in awe of the incredible women I met, pursuing their passions and making no apologies for their independent and fulfilling lives.

In September 2020, I celebrated a decade as a writer. Ten years prior, while pregnant with my first daughter, I pressed pause on my teaching career. It was a risk to walk away from a regular paycheque and begin an unpaid internship with an online platform. But one month in and three writing assignments submitted, I quickly realized that the fluttery feeling in my stomach was more than just the early weeks of pregnancy. I realized that writing is what I've always wanted to do—to learn about and share the stories of others. It was the best risk I ever took.

My mom understood implicitly the beauty of transformation, as well as my fascination with words. She had watched me, her only child, devour a book in a day, and she indulged my love for music. I was obsessed with song lyrics and Sting. I fondly remember her dancing with me in our living room as The Police's *Synchronicity* played on endless repeat for an entire summer. She encouraged my creativity from a young age and didn't give off an inkling of doubt when I decided to leave the stability of teaching for the uncertainty of writing.

The idea for this book came about while driving along a sunny stretch of the Trans-Canada Highway in rural Saskatchewan in July 2020. I and my husband, Christian, and our two daughters—Cali, then nine, and Elle, seven—had been on the road four days, having recently packed up our family home in Ottawa en route to our new life in the beach town of White Rock. Canada's stunningly beautiful west coast with its majestic mountains, lush rainforests, and endless ocean views had been the one constant in my young family's ever-changing lives as we would visit often during winter and summer holidays. After several moves around the world for Christian's job with Global Affairs Canada, we were all ready to put down roots. As enticing and exciting as our international way of life appeared to outsiders, we were in search of something more stable. At least for the next five years. Our dream of raising a globally minded family was put on pause, and the idea of

being in Canada appealed. Especially once the COVID-19 pandemic hit.

In December 2017, we had returned to Ottawa after what can best be described as a challenging seventeen months of living in the Philippines. Three weeks prior to our scheduled departure date from Manila, my mom Ruth died from an aortic rupture while having lunch with her two best friends in Ottawa. Finding myself back in my hometown without my mom left me feeling detached and weighed down by memories of our life and times together. I felt strongly that Ottawa was not where I, where we as a family, were meant to be.

We had been back in Ottawa three months when I completely became undone. One night in March 2018, when Christian was back from the Philippines for one of his weeklong visits, I went down to the basement of our rental unit where we had stored all my mom's belongings. I came upon an open box filled with photographs. Photos of my mom at her graduation from Queen's University; photos of me as a baby and a toddler; photos of us on our trip to California in the spring of 1982; photos of my mom beaming her beautiful smile. Within minutes I was sobbing. My tears brought on physical pain—pain so sharp I collapsed onto the floor and curled into the fetal position as I clung to a photo in which I look about five or six years old. My mom holds me on her lap, her engaging smile daring me to, if just for a moment, believe that I am looking at the real version of her. But I am not. I am looking at a photo that is weathered, the edges beginning to tear. Christian was scheduled to leave in a few days' time for what would be his final trip back to the Philippines before he returned home to stay in May.

My husband could not fix what was broken; he could only be there, and even that was temporary. My sadness surpassed any emotion he'd ever witnessed in me during our thirteen years together. I looked up and whispered, "I left often, but I would always return, to here and to her. But not this time. This time she's not here." In that moment, we both realized that for me to move through grief, we would have to move.

But I couldn't snap my fingers and wish us to another place. I had to face my fears. I had to find the strength to somehow push through the days before the opportunity arose to make that move happen. The upside of being in a place that pained me was the purpose that very pain fuelled.

There were days and weeks where my motivation was lacking—in fact, I didn't write for three months after waking up that Sunday morning in Manila to the news that my mom had died. The last thing I wrote before those three months was her obituary.

I yearned for some semblance of rootedness and connection, something I attempted to find during this time back in Ottawa. But no matter how tangible my efforts, I knew in my heart it was forced and feeble. In the meantime, until that move happened, I had to find a way to make the most of my surroundings.

I WAS introduced to interior designer Henrietta Southam through a mutual friend who believed that together, Henrietta and I could produce an intriguing profile about her work and travels. Henrietta was the breath of fresh air I desperately needed, a muse of sorts, to get me back into writing. Henrietta is strong, passionate, and creative without apology. Our collaboration led me to writing for two Ottawa publications. I am forever grateful to Henrietta and my editor, Pam Dillon, with whom I worked over the next two years. Also, the many passionate local entrepreneurs and artists whom I interviewed, each of them infusing me with inspiration that revived my own desire to create. Without them, I may have never rediscovered my purpose in life: to write. Nor would I have found the courage to embark upon the journey of writing this book.

"Bloom where you're planted." My friend Clare Hynes, a brilliant British accessories designer, said these words to me back in 2016 when I was struggling to find topics to write about in the Philippines. I took her words to heart and reminded myself that it was important, no matter how much I hurt, or where I was in the world, to find purpose from within.

Those words came back to me when our world changed in March of 2020. I was scared. But I was also hopeful that as a global community, we would find our way through the pandemic and come out the other side of it better. Kinder. Enlightened. Living with intent. I had already experienced one of life's greatest losses: the death of a loved one. Not going on a trip or getting my hair cut seemed like small inconveniences in the big picture of life. My hope was for people everywhere to find a way to move through this moment in history minimally broken, to instead focus on connecting with others, to keep active and healthy in both

body and mind. I continued to write and support entrepreneurs and creatives through my writing.

The pandemic-imposed isolation had Christian and I, like many others around the world, discussing our options. A move west was placed on the table, and as a family, we agreed that now was the right time. As spring turned into summer, and our impending moving date approached, I became both fearful of the unknown and excited for the new opportunities that awaited us on the west coast. I had already begun to make a wish list of women whom I had found on Instagram or had been introduced to by friends and previous interviewees. By the time we were halfway across the country—literally in Saskatchewan—the list was nearing thirty women.

Over the past few years, my profiles tended to focus on women pursuing their passion in various sectors. Initially, this was an unintentional shift; however, with each interview, I realized that the stories of women, the real stuff, is often left untold or sometimes presented as a polished version. I saw my two daughters' eyes light up every time we read a page from the *Good Night Stories for Rebel Girls* series by Francesca Cavallo and Elena Favilli. I knew how important it was to continue writing about women who often have layers to their journey.

My hope for this book is that it will inspire. I offer it as a gift to future generations of creatives and entrepreneurs. We want to read about the journey toward success and fulfillment. This journey, fuelled by each profiled individual's creative energy, is an ongoing process. We're always thinking, breathing, and finding inspiration in our daily lives. This book, and these stories, isn't about financial success. It's the story behind the person—the movement, the message, the voice, the words, the images, the product, the brand, and the community they've each built. This book is a collection of interviews that highlight the path and importance of creators and collaborators.

Artist Athena Bax put it beautifully when she said, "I'm a big fan of helping women tell their stories. Especially when the stories are about success achieved through soul work. Often hardship and sad stories dominate." And all stories are welcome here.

This compilation of interviews is something I've been working toward all these years as a writer. What I've learned over time is that it's the people like the ones I've profiled here whose creativity, brand, product, and ideas inspire, support, and fuel others' lives with purpose and positivity. People who are passionate not only about their work but also community and giving back.

This book is my pandemic passion project, an attempt to use my experience and enthusiasm to infuse some form of positivity into a world that needs inspiration, of stories, of reading about the journeys of incredible people working hard (oftentimes against the odds) to pursue their passion and give to others. As you read through the profiles on the following pages, I hope that you feel a connection with each of these stories and celebrate your own purpose and passion in whichever form that may take.

Victoria Ashley

Founder, Laundry Day

"Our pieces are designed for everyone to enjoy, but women, in particular, feel very connected to the brand. We provide products that normalize and enhance the cannabis experience, and we create an atmosphere that feels approachable and exciting."

What is one of your earliest childhood memories?
I grew up in the small town of Arthur, Ontario. I can remember always feeling like a bit of an outsider, and I always knew that I wanted to branch out and explore the world beyond where I grew up.

Were you surrounded by and exposed to various forms of creativity as a child?
My family had always placed more emphasis on academics and more traditional schooling/career trajectories. One of my siblings did pursue art in school; however, they are now a lawyer. I wouldn't necessarily say that I grew up in a creative household, but I think that growing up in the age of the internet and television impacted my creativity and was where I found most of my inspiration.

There are many great aspects about growing up in a small town, but I never really connected with where I grew up. I always felt a little bit out of place and looked forward to being able to explore beyond my immediate surroundings.

What brought you west?
After college, I had been living in housing where lots of students came and went. One of my new roommates had just arrived from Tofino for the summer, and after learning more about it I was sold. I wasn't too attached to my life then and was young and naïve. My decision to move west was very impulsive. After googling Tofino a few times and sending out applications, I had accepted a job and was ready to move. It was a bit of a difficult transition at first, but the west coast is now home.

Your brand Laundry Day "is on a mission to provide more approachable, design-forward products that dispel stigmas, redefine outdated expectations, cater to modern voices and elevate and expand the industry's status quo to change the narrative behind cannabis use."
In my early twenties, I had experienced misdiagnosed IUD complications for three years. Throughout that time, I had visited numerous specialists for pain and was prescribed painkillers as treatment. It was during this period that I had begun using cannabis for pain relief and as a sleep aid. Cannabis use was not really being talked about in mainstream media, and it was still very stigmatized, especially for women. I felt a disconnect with how this plant was helping my physical and mental health and how it was perceived to the outside world.

I took ownership over my relationship with cannabis and decided it was time to stop using my partner's old pipe from high school and to treat myself to my own stash and pipe. I drove three hours to the nearest big city and was so excited to finally have my first pipe. As soon as I approached the smoke shop, the neon lights and door plastered with posters felt very uninviting. When I entered the space, I felt uncomfortable. I had stepped into a world I didn't feel welcome in. I ended up purchasing a glass pipe

in a panic and walked out with something I already wanted to hide under my bed. I knew then that I wanted to create a company that provided an entirely different experience for the modern cannabis user.

Laundry Day focuses on incorporating the ritual of smoking cannabis and "taking ownership of this daily ritual."

Taking ownership of my relationship with cannabis was about acceptance. Accepting and appreciating all the benefits it was having on my health and wellbeing.

What was the timeline of Laundry Day?
I had initially worked on a prototype for about one year before it finally hit the shelves of Merge, my retail boutique in Tofino, BC. There were a few iterations that I played with and landed on our Tanjun Pipe—a little staircase-like design which doubles as a pipe and an incense holder.

You currently live in Victoria. How does the physicality, creative energy and culture of Victoria inspire you and your designs?
I love living in Victoria; I spent most of my twenties living in Tofino. Both places have incredibly supportive communities and lots of creative people working on interesting projects. Being surrounded by others who have a vision and are willing to put themselves out there has been very inspiring for me.

What is the story behind the name Laundry Day?
Laundry Day is the one day a week where you really take care of yourself and give yourself an excuse to unwind. Maybe you clean the house, do laundry, have a bath, wear comfy clothes, and just chill.

How was Laundry Day received by the cannabis community?
I'm so grateful for the support that Laundry Day has received over the years. I think that our products speak to a demographic that had never felt spoken to in this space before. Our products encourage people who may have previously felt unwelcome in the space to explore their relationship with cannabis.

Who have been your biggest supporters as you build the brand?
People who enjoy curating their spaces and experiences and those who have an eye for design have gravitated toward our products. Though we make our pieces for everyone, women especially feel connected to our brand. We help normalize cannabis use and do all we can to make the entire experience feel approachable and exciting.

How have ideas about smoking marijuana changed in western culture? Is there more acceptance and less taboo around the topic?
I think that we are very fortunate to live in Canada and experience cannabis the way we have, especially on the west coast. We have come a very long way in terms of acceptance, but it is important to remember that there's still a great deal of stigma surrounding the plant, and there are many people still in prison for cannabis-related convictions. BIPOC communities in particular have been devastated by cannabis-related injustices (especially in the US), and it's important that we talk about that and support organizations working toward policy changes and reparations.

Do you have any training in design?
I design all our glassware and have recently started working closely with a product designer for some of our other products. I don't have any formal training, just lots of self-taught techniques and free online courses!

Do you have a specific space in which you work?
I currently work from my home or out of Laundry Day's Headquarters in Rock Bay, an industrial area of Victoria which houses lots of small businesses and artists. Our space is filled with fun and interesting furniture pieces and art. Mood and atmosphere are everything to me (which is why I started Laundry Day). For example, I've never used our overhead fluorescent lighting in our office space. I need music to concentrate, and the lighting has to feel just right. If I am working from home, I will usually have candles or incense burning all day. I love to feel comfort and warmth wherever I am.

Laundry Day started as one-woman operation but has since expanded, yes?
Laundry Day has always been made possible by the collaborative efforts of other creatives (photographers, graphic designers, etc.). In this past year, we've grown into a small team of both in-house employees and contractors. I could not imagine tackling everything alone at this point, but I think that having been alone in the business for the first

three years, I was able to really understand every aspect of the business to prepare me for this growth.

Which creatives and entrepreneurs do you admire?

I'm inspired by passionate people who wholeheartedly believe in what drives them. As I get older, I find that I truly connect with people who believe in something, and those who do not let fear hold them back—whether that means starting your own business, putting your art out into the world, or working toward changing policy and bettering communities. These diverse perspectives are what inspire me.

Are there any misconceptions about cannabis you'd like to clarify?

Cannabis always felt like a bit of a "boys club" to me. I want women to know that there is a place for them in the space to explore their relationship with the plant.

How has being a primarily online business been of benefit?

It was always my goal for Laundry Day to be an online business. I love that being online allows us to reach people who may not otherwise have access to products like ours. Throughout the COVID-19 pandemic, we saw 600 percent year-over-year growth in our business. We worked hard to build an online presence over the years, and when the pandemic hit, our community showed up for us. I think that people were spending more time surrounded by their belongings in their space, and honestly, people were smoking more weed. Our products provide our customers an excuse to unwind, and people needed that allowance throughout all of this.

You've expanded the Laundry Day line to include candles—and you also love fashion! Can you tell us more?

It has always been my vision to integrate décor into our product line. I imagine that all of our products can enhance the Laundry Day experience without being exclusive to the cannabis user. Without sharing too much, we do have some great collaborations launching this year which include cushions, clothing, and more.

Do you have any words of advice to others looking to embark upon entrepreneurship?

Build a strong community of entrepreneurs and business owners that you can check in with and talk to about your struggles and your wins. Being an entrepreneur can feel very isolating at times. You will go through a lot, and there is only so much your friends and family can support you with. It is so important to surround yourself with peers in your industry and outside of it, those who are a few steps ahead of you, and those who you admire.

Where do you envision yourself and the brand in ten years?

I feel very connected to the west coast, and I can see myself being here for a long time. As for the brand, I believe that Laundry Day will become a household name.

Tracey Ayton

Interior, food, and lifestyle photographer

"As I leaned over and pressed the shutter button, I thought, *This is the beginning of what I want to do for the rest of my life, and as long as I have a camera, I will never be bored.*"

Were you creative as a child?
I was very visual and loved to paint, redecorate my room, colour, and cut things out of construction paper. My mom gave me ample freedom to explore what interested me. My childhood was devoted to painting, cutting paper, sprinkling glitter over things. I never once thought that creativity was a part of me, and that creativity would be the greatest tool I have. Back then, to be creative and make a living was a far-fetched concept. I'm grateful to my parents for giving me the freedom and opportunity to let me figure it out on my own.

At what age did you begin to have an interest in photography?
I was in my early twenties when I discovered photography, after numerous attempts at being something else. After one year of taking all the required courses at college and failing most, I found myself with an "incomplete" status on my records for the Legal Assistant Program. It was liberating.

I later signed up for a graphic design course at a community college. A fellow student saw that I was struggling. I will never forget her because she changed the course of my life. She saw that whatever vision I had in my head I struggled to transfer onto paper. Because I struggled to draw, she suggested I consider taking photography courses. She said that the camera would be the tool with which I could express and share my vision.

With photography, I found my passion and my people. The anticipation of a photo developing in the chemicals in the darkroom inspired me to take more photos and learn as much as I could to create more images. For the next five years, I took as many photography courses as I could. And worked at the One Hour Photo Department.

At age twenty-two, I started a wedding photography business that lasted twelve years, but I kept working at the One Hour Photo because it provided me with medical and dental benefits.

In time, things shifted. The passion I initially felt to photograph weddings started to take a toll on me. I was losing interest, and it was showing in my work. I remember one wedding: the cake was beautiful, the flowers stunning, but I had no interest in photographing the bride and groom. I was in my element photographing the cake and flowers, immersed in taking photos of beautiful inanimate objects. I didn't want to leave all the prettiness at that table and go to photograph the couple as they made their big entrance. That's when I knew it was time to change things up.

You've said, "I fell into being a professional photographer." Tell us more about how this happened for you.
As I walked our dog Griffon one evening, I passed some gorgeous homes and thought, *If I want a nice house to photograph, I may as well try to find one.* I knocked on three doors in my neighbourhood. If I could capture some great images of one of these homes, then maybe...

All three homeowners opened the door, and recognized me from the One Hour Lab. They welcomed me in and kindly offered to help me out.

I was given the freedom to move through these three beautiful homes and take photos. This was an opportunity to learn how to photograph interiors at my own pace. I approached national and international publications and had every one of those homes published. Interior designers started emailing me to photograph their work, and my career kept evolving.

Tell us about first photo you took that made you think, *Maybe this is something I want to pursue as a profession.*
I remember taking a photo of my shoes as I stood on the beach—it wasn't an original concept, but for me, as I leaned over and pressed the shutter button, I thought, *This is the beginning of what I want to do for the rest of my life, and as long as I have a camera, I will never be bored.*

Do you have any formal training in photography?
A good photographer possesses both technical ability and an inherent ability to see and capture what they see in the viewfinder. If you love what you do, it shows in your work, and you'll end up with a photo that speaks to the viewer.

At first, I had to understand the mechanics of a camera and how it works. I carry these lessons to this day.

I will forever be more of an artist than a technical wizard, and having learned on a film camera has allowed me to be more intuitive with digital photography. Instead of looking at shutter speeds and f-stops, I was able to see what a photo looked like immediately when I changed the settings. This opened a whole new way of shooting. I was able to spend more time on finding that composition than having to figure out the best exposure and waiting for the film to come back from being developed to see how it all turned out. I was able to see what my photo was going to look like instantly. To have that freedom and not have to worry about technicalities made room for even more beautiful photos.

There's a stunning simplicity to your images. Is this intentional?
My Instagram feed is a labour of love. I intentionally try to keep a consistency within my feed. I want to show my followers what I'm up to daily, but I also make sure to curate my feed with a consistent colour scheme. Aesthetics are important; most people describe my photos as being "light and airy" but contrasty at the same time.

I live in a little beach community called Boundary Bay, located in a town called Tsawwassen, which is in South Delta. Centennial Beach is thirty steps from my home and besides my dog Frankie, it's the biggest source of inspiration. The subtle hues of the driftwood, the texture of the sand and shells—I love it all!

Why focus on interior, food, and lifestyle images?
I've long been an avid reader of *Martha Stewart* magazine. She can make an outhouse look beautiful. I admire this about her and wanted to capture beautiful spaces too, which is why I enjoy interior photography. With it came food and taking photos of a beautiful pie on the kitchen table, sitting on top of a red checkered tablecloth. I learned that even the smallest details in the styling of an entire house or small vignette are key. My photos tell a story. Using my intuition and having a vision are the most useful tools. I move objects with my hands to create and place things in a way that tells a story. It's all about creating a space where someone wants to live. Even the smallest vignettes can evoke a feeling of happiness.

I recently stumbled upon your "other" passion project, @traceyaytonhome, on Instagram, where you showcase "small batch, handmade, home goods, inspired by seaside living." Can you tell me more about this passion?
Since moving to our home—which is thirty steps from the beach—six years ago, my followers on Instagram have loved this "beachy lifestyle" that has evolved in my photos. Many of them give a glimpse of my walks on the beach with Frankie, or behind the scenes at an interior photoshoot. In spring 2020, during the first two months of the pandemic, I wasn't able to work. This allowed me time to open a shop that would give my followers access and enjoy a piece of this "lifestyle" that I've created. Those two months "off" allowed me to put the wheels of this project in motion. I contacted some of my favourite artisans to create exclusive handmade products that reflect the lifestyle I've curated in both my personal and professional worlds. All the artisans are from BC, except for one from Windsor, Ontario. Selling online was a perfect scenario because people couldn't travel.

Your dog Frankie often features in some of your photos—tell us more about Frankie.

Oh, Frankie. She is a sweetheart! My husband and I were never able to have children, so we've always had a dog, and they are such a big part of our lives. Frankie is a silly character and cute as a button; it's hard not to take a photo of her. She plays a key role in my Instagram posts. Turns out everyone else loves her too. I have to laugh because the photos of Frankie are far more popular. I sometimes think that my followers prefer the personal, simple stories that I share in place of the incredible homes I shoot.

What do you enjoy about collaboration?

I love to see what other entrepreneurs are creating. It's important to support artists and their work. I wanted "Small batch, handmade, home goods, inspired by the seaside." I wanted to be different and see items no one else sold and to keep bringing in different products to keep it fresh. The biggest challenge is to stay ahead of the latest trend. I love the process of finding an artisan with that perfect aesthetic and creating with them a product you won't find anywhere else. The only mass-produced product we have is our bike basket, but for me to stay true to the "handmade" theme, I've had my seamstress make special liners to go inside them.

What are the benefits of mentorship?

I have never worked with a mentor, but I would love to if the opportunity ever arose. On the other hand, I would love to mentor someone; perhaps that's why I love putting on styling workshops. There is a saying: For you to grow and gain more inspiration, you need to share what you already know and inspires you, to make room for more growth and inspiration. It's important to empower others and to share all that we know with women who love to learn.

Your work has been featured in *Harper's Bazaar*, *Martha Stewart*, *House & Home*, and *Western Living*. Congratulations! For someone who "fell into photography," how did being featured broaden your exposure and opportunities?

Honestly, the best feeling is to be recognized for doing what you love to do. I can't take all the credit for getting published, though. I'm simply photographing my client's work, so it's a celebration for both of us. I'm eternally grateful to the neighbours with beautiful homes and those three doors I knocked on many years ago. I'm grateful because it was the images of those homes that helped me get my foot in the door with editors and publications.

How did the pandemic shift our ideas about home?

There's been a shift toward focusing more on our living spaces, seeing as we're spending so much time there. People are working from home; they don't want to work in the living room or kitchen. They need to disconnect from the rest of the house. Kids are also at home in some cases. These circumstances forced people to create workspaces and re-think how we live in our homes.

Athena Bax

Artist

> "I feel so blessed to make a living painting. I genuinely feel that my work is here to help others."

What is your first memory of art?

My first memory is of colouring books. I was excited, challenged, and a bit bored, yet colouring books inspired me to make my own subjects to colour. I was also obsessed with Crayola crayons—the giant box that offered *all* the colours was my dream.

Were you surrounded by creativity as a child?

My mother was resourceful when it came to creativity. She was amazing with floral arrangements and cooking, and she was naturally good at most things she attempted. Later in life I found out how talented my father was. He was a good illustrator. He told me he always wanted to be an architect.

Was art a pivotal part of your development?

Yes. I truly needed to have art in my life, but I had to fight for it. The arts in my family were encouraged, but only recognized as hobbies—not because my mother did not think I was any good, but it was more a reflection of how she was raised. Sadly, survival mode was so ingrained in her that her hopes for her children to be successful meant something more. So, a traditional education was favoured. Thankfully, I had teachers in my elementary school that provided resources and opportunities for me to excel in my art. I was put in a Grade 6 art class when I was in Grade 3. My teachers also paid for me to join a dance school. That later led to me receiving a full scholarship to all their classes. My Grade 7 teacher built a darkroom in our classroom; he never restricted my time in there, and he allowed me to skip almost all my classes to be in the art room—but likely only because I was already a straight-A student. Can I brag? I was only eleven!

After high school you started working with a company in art direction and creation of entertainment software products for clients such as Disney and 20th Century Fox. What that was like for you?

I graduated high school in 1987, but my first job was in 1983, in fashion, at a store in the mall. I was thirteen. I've not stopped working since. I started working in entertainment software shortly after high school. I did not have any formal training, and I had hoped to go to Emily Carr University of Art and Design after high school. I had received the art award in 1983 at school, so attending Emily Carr was my plan, but the job at Distinctive Software was offered so I took it instead. I have no regrets. Distinctive Software went on to become a part of Electronic Arts, an amazing experience in a culture I really knew nothing about.

After working in the above position, you then became a part of the internationally respected MAC team. How did these experiences fulfill and motivate you?

I worked with MAC for several years facilitating their paid services, and for a short time as a trainer. The experience with makeup was amazing in a different way. I went from a very male-dominated environment to a very feminine-energy environment. It truly was fine art to work on human features, and so gratifying to see instant results while helping women see themselves in a different light—literally, sometimes, by breaking makeup habits that told them

a false story. I went on to audition for an international makeup team that supported the hair product brand Wella, and Proctor & Gamble.

I flew myself to Los Angeles for a three-day audition for a company called Sebastian, owned by the Wella Group. There were 500 applicants. I didn't really know what to expect. I won one of twelve spots. As a team we did fashion weeks and taught in-field artists the new trends in "train the trainer" classes. I spent a lot of time on an airplane traveling the east coast of the us. We had a gorgeous studio at 30 Rockefeller in New York. Alas, all things came to an end as the team was slowly dismantled. It was seven great years of being exhausted, but it was all worth it. What I realized is that women are fascinating; their love of makeup really comes from a very self-scrutinizing eye. I should know!

Let's talk about that moment in 2003 when you decided to start painting full time. It started with a portrait of your mother, who died young from leukemia.
Yes. This painting was significant because it was the first time I had created something just for me. I also felt different about my abilities when it was done. Mind you, I think my late mother or an angel helped me paint it because it took me only eight hours to complete through the late night and into the early morning.

It was also the first time someone who knew me told me they thought I should do this full time. Something clicked—the courage, the energy, the care, it had all arrived for me to dedicate my life work to painting. No regrets on that decision

The painting was and still is my most magical—the light and paint strokes around my mother's face are just so not my way of painting. I believe it was a higher power saying, "Here, see the light . . . go . . . paint."

Would you describe yourself as a self-taught painter?
I have no idea what makes a great painter. Perhaps it's how one feels when one first sees the work in front of them. Art either moves you or just gives you an opinion. If it moves you then you can go deeper into that as a start to visualizing how the painting can live in your home. Otherwise, one may criticize, finding reasons that maybe it won't work in one's home. It all comes down to self-honesty, love at first sight, or rejection. As for technique and talent, I'm not sure. I've seen a red circle fetch $50,000, so it's all up to how a piece makes one feel in their head and heart. There is great

value in formal training, but to answer your question, for me the lack of voices in my head telling me what is right or wrong is a blessing. Stumbling and fumbling with the paint is not a big deal for me. I never feel that I'm doing something wrong. Ignorance is truly bliss, I guess.

Do you see a recurring theme in your work?
The recurring theme seems to be "blending." I *love* blending so everything seems to melt into each other—except in my animal portraits; they require a bit more discipline with my thoughts. The blending technique is rather magical for me because the effect is the soft focus, but the relationship between colours, water, brush pressure, give feeling—transparency and opacity right next to each other. It's almost like seeing through the skin of a flower petal.

If we were to talk a walk through your creative process, what would that look like?
I like deadlines. If I'm painting a commission piece the concept has been identified and agreed upon, so I have an open-and-shut case to work on. But if I'm in development of something that interests me—for example, my current hydrangea series—they can take months and years. I have one painting that has transformed twelve times, and it's going on seven years of development. I like to see where a piece goes—push the paint to create something that I've not seen before in my work. I guess I don't want to bore myself. My wish is that whoever has a piece of my work just loves it and welcomes it into their home like a new family member, and that they never tire of the "hello" they give it whenever they walk past it.

Is there one piece with which you feel a special connection?
My mother's portrait. But honestly, I call them all my children because I really do like them all the same. I often say, if it's on the easel right now, that's what I'm currently obsessed with.

Do you have a specific space in which you work?
I have a wonderful studio space I've been renting for over a decade now. It's improved in its aesthetic since I first moved in. The ceiling is high, so I've hung five-plus chandeliers that seem to float. The theme is creamy white and black, much like the French or old English townhouse feel. I've currently acquired two antique mantles that I've

painted white. I think I'm determined to turn the place into Buckingham Palace meets New York loft. Music-wise, for years I played Sarah McLachlan while I worked. Now I'm listening to old Dean Martin and Frank Sinatra for some reason. Also, some Bon Iver played for some time, which was random. As for scents, I'm in love with the Christmas tree candle I have, so I burn that when I remember.

How does the physicality, creative energy, and culture of Vancouver inspire you and your work?
Nature is my main source of inspiration. The ocean is where I went to in the beginning. I studied the water over the rocks, wet and dry. The seawall offered the look of paintings in my mind every second I walked. Photographs are how I capture the outdoors. I have stacks of my own reference material at the studio. I can identify the smallest detail that made me take that photo; even if it's years old, I can still see the inspiration in a colour or leaf.

Your work is collected by both private and corporate collections, including that of Bill Clinton.
That was an awesome moment for me, to communicate with the former president's people on how to capture a portrait of his beloved late dog Seamus. The painting was commissioned by his friend, philanthropist Frank Giustra. Mr. Giustra has collected my work since the beginning. Thus, it was through him that I was graced with the task of painting the pup. President Clinton sent me a note that year saying that the family was enjoying the painting and that it was time Seamus shared the spotlight in their house.

You've said, "My art is here to serve." Why is philanthropy important?
It's simple: I feel so blessed to live and make a living painting. I genuinely feel that my work is here to help others, that our purpose on earth is to help others help themselves. I believe we can't do everything, but where our joy is, where our personal joy and good work comes from, is where we have it to give. I will paint for as long as live.

Can you describe your dream space to exhibit your work?
I guess I'm living the dream in my current space. I'd like to work on having more people come by to see the work. The pandemic made me appreciate that fact more.

You've made mention of the connection between art and fashion.
For me they coexist as daily fuel. I love fashion, as inspiration and to wear. I feel physical joy when I create clothing looks; it's my happy place. Not terribly unusual, I think, that I'm working on a side gig creating vintage, re-imagined pieces—mainly coats. But that's another story.

How was your work affected by the pandemic?
The pandemic has been a good thing overall for my work because it's allowed the distractions of life outside be very silent. Most artists work solo in quiet anyway, so having a cleared schedule let the quiet details in my head move forward. It's been a productive time.

The negative is the lack of social events. I love my friends. I miss them. We seem to all have gone into a hibernation.

Why is art important, especially now?
Art is important for so many reasons. If it's art in your home, there's a measurable energy that lives in the work. Something made with love gives love. A print cannot emit that energy. During this pandemic, being creative or seeking creativity is like a gift that is finally ready to be opened. Our walls, our pantries, our sewing machines are all there to facilitate growth. Creativity is a way to heal. We don't need to be sick—we just need to feel that something is missing. You will quickly feel the gift of tangible love, like art. I realize that my answer to this question is so artsy, but I know it to be truth. My hope is that this pandemic will have given the gift of art to so many people and that it will have allowed different forms of art to emerge from the busy place that was once occupied with something else.

What words of advice can you offer someone looking to explore a profession in the arts?
Ask someone accomplished if you are good. I did. Before I took the leap of faith, I asked Vancouver-based artist Shannon Belkin her opinion. She gave me the green light while sitting at the bar at Earls. I was grateful that she met me and gave me thirty minutes of her time. Those thirty minutes will be felt throughout my entire life.

I also feel that we truly know what our calling is. It's a fine line between *I can do it* and *I want to do it*. We just know. And that knowing is usually there from when you were little. I think we start our true careers at four years old.

Laïla Bédard-Potvin

Founder and creative director, harly jae

"There is much value in owning a small closet full of pieces that you love, and having a collection of stories about the people you support through your purchases."

Were you a child who enjoyed playing dress-up?
I don't recall playing dress-up a lot, but I do remember designing clothes for my dolls. I spent a lot of time with my grandparents as a child. They ran a care home for the elderly, and I was sort of everyone's granddaughter there. One lady in particular loved knitting and spending time with me. I would tell her what kind of outfits I wanted for my doll; I would pick colours based on the yarn she had, and she would knit for me. It's a very sweet and unique memory I'll always remember. My dolls were very stylish.

What was the fashion scene like where you grew up?
I'm from a small town that's about forty-five minutes outside of Québec City, so going shopping there was a big event. I think that, compared with Vancouver, people dress up more in Québec.

How would you describe your style?
An ever-changing and experimental approach is how I would describe my style evolution. This definitely describes my clothing choices as a teenager. I started caring about what I wore at a young age—probably too young, to be honest. In my hometown there was one nice clothing store, and as a child my grandma took me shopping there *a lot*. I remember adults telling me how well-dressed I was. As a teen I followed all the trends (low rise jeans, anyone?).

I remember going from punk rock- to hip hop–inspired clothing in the same high school year. I cringe when I look back at photos. Later in my teens it was all about brands over style. I consumed a lot of clothing during those years.

When did you realize that fashion would be your future?
It's funny to think about this because it's almost like it was written in the sky, yet I could not see it. Fashion has always been such a big part of who I am that for a long time I assumed it was the same for everyone. I did not know I had an affinity for it. I did not make concrete plans to study fashion until I was nineteen. And even when I made that decision, it never crossed my mind that one day I would have my own brand.

You moved to Vancouver in 2011 to pursue a career in fashion. What inspired that choice?
I came to Vancouver because I did not get accepted into my dream school in New York City. The news came as a shock, as at the time I was certain I would get in. Since I did not want to wait until the following year to start, I searched for schools that offered a shorter program. I found Blanche Macdonald Centre's one-year diploma program. I intended for it to be a trial run to see if I truly wanted to pursue a career in fashion. The plan was to re-apply to the New York school the following year. A couple months later I found myself in Vancouver for the first time. I was twenty and did not know anyone here. I had to grow up quickly!

I spent the following year studying the ins and outs of the fashion industry, and when I should have been ready to jump into the career I always wanted, I instead felt lost and misled. I had come to the sad realization that the fashion industry was not as glamorous as I once thought.

That year in fashion school, combined with being away from everything and everyone I had known up until then, was transformative for me. For the first time I could be who I truly wanted to be without the judgement and preconceived ideas of the people I grew up around. Until then I was so focused on what I looked like and what people thought of me. It was freeing to have the opportunity to start over and rebuild my sense of identity.

While this personal change was happening, I was learning things about the fashion industry that did not align with who I was becoming. After I completed the program, I took a year off. I was twenty-one and had no direction. It was a challenging year trying to navigate what was going to be next for me. I eventually decided to go to university with the intention of finding a job with a non-profit organization.

When did the idea for your clothing brand, harly jae, come about?

It was an aha kind of moment. Before even finishing university, I got that nine-to-five, non-profit job I had my heart set on. I felt like I finally should be happy, yet I wasn't. I had never worked an office job, and oh, man, it was not what I had imagined! Three months into that job I took a trip to Hawaii. I was soul searching and made a commitment to myself and the universe: *When I return home, I will say yes to every opportunity that comes my way.* The idea behind this was that I would meet new people that would perhaps show me the way to what I should be doing with my life.

The night I got home from Hawaii I received a text. A friend of mine was starting an ethical bathing suit line and she needed my help with her photoshoot that was taking place that weekend in Tofino. It seemed impossible for me to go at first, but I made it happen because I wanted to honour the commitment that I had made to myself while in Hawaii.

I think of that weekend as the event that changed my path. I spent a few days in Tofino with women who were creative and were pursuing their passions. I saw that it was possible to lead a totally different life and that I too could build a fashion brand that would align with my values. Et voilà!

After that weekend I immediately started to work on my brand. harly jae pieces are timeless. They are beautifully made with great tailoring in a colour palette that will never feel out of style. And everything is ethically made right here in Vancouver.

Tell us about the name harly jae.

The name *harly jae* means "Jess on his Harley Davidson." Jess is my dad who passed away when I was eleven. He always lived his life a little differently. Unfortunately, I was too young to appreciate his unique perspective back then; I was more concerned about fitting in. Since harly jae is my way to shake things up in the world of fashion and to create my own path on this earth, it seemed well-suited to have the name be a reminder of who forged these values in me.

Why did you decide to stay in BC?

BC totally changed me. I feel at peace here. I love the proximity to the ocean. It feels like home to me. I also met my husband a couple years before starting the business. I could have never pursued this dream if it was not for all his support. Right now, living here simply feels right.

Tell us what it means to be a "Canadian slow-fashion house."

I love this tagline because when I picked it, I had never really seen anything like it. I am proud to be Canadian, and with my Québec upbringing and now living on the west coast I feel *Canadian*. As a designer I feel like I bring a Canadian perspective to my clothing.

I like *fashion house* because typically only the big names use this term. Paired with *slow*, it's a reminder that I want harly jae to be around for a long time and achieve big things, but I will do it at a slow and sustainable pace.

I have been in business for four years now, and it has been exciting to see the shift toward sustainable fashion consumption. It's almost mainstream at this point! I hope it's here to stay because it is our only way out of the damage fast fashion has created. Once we start shopping mindfully, it's hard to go back to overconsumption. There is so much value in owning a small closet full of pieces that you love—and stories about the people you support through your purchases. I did not know clothing and accessories could bring so much joy, yet they do when you carefully plan for each addition you make to your personal collection.

How can we make slow, sustainable fashion accessible to more people?

We've been told we need the newest, shiniest thing. There's freedom to be found in establishing your own shopping rules rather than following the marketing tactics we are fed.

We need to look at pricing in a different way. I thrifted most of my clothes and accessories during harly jae's first years because I wasn't paying myself a salary. I did not have the means to support small designers back then, so it was my way to be mindful. Now that I can shop from sustainable brands, I find I spend less on clothing and accessories than I used to. I plan my purchases. Less is more, and I prioritize quality over quantity. I also like to think that you *invest* in slow fashion because the pieces you get can be resold; they hold value.

Tell us about the Zero-Waste line.
When we make our clothing, there is always a little fabric that ends up unused. These small fabric off-cuts would typically end up in the landfill. In the spirit of lessening our waste, we collect these fabric pieces and give them a life of their own. The benefits of this collection are to create more with less. From scrunchies to hand towels and bandeau tops, we could create brand-new pieces out of what would otherwise be waste.

All our clothing is made here in BC by two very small teams. It's a small operation that I think would surprise most people. The benefits are that we get to produce everything in small batches to avoid overstock and that I can drive over to check in on what's happening at any given moment. I value the relationships I have built with everyone over the years. It makes running this business very special.

What have been some of the challenges and benefits of building your own fashion label?
The biggest challenge around building harly jae was to keep at it when I first started. It was not an overnight success, and it was hard to see the big, long-term picture at times. I am glad I pushed through those hard times to get to where I am today. The most surprising benefit to starting this business has been the community. Every day I get to interact with amazing people, mostly women, who are our customers, suppliers, other small business owners, and change-makers. They have been my biggest supporters and make this job incredibly fun. There really is a movement of women out there who are making it their mission to promote slow fashion and small brands, and I'm so thankful for that.

Who, where, or what inspires you?
My focus is always to create extremely wearable pieces. The people who inspire me the most are everyday people I see on the street, or effortlessly stylish women I find on Instagram. I want people to feel light, calm, and empowered in my clothing. I achieve this through the silhouettes I create based on vintage clothing and photographs I find. The fabrics I use are a big part of our aesthetic. An entire collection can be inspired by a single type of fabric I discovered.

Your new studio space is stunning—so airy and filled with natural light! What is it like to work there?
You could not have said it better—that is exactly what I was looking for when we outgrew our first studio: a space and décor that is a true reflection of everything that is harly jae. There is beautiful natural light, a vintage touch with the arched windows, and calming, neutral tones. Every time I walk through our doors, I feel calm and inspired. It's a feeling that does not get old, and it is a feeling I hope my customers share when they come visit and when they wear harly jae.

You recently became a mom. Congratulations!
Thank you! If I'm being honest, I did not particularly enjoy pregnancy. I had a very hard first trimester both physically and mentally. I was unable to work on my business for three months. I eventually felt better, but by that time I really needed to play catch up and go into planning mode to ensure the business could support a full-time employee when I had my baby girl. It wasn't a particularly creative time for me, unfortunately. It's hard to take care of myself right now, but I'm not feeling bitter about it. I love being Reya's mom, and my attention is mainly focused on her right now. As for the brand: I still work, but I have an incredible employee that has allowed me to offload some major tasks (shoutout to Christi!).

How has the pandemic affected you?
I feel fortunate that the pandemic has brought a lot more good than bad into my life. My then-fiancé and I spent a lot of quality time together during quarantine, and even though we did not get our dream wedding in Greece, we instead had an intimate local wedding that was perfect. This time of stillness made me realize I was ready to become a mom and take my business to the next level. I spent a lot of time working on myself and feel totally renewed. I leaned into the unknown, and it paid off.

Leah
Belford

**Jewelry designer,
Leah Alexandra Jewelry**

"To me, this is more than just a business. My whole life is wrapped up in it, and I wouldn't have it any other way."

What is your first memory of jewelry?
My grandmother wore a goldfish necklace daily. It had ruby eyes and moving scales that always captivated me. I often get inspired by antique jewelry, so naturally we made a "Nana Fish" to add to our collection!

At what stage of life did you realize that designing jewelry was your passion?
Like so many young girls, I often had embroidered or "gimp/plastic" friendship bracelets. It wasn't until around age eighteen that I discovered a gemstone bead supplier, and after that my love for designing jewelry blossomed.

You mention having "a lifelong obsession with gemstones." Can you tell us more?
This obsession was also sparked by one of my grandmother's pieces. She had a ring with different birthstones—five to represent each of her five children. I was smitten with it.

What is the first piece of jewelry you designed?
A bold turquoise "nugget" necklace—sadly, I sold it, but I have several early experimental pieces that I have stashed away for trips down memory lane.

Would you say that a good designer draws on both formal training and inherent talent, along with real-world experience, to create beautiful pieces? What has your journey been like in this regard?
My design training began at Ryerson University, which is where I received a bachelor of fashion communications. Shortly after graduating, I left Toronto and moved to Vancouver, where I worked for a local jewelry company and deepened my love of gemstones. I then enrolled in a metalsmithing course, followed by an internship with a local goldsmith. It was during this time that I began slowly but surely collecting materials to create my own pieces I felt couldn't be found elsewhere. While my educational background is an important part of my journey, I believe that taking initiative to learn more and teach myself is what has helped me grow the most as a jewelry designer. Formal training is great for teaching theory and technique, but some things cannot be taught. Passion and talent are invaluable qualities that make a designer unique.

Which jewelry designers and creatives do you admire?
I follow a lot of interior designers and photographers. It's difficult to choose just a few, but interior designer Athena Calderon and photographer Brit Gil are two amazing creatives that inspire me.

Who, where, or what inspires you and your designs?
One of the most influential aspects of my design process is travel. I love getting to experience new places, each with their own unique story to tell, often spanning centuries back. These histories are what make these places special, and I strive for that same storytelling quality in my designs.

Each piece is thoughtfully designed and made with quality materials so it can tell a story that transcends time and place. We call our jewelry "future heirlooms" for exactly that reason, whether it be a token of ever-growing love, a talisman that provides protection, or a gemstone that enhances wellbeing. Jewelry is a special part of people's lives and can be passed down through generations. I feel so lucky to be a part of the very intimate and special experience of giving and receiving jewelry.

Can you please walk us through your process when designing a piece?
For me it often starts with sourcing the stones. The colours, shapes, faceting, combinations—they often spark inspiration for a new piece. From there I make a sample and take it for a "test drive" and review it with my team. Basically, it must be something we all love and want to wear. Once approved, it goes to our creative team where it is photographed for launch. Meanwhile, I price the item and give it a name. We show new pieces to our retailers first, and a short while later is goes live online.

You shared with me that the studio space and showroom are a pivotal part of your creative process and brand. Can you tell us more about this space?
We have a unique heritage studio in the heart of Gastown. There's natural light streaming in from both sides, which is important when being creative. We always have a variety of music on, which gives our space a casual, social feel. We're primarily all in one open space, which means we've gotten pretty good at tuning out the white noise and staying productive.

"Our business is fuelled by eight vivacious women who each play an integral part in what the brand has become today." I love this. It speaks volumes of how you cherish everyone on your team. What is the vibe in the studio and showroom?
We spend so much of our lives working, and while some people may look at that as a negative thing, I prefer to see it as an opportunity to spend my time fully invested in my passion.

A workplace is a delicate ecosystem that requires care and balance. Passion and a positive attitude are important things that I look for because it's important to me that my team feels as excited and happy as I do when I'm at work. In the studio, we've kept the design of the space very open to embrace the importance of community, collaboration, and communication that contribute to an inviting atmosphere.

Build your community. Building a business on your own can be all-consuming and isolating when you're just trying to keep plugging away at all the building blocks. Take time to build relationships with other like-minded entrepreneurs. Share trials and tribulations. We all have something to offer each other, whether it's support, inspiration to think bigger, and encouragement to keep striving.

You're inspired by travel. Which places in particular? What about travel moves you and inspires your designs?
I like alternating between somewhere with grit and somewhere completely peaceful and remote. For example, the stark contrasts of India and its challenges, adventure, and overstimulation really move me; it also happens to be where most of our gemstones are cut. To recharge, I often return to Barbados. It's a familiar paradise as I grew up visiting my family there, and I'm obsessed with the food and culture as well as the turquoise water.

What is your dream travel destination?
At this point, anywhere is a dream! I'd like to revisit and spend more time exploring Corsica, an island off the south coast of France. It's unspoiled by tourism and has so many remote beaches and villages to discover.

You were born and raised in Ontario and have now rooted yourself here with your brand. When did you move to Vancouver?
I was born and raised in Ontario, and I moved here when I was twenty-two. The following year I started my business, never imagining it would go this far. Fast forward to the present day: The company and community surrounding it was built from scratch, and I have such strong roots planted now I would never want to move away from my team. I consider it a permanent home base from which to do a lot more travel in the future.

Your designs have been featured in *Vogue* and *Elle*. Congratulations! Celebrities such as actors Jessica Alba, Reese Witherspoon, and gold medal Olympian ice dancer Tessa Virtue have worn your designs. You launched in 2005, years before social media platforms such as Instagram became integral parts of branding. How did you grow your brand, and do you feel you're growing at a pace that's right for you and the brand?

Thank you! It's an amazing feeling to see Leah Alexandra pieces being worn, whether it be a celebrity or someone visiting the store. Every year, the brand grows more and more, especially now with the wonderful exposure and connection that social media provides. To me, this is more than just a business. My whole life is wrapped up in it, and I wouldn't have it any other way.

Having a personal approach to marketing allows the customer to feel connected to the brand on a deeper level while they feel part of the journey, which ultimately gives the brand's platform more influence. The social media content is a mixture of quality photographs of the jewelry, behind-the-scenes glimpses into production and what's happening in the studio, documentation of my travels around the world for pop-ups, tradeshows, gemstone sourcing, and general inspiration. Nurturing that organic connection and showing the human side of things is what I believe makes a brand strong. We've got lots of new things on the horizon, and I can't wait to share it all with the world!

You're opening a shop in the Fairmont Hotel, Vancouver. How do you think this will expand the brand?
This has given us an opportunity to create a physical space that truly reflects the brand. Our store is not only about the product—it's very much an experience, especially with our welded "Spark Studio" bracelets. Stay tuned on the next location.

What have been some of the challenges and positives of the pandemic?
We are very fortunate to have a business that is primarily online based. The biggest challenge in the beginning was getting everyone set up to work from home; there are so many moving parts with jewelry production and shipping orders out internationally. The biggest positive was taking this as an opportunity to slow down and enjoy the simple things. Vancouver is not a bad place to be stuck for a while.

Have you found new inspiration during the pandemic?
I've always relied on travel as the biggest source of inspiration, so this has been a time to discover new avenues for that. I'd say it's been a reminder of the importance of human connection above all. How fun that we get to be a part of that with precious tokens of meaning.

Jewelry has marked many of my most memorable life experiences, from the births of my two daughters and the passing of my mom. Why do you think that we make such strong connections with our pieces? And how do you as a designer ensure that each piece you create has a sense of connection and timelessness for the wearer?
Jewelry has a very special way of encapsulating emotion. Whether you're wearing a piece that was given to you by a loved one, passed down from generations, or bought for yourself, it holds special meaning. We wear these pieces every day, on special occasions, or as a heartfelt reminder. Every piece is designed with a story in mind. Its materiality, design, and quality are what make a piece timeless, but it's up to the wearer to make it their own (and that is what makes each piece special).

How do you hope people feel when wearing your jewelry?
Loved, empowered, and beautiful!

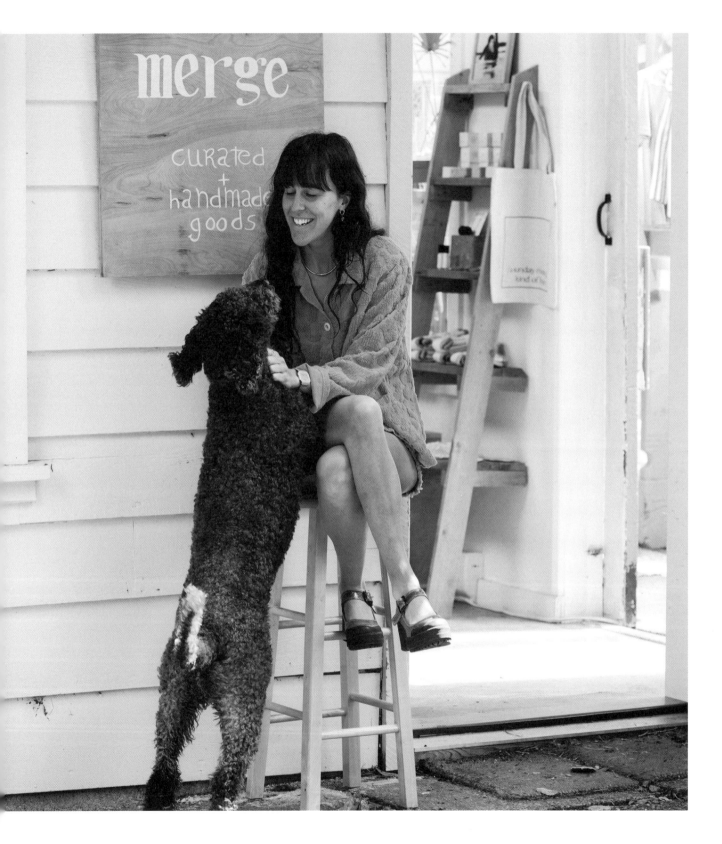

Laurie Boudreault

Creative director, Merge

"I'm very lucky that I'm living the life I've imagined for myself."

How did your hometown shape you?
Québec City is a beautiful European-like city that, although small, offered up the opportunity for me to see cool exhibitions, partake in creative outlets, and shop at thrift stores and enjoy many seasonal festivals.

What motivated you to move from Québec to the west coast?
I fell in love with surfing while travelling. After coming back home from a year-long backpacking adventure, I craved the waves. There's no surfing in Québec City. I made it a goal to have surfing as part of my everyday life.

My dream was to move to New Zealand. I had travelled there for six months in 2011 and it left a lasting impression. But then I heard of Tofino and thought it would be a good first step toward attaining my goal. I'd still be in Canada, so there'd be no worry about visas. I moved to Tofino in 2013. I was twenty-three, thinking I'd stay for a summer. Nine years later, here I am still, loving it!

You have a deep love for surfing and surf culture.
That year-long backpacking trip was one of the best times of my life. I travelled from Iceland to Fiji. I worked at surf camps in Portugal, France, and New Zealand while also learning to surf. One of my favourite memories is living and working in a surf camp located in the beautiful town of Ahipara, New Zealand.

Have you always been inspired by aesthetics?
Absolutely. My eyes shine looking at tiny bits of shells crushed on the beach, forming a beautiful sand-like layer with a zillion shades of whites, beiges, and blues. A well-designed object or a thoughtful detail gives me butterflies. I'm a paper texture addict and always appreciate nice packaging.

I have a background in fashion design as well and enjoy fashion books and images of high-end runway designs. I really felt a connection with fashion design from a young age. Later, as a teen and in my early twenties I would close my eyes and see the fabric moving, the details of a jacket coming alive. Edgy and unique concepts would come to me in a very organic way. It's a big part of who I am.

You run the successful lifestyle store Merge, a shop focused on "thoughtful objects and lifestyle."
This has been our idea since the beginning. It became more of a lifestyle store over time. We started sharing more about our ways of seeing the world with our clientele and noticed how they connected with our vision and values. We also took note of people sharing stories of their connections to the goods they purchased at Merge and the joy it brings into their everyday life.

Merge is an extension of myself, in that the shop aims to celebrate a coastal lifestyle through pieces that enhance our lives. This idea is a pivotal part of the inspiration behind Merge.

Tell us more about this brand statement: "Merge is a lifestyle shop with a focus on providing long-lasting goods and Canadian-made products. Our selection aims to effortlessly inspire and uplift simple moments

and rituals while celebrating human connections and empowering creativity within the marketplace."

I feel like we're always working hard to maintain the mission above, to find products that are thoughtfully designed and made by small businesses. The items we carry are unique and stand apart from mainstream, mass-produced brands. We want to offer people both a physical space and online platform where they can purchase items that empower and support the creativity that is out in the world. In showcasing the pieces and products made by talented craftspeople, we help our clientele connect with the stories behind the brands and hope they will find inspiration to be creative themselves. The main obstacle is to focus solely on local and Canadian brands. We sometimes make exceptions, and there's often a good reason behind carrying a non-Canadian brand.

Please walk me through your journey of opening Merge.
In 2015, my friend Victoria Ashley (who owns Laundry Day, a high-end smokeware line) and I were both looking for a workspace. I had a jewelry line at the time, and she was doing leather crafting. We came across this abandoned little building in an alley in downtown Tofino and saw the potential of the space. We had more room than we needed for our work and thought we should showcase other designers, like a brick-and-mortar version of Etsy. Although we were nervous, young, and had little money, we took a leap of faith. What was a little hidden blue house became the now-adored pink shop that is Merge.

We renovated the building and worked hard to build our store. The goal was to create a trustworthy place where we could approach brands to work with on a consignment basis. That was a great way to start as we didn't need cash flow. We spent most of our time there, while working part-time at other jobs, pulling doubles (at our store during the day, serving in a restaurant at night) plus countless hours at home.

Victoria and I professionally parted ways in 2018. I had a bigger vision for Merge, and she wanted to focus on launching Laundry Day before the cannabis market opened. We're still best friends and talk on the phone about life and business.

In addition to your formal training in fashion and graphic design, did you take business courses?
I wish I had taken business courses. It's been a learn-as-you-go journey. Thankfully, I've always been good with numbers, and I'm disciplined and dedicated, trusting the path and my instinct. I'm always learning about marketing, managing employees, time management, building a brand and so much more.

My background in fashion and graphic design has helped me so much! I do graphic design daily with Merge, whether it's designing the new stickers for the bag, the logo for the roll-on perfume, the Instagram polls, a new tee illustration, etc. Sourcing brands and creating my own brands within Merge has helped refine my eye for visually strong aesthetics

My fashion design background has helped me better understand how to source materials, speak with factories, understand quality, and create Merge capsule collections and technical sheets. I also did an internship for a designer in Paris in my early days; she taught me the importance and beauty of natural fibres.

At the shop, I know how I want the items to be displayed in the store to create certain themes. It's important for me to show care via attention to details and what and how we curate the shop, both in store and online.

My instinct for the store is to focus on a brand to stand out for its quality, ethos, and uniqueness. We also make sure that we showcase *la crème de la crème* for each category of products. For example, we carry what we think is an amazing body cream, not ten different ones.

What makes Merge unique?
Our capsule collections. We seek what is missing in certain product areas and look at how we can incorporate a collection that will allow us to work closely with makers, small businesses, and sometimes bigger companies to produce a store brand line of goods.

Our curated collection of goods focuses on quality everyday products and surf-inspired pieces.

As a brick and mortar, I ensure that the details—mailing stickers on the boxes on which we handwrite each customer's name, the Spotify playlist card we give customers so they can tune into what we listen to, messages on our social platforms—create a unique retail experience.

I feel it's important for a business to find its niche and be genuine. You can't do it all, and you can't please all.

At Merge, our focus is to showcase Canadian craftsmanship, alongside locally made goods. We think it's rad to tell someone, "Oh yeah, the mug you picked was made thirty minutes from here!" or "The girl knitting your sweater has a master's in knitting and lives on Vancouver Island." We want to support the creative community who produce

with passion. We want our customers to invest in items that have a story, that aren't mass produced and can be a meaningful addition to their life. There are so many amazing brands coming out in Canada, and I love supporting that.

We carry beautiful, thoughtful objects that are born from creative individuals who are passionate about ingredients and sustainability. Our aim is to support and sell brands that care and do good in the world.

The same goes for our Merge goods. I take inspiration from Alan Moore's book, *Do Design* in which he says: "Design elevates, nurtures, and improves our lot... Have nothing in your house that you do not know to be useful or believe to be beautiful."

You often say, "Do what is true to you," and "Never stop being curious."

As women, we need to believe we can archive anything. I have been told from a young age, that things always seem to happen my way. I attribute that to the fact that I listen to instinct, make changes if needed, trust the path, and vibrate on a high frequency when I can and dare.

My personal and professional lives are intertwined. Merge is an extension of who I am as it's how I express myself in the world. Everything I do on the daily can be a form of inspiration for my business. To never stop being curious, for me, is about staying aware and open.

Who have been your biggest supporters?

My friends, especially Cristina Gareau, who gets me and my aesthetic like no one else; my family for always believing in me; our customers and community who keep sending words of encouragement and love; my friend and previous business partner Victoria; my partner Jason—who understands the concept of beauty and who patiently listens to all my worries and thoughts while offering up great business advice—and Valérie Minville who was one of my first employees.

What are some future projects, ideas, and brand collaborations?

What a fun question! We're currently at work on a line of glassware; a t-shirt that shares a collection of quotes I've lived by, from two notebooks written over four years; a beautiful and purposeful beach bag that can go anywhere; and a stunning glass for your daily beverages.

In the next couple of years, we aim to launch a Merge denim collection, a home organizer item that will help achieve work/life balance, an oil for sun-kissed hair, and much more. If money were no issue, we would be as busy as Santa Claus the month before Christmas, designing and producing new items. We're not short on ideas here.

Who, where, or what inspires you?

What inspires me most is how this small community focuses on living with the elements, enjoying one's home and connecting with friends—simple yet important things. Surfing is also a big part of my life; it's what fuels and fulfills me, which in turn benefits how I approach my work and overall happiness. A good surf often takes over my work, and Merge has to wait when it's on.

I feel a strong sense of belonging in this supportive community; not everything can get done right away, and you can always ask your neighbour for help.

How has the pandemic affected you?

Personally, the pandemic has inspired me creatively. Overall, it's been hard. Not travelling, which is when and where I find inspiration, and not seeing my family, has been difficult. Also, I miss connecting with friends.

For the business, it was hard to pivot. We closed for two months at the beginning, but to my surprise, it was wonderful. It's as if we stopped time for those two months. I surfed a lot; the town was peaceful; I puzzled and made sourdough bread. It was really something beautiful, to pause. I learned how to slow down, to accept that things might get done later, to be patient, to lower my expectations and quiet my tendency to over-achieve.

After this quiet period, business boomed. We launched a new website, our online did better than ever, and being in our fifth year in business, it felt like there was a significant switch, with Merge heading in a whole new direction and becoming its own thing.

Do you have words of advice for those looking to embark upon entrepreneurship?

Work hard. Focus on what you're good at and hire people more knowledgeable in other areas for the remainder. Define what makes you special and go for it; don't compare yourself to others. Learn from inspiring people; don't hesitate to ask questions. Create balance; time out is as important as time in. To be energized and inspired, you have to take a step back and be human. Play, connect, and create.

Erin Brillon

Creator, designer, entrepreneur, Totem Design House

"One of the healthiest things we can do for ourselves is practise our culture."

Can you share with us a fond memory from your childhood?

Spending time with my grandparents. I am the eldest granddaughter of my Haida grandmother and Cree grandfather, and my brother and I were showered with a lot of love and attention.

You have a rich and diverse background—Haida and Cree Nation (mother), and Irish and Italian (from your biological father). How did each contribute to your understanding of culture?

In my lived cultural experience, I only have one side of my family: my mom's. My biological father and his family were not involved in my life, so my only cultural experience is that from my grandparents who were a pivotal part of my life. I didn't know I was anything other than Haida and Cree until I was nine years old. It's a funny story, in that my brother and I had the same teacher for Grades 3 and 4. Every year our school hosted International Days where each kid was expected to present on their culture. My brother presented on Haida one year and Cree the next. Then, when I was in her class, I did the same. Mrs. Clarke asked me why I didn't want to present on my Irish culture, and I replied, "I'm not Irish." She said, "Well, you must be; your last name (Rooney, my birth surname) is Irish." I went home after school and said to my mom, "Mrs. Clarke said I must be Irish, and I said I wasn't." My mom replied, "Yes, honey, you are Irish." I burst out crying. I had no idea, and I felt so disillusioned.

How did your upbringing influence your path?

My grandmother was both very religious, but also somewhat paradoxically, very in tune with Indigenous spirituality. It seems sort of like holding opposing beliefs—to believe in God and heaven, but to also believe in reincarnation and spirituality and intuition. But this was how I was raised—with morality and goodwill and service to others, but also awareness of and connection to my intuitive higher self. My mother was deeply involved in personal development and spiritual/psychological healing modalities as a means of healing from our inherited intergenerational trauma. I was introduced to those ideas at a young age. I also sought out native traditional healing ceremonies from my mid-teens onwards. I was born a curious person and have always sought to understand practices that can help us live healthier and happier lives.

How would you describe your path?

As a young child I was very confident and expressive, and while I enjoyed a lot of alone time, I was also outgoing and thought of myself as a performer. I sang and danced, and although I was not trained in any specific style, I used to win competitions in singing and dancing. As I grew up, I became more introverted and less interested in performing. My earliest work was assisting my mother with selling native art. We moved to Skidegate after I graduated, to open a seasonal gift store before we moved on to open an art gallery in downtown Vancouver when I was nineteen years old. That business failed due to a funding nightmare from what was known then as the federally funded "Aboriginal Business Canada" program. We closed the doors and went on to coordinate healing workshops in Indigenous communities. I then went on to work with

Indigenous youth and families at a local non-profit. I have come full circle in that my business is centred on Native art, but we are also a social enterprise which helps support a non-profit that is focused on the empowerment of Indigenous People. It's wonderful that I'm able to pursue both passions simultaneously; as my business grows, the more I can contribute to the greater good of my people.

"My life's work has been dedicated to the empowerment and healthy development of Indigenous youth and families." Tell me more about this statement.
One of the healthiest things we can do for ourselves is practise our culture. My kids were a big motivator for me to be more open to sharing and teaching about my culture at every opportunity, from sharing songs and coordinating cultural activities at the Aboriginal Head Start Preschool to forming and participating in cultural groups. I also have a passion for nutrition. I was fortunate to have a mother and grandmother who were very diligent about feeding us quality food and utilizing natural remedies for all manner of physical issues. As a parent I relied heavily on nutritional interventions for my kids. I was able to manage my own chronic health issues and my boy's ADHD through nutrition. I also rely on maintaining balance in the four aspects of self as laid out in the Medicine Wheel—mental, physical, emotional, and spiritual.

In the many years you've been doing the work, have you seen a positive shift?
Our communities have a long way to go in terms of healing from the effects of colonization and systemic racism. We are still facing issues around substance abuse and domestic and sexual abuse. While there may be more success stories in our communities, with strong leaders and healthy marriages, we still have a way to go to become our healthiest and happiest selves. This is why I will always be a part of the solution, and why I formed the non-profit Copper Legacy Indigenous Empowerment Society.

Can you share your thoughts on the importance of keeping Indigenous culture alive?
This is a big question. There are many challenges to being a contemporary Indigenous person who wants to maintain and uphold tradition while at the same time adapt and evolve. It's like walking a fine line between what you want to do and what is culturally appropriate. I feel like we always have to be mindful of hearing feedback and adapting to keep things culturally appropriate—and always questioning whether there are things we should represent and things we should not represent.

Tell us about your early exposure to art and how it informed your vision as a creative.
I remember my mother taking my brother and me to the Museum of Anthropology in Vancouver when I was a child. I felt profound awe and reverence for our art forms, and I wanted to know more about our culture. I don't consider myself an artist, per se; my brother is the true artist in our family. He is a master, and there are few who hold his level of ability in metal work (jewelry). I am creative and have a very strong sense of aesthetics, but I am equally a logical, business-minded person. I started making clothing for regalia for my family. I love working in Melton wool and leather appliqué. I also love to work with seal fur, abalone and dentalium shell (tooth shells used in traditional beading or as currency) for garments and jewelry. I love collaborating with both my brother and my partner, Andy. This is truly a traditional means of working culturally, this collaborative process between male and female. Men traditionally did a lot of the designing, and women traditionally did a lot of the weaving and appliqué and clothing-based production.

How has being a mother inspired your work?
I have raised five children, three biological and two foster relatives. Parenting has been my motivating force to continually develop myself and do hard things. I have never wanted to be a parent who encourages my kids to "go for their dreams," but then be too scared to pursue my own. I feel it's my duty to set a positive example of really stretching yourself and your abilities. I strive to find opportunities for my kids to push themselves outside of their comfort zone, while I always cheer them on from the sidelines saying, "You can do this!"

You're active on Instagram, imparting messages of self-love, strength and community. How does your social media community impact your work?
The thing I appreciate most about social media is having instant interaction with our community. I avoid using language like "followers," because whether I know the people as individuals or not, these people are our community. My business would be nothing without their ongoing support. I am also continually inspired by the immense creativity, resilience, and gumption that I am witness to daily from fellow Indigenous women in this community. We face so

many challenges—tremendous adversity, trauma, loss, dysfunction—and yet there we are, showing up and growing strong despite it all.

What was the inspiration behind TDH, and how has it evolved?

I initially wanted to start this business back in 2004, but my kids were so young, and my brother lived far away. It wasn't the right time. We used the word *totem* in the name because it has meaning within both our tribes. We descend from two culturally different tribes: Haida being coastal, and Cree being plains Indian. We have Haida totems that depict our family/clan crests and lineage: from the Cree side, totem animals, where animals who guide and speak to your being are often worn as amulets (bear claw or eagle feathers, for example). But in our modern age, Indigenous people not only wear animal crests to display their lineage but to imbue the quality of the totem animal in much the same way that our ancestors would wear an eagle claw, or bead an animal onto a pouch. It's a recognition that the energy of the animal is strengthening the energy of the wearer. And since we no longer wear traditional garments outside of ceremony, we still desire to show our cultural connections. I've always referred to our apparel as contemporary regalia. Relating back to the fashion industry, the big ateliers in Europe are referred to as a "design house," so I wanted to show that we are a cultural design house—Totem Design House.

TDH can be found in the Smithsonian Gift Store. That's amazing! How did that come about?

The first year we attended the Santa Fe Indian Market in 2016, the lead buyer for the Smithsonian Institute stores stood in line at our booth to check out what the buzz was about. He witnessed the crowd's response to our products before he could even see what it was. By the time he reached us he had waited twenty minutes; he was in a rush, so he handed me his business card and said, "We'd like to sell your work at the Smithsonian Museum Gift Stores, get in touch." At that point we weren't ready to produce at wholesale levels, so it took a year or so. Andy and I happened to be a part of an entourage of Indigenous artists and culture keepers that got to go to NYC and Washington to see the Northwest Coast archives at the Smithsonian. I brought some samples with me and made an appointment with the buyers at the Smithsonian in Washington, and that is how they ended up being my very first wholesale account.

Is supporting your community the foundation of your work?

Yes. Between the ages of sixteen and twenty-four, I spent years attending and coordinating healing workshops for Indigenous people across BC. Not only do I suffer from the intergenerational impacts of the residential school system, colonialism, and all that comes with that, I have been witness to many hundreds of Indigenous people's healing journeys. Supporting people through the most unimaginable traumas makes you wonder how anyone can survive bearing such pain. I have to recognize my privilege in that I was protected from so many of the adverse conditions that my people have had to endure. My early work was so focused on the healing and empowerment of our people because what I know for sure is that we cannot be our highest and best self without support, role modelling, and healing. The ongoing injustices that Indigenous people face is a constant source of upset for me; it's not something I can just ignore in order to pursue my own passions. We don't win unless we find a way for all of us to be uplifted.

Tell us about people who inspire you.

I always refer to my grandparents as being the people who inspired me the most. My Haida grandmother Evelyn and my Cree grandfather Wylie suffered early traumas and a lot of adversity in their lives, and yet they were both so caring and giving. They were the kind of people who always knew how to make everyone in their life feel special. Because of them, when it's my time to be a grandparent, I will follow their lead in emoting unconditional love and close connection, something that unfortunately my kids did not have. The desire to uplift our people is something I've inherited.

What is your hope for the future?

My hope is that we have enough creativity to think outside of the box to reimagine a world that isn't as heavily reliant on capitalism and consumer culture. I have discussions with my children about their future children, and how we plan to raise them—homeschooled, on the land, learning how to hunt and cultivate food, and reincorporating those pre-contact ways of being in the world. Our hope for the future is in striking a balance between the things that technology can afford us and connection to the land and our culture in ways that are healthier for us, as individuals and tribes, and for the planet and all the beings that we share it with.

Gabrielle Burke

**Ceramic artist,
Community Clay**

"Follow your heart. Listen to it, even if people are telling you no. If you are authentic and doing it for the right reasons, everything will fall into place."

Were you creative as a child?

I was! My mom came downstairs one day and found me sewing Barbie clothes. She was also called in for a chat with my kindergarten teacher because I was drawing in 3D on my own, which apparently is not usual. I've always had a creative mind—I think it comes from being an introvert. I was always off in my own little world, keeping myself busy. You could sit me in a corner with some toys and I would be happy for hours.

What is your first memory of clay?

When I was young, my grandparents were getting some work done on their pool, and the contractors left a wheelbarrow of cement unattended. I went over and took a couple of handfuls and made them into balls that I let set. I was fascinated! Later, when I learned about ancient civilizations making pottery from clay found in creek beds, I went down to the ravine beside my house and dug up some mud. I made a bunch of little pinch pots.

Where did your inspiration take you from there?

I started working with clay in high school. I would stay after school practising until seven or eight at night. I knew all the janitors. It was exploratory and a safe space for me.

I majored in visual arts at Emily Carr University of Art and Design. At that time, ECU didn't have a ceramics designation. I got called into the counsellor's office because I was taking mostly ceramic classes, and I presented the perspective that ceramics is multidisciplinary. I like to incorporate sculpture, photography, painting, and printmaking in my practice. I took supplementary courses in other departments to support my work.

My time at Emily Carr allowed me the space to start asking questions. Growing up in a traditional family as a female and Roman Catholic, I was not allowed to ask too many questions. My time at ECU normalized critical dialogue and created a safe space to converse openly.

Prior to opening Community Clay you worked as a product designer. What did that involve?

I designed paintings, accent furniture, accessories, lighting and framed prints for a local home décor company. I would travel to China and Vietnam and work with factories, as well as across Canada and the US, setting up showrooms. My time there showed me that currently, we create a lot of stuff—as a society and as producers. Coming from ECU, a lot of what I designed for the company had meaning; however, the buyers didn't care. They just wanted beautiful paintings for their showrooms. Which I do think is necessary—everyone should curate a beautiful life—but I felt that it should mean more. The things we choose to surround ourselves with in the minutiae of our lives shouldn't be something that you don't know anything about and just want because we need *things* in our lives to make us feel secure; they should inspire us, make us think.

I was sitting on a plane to Atlanta, Georgia to set up a showroom, and I realized what I was doing wasn't making the impact I wanted. I had a lot of experience and education within the ceramic field, and I wanted to impart that

on our community. A lot of my friends I went to school with were not working in the industry. It's challenging—artists have to work in multiple studios and often have another part-time job to make a living. I wanted to create a space that supported the artists who help develop our community, as well as enable a safe space for people to create (like I had in high school).

The studio has slowly been growing ever since the first day I touched clay. It's evolved on its own over the years as opportunities arose. In 2017, I started teaching (as a source of income, I volunteered for many years prior) in a tiny two-hundred-square-foot studio. We've been in our current location since December 2019.

You've said, "I'm enamoured by the way ceramic objects inhabit our daily lives, how people rely on objects such as mugs and bowls and have an interpersonal relationship with them." Can you share more about this?

Every object I make is thoughtfully designed. I consider who will use it, and why and how it will be used. I make items knowing that this is permanent. When I teach, I try to relate to students the process of letting go of things that don't quite work out like you want. Instead of fighting with the clay, cut it in half, consider what's happened; learn from it and move on. You will learn more from the process of creation than you will from trying to rescue something that's already gone. Once you've learned how to make it, you'll instinctively understand how to fix it. I believe that we shouldn't spend our time fussing over things that didn't work out when we could be using that time to create something new.

Who, where, or what inspires you?

The people who come to the studio inspire me. I've been creating for seventeen years, and because my practice is very minimal, I have a lot of knowledge that goes untouched. The students and members are new to the medium and have so many questions! It gives me an opportunity to revisit techniques and skills that I don't use on a regular basis. Their excitement and fervour inspire me and affirms that the studio is doing the right thing. It comes from the heart. It's authentic.

My own practice is inspired by being outside. When I'm sitting on a ski lift or laying in my sleeping bag watching the sun rise over the mountains blanketed in snow, and everything is quiet, things fall into place. The energy from hiking up a mountain spurs the creative juices. There's something about being in the wilderness that allows everything to make sense.

Who has been your biggest supporter as you build the studio?

My aunt. She's been there every step of the way. She would fly out to Toronto with me to help me with shows. She'd come to Vancouver (she lived in Edmonton) to help when I had several shows happening at the same time. When the rest of my family was telling me to get a "real job," she was there by my side. She had concerns, as what I've done has come with considerable risk, but she always supported my inspiration and passion. She believed in me.

Tell us more about the studio space.

Our goal is to enable a safe space for people to creatively express themselves. This is more than just about slinging pots. Through the pandemic, this means ensuring people feel comfortable being there, as for a lot of our members it's the only thing they do outside of the house. It's important to me that our members feel supported. I wouldn't be here today if I hadn't had access to the studio in high school; having that experience through my trauma has made me realize how being creative in a challenging time can save your life. It is important that the culture we create at the studio resonates with that. Sometimes we have deep existentialist conversations; sometimes we open up about our experiences; sometimes we just listen to music and create. The studio is a space for everyone to come as they are.

You bravely shared with me that part of the inspiration behind building Community Clay comes from a place of trauma. Can you share more about this?

I think the most important thing to understand about trauma is that we are not alone. We all experience challenging times, and it's different for everyone. Even though what has happened may be unique, the experience of moving through it is something we can all relate to. Trauma for one person could be the result of a partner shutting them down, or physical or sexual abuse. By having gone through my own trauma I have been able to hold space for others. While I may never comprehend someone else's unique experience, I can understand what it felt like at a core level. That's why the studio exists.

What are the therapeutic benefits of working with clay?
You have to focus on the clay. It requires you to step outside of your own experience for a while. If you're sitting at the wheel attempting to throw while stressed out about work or family, you won't get anywhere. You have to be present with it. It's a meditative process that gives you a break from routine, where you leave your life outside and come to breathe and move.

Have you seen transformations occur during a class or workshop?
I've had very special connections with people in the studio. Sometimes people come and they need to talk, and because of the work I've done I can support the conversation. I've contemplated a degree in counselling to take it a step further, and I've considered creating a therapeutic program with others, but it hasn't aligned yet. It's something I would love for the future.

Can you tell us about the inspiration behind the striking combination of white and blue in the pə'sifik collection?
I'm Portuguese, and in my culture it's a tradition to have a ceramic rooster in your kitchen for good luck. I grew up staring at a blue and white one on top of the stove. I took a ceramics history class at ECU and I loved learning about how basically every culture has their own version of blue and white pottery. I wanted to create a modern version of the blue and white rooster—which still hasn't happened—and spent a long time considering how the tradition of blue and white relates to me, and how I can integrate the decoration in a contemporary way. I grew up in Crescent Beach, and I always come back to the ocean; I was first inspired by the design that dappled waves make on a clear day on the ocean floor—similar to that of a pool. I started looking at the water and the patterns in an abstract way, and when I learned about bubble painting, I spent the better part of a year developing the technique to create the crisp bubbles.

There's a stunning simplicity to your work. What guides your design process?
I spent a long time trying to decorate dinnerware because I thought that to have a style you had to put a lot of work into

it. Then I realized that they had to be designed. I want my work to speak for itself. All the pieces make sense and are made for a reason. Nothing is unintentional. I don't think that food and the vessels that hold it should be fighting one another for attention. It's a conversation. They should speak to each other. Even the pə'sifik collection, which has surface decoration, creates a dialogue.

How has the pandemic affected you?
The pandemic shifted the business. I shut down for several months and financially suffered. But I regrouped and reorganized. I had had plans to move online and create a team in the next year or two, and the pandemic accelerated this. Now the business is growing exponentially every quarter. I will continue to support the studio in growing. I'm not 100 percent certain of what that looks like right now, but I have dreams.

The pandemic also taught me that I can't do everything myself—and that it's important to take care of myself. If I want to support others, I need to support myself. This means deleting work emails from my phone and setting work hours. For a year I worked nine-to-thirteen-hour days and had about four days off. It's just not sustainable, especially while trying to worth through PTSD, on top of dealing with the anxieties of the pandemic. It taught me perspective.

Why is art important?
Art is important because it teaches us about ourselves and others. It provides new perspectives outside of our own experience. We can see the world through someone else's lens.

Can you offer some words of advice to others looking to embark upon entrepreneurship?
Follow your heart. Listen to it, even if people are telling you no. If you are authentic and doing it for the right reasons, everything will fall into place. It will be challenging, and it will call for you to rise, but it's worth it.

Ndidi Cascade

Musician

> "Hip Hop has been a source of energy and inspiration for me. It helped me to become more comfortable in my identity as a person of colour."

What is your first memory of music?

One of my earliest memories was listening to Michael Jackson's *Thriller* album in 1982 when visiting my dad on Vancouver Island. I'll never forget staring at the album cover photo—I was completely enamored and couldn't take my eyes off it! After that moment, I was all about Michael and all about vinyl. I used to play my mom's records for hours, listening to them as well as staring at the covers, allowing my imagination to run wild. My stepdad, Joe Amouzou, a musician who comes from a well-known musical family in Togo, brought so much live music into our lives. He would play guitar and percussion and teach us African songs. This is when I first started to engage in live music at home.

As a kid, I also listened to the radio and watched a lot of Much Music. The first mixtape I listened to was given to me by my neighbours, some cool older Caribbean boys, who managed to get their hands on some NYC street mixtapes. I was in awe listening to groups and artists like Queen Latifah, Salt-N-Pepa, Audio Two, The Fat Boys, DJ Jazzy Jeff & the Fresh Prince—some of my earliest hip hop inspirations.

Was your love of music encouraged?

My grandmother was a music/piano teacher. My mom wrote a lot of poetry when she was younger, and my dad was playing African drums when they met. It only makes sense they gave birth to a child who would eventually master rhythmic poetry.

My love and interest in music was strongly encouraged. My mom believed in my talents. She enrolled us in several extracurricular arts programs. My mom was a such beautiful soul, a kind-hearted empath who lay her own life down constantly for her children. As a single mother, she did her absolute best to support all our dreams.

You're of Nigerian/Italian/Irish/Canadian heritage. How has music spoken to your diverse identity?

My musical listening journey reflects my biracial experience. I've been mostly influenced by European-American and African American music and culture.

I grew up listening to and appreciating a wide array of music. When I was kid, it was pop music, like Madonna and Michael Jackson. In the early years of high school, I listened to pop-rap like Maestro Fresh Wes, Young M.C. and Rob Base. By the middle of high school, I moved more toward The Smiths, Depeche Mode, The Doors, and Nirvana. At the end of high school, I moved back to hip hop bands like Cypress Hill, The Pharcyde, Souls of Mischief, and Digable Planets. It wasn't until quite recently that I become more aligned with my Nigerian music culture. In 2015, I went to Nigeria and was immersed in Afrobeats.

I feel all my ancestors in my blood. It's interesting being a biracial person, especially a light-skinned, English-speaking, biracial person who can code-switch if needed. I know what it's like to be both racially oppressed and hold privilege. It's as though I'm existing as grey in a seemingly black-and-white world. I embrace my identity, even though through the years I've had many moments where I've felt a lack of belonging.

You were born and raised in Vancouver. How has this informed your experience as an artist?

I have always felt that Vancouver has a unique global perspective. We are living in a part of the world where we are comfortable and privileged enough to observe diverse global cultures. Although being from Vancouver gives me a unique perspective, I find artistic authenticity can at times become stifled. For instance, some have the opinion that it can often be difficult to pinpoint a particular Vancouver sound. I managed to find my sound after being inspired by many of the local freestyle rap artists. Being in a position where we can consume global music cultures freely, it's almost necessary to improvise to find a unique sound. I am inspired by the openness of our social gatherings—for example, in club and festival culture—and find myself feeling inspired by this rich diversity. The natural landscape has also helped to shape and inspire me as well.

What is one song that moves you?

"Somewhere Over the Rainbow," by Israel Kamakawi-wo'ole.

At what age did you realize that music was your path?

I was around twenty-six. It was at this age that I started recording songs regularly, touring, teaching, and making money from music-related work. It has been a learn-as-I-go journey.

When did you first perform live in front of an audience?

The first time was in 1996. I was attending Simon Fraser University and was in the Association for Students of African Descent. Through this association I had my first show, an event thrown at a Vancouver club called Level 5. I had only one sixteen-bar verse written that I wrote for amusement, inspired by Wu-Tang Clan. When I was asked to do the show, I was like, *Well, I do have one rap that I wrote for fun—I guess I could perform it.* I was extremely nervous. I did the show, and people were so moved that afterwards they kept asking me when my next show was. I was like, *Well, I guess I should write more raps.*

Shortly after that I went on to co-create a group called the Sola 5 Drops. We were the first all-female hip hop group in Vancouver.

You describe yourself as a hip hop vocalist, songwriter, recording artist, educator and program facilitator.

I access all these parts of me within all my passions. For example, when offering my hip hop education programs

at schools, I engage my capacities as an educator *and* hip-hop vocalist by simultaneously teaching youth about the history of hip hop, how to write and record songs, and inspiring youth with a performance—all of which can facilitate their artistic growth.

What is the appeal of hip hop for you?

Hip hop has always been a source of energy and inspiration for me. When I first discovered hip hop as a youth, it uplifted me out of some big life challenges. It helped me to become more comfortable in my identity as a person of colour. Hip hop is rooted in deconstruction and reconstruction. Hip hop also reflects the socio-cultural spaces of the time. This is what make hip hop unique, raw, real, and constantly evolving. It is also a powerful tool for marginalized voices.

You've said, "I facilitate and manage programs that use hip hop, spoken word and dance as a medium for healthy self-expression." Why are these programs pivotal in our communities today?

Hip hop culture is such a powerful force, especially for young people. Hip Hop found me; it gave me energy and inspiration; it empowered me and gave me a voice. It was therapeutic. I intend to help others find this same kind of inspiration and healing. This is how I use hip hop education programs—as a tool for personal development. Hip hop is rooted in community empowerment; the four main elements of hip hop culture—dee-jaying, breakdancing, emceeing, and graffiti art—empower marginalized young people to find purpose and a voice. I witness happiness and self-discovery with the groups that I work with. I remember being on tour with my band Metaphor; we did interactive hip hop shows at elementary schools around BC. At the end of our show, we did a freestyle with volunteers from the crowd. At one of these shows, a young boy came up and grabbed the mic and started to freestyle rap incredibly! The crowd cheered, and some teachers began to cry. Afterwards, one of the teachers shared with us why that experience was so powerful: the boy on the mic had learning disabilities; he struggled with reading and writing, and he hardly spoke. At that moment I knew that I wanted to do this kind of work for the rest of my life.

Community is a key component of your life. Can you tell us more about what this means to you?

I've always enjoyed social gatherings of all kinds. I love attending them, and I love throwing them. I recognize

the value in social connection. I love bringing people together, and now I enjoy curating music-centered events. I am a firm believer that connection is the meaning of life. Without healthy connection we can often become lost. A disconnected community is an unhealthy community.

Who, where, or what inspires you?

People who inspire me include: my mom, Monica McGovern; Melanie Tonia Evans; Dr. Gabor Maté; Alicia Keys; Shad; Sade; Bob Marley; Khalil Gibran; Tonye Aganaba; and Khari McClelland to name a few.

Places that inspire me: Pacific Spirit School (where I teach); Haida Gwaii; the Kootenays; the Sunshine Coast; lush, forested areas and fresh lakes.

What inspires me: Laughter, affection, playfulness, creation, connection, dance.

Do you have dream stage where you'd like to perform, and do you have a dream collaboration?

My dream stage would be the Global Citizens Festival, and my dream collaboration would be with Alicia Keys.

What do you need to be creative and productive?

No distraction, which is very often hard to come by. I am most creative when in a healthy state of mind, body, and spirit. I need minimal stress, few or no intoxicants, and plenty of rest and exercise. Oh, and fresh ginger-lemon-turmeric tea!

How has the pandemic affected the music industry and live performance?

Many music artists have had to pivot into finding other income streams. Luckily, I was able to continue performing and teaching with Zoom. Since spring 2020, I've become accustomed to performing into a camera lens. When moving back to live shows, I will definitely have to warm up to a live crowd again. I truly feel like the music industry will be permanently affected, or at least affected for a long time to come. In wealthier countries with higher vaccination rates, live music may begin to thrive a little more as time passes. However, I am cognizant of what is happening with the pandemic on a global scale, with vaccine apartheid as well as vaccine hesitancy. And when I think of all this along with the rise of COVID-19 variants, I can't imagine borders opening for a long while, therefore further restricting music tours and concerts. Eventually we will learn to live with COVID-19, and we will find ways to tour and perform, even if on a more limited scale.

How has the COVID-19 pandemic affected you?

I have come to appreciate quality over quantity. When the pandemic struck, my first response was to protect my immunocompromised mom from getting COVID-19. I locked down our house for months and poured so much time and energy into keeping our family safe. All my work teaching and performing came to a halt. I spent a lot of time home and online. I became more hyper-aware of what was happening globally, as did much of the world, with so many of us stuck at home glued to our screens. This is why social media movements, such as the one behind BLM, became so powerful; I call this the George Floyd era. Many of us were forced to re-evaluate our priorities and look deeper within. With less distraction from our usually fast-paced lives, many of us became more sensitive to and aware of environmental and human rights movements. Personally, as an artist/educator with a focus on inspirational content, I was given an opportunity to work online and reach more of a global audience; the ability to bring great minds and hearts together over Zoom has become a very powerful tool—I consider this technology a golden opportunity for all of us. Before the pandemic, I wasted much of my time over-socializing, and staying home has made me truly appreciate quality connection with others. That said, I do miss dancing and hugging with others.

Can you share some thoughts on how music brings people together?

Music is vibration, word, sound, and power. When a person sings, dances, freestyles, or plays an instrument, it can become like a healthy meditation, which is good for the mind, body, and soul. When humans dance, vocalize, or play together, it creates a cipher of musical creation catalyzed by connection. Connection is healing. The vibration of particular melodies, the inspiration of particular lyrical content, the memory trigger from a particular musical piece—all these things make music powerful. When we listen to a piece of music that brings a warm sense of melancholy to our hearts, that even at times can trigger tears, we know that music can reach into us on a soul level. I am forever grateful for music as it continues to nurture my life's purpose.

Ellen Castilloux

Special education support worker and fitness coach, Inside Out

"I will spend my entire life aspiring to this kind of authenticity and realness and will never get close to the level of authenticity my clients have."

What is your first memory of movement?
I'm four years old, running around the living room coffee table to the music of one of my mom's CDs. I remember enjoying the feeling of energy and heat rising in my body; I remember it making me feel alive and happy. Movement has always been tied to music for me because I grew up in a house where there was always dancing and music playing.

Why is movement vital to your well-being?
I remember playing T-ball and dancing in the outfield, trying to catch bugs and butterflies and drawing patterns in the gravel. That was the first and last time I was in involved in team sports. Dance was my passion, and by my teens I was doing school part-time and training in dance four to eight hours a day. I cross-trained at the gym, doing strength and cardio work as well as yoga. Movement is the thing I do, the place I go, to focus on myself, to build a better, stronger, more versatile me. Any time I've diverged from it, I've felt a sense of loss, like I am no longer myself. Movement impacts me on a chemical and physiological level.

Do you have a favourite form of dance?
Over the years I've had the opportunity to sample a wide variety of dance styles. Contemporary was my favourite because it offered me the most freedom. I was a young person who didn't like rules or being told what to do. In contemporary, I was encouraged to strip away the structure and predictability of classical dance styles. I could play with other styles for influence and flavour. I could be raw and bring my uniqueness. The feeling is magical. It was the perfect environment for self-discovery and the beginning of a lifelong passion for self-reflection and introspection.

You now run Inside Out Fitness with Elly, a movement-based therapy where you create custom-design fitness programs for individuals with neurodiversity. How does fitness help someone with neurodiversity better navigate the world?
Neurodiversity is a term used to describe brain differences. These differences can be in reference to emotions, cognition, functioning, learning, sociability, etc. The benefits that fitness can have for someone with neurodiversity are really the same benefits that every person experiences: improved heart health, flexibility, weight management, mental clarity, reduced anxiety. However, people with neurodiversity are at a higher risk of struggling with physical and mental health. Yet there has been less accessibility to fitness for this demographic. Yoga is especially beneficial. I've noticed that teaching intentional breath work through yoga has allowed my clients outside of class to be able to focus on breathing, which can greatly reduce anxiety and help with behaviour management. It's also a really positive thing for young people with neurodiversity to feel that sense of community and to be part of a group setting, which allows for friends to join together, with a shared goal and task, but without pressure on social and/or verbal engagement (which can be anxiety provoking).

My sessions do not centre on behaviour intervention. I think that's important because a lot of people—those with autism spectrum disorder, in particular—may spend a large percentage of their day in structured ABA (applied behaviour analysis) therapy routines. It's great to create opportunities for young people to participate in activities that are not a part of their therapy programs. There are a lot of awesome aba programs, but I feel it's important to offer inclusive, non-therapeutic options.

Why have you chosen to work with this population?

I have always been curious to learn more and work closely with people who are non-verbal or limited verbally. When I considered a career in this field, I reflected on my years training as a dancer, studying personal expression and storytelling, all through the body and face. I realized I'd been studying non-verbal communication my whole life. I wondered if that would translate into my work as a behaviour therapist, and it absolutely did. You can never reach the end of learning because each new person presents a new language of their own.

What was the inspiration behind Inside Out?

The more time I spent in the autism community, the more I started to notice gaps. I would try to put myself in the shoes of parents with children with developmental differences and would ask myself, *What kind of programs and support would I want for my child? What kind of programs and support could be created to enrich these people's lives and provide more opportunities for meaning and connection?* For people who are limited verbally, feeling empowered in and connected to your body can be transformative. When you don't have your words, your body becomes your words. Thus, a focus on movement and body awareness felt important to me. Creating opportunities for social connection that wouldn't be anxiety provoking or focused on traditional conversation skills was key. Teaching fitness skills and comfortability in a gym setting so that young adults could have a place to go in their community, and an independent hobby that would have positive health benefits, felt important. Working in public schools, I felt there was so much more we could be teaching that would be practical and meaningful for these kids. I started connecting my students to gyms and rec centres in their community, introducing them to the staff and teaching them individual gym routines in the hopes that this would be something

that would continue to be a part of their life long after they graduated. And then it snowballed. I realized this was a huge area of opportunity, and I wanted to started creating programs for this community.

Why the name Inside Out Fitness?

The name Inside Out was inspired by a trait that I admire in the people that I work with. I find that the majority of people live their life from the outside in, strongly influenced by our social conditioning. In contrast, something incredibly beautiful about people with autism spectrum disorders is that they are more often guided by their internal compass—what *makes sense* to them or what *feels right* to them. There's a lack of filter between the inside story and what is portrayed on the outside. It's inspiring, beautiful, and it's not a problem. I want people to know that Inside Out Fitness is a place where living from the inside out is celebrated, and that you won't be asked to contort yourself to fit into the typical social expectations that might exist in other yoga and fitness classes in the community.

How are you qualified to work with people with autism spectrum disorders?

I completed my Bachelor of Science (Honours) in Applied Psychology, from Anglia Ruskin University in the UK. This provided me with a background not just in working with people with developmental differences, but also a better understanding all people, communities, scientific research and data collection, and ethics. It was a great jumping-off point for me, and I had many opportunities to study the impact of movement on anxiety and mental health. I am also a trained and experienced ABA (applied behavioural analyst) therapist. The fitness piece came from my background as a dancer. I have over twenty years of training and experience. I worked as a professional dancer, taught dance, trained in yoga, aerial yoga, kickboxing, power lifting, Pilates and many other styles of movement. Recently I took a course called Autism Fitness, which brought together both of my worlds and offers a systematic and effective approach to teaching fitness to people with ASD. I think the ultimate benefit of my work is simply that I love it and it inspires me and brings so much joy. It challenges me in the right ways, pushes me to deepen my patience and compassion, teaches me about my own edges and opportunities for growth, and has me always meeting new people.

How do you go about designing a program?

This can look dramatically different from person to person. I usually start with a conversation with the parents to gain a bit of background and understanding of the client's experience and exposure to fitness and fitness environments, as well as triggers, likes and dislikes. Sometimes it's a matter of simply going into a gym, standing on a machine for five seconds, stepping off, cleaning the machine to become comfortable in the space. The important thing is to start off at a level where we can guarantee success, and that it will be a positive experience. I build on skills gradually from wherever the starting-off point is. I take data during sessions on success and level of independence during workouts, to ensure we are always progressing, but at a pace where the session can remain successful.

How is community a key component to your work?

Building community is a fundamental aspect of my program. From my research, I learned there hasn't been enough space carved out for developmentally diverse populations within the fitness community. I believe that building that community begins by creating programs and opportunities. For a lot of my clients, it's not about creating a structure for social time or conversations, but rather just a place to be near friends, sharing an experience, having a routine of meeting regularly with people you care about, and having a space where you feel free to be yourself.

What is one of the biggest misconceptions about people with autism spectrum disorders?

I think one of the biggest misconceptions about people with ASD is that you can make any assumptions at all. People with ASD are just as diverse and individual as the rest of the population. One of the common assumptions is that people with ASD are not affectionate and do not like physical touch. I've worked with some exceptionally affectionate and cuddly kiddos with ASD. We shouldn't assume anything about people in general. People will show themselves to us if we're open enough to not let ourselves and our presumptions get in the way of really getting to know a person. We miss so much when we think we have a person figured out.

How has the pandemic affected your business and the families you work with?

Launching this business during the pandemic has been a challenge, and it's definitely slowed my momentum. I've had to periodically put in-person training on pause because physical distancing and mask wearing while participating in physical activity is just not possible for a lot of my clients. That said, during the warmer months we have moved training outdoors, which has been very helpful. We will meet at a field, park, or track. There have been a few months where we've been able to train in gyms, recreation centres, and studio space, depending on public health guidelines and what I feel is safest for me and my clients. I would love to open my own physical space—it's part of my ten-year plan.

You started this business after becoming a mom yourself. How was that for you?

I began to develop my model for Inside Out Fitness while I was on mat leave with my first son, and I launched the business after he was born. For my partner and I, it's really important that we instill in our boys the values of kindness, compassion, and generosity toward others. I think that having these conversations is a good start, but what you model to your children is what will really make a lasting impression. I share with them what I do—and more importantly, why I do it—in the hopes that they will grow up to relate to it and want to emulate in their own way. I hope that as they get older I will be able to create opportunities to involve them in events so that they can become a part of this amazing community and learn to relate to people in a special way. I feel like what we are exposed to and involved in at a young age becomes second nature later in life. I'd love for our boys to always feel comfortable connecting with people who are different from them, and to always have an open mind.

Where do you envision Inside Out in ten years?

I would love to see a permanent facility, a full timetable of classes, a team of amazing staff, and maybe even a collaboration of services. I've dreamed about having different branches—Inside Out Fitness, Inside Out Beauty, Inside Out Counselling. There are already some amazing autism centres that are established in Vancouver, but for me, I find most have a clinical feel. I'd love to create something with a fun, boutique feel and atmosphere. I want to bring neurodiversity into the mainstream. I really think there's so much opportunity to create and build services and spaces for this community. The sky's the limit!

Justine Chambers

Contemporary dance artist

"Dance forces us back into our bodies, back into feeling, back into having feelings, and back into feeling others. Dance has an empathic potential that is unlike anything else."

Did you know instinctively that dance was your passion?

I got serious about dancing around age thirteen. I trained in ballet at a school with Nesta Toumine and also at Le Groupe de la Place Royale, both in Ottawa. Dance made sense to me even before I started thinking about it as a professional designation. I felt calm and connected when I was dancing; it had the ability to become a place, not just a series of actions—a collapsing of time and space where I could exist with a kind of ease that I didn't carry with me in my daily life.

You're celebrated as a dancer, choreographer, and teacher. What is your creative process like?

My process is very project dependent. In that way, my process is always evolving. My hope is that I'm always in a critical dialogue with myself and my peers around expanding ways of making dance performance. While movement and bodies are always at the centre of my practice, in the last several years the work manifests in a number of ways.

I have always been a teacher. It is inextricably linked to practice. I always speak of my practice as being fourfold: dancer, choreographer, teacher, and student. Teaching allows me to be in a continuous feedback loop with dancers about movement, moving, articulation of movement ideas, and our individual and shared values and ethics associated with dancing and performing. I find teaching to be very rewarding, and I often feel it is where I learn the most about what I do. Currently I teach at Ryerson University, Ballet BC, Modus Operandi Training Program, and Arts Umbrella.

How would you describe your professional path?

I went to Ryerson's Theatre School after high school and studied dance performance. At graduation I was offered a job with Desrosiers Dance Theatre. I left Desrosiers in December 1999 and began an independent dance career working with a number of different choreographers in Toronto. This was also the beginning of my choreographic path. I met my current partner in 2004 and moved to Los Angeles. After nine months in Los Angeles, I decided to quit dancing. The work in LA wasn't engaging, the pay was barely enough to live on, and I was feeling heartbroken by the milieu. In 2006, I moved to Vancouver with my partner to do my MFA, and I incrementally made my way back to dance. This began with an invitation from visual artist Kristina Podesva to make something for her MFA project Colour School; then, within a year or two, I was back in the hustle again—teaching, making work, being a rehearsal director and an outside eye.

After I left Desrosiers Dance Theatre, I was invited into a project by Julia Sasso, whom I really admired. The project was titled *Beauty*, and it had an extraordinary cast of contemporary dance heavyweights: Michael Sean Marye, Michael Trent, Ron Stewart, Heidi Strauss, Michael Moore, and me. I couldn't believe I was in the room with those folks. I loved every second of that process.

In 2002, I went to Brussels with my colleague and good friend Jenn Goodwin. She made a work titled *The Wet Trilogy*, and we performed it as part of a festival of

Canadian and Belgian emerging work titled *Danse en Vol*. I was exposed to teachers, techniques, and work I otherwise wouldn't have had access to at that point in my career. Those experiences were very influential.

Vancouver is where I genuinely developed my choreographic practice. Though I've struggled with the city at times, I wouldn't have made the work I make unless I was here. There is something about the geography, the size of the dance community and its history, and the relationships I developed within the visual arts community that have allowed me to give myself permission to follow my interests.

When I think about the challenges, they greatly outweigh the highlights. It can be fundamentally challenging to be an artist. There is so much scarcity within the milieu that it can become the focus of the work instead of the work itself. I feel I have been especially fortunate because I have been able to surround myself with folks that are exceptional at what they do and are simply just exceptional people. Their artistic and emotional support has provided the lift I need when shit gets heavy.

Who is a dance instructor that stands out for you?
My training has never ended; it has just evolved and taken different forms. There have been many instructors who have shaped how I feel about dancing or how I approach it: Ken Roy, Nesta Toumine, Vicki St. Denys, Roxane Huilmand, Frey Faust, Kelly Keenan, Helen Walkley, Jeanine Durning, Alison Denham, and Lee Su-Feh.

Your work is exceptionally physical and emotional. How do you ensure that you're performing and working in peak form?
I think as a mother, a partner, and a working artist it's hard to ever feel that I am in peak form. Often, I feel I'm in a kind of form that allows me to continue to keep all the plates spinning. Depending on the project I'm working on, I focus my attention on what is needed for that particular piece for the duration of the work period. Sometimes that means doing a rigorous physical warm-up, and other times it means reading and/or writing. In general, taking one or two baths a day are a key part of my wellness regimen, as is stretching and using various props to release muscles and open articulation points in my body. In the last few months, I've been giving myself gua sha face massage. I see an osteopath and acupuncturist regularly.

What are the benefits of mentorship?
I have had the distinct privilege and honour of working with the formidable Margaret Dragu for the last several years. She invited me to work with her, and while there has been no declaration of a mentor/mentee relationship, I can't help but absorb her wisdom. We continue to work together, think together, walk together, and share all things art. I am incredibly grateful for her presence in my life. She is the epitome of what I hope to be when I'm considered a senior artist.

I also have to acknowledge the deeply meaningful peer mentorship that continues to bolster my life and art. I feel fortunate enough to be swaddled within a group of dance/theatre/art/maker friends and colleagues who continuously ask that I am in a playful and critical dialogue with myself and the milieu. This group of people are scattered across the country and beyond. Without them I wouldn't be able to orient myself.

How has your approach to creativity evolved?
Everything has changed, and everything has stayed the same. As a single young woman, I was in much more of an acquisition relationship with my career. I was trying to get chosen, get in, get the grant. Now I have a larger interest in fostering relationships and acknowledging *how* I am in relationship with people and places. Many of the things I lusted after as a younger woman don't serve my life as a mother, and yet my ambition doesn't fade. It has proven to be in a constant state of change.

You have an incredible son, Max. Did becoming a mom alter any way in which you move and create?
I was almost forty when Max was born. Being pregnant was not my favourite, I won't lie. I had glorious hair and nails, but the radical expansion and the sense that the interior space of my body was no longer mine was destabilizing. At the five-month mark I "peaced out"—I stopped teaching and dancing and focused on choreography and relaxing. It was a new approach to life for me. Being a new mom in the dance world was a wild ride. I assumed that I could do what I had always done, and in many ways I did just that while being very cognizant of the fact that I wasn't the same person and my desires and needs had shifted. There was this overriding fear that I would no longer be relevant, or perhaps I would be erased, because I was now a mother (which is something, historically, we have seen happen to so many

women). If anything, I started pushing further in the realm of dance and also tried to be an extraordinary mother. All of this comes with ridiculous expectations that could never be met, which came at a cost to my sense of well-being and placed me in a perpetual state of deep fatigue. It has taken a while, but I have incrementally figured out how to prioritize being a present mother and continue to make work in a way that supports my health and happiness. I am most proud of the work I've created in the last five years. My work and motherhood are inextricably linked.

Tell us about "collaborative creation."
For me, this is the alchemy of two or more individuals coming together to create something they never would have been able to create had it not been made by that specific group of people. I also like to think about it as the development of a shared practice. As a choreographer I work with very specific people. I don't hold auditions or pick individuals solely because of their physical prowess. I need to work with people I love, or at least care very deeply for, so we can be in a critical dialogue with each other and the work. It is also important to me that the people I work with feel valued and then feel free to contribute to the work with vulnerability. This way I feel we can work on difficult things without having difficulty with each other. As a dancer, I believe collaboration means two things: First, I work to be present with the conceptual or thematic framework of the project and willingly offer my thoughts and ideas in service to the project; secondly, I enter into a personal creative process around the artistic proposals in the room, so that in the practice of the work I am offering something to my co-collaborators by simply working.

What does the term "close observation" mean to you?
Close observation is how I move through the world. I'm always keenly attending to social codes, modes of behaviour, and physical relations between people. I have been told that I am a master code switcher, and I believe this is because I'm a biracial Black woman. I joke that I am ambiguously brown, but in all seriousness, I ascertain being racialized has a lot to do with acutely observing the world around me; it is how I discern where and how I will be safe inparticular environments.

I pay close attention to physical communication between people, the class/race/social codes of every space I enter, and perceived normative and non-normative modes of moving. In my work, I think that I ask that everyone pay attention in this way that I have been trained (by my mother) and forced (by the world) to consider my own body. In my work *Family Dinner,* I look at social codes of dining and entertaining. In *Choreography Walk,* I ask that participants consider how they move through the city, but also how the city is moving them in terms of architecture, topography, urban planning, civic power, governance, and access.

How has the pandemic affected your work?
Specifically, it brought about the end of touring and travel for work. In the last five years, most of my work has required a significant amount of travel every year, and this shift is what I feel the most. My last live performance was March 6, 2020, and I miss being in the act and watching live performance. I'm also sanguine in the fact that taking a pause from it allows us to feel live performance's meaning and significance in our lives, which is something that can be taken for granted. I have continued to make work and have had the challenge and pleasure of discovering how dance and choreography can live and be shared through different media. While I don't have a desire to make dance on screen, I have recently created a live performance for Zoom in collaboration with some of my students, which has been very satisfying.

I've been teaching over Zoom, which has had me grappling with the loss of the transmission between bodies that happens when you share space together. In spaces where I can teach live, there are different restrictions to consider. I find myself quite taken with the ideas of orientation and disorientation in a way I never quite had to think through as a dance teacher. Teaching folks who are confined to dance within a box while also trying to convey ideas around taking up space and sweeping actions is, again, a challenge, but not impossible.

Why is dance important, especially now?
Perhaps this moment makes our desire for it more palpable, but it always holds importance. Otherwise, we wouldn't bother doing it. Dance forces us back into our bodies, back into feeling, back into having feelings, and back into feeling others. Dance has an empathic potential that is unlike anything else. Moving in rhythm together is a way for us to simultaneously feel the same and acknowledge our differences.

Alice de Crom

**Owner and principal designer,
Floralista Flower Studio**

"My parents taught me to care about the details that make the difference between ordinary and excellent... how to make time count by being quick, decisive, and efficient. Those lessons have universal application and positively influence my life and approach to work."

What is your first memory of flowers?
Everywhere outdoors around my childhood home there were flowers. My family grew flowers commercially, and I remember looking down at a sea of colour and a little blue pansy face was looking back at me.

Both your mother and father were horticulturalists. How did their work and passion shape you?
Any horticulture venture has at its heart something sensitive and perishable. My parents were both serious professionals who met in horticulture school; they taught me to really care about the sort of details that make the difference between ordinary and excellent, and that you have to make time count and capture the moment. They always said that they wanted me to be guided and educated so that I could contribute.

I spent every summer till I was fourteen on my grandparents' strawberry farm in Saskatchewan. My grandpa instilled the value of hard work in me and my brother from the earliest age. He was always coaching and teaching us,
and we genuinely wanted to earn his praise. We were also paid for picking strawberries, which was in itself pretty motivating! But life on the farm was all about learning how to work.

You grew up near Fort Langley. How did the physical surroundings inspire you?
I loved where we lived, growing up in this beautiful part of the Pacific Northwest with the ocean nearby and the snow-capped coastal mountains always in view. Our family had a membership at VanDusen Botanical Garden, and we went there often. I actually had a strong grasp and interest in native plants, and my parents would teach us the Latin names. My botanical nickname as a child was *Alice procumbens*, after *Gaultheria procumbens*, because I ate so many of the red wintergreen berries we grew.

How did your lifetime love of botanicals guide you on your professional path?
I started with all the courses offered at the Maureen Sullivan Floral Design School in Vancouver from basic to advanced and bridal. I took a set of short courses in business entrepreneurship from BCIT as well as a breakthrough master design class from Sarah Ryhanen and Nicolette Camille in New York City. I was able to attend international workshops from leading designers in locations such as Mexico City and New Zealand. For on-the-job experience, I worked in three different retail shops before opening Floralista. One of my most valuable educational experiences was a business workshop by Shanna Skidmore in South Carolina for owners of creative businesses.

You opened your first flower venture at age nineteen! Tell us how that came about.

I grew up in a family business, and my parents really encouraged and supported the idea of me working for myself once I discovered that I wanted to be a florist. I couldn't wait to accept my very first wedding order. I also made dozens of grad corsages and boutonnières at the dining room table. My first open-air market launched from my stepdad's garage.

2022 marks the ten-year anniversary of Floralista. Congratulations!

Thank you! Those ten years have really flown by, but most people don't realize there is a less glamorous side to floristry which is actually hard, dirty, and cold work. I have worked incredibly hard to accomplish what I've accomplished so far. I am really proud of where I stand.

Who have been your biggest supporters in this journey of creative entrepreneurship?

Where would I be without my amazing customers, my team of professionals, and the unfailing support of my family? We are also lucky enough to be a destination for people from all over the Lower Mainland, and some people even fly in to attend our workshops.

What was it like when you were first opening Floralista?

I was still a barista at Starbucks when I started floral design classes. We got to take our design work home, and my manager let me put my flowers on display, so it was natural that many of our regular coffee customers took an interest when they found out I was planning to open my own design studio. I had a lot of support from the earliest days.

Are your parents involved with Floralista?

Yes, my parents are involved. As a matter of fact, I talked my mom into buying the work–live studio where we started retail operations ten years ago. She has been my business partner and still helps me with some of the bigger wedding and event setups. My stepdad Dennis has been an invaluable supporter, and my dad and I sometimes travel together on garden tours; he gives me key advice whenever I ask.

What key characteristics are pivotal for the space in which you and your team create?

My design work would probably best be described as a garden-inspired from the palette of an impressionist painter. I like to think it has some of the essential elements of Gertrude Jekyll's English Garden. I draw so much inspiration from my own flower garden and actively observe the ways flowers behave and change—for example, the evolution of colour from bud to open bloom on a Distant Drums rose, or the beauty of a chocolate cosmos head after the petals have blown off. Designing outdoor wedding installations is an incredible design experience because the locations are always exceptional, even before all the glory of floral are added. It is truly the finest of design experiences. Our studio is also special because the space has gorgeous natural light and tall ceilings, and I work next to a bank of windows that are flooded with sunshine. It's a beautiful setting and brings out the very best in both me and my flowers.

Floralista is a true team effort; please tell us more about how you work together.

You need a team to accomplish great things! I offer leadership and direction to nine of us right now. We are designers, shop assistants, and a client relations specialist. I think if someone quietly observed us, they would see a team just buzzing with activity because flowers are high maintenance and need constant care and attention. We all play an essential part in each beautiful order that is placed in the hands of a delighted customer. They would see stems being trimmed into fresh water, designers with hands overflowing with blooms, bouquets wrapped in layers of tissue and paper, card messages meticulously written by hand, and store customers given singular attention. But behind the scenes, there are coffee runs, treats, and music to keep things humming along.

What are your favourite elements about your craft?

Flowers are infinitely beautiful. They offer colour, texture, and form with the natural challenge of being delicate and perishable. Nature offers me everything I want, from exquisite and graceful to whimsical and dramatic. Whether it is a bloom or cluster of leaves or stems of fern, each contributes something important and essential to design.

Tell us about the importance of sourcing locally and supporting local businesses.

The second biggest flower auction outside of Aalsmeer, Netherlands, is located right here near Vancouver. I rely solidly on local flower producers. Some of the most incredible and beautiful garden roses are produced nearby. But there are also flowers that are grown in Japan, Italy, and California that are second to none. I have a broker who buys for me at Aalsmeer when I require something very special, but our local growers are unquestionably our mainstay.

What are the benefits of collaboration?

My first collaborative work was with photographers, and this remains a constant. Creating content for social media allows for so many collaboration opportunities. I have learned how valuable we are to each other and how important these relationships are.

Can you describe a memorable, standout flower order?

The big, over-the-top orders are always so much fun! Two hundred roses in the trunk of a car for a Valentine's lover comes to mind. But equally memorable was a mother asking me to make a posy small enough to fit into the tiny hand of her four-year-old.

Please tell me more about the man who had friends and family order a total of thirty bouquets of flowers from Floralista for his wife's thirtieth birthday. What an innovative and beautiful way to celebrate her and support a local business!

He called and said, "You're my wife's favourite florist!" We tried to make all of them different. She actually ended up running out of vases and had to put some of the bouquets in her blender jars. She messaged me later on Instagram— she was definitely overwhelmed in the most wonderful way.

Who, where, or what inspires you?

Since becoming a florist I have travelled as much as I can to as far away as New Zealand with the intent to get to know flowers better. And along the way I have met people who love flowers like I do. I am still fascinated that flowers mark both birth and death and every important occasion in between.

What is your favourite flower, and why? Not sure that's a fair question to ask . . .

That is like asking a mother to name her favourite child! Well, if you must know, roses are my special favourite— garden roses in particular. I have quite a lovely selection in my own personal garden, and some of them make their way into our bridal bouquets.

How has the pandemic affected your business?

People found that flowers were a way to connect and send love and support as only the language of flowers can express. The way the pandemic affected gatherings and events definitely impacted business, and we are not yet out of the woods.

Why are flowers—and the act of buying flowers for others and ourselves—important, perhaps now more than ever?

Sales have increased during the pandemic, even when our store was closed to in-person shopping. I think flowers in their fragility and beauty remind us of all of those qualities in the human experience.

Where do you envision yourself and Floralista ten years from now?

I would like to open a second location someday. It is a goal. Also, I hope to take creative inspiration trips once we can travel again. I also want to perfect my business model and invest even more in the professional development of my staff, with more time to specially mentor my designers. Like all things creative, Floralista has so much potential to evolve and change with time. I am always going to keep improving Floralista.

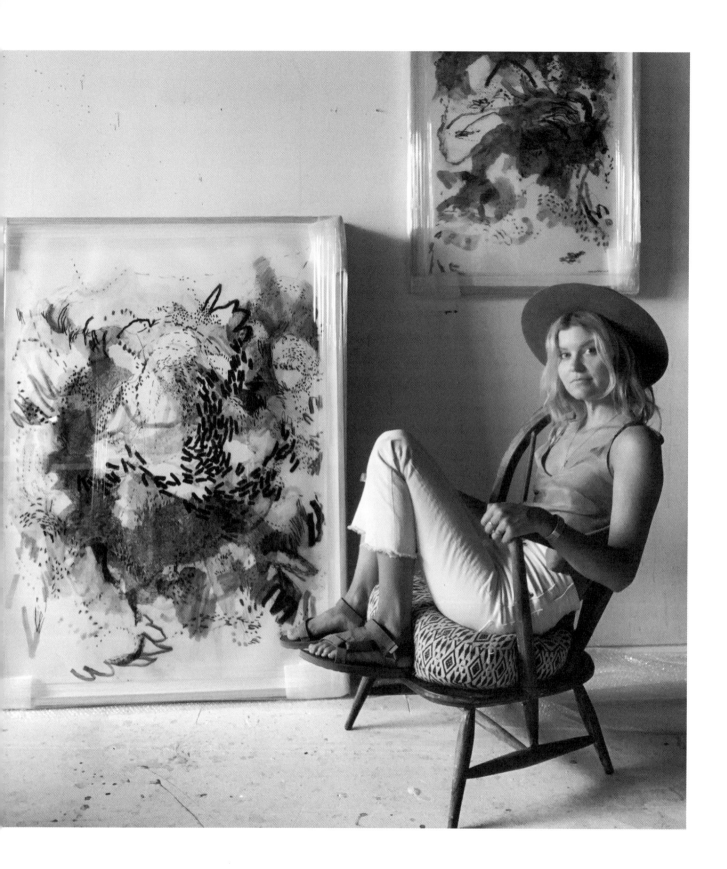

Sarah Delaney

Artist

"I always identified and labelled myself as being an artist. I clung to this declaration, and it became part of my identity from an early age."

What is your first memory of art?
Before I started attending preschool or kindergarten, my Gramma Rose would occasionally look after me. I would have sleepovers at her house. It was a respite from the chaos of my three siblings—the four of us were born only five and a half years apart.

I have fond memories of her drawing my picture. They were simple, full-body drawings that she'd sketch out with pencil on the scraps of paper, like the backs of opened mail. She would never draw the hands or the feet because they were too complicated. Once I learned that she could draw them, I made her do it all the time. I don't think I had ever seen anyone draw so realistically before. I grew up thinking she was a secretly wonderful artist. It's a memory I will always cherish.

Were you exposed to other forms of creativity as a child?
I think of my parents as "yes people." They have always encouraged us to follow our curiosities and pursue our passions and interests. We picked out our own outfits from the time we could walk, made our own school lunches from Grade 1. They celebrated our self-expression and independence while providing guidance where needed.

My mom bestowed her love for travel to her children, infusing its importance in us from a young age. While in Grade 3, my parents took us out of school for a month so that we could travel all over California in an RV. My mom bought each of us our own cameras and unlimited rolls of film so that we could document the adventure. I alone took over twenty rolls. She spent hundreds of dollars on developing (and her kitchen remained unfinished). The memories we made during this trip left a lasting impression on me and a sense of fondness that I still enjoy.

Storytelling was a big component of play, and thus a strong imagination was celebrated. As the oldest, I took delight in making up stories of magical lands and imaginary characters and sharing them with my siblings. I wrote and illustrated a lot of stories as a child. Character development was always very interesting to me: In elementary school I kept journals of imaginary people, citing their general interests and dislikes, their physical features, their family members, etc.

I think this also gave me a strong foundation and insight into my own character. I always identified and labelled myself as being an artist. All major decisions in my life have been based around me being an artist.

You grew up in Kenora, Ontario. What was that like?
To this day, I am continuously reminded of how few 1990 pop references I get; I blame this on the environment I grew up in. Our only TV channel was CBC Winnipeg, and our slow dial-up internet shared the same landline as our fax machine. Kenora is a small, somewhat isolated town on the Boreal Shield. Our nearest cities are Winnipeg (two hours west) and Thunder Bay (six hours east).

When I was one year old, my parents moved us onto a five-acre property, twenty minutes outside of town, where they still live today. Here, I was exposed to the outdoors; I grew up in nature, surrounded by woods and lakes.

My mom would urge my brothers, sister, and me to go outside and play. We spent our days free to roam the woods or play in the sand. In the summer, we would make forts out of fallen sticks. In winter we would dig tunnels through the snow piles that my dad made when plowing the roads. We moulded bowls out of clay down at the lake and built roads and hills in the sandbox.

We were always encouraged to connect and engage with nature and the outdoors. We climbed and planted trees; we learned to identify them from their needles or leaves and bark; we watched them grow throughout the years, and we collected their pinecones and gave them to our mother as gifts. We carved our initials in the tree trunks, and we counted the rings on our firewood.

Our parents taught us that the earth was made for using and interacting with. When I was young, I helped my dad pack down the transplanted sod he had tilled and dug up from another area in the yard. Later I would tear up the wet spring grass with my dirt bike. Each year when I visit, the soles of my feet harden as I go shoeless, running all over that same yard.

You moved to the west coast in 2004. What was it like?
When I was in the Grade 3, I declared that I was going to be an artist when I grew up, and I stubbornly never wavered. My plan was to attend a university for visual art. I decided on the location after spending the summer in Québec City between Grades 11 and 12. There I met a couple of girls from Victoria. We got along really well, and they told me that I reminded them of their hometown—a sentiment that warmed my homesick heart. They listed all the reasons why I would love Victoria—among the attractions listed was a thrift store they thought I'd like, the bunnies on the university campus, and a mild winter. So, the following year, when I was applying for universities, I added University of Victoria to my options.

At the age of eighteen, I moved across the country to the college town of Victoria on Vancouver Island. That was almost two decades ago.

On weekends I'd take solo trips on municipal buses to all corners and crevices of the city. I travelled as far as the line went, then hopped onto another bus. I liked to see how far I could go using just my university-issued student id card. These trips gave me strong feelings of freedom and fulfilled my desire to explore the unknown.

How did this time prepare you for your vocation?
There is no right way to prepare for being a professional artist. And there are so many types of artists. For me, as a conceptual, abstract painter, I believe that formal training was essential for my art practice. Despite growing up as a creative individual, my foundation and growth as an artist is rooted in my undergrad. My studio practice would look a lot different had I not experienced my four-year university education, especially during such a formative time.

That said, there are many components of being a professional artist that just were not part of the curriculum. In the university setting, the logistics of selling artwork were not covered, and that is something that I struggled with immediately out of school. All discussions were focused on art theory, art history, critical thinking, and general technique. Everything involving the business side of my practice I had to learn through trial and error in the real world.

When did you realize that art as business was a real possibility?
When I was twenty-two, I graduated from art school and moved from Victoria to the big city of Vancouver. My employment experience of working at private and academic art galleries, coupled with my education, eventually got me a job at a small gallery. I was making work in the evenings and weekends, but I didn't know how to grow. I was proud of the work I was making, but it wasn't bringing me the happiness I needed. I didn't know how to turn my work into a career.

Soon I was in my mid-twenties, and my art wasn't selling. I couldn't see where my future was leading, so I made an impulsive decision to enrol in design school. I took an interior design program—a field in which I figured I could get a job—which was a detour from my art path. It took me three years to complete the program, during which time I gave myself permission to quit my gallery job and start a part-time retail job. Despite only making minimum wage in a very expensive city, I was able to make new friends and do work with lower stakes. It served as a bridge between a place where I was unhappy and my future self.

After completing the Diploma of Interior Design program at Vancouver College of Art and Design, I worked as a visual merchandiser at the retail company I'd been working for, and then briefly as the furnishing coordinator at a residential interior design firm. These jobs were not long lasting—I went into them with less loyalty to the companies

and more awareness of who I was. This was a major step in my evolution and self-development; my priority was my happiness. Once I reached my late twenties, I had more life experience, more connections, and ultimately more self-worth. By this time, I was able to see a clear thread between my state of mind and my creative output and vice versa. I could see that my creativity was important to my wellbeing, and I couldn't compromise on that.

Tell us about your creative process.

The idea phase is always pulsing around in my being. There are some themes that I've been exploring in art for decades, and they continue in each of my series, like a through line you can draw. Other concepts, ideas, and techniques pop up as I experience them. These novel ideas are the jumping off point for a new series of paintings—a hypothesis that needs examining.

All series begin with time to experiment and learn. Sometimes that idea is straightforward, while other times it's a concept that I have to figure out how to translate into the visual world. Sometimes the concept evolves in the studio. Setting time aside to work out ideas is essential for growth and development. This step takes time and sometimes involves sketches, or writing, or researching.

As the body of work starts to take shape, a clear direction is formed, and the paintings generally come together easily. If they aren't working or don't fit into the parameters of what I'm trying to convey, they get set aside or destroyed.

Do you have a specific space in which you create?

I have a space I rent in a studio building. It's about three hundred square feet, with high ceilings and a window that I keep open most of the time. I've strung string lights from the beams and crowded upper shelves with plants. I paint the floors white once a year, but for most of the time they are pretty dull. The walls and corners are stacked with canvas stretchers, and the drawers are overflowing with papers, string, wire, canvas scraps, and acrylic mediums.

The potential for productivity really starts with my mind, then body. If I'm in a good spot mentally, I surge good energy and become unstoppable. I find that my creativity is most abundant when my inspiration cup is full and I'm riding a high of happiness. This is more or less my resting spot and how I'm used to feeling.

However, occasionally I step into my studio with built-up anxiety. Feelings of jealousy, doubt, and defeat trigger me and generate a recipe for failure and often lead me to take creative risks I'm unhappy with, while my inner critic blasts me. My abstract paintings are intuitive, and big markings and decisions on the canvas are made within seconds. My work requires me to be in the moment of creation and not focused on overthinking and considering what-ifs or what's next. Moments of uncertainty and apprehension are better spent writing about my work.

I've also learned to be accepting of the anxiety and its side effects. I've surrendered to it, as there's no getting around the fact that it is just a part of who I am.

How has the pandemic affected you?

I spent a lot of 2020 and 2021 working on staying positive and exercising patience. Admittedly, time during the pandemic has been difficult for me. I am very comfortable being by myself, and although I miss hugging people and visiting friends and family, the hardest part was being told I couldn't leave and explore. During lockdown phases, I stayed close to home, walking the same ten blocks to and from the studio each day. It was hard for me as I felt stuck doing the same mundane daily actions.

A substantial part of my identity is my freedom, my free will, my free spirit. In the past, when I could feel my anxiety approaching or negativity creeping in, I took it as a cue to change the scenery. It means my inspiration tank is depleting and I need a refill. Exploring new landscapes and experiencing new cultures is a sure way to give me the boost of inspiration that my soul craves. I've learned that I must tune into my body and listen to my heart. I use this as a guide for how to run my day or week, scheduling my studio practice around it. I know from experience that if I ignore my anxiety it will manifest into a darker place.

The universe is telling me that there are things you just can't plan or prepare for, and that's okay.

Where do you envision yourself in ten years?

I see myself with many adventures and trips in my pocket. I really hope I can continue to feed my inspiration bucket, see more of the world, and attend more art residencies. I hope I become increasingly comfortable with challenging myself. I hope to develop my painting abilities, but also step outside and study new artistic disciplines that can be implemented into the work. I hope I follow my heart and make choices that are good for the planet and make my heart sing.

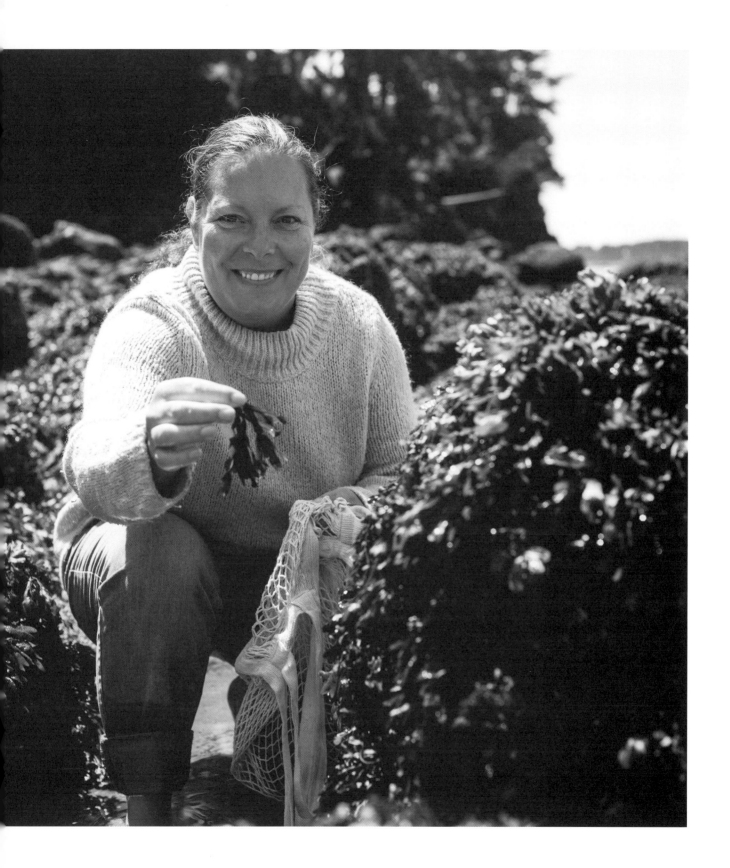

Tanya Droege

Founder, Sealuxe

"If you have a passion, follow it, research it, and think about the qualities you have that set you apart from everyone else."

Your connection to the sea is strong. Can you share more about this?

It's very difficult to talk about the loss of my father. He died when I was quite young. He was lost at sea when his boat overturned in rough weather when he was fishing up near Savary Island on the Sunshine Coast. I could take comfort knowing that he died doing something he loved in a place that was very special to him, but that doesn't make the loss easier to handle, even after all these years. His legacy is the love that I have for the ocean and the passion for exploring this beautiful part of the world.

The summers of my childhood were spent exploring the ocean and mountains, from Powell River up to the Broughtons. My older brother and I became master clam diggers and made lots of money at it. We dug up some incredible things, most notably a military bomb and a giant sand worm with a girth larger than the width of my hand. We were also stalked by wolverines—twice! My parents let us explore low tides and open spaces in the wild as long as we were in earshot and they could see us. I learned so much during those years of coastal exploration. I owe my love of the ocean, the wilderness, and foraging to my dad, and I will be forever grateful for this gift.

You had your daughter Ceara at age eighteen. What was it like to be a young mother?

It wasn't always easy. In fact, it was really difficult at times, but those difficult times gave me strength and confidence as a young mother. Ceara's father wasn't very involved. I tried to make it work with him for the first six months or so of her life, but he wasn't interested in being a dad or part of a family. When I look back, sometimes I can't believe I made it through that time. But I did my best to provide Ceara with as much as I could afford, and with the best life experiences possible; I think these challenges benefited both of us in the long run. Looking at her now, I'm proud of the woman she's become—thoughtful, kind, intelligent, generous, hardworking. Her upbringing gave her a different perspective. She doesn't take anything for granted, and much of that is probably due to the circumstances of her upbringing.

How did this experience affect me? I suppose it changed, or at least shaped my priorities. When you're in your early twenties and your friends are partying and you're raising a toddler, it's not the life you envisioned. But truthfully, I don't think I'd change a thing. It wasn't easy, but it was rewarding. And really, what did I give up? More hangovers? My experience gave me more focus, determination, and confidence. In my early twenties I packed up and moved to Nanaimo to start school. Ceara went to kindergarten, and I went to Malaspina (now Vancouver Island University).

I learned very early on that everyone has an opinion and advice on how I should raise my daughter, so I started reading all of the parenting books I could get my hands on to form my own opinion. I did the best I could for my daughter, to give her the best life I could afford both from

a financial and personal/emotional perspective. Her childhood was spent outdoors, and I focused more on experiences than things. It helped that as an only child with a charming personality, a hearty laugh, and a silly sense of humour, she was given an abundance of unconditional love not just from me but from everyone who knew her. This love really helped guide her to become the best that she could be.

At nineteen, life threw you a curveball. Please walk us through the diagnosis that would forever change the course of your life.
That was a tough time for sure. "Really? Cancer? As if being a single mom isn't hard enough!" It was certainly an eye opener and a stressful time. But I think being as young as I was probably helped with recovery.

When I was nineteen, I noticed a lump in my neck, and subsequently had several biopsies. I was told that it probably wasn't cancer, but it could be. At the same time, my doctor was having a really challenging time trying to stabilize my thyroid, and he suggested I look into seaweed. I was now in my second semester of my second year of university, Ceara was in Grade 1, and I became ill. I was lethargic, couldn't focus, couldn't remember, gained weight easily but couldn't eat, and I was having a difficult time swallowing. It was obvious that something wasn't right.

Can you share how your cancer experience became the motivation behind creating safe, clean skincare?
I had a doctor who suggested seaweed as a supplement, as it's high in iodine, and iodine is helpful in keeping your thyroid functioning properly. On his advice, I started taking seaweed in capsule form. I didn't notice a difference at first, but then my hair and nails started growing quickly and became healthy, and my skin was glowing. The more I researched, the more I began to discover so many positive attributes—not just for my situation, but for many other benefits. And to top it off, seaweed is fast-growing, renewable, and considered a huge part of the lungs— and overall health—of the planet. It checks off so many boxes! As it grows in popularity and is commercially viable, there will be economic reasons to not just harvest, but to also farm these miracle plants. I really believe we're seeing just the tip of the iceberg as far as what seaweeds can offer, from a

food source to a vitamin/mineral supplement, to skincare, which has obviously been my focus for the past few years.

Fortunately, the cancer didn't return, and while it would be nice to have my thyroid back, I'm certainly more fortunate than some.

When did the idea come about for Sealuxe?
I've always made my own personal care products as well as for gifts. I started down this path by making a range of handcrafted products, like Christmas tree decorations, for gifts at seasonal markets. It wasn't supposed to be a career, and I wasn't expecting it to be a huge money-maker, but it was fun. Not surprisingly, most of the items were ocean-themed, including a product I called Beach Glass Soap, a jar of small pieces of soap made to replicate ocean-smoothed pieces of glass you find on a beach.

The Beach Glass Soap became a big seller, and after taking a course on soap making, I began to develop other products, which led to more research on the benefits of seaweed in skincare and the development of additional products. Soon gift items were replaced by skincare products, and Sealuxe was born.

There are products out there, but not as many as there probably should be based on the benefits of seaweed. I am a believer, which is why almost every product I make contains some form of it. I think we're really on the cusp of this being more of a mainstream product as more and more people realize how great this stuff is. And honestly, nothing makes me happier that getting feedback from customers that one of our products made a significant difference to their life or solved a nagging issue with which they're struggled—it's very gratifying.

Clean ingredients—why are they important?
We need to listen to how often people complain about the chemicals in everyday products and look at the statistics for health-related issues over the past few decades. I'm not going to make unsubstantiated claims that Sealuxe products are a cure-all, but I see more people reading ingredients lists and questioning all these additives that they can't pronounce. Not all of them are necessarily bad, but who has the time to do this kind of research? In my experience, people want to know that what they're buying comes from good, clean, natural, ethical sources. What I

did notice when I first started was that clean and natural brands weren't making their products as luxury items—they were made for people who were already heading down the path of good health. I wanted to make products that felt like a luxurious product when applied but also have it affordable for a struggling single mom to buy.

We've seen seaweed as a main ingredient in the Asian skincare and food industries for some time. Are North Americans warming up to this mineral-rich ingredient?
Slowly but surely. I think there's been more interest lately, but it does feel like quite a slow adoption of this amazing super-plant. I think it's the optics: people think of seaweed as this slippery, salty stuff that washes up on shore. And others just know it as the stuff keeping our sushi rolls together. There's an incredible variety of edible seaweeds right in our backyard. And we're doing our best to promote them not just for their edible properties, but in our case for their benefits to your skin health. And I don't know anyone who doesn't want healthier skin.

Everything in your product line is made in-house, yes?
When I say our products are made in-house, I mean they literally are made in our house. My husband has been very patient and supportive as Sealuxe has taken over a good chunk of our home. When you walk in through the front door, you're in Sealuxe. On the plus side, our house smells pretty nice most of the time. My goal is to be able to move to a location off-site as soon as I can, but in the meantime, it's been great being able to grow this business from home without the extra expense.

You've organized several beach clean-ups at Crescent Beach. Can you tell us more?
Given my love for the ocean and the coast, I felt like it was something I really needed to do, and the response was great. While I always thought it was a very clean environment, you notice a lot more when you walk with your eyes on the ground looking for garbage. I was shocked at how much we picked up! While it seems like a huge task to change people's attitude, it has to start somewhere, and I'm happy to be able to do my part and spread the word.

Where do you see the brand in ten years?
That's a tough question because I dream big! I would really love to be a brand like Patagonia, who builds great products, causes no unnecessary harm, and uses their brand to protect nature. I think I'll be happy if we can continue to raise our profile, hone or perfect our branding, and are able to support ourselves and our staff while continuing to create products that make a difference in people's lives.

What do you do for self-care?
I have a lot of rituals. I'm a creature of habit but also really busy, so I make sure I start and end my day giving myself a little love. I take baths regularly, and for every bath I take I turn my little bathroom into a spa-like atmosphere with candles and soothing music. I also love the app Headspace at night to end my day, usually after my bath.

I love mornings and wake early, do my skincare routine, ease into my day with coffee and snuggles with my dog, and make a daily goal in my daytimer before I hit the ground running with Sealuxe work.

Can you offer advice to a young entrepreneur with a dream?
If you have a passion, follow it, research it, and think about the qualities you have that set you apart from everyone else. Find good, supportive people to work with, and don't be afraid to fail or ask for help. It may sound like a cliché, but it's true that you can learn as much or more from your failures than your successes, and you can learn a lot from other people's success and failures. Get up, dust yourself off, and use what you just learned to make yourself a better person and better entrepreneur.

I've doubted myself along the way at times, but it's been a great journey so far. I've learned a ton, and I have a long way to go. I'm definitely excited for what the coming years will bring.

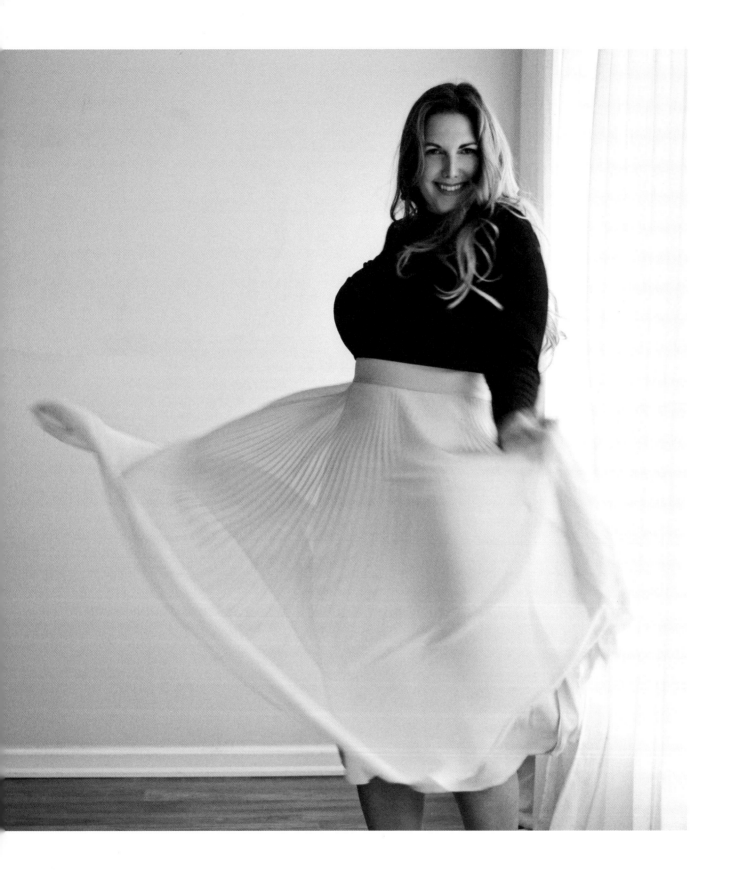

Charlotte Elizabeth

Curve model, content creator, brand consultant, confidence and style coach

"Confidence breeds positivity."

What is your earliest memory of helping someone?
My earliest memory is of helping my two-year-old sister out of her crib, when I was four. We'd tiptoe upstairs in the mornings to snuggle with our grandmother.

How did the landscape of BC inform your professional path?
I was born in White Rock, BC, which is where my grandparents ended up after immigrating to Canada from Germany in the 1960s. My grandparents' love for the outdoors and exploring BC was the reason my parents met as teenagers, when my father's father and my mother's father met over the sale of a cabin. My parents' romance led them to elope when my mom was only eighteen, and my dad twenty.

When I was halfway through elementary school, our family moved to the Sunshine Coast, where life was quieter and enriched by nature and Indigenous culture.

Tell us about the early days of your career and where it's brought you.
I started in marketing and events through promotions work while in college, collaborating with corporate brands as part of the marketing teams at events. I was studying business and the arts and was on the fence, trying to choose between working in marketing or a helping profession like counselling—and I am still energetically pulled between those two options. In year two I was offered a full-time position with a brand in Toronto running their western promotions. Being young and struggling to make ends meet, I took it and ran with it. I got into the fashion marketing side of things through becoming a plus-size model ten years ago. Learning about social media, embracing that, and building a community online, I was able to have a presence that brought brands to me. A number of years ago I decided to move forward in an inspired joint venture to open an online values-based fashion store that uplifted brands who shared my values of vegan and ethical production. I learned so much about the world of e-commerce, production and burnout, and had to eventually walk away. Though I could see leaving as a failure, I really see that experience as a time of growth and determination and learned what was healthy for me emotionally, physically and financially. Now I partner with brands not only as a model or content creator but as an ambassador speaking to the brand and products, being part of events, pop-ups and even helping clients to coordinate, produce and host them. I truly feel lit up when I am able to use these skills and work together to build community.

Do you feel that a combination of formal schooling and real world, hands-on experience make for the best kind of training?
My training is not formal by any means. Although I did attend college with the intention of getting my degree, halfway through I was offered a position in a field that greatly interested me. Let's say the "starving student" jumped on that opportunity. I have so much respect for folks that live on their own, work to support themselves, and pay to put themselves through school. That is what I was doing, and it was not easy. I was still young and undecided on my exact direction, so I took the opportunity on what I called being paid to learn! I would love to return to

school one day, and I have completed a handful of courses and training over the years. It's healthy to keep learning and growing; formality isn't specifically needed in all fields, especially in entrepreneurship.

You exude positivity. How do you cultivate that in your life?

As a young child who felt hurt and unsure of herself through strained and irregular family dynamics, changing schools, and being in unfamiliar and not-always-friendly places or experiences, I was not confident. I consider being confident as coming back to myself, learning to be open and vulnerable while finding that feeling of being safe. Confidence breeds positivity; to me those two are connected. I do my best to share in an encouraging way, but positivity twenty-four-seven isn't realistic for any of us. We all go through our ups and downs—in no way am I a supporter of the "good vibes only" mantra. I believe we need to create space for ourselves and each other to be real when we are not feeling positive. On the flip side, we can consciously choose to focus on positive thoughts and experiences as long as we aren't bypassing or pushing down the "negative" stuff. Now I love to smile and share big laughs, especially when I am meeting new people! Being around good-hearted, open-minded humans lights me up.

The motto on your website reads, "Compassionate choices create a kinder world." Can you tell us more?

Kind Lifestyles was inspired after I chose to go down the ethical vegan path five years ago. My eyes were opened to things that I'd previously chosen to not focus on or pay much attention to. I was inspired to learn about the ethics around production of goods, human rights, animal rights, equality and how we can be more conscious as consumers and producers. Kind Lifestyles originally had started as a blog and has evolved into a platform where I share all of my business offerings. Choosing from a kind perspective is a way of being or a lifestyle choice; this is also put forward in my client partnerships and the values-based content created.

Is there a connection between your long list of services?

I'll use this analogy: When we eat pie, we usually cut it into pieces and share it around, the same pie with multiple slices. All these services are interconnected and complementary of each other and go hand in hand with my professional experience.

For content creation, production, events, and modelling, I work primarily with fashion, accessories, beauty brands, and some food and beverage companies, but I'm not limited to those. Our mutual focus comes back to our shared values arounds slow fashion, ethical production, fair fashion, and sustainability.

The women I work with are each on their own self-growth journey, and body acceptance is part of that for many of us. Modelling can be a gateway to challenge ourselves from bringing up insecurities we may have thought were put to bed, such as comparing oneself to others, or hearing "no" and taking it personally. Getting into modelling can feel amazing when you get affirmations and praise, but there is a flip side to that. Along with being a support system for one's personal growth, I educate people on the ins and outs of the business, the how-to's, and the do's and don'ts.

I love your Instagram handle, @charlottecurvemodel. Tell us more about how it came into being.

When I chose my handle years ago, I didn't really resonate with the term *plus size*. My body is curvy, and I've never been keen about being stuck in a category.

The first time I modelled was at an event at a local mall; I was five years old. As a teen, I modelled for local stores and brands but honestly did not think much of it. I was a straight-A student and super focused on school. It was the late '90s, and there really was no such thing as curve models with careers in my orbit. Media only showed one size—"skinny"—as acceptable back then.

I got into the business later in life at age twenty-eight and invested a lot of time, money, and energy into my portfolio. I travelled and worked in different markets in Europe and the us. And I also heard the world *no* a lot. Over the years, I felt like a failure; life was a hustle, especially when a lot of brands weren't yet extending their sizing or even showcasing different-sized models. Now, everyone wants to use unique models, in shape, size, height, and ethnicity; this market growth has given me many more opportunities. Many of us living in larger bodies have been out here fighting for our place, to be seen as worthy—to be more than just a body, to be human beings living our life doing all the things that were once only allotted for thin folks.

How do you decide which brands and products you promote and represent?

When I first started, I would work with anyone. Now that I am established in my career, I am able to align my personal beliefs and boundaries around what I want to promote and be a part of. Often brands will reach out directly to me, and we will discuss together or with my agent if we are a match.

Please describe your approach to collaboration.

I love working with brands to help accomplish their vision. It's invigorating to be able to use my creativity to help build a brand and share their message, with my own spin on it. I love working with other humans.

How have people responded to your look and message as a model?

In the earlier stages of getting into the business, there was hesitancy about my age at the time, twenty-eight. I was told, "We are only signing junior models," and "You're not tall enough to balance out your curves." (I was then a size 12; now I'm a 16.) I was asked, "Why do you try to be younger than you are?" and told "You should just be you." I felt like there's no trying because this is just how I look.

Now, as an established model, and with the shifts happening in the industry, most folks just rave about my natural hair; I'm starting to get some silver streaks here and there. Most people don't believe me when I tell them my age. I believe my upbeat attitude, confidence, and personality outshine however my body looks. One compliment I love to receive is when someone says I have good posture. I am into yoga, dance, and feeling strong, soft, and extended in my body. Standing up straight—that's my jam.

Is this inclusive attitude here to stay?

Yes, and it's about time! The world is becoming so connected through social media and the internet. Beauty standards really vary depending on where you are in the world. It's starting to feel like a melting pot, and this is changing and shaping our North American view of beauty, which is a good thing. Women's voices are being heard; we have been demanding this! But now it's our opportunity to grow even further. Now that we have access to diverse beauty ideals, we no longer have to be defined by them.

Can you tell us about a standout experience?

Early in 2021, I had the amazing opportunity to be a part of Canadian icon Bryan Adams's video "So Happy It Hurts." What a thrill to be asked! He is a rock legend and features women in his video that don't fit the typical standard of thin beauty ideals, what we repeatedly see in the majority of film/TV and music videos. I love and appreciate how progressive and inclusive music and art can be. It was pure joy being a part of it, so big thanks to Bryan for including me and Jihan Amer. For me, movement and dance are an expression of personal freedom. Let's shake up the beauty standard; let's shake up perceptions of what a woman's value is!

Who, where, or what inspires you?

Folks who rise beyond adversity are a big inspiration, as are people who act with compassion and create a safer and kinder world.

How do you define success?

I have mixed feelings around success. I ask myself, *Do others see me as successful?* It's just not how I see myself. Maybe that's because I have been conditioned to believe success means certain things that I have not accomplished yet. I understand that success is putting yourself out there and that it's coming to the world with an open heart. It's building a career I am passionate about. It's about learning balance in place of continuing a cycle of burnout. It's breaking away from family cycles. And I always ask myself, *Is it a good thing to keep pushing oneself forward? Is there also a time to create space and compassion for "failures," for things not working out as planned?*

Where do you see yourself in ten years?

I'd like to go back to school to pursue further education in a helping profession like counselling. I see myself having my own inclusive vegan fashion brand. I will continue to advocate for body inclusivity, neutrality, and personal growth through all my media channels. I will be a rocking, mature model at the age of forty-nine, flaunting the greys. I would like to strengthen my outreach and career in media through hosting a TV show that focuses on Kind Lifestyles for all, personal growth, healing, and community.

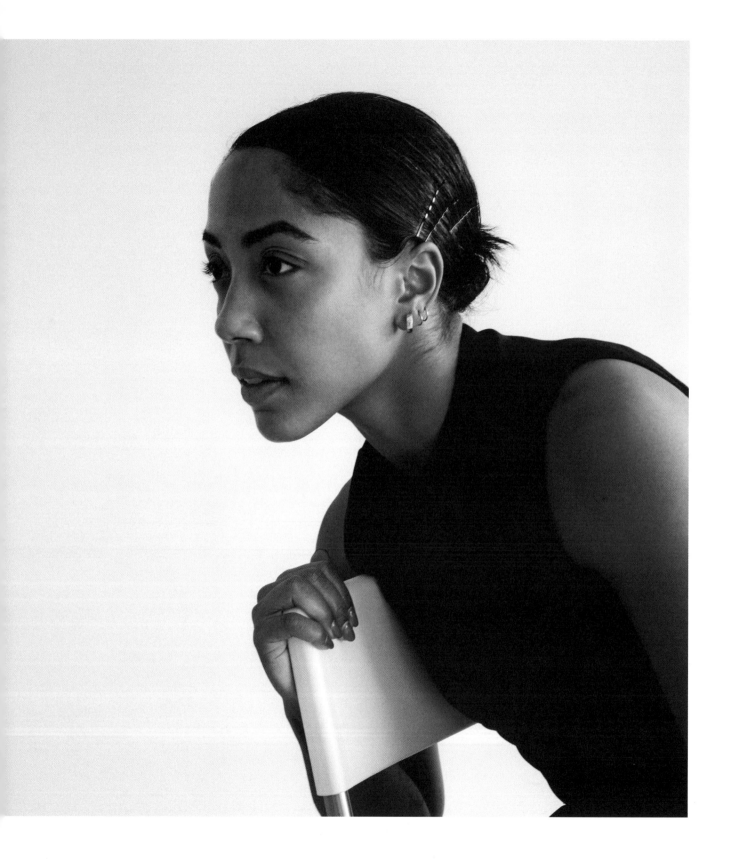

Livona
Ellis

Dance artist, Ballet BC

"I am intrigued by the subtlety of a dancer and how they can achieve virtuosity with stillness."

What is your first memory of dance?
My first memory is when I started ballet classes at age six. I remember walking up the stairs to the classroom and having my leotard and tights already on, and I was carrying this little dark green Harrods bag my great aunt had given me that summer. I don't remember much about the class or dancing; I just remember feeling nervous.

Were you exposed to various forms of dance growing up?
My mom and aunts would always dance around at family events. I have memories of them at my grandparents' during Christmas, playing disco music and dancing and laughing, reminiscing about going to socials when they were younger. Every summer, my grandparents would take me to these big picnics put on by their friends in the Guyanese community. It would be an afternoon of fun games and races and lots of food, but what I remember most is the dancing. The soca music would be blaring, and everybody would be dancing. That is where I learned what rhythm is.

You were raised by your mom and stepfather. Did they encourage you to explore dance?
My parents have always supported me in dance. My mom was an athlete herself, so she really encouraged the discipline and focus that dance offered me. I was raised by my mother until I was eleven. Being a single parent had

its challenges, especially financially, but my mom did everything she could to keep me in dance. She always said, "You're not going to be one of those kids who just hangs out at the mall doing nothing." When my stepfather (who I consider as my dad) came into our lives, he understood how important dance was to me. I feel grateful that I could always focus on my passion without having to convince my parents that this life path was valid.

I was twenty-two when I met my biological father for the first time; I was in Holland for dance. It was interesting because what should have been this monumental moment in my life actually felt quite normal. I was just curious about who he was and not expecting anything, so it made the situation less awkward. I had no hard feelings or resentment. I did wonder if he would understand what I do as a professional dancer. I was relieved that he really appreciated that dancing was my career, and he was excited to learn more.

Your dance training was principally spent at Arts Umbrella. How did this equip you?
When I started at Arts Umbrella, I really enjoyed dancing, but it wasn't until I joined the Apprentice Company that I knew that dance was it for me. The Apprentice Company was an extra program where you would rehearse on Tuesday nights and all day on Saturdays. It was set up to model a professional company. We would have guest choreographers and extra performances outside of the training program. The director of the company was Emily Molnar; I was so inspired by her dedication to the art form and was drawn in by her intensity. She gave us the responsibility of a professional dancer and treated us like mature adults. I was thirteen years old and in an environment that gave

me the freedom to develop and grow as an individual and as an artist. From that point on I was hooked. Dance was everything to me and I knew I could never leave it.

I completed the Dance Diploma Program (grad program) in 2010. It taught me so many things that have helped me succeed in dance but also in life. The program was, to this day, two of the most intense years of my life. It's set up in a way that pushes you to your limit and then some, and it's not until the storm has passed that you can fully process all that you have learned. It taught me how to manage my time, communicate clearly with others, and it's helped me to really listen, to push myself and also be patient with myself. I figured out so much about myself as a person and how I wanted to interact with the world. What do I value? Why is it important? What do I have to say?

During my time in the grad program, I got to work with some incredible voices in dance. I feel very lucky to have been exposed to so many artists, but what I cherish the most is the time I had with my teachers. Life moves quickly now, and my focus and priorities have shifted as a professional. There was something special about spending every day with the same people, all with the same goal, all failing and succeeding together. Not knowing what we didn't know and being okay with it.

I started dancing with Ballet BC as an apprentice right after I graduated from Arts Umbrella. I didn't have a formal audition. Emily Molnar had just taken over the company but the year before was on faculty at Arts Umbrella. I rehearsed with her every day in the grad program, so I suppose that was my audition. I'm grateful for the many years I was able to work with her at Arts Umbrella. She was a huge part of my growth as a dancer, and I was thrilled to have the opportunity to keep learning from her. Having her support at the front of the room was a wonderful way to transition from student to professional.

How did your life as a dancer align with your growing independence as a young adult?
During my time at Arts Umbrella, I was living at home with my parents. I don't think I would have survived otherwise. I was fortunate to have their financial assistance, meaning I didn't need to juggle a part-time job with my very intense training program. I didn't move out until I was twenty-two. It was my third season with Ballet BC, and I had gone through a breakup—and it was time for me to gain some independence. I moved into a house I found on Craigslist with two male strangers. When my mom came with me to get the keys, she looked around, and with a very concerned look on her face asked me, "Why did you pick this place?" There was a hole in the wall, but it was in my budget, and I was desperate for some freedom.

You're now a faculty member at Arts Umbrella. What is that like for you?
When I teach, I have to find ways to articulate my ideas in ways that many different dancers can access. The process of doing this really makes me think about and question the things I work on as a dancer myself. I often laugh to myself because now that I am in this position, I can hear all of the things that my teachers would say to me, and it is so clear to me now with this perspective. I am also in awe of this next generation of dancers. The way they think and move and have so much confidence in their individuality is inspiring. Some of the most rewarding moments are when my students think for themselves. Of course, I am thrilled when they achieve something physical or technical, but when I see them thinking for themselves and problem solving, I feel like that's the thing that will stick with them as they move forward.

You left Ballet BC for some time. What prompted the departure and return?
I left after eight seasons with the company—I felt it was time to go explore. I had learned so much and was always challenging myself to never become complacent, but I needed a change in my life. I wanted to live in another city, dance with different dancers, be a different Livona. I grew up, trained, and danced professionally in Vancouver, and I was itching to be in a place where no one knew me. I wanted to see if all the things I valued in dance and life made sense in another context. I spent two years away from the company. I worked with a few artists here in Vancouver and then spent time working in Germany and Switzerland. It was crucial for me to gain some independence and have time to reflect and see and meet new people.

When I heard that the direction at Ballet BC was changing and that Medhi Walerski was the new artistic director, I knew this would be a place I could come back to and continue my artistic growth. I have known Medhi for ten years now, first as a dancer in many of his works with Ballet BC, and most recently staging one of his pieces with a company in Hanover. He is a true artist and I admire him greatly.

He is so generous and supportive, and I feel an immense amount of trust from him that has allowed me to trust my own instincts more. Ballet BC really feels like home.

Which choreographers, dancers, and types of dance inspire you?
Choreographers: Crystal Pite, Sharon Eyal, Dimitris Papaioannou, and Pina Bausch.

Dancers: Jermaine Spivey, Doug Letheren, Christopher Roman and many more.

Dance forms: contemporary, street dance, vogueing, and ballet.

I tend to draw inspiration from the people around me. There's usually a question I want to answer or work through in my process, and I use my personal experiences because I have the most knowledge on those subjects. Lately I have been inspired by film; I look at the cinematography, and it gives me ideas on how to structure a piece. The effect that editing has in a film is something I'm curious about in live performance. I'm interested in how I can achieve this affect with moving bodies in space.

How have you evolved as a dancer?
2022 will mark my tenth season with Ballet BC and my eleventh year dancing professionally. I feel like a very different dancer. Over the years I've learned to take my time and be actively present. As my body has changed, with injury but also knowledge, I have started to understand how to play with the balance of the physical and intellectual. I feel less stressed about the little things and more grateful every time I have the opportunity to share my art.

Who have been your biggest supporters on this journey?
My grandmother was one of my biggest supporters. She believed in me, and that was huge for my self-esteem when I was growing up. I knew I could always rely on my family for guidance, and I learned so many important life lessons from my grandmother. She was the most caring and nurturing woman, had such an infectious giggle, and always put her family first. It is still surreal to me that she is gone. I think of her every day, and she's often in my dreams. Her passing was the moment when I realized I was fully an adult; somehow it felt like my childhood went with her. I feel a responsibility to continue her legacy; it is really important to keep her traditions going and to keep her spirit alive. I'm finally at a point where I feel I can make work about her. She has impacted my life so profoundly, and I want to pay homage to her.

Your work is exceptionally physical. And emotional. How do you ensure that you're performing and working in peak form?
This body needs all the help it can get. I go to physio or massage once a week, and I have an array of tools at home to help with all the aches and pains. I've had two knee surgeries, one at age sixteen and another at twenty-seven. Since my last surgery, I have learned a lot about my body and what I need to do to keep it running. I've started biking every day to help with inflammation in my joints and range of motion. I've incorporated more supplements into my diet, and I am all about Epsom salts baths. When I was younger, I didn't pay enough attention to my body, but now that I have a chronic injury I prioritize a proper warm-up and cool-down. Being injured is a blessing if you can come back from it stronger than before. My recovery was emotionally exhausting, but I am thankful for what it taught me: patience, perseverance, and to not take my body for granted.

How has the pandemic affected your work?
The pandemic has been hard to navigate, but I am trying to stay positive and open. It took time to get used to teaching students in a mask. It's hard to read their expressions and vice versa. It's also a challenge to find ways to articulate myself with words where I used to be able to use touch.

As for performance, I'm still getting used to not having that outlet. I have to say that holding on to that frustration wasn't doing me any good, so I let it go. With everything that is happening in the world I am privileged to be able to work and to do so safely. Yes, the arts are suffering from this pandemic, but I also think it's in our nature as artists to adapt and overcome. We will come out on the other side of this with a reinvigorated passion for what we do.

Why is dance important?
At this moment in history, with all the pain and injustice in the world, art is an escape for the soul. Art is a way for people to express themselves and create another reality. Dance allows us to connect with this universal language. Talking with our bodies, in whatever shape or form, is innate to humans. I think there is profound transformation that can happen when watching dance.

Laurence Fisette

Chef

"Up until this year I had only worked for women chefs, which is incredible. It just happened this way. I think it's one of the reasons why I feel confident in the kitchen."

What is your first memory of food?
As a baby, my face would light up whenever a plate of food was placed in front of me. I would climb up onto the kitchen cabinets and grab anything with chocolate to share with my sisters. Making pies with my mom and grandmother "Gigi" around age five is another fond memory. We would make tourtière around Christmas, and I would decorate them with *fleur de gui*—poinsettia made out of red and green pastry dough. I think it was also at this age when Gigi asked me what I wanted for my birthday and I said, "A bag of ketchup chips." I was a gourmand kind of kid.

Was food something that brought people together in your family?
Food preparation was always a big part of my life. Both my mom and dad loved to have big dinner gatherings with friends and family. I grew up surrounded by a passion for food. I know it's a cliché, but my mom's food always tastes better. She's very creative in the kitchen. My dad loved to follow French recipes from cookbooks and enjoyed incorporating fancy ingredients such as seafood, nice cuts of meats, beautiful oils and vinegars. There was always a lot of butter.

I was Born in Magog, a small town southeast of Montréal. My grandmother owned a restaurant all my life until she retired at seventy years old. My mother was a stay-at-home mom until I was ten, and then she started working in various restaurants but mainly helped out at my grandmother's restaurant. She now works as a cook on boats; one of her forever dreams has come true. Both my mother and grandmother are the ones who inspired my interest in all things food.

Québec is known for its food culture and for creating some of Canada's most unique and delicious delicacies. How did you personally experience this?
My grandmother cooked a lot of classic Québécois food. My two favourites that I could not resist when I went to visit her at the restaurant were *soupe aux pois* and *tarte aux sucres*. I can still hear Gigi say, "I thought about you, and I made split pea soup. Have a bowl!"

At what age did you realize that you wanted to pursue a career in the culinary arts?
After high school I was lost. I didn't know what I wanted to study, so I went travelling—Africa, Hawaii, Bali, Singapore, Mexico, the west coast of Canada and the United States. I've crossed Canada five times now.

I did not go to school for cooking. I started working in a restaurant when I was thirteen years old, making cutlery rolls at the same restaurant where my older sister worked as a server. I went from roasting coffee, to being a barista, to making sushi. Then I went on a road trip to the west coast with my best friend Charlotte. We wanted to go pick cherries, but that didn't work out. We ended up working in the restaurant of an old boat. At twenty, I started working at Café Bliss and Be Love in Victoria under chef Heather

Cunliffe. They serve the most beautiful and creative vegan cuisine. After this experience, all I wanted to do was work with real food.

During my travels, I completed two hundred hours of yoga teacher training in Bali. I taught yoga for a year at a resort in Tofino a few mornings a week while cooking at night full time. I had to choose between the two. It was too much. I could not do both well.

Tell us about the importance of mentorship.
Heather Cunliffe is the first chef who made me realize that I wanted to work with food and become a chef. She introduced me to plant-based food and fresh produce—food that is nourishing.

My biggest influence and most important teacher in the culinary world is chef Lisa Ahier, owner of Sobo in Tofino. Sobo was the only restaurant I wanted to work at because meat was not the focus of the menu. Lisa is pescatarian, and her menu reflects that.

I was young when I started working for Lisa, around age twenty-two. I learned everything at Sobo: flavours, cooking with soul, a variety of techniques. Two years in, at age twenty-four, I was promoted as sous chef and became a leder for the first time. I gained so much confidence, and this confidence stays with me years later.

Another mentor that made a difference in my life is Janice Tiefenbach, chef at Elena in Montréal. When I moved back to Montréal, I was looking for a job that focused on pasta. I began working at Elena as the garde-manger station and was soon promoted to pasta station, then sous chef. Janice was a hard chef to work for because she knows what she wants, and she wants it perfectly executed. At first, I avoided her in the kitchen (she can be a little intimidating, I hope she will not be offended by this!). She made Elena one of the best restaurants in Montréal, and she also became a close friend of mine. We went on a foodie tour to New York together, and we would hang out outside of work. She showed me perseverance and how to make ingredients shine; I really like and respect that. She studied art, and it shows in the presentation of her food.

Also important are chef Emma Cardarelli at Nora Gray in Montréal, and Ryan Gray, co-owner of both Nora Gray and Elena.

I did a few short stages in New York; one of them was for a month at Dirt Candy with chef Amanda Cohen. Her vegetable-focused restaurant is more like a vegetable lab, pushing the limits of what can be done with produce.

I admire a chef that does great food and has something to teach that no one else can. Anyone who shows respect for employees and building a strong team that feels like a family is important to me.

Can you describe your favourite meal?
A family-style setting, with fresh pasta; a whole roasted fish, lightly seasoned and finished with a squeeze of lemon juice; a big salad with whatever is seasonal. Some natural wines. For dessert, something simple like homemade whipped cream and berries. Oh, and we would be eating cheese and bread while cooking the meal.

What brought you to British Columbia?
In 2012, when I was nineteen, my friend Charlotte and I were looking for a new adventure. I was just back from six weeks in Senegal and I still had the travel bug. We took my old Nissan Sentra and drove across the country hoping to find work as cherry pickers. We stopped at the first farm we saw on Vancouver Island and pitched our eight-person tent. We were cozy and had plenty of space. But cherry picking was not for us, as we made only a few dollars a day. It was really hard work and early hours. We heard that there was a really beautiful place at the very end of the road.

I was blown away by the natural beauty of Tofino. I have always been the odd one in my group of friends and family, but in Tofino I felt like I fit in. Time is different here; people live slowly and make plans depending on the weather and the tides. I'm inspired by nature, and I love to sit, drink coffee, listen to music, and watch the ocean. I remember describing Tofino as *un calme étrange*, or a strange calm. I was hooked.

What was your first job in Tofino?
First, I had to translate my resumé from French into English at the Tofino library. I didn't speak English very well, so I couldn't be too picky. I applied to Beaches Grocery and got a job there; it's a little grocery store that looks like a wood cabin. This is where I learned English. It took some time, though: someone once asked me for straw, and I pointed at the strawberries.

Before the pandemic, you worked at the Wickaninnish Inn in Tofino. What was that experience like?

I had been working at The Pointe Restaurant for a couple of months before we had to close due to the pandemic. I was hired as an entremetier, which is the "vegetable chef." Even though I only worked there a couple of months, I felt part of a team. I met some very talented chefs such as Carmen Ingham, who is very knowledgeable, creative, and talented.

The Wickaninnish Inn is a very professional kitchen. This was a place where I was hoping to continue my learning; I was looking to refine some techniques and work in fine dining. I will return once they re-open.

You went back to Montréal after being in Tofino for a while. Can you tell us more about that?

After five years of not being close to my family, I felt the need to reconnect. Also, my sister Sara called to tell me she was pregnant; this was my new reason for returning to Québec. When Sara had her first child, I was there to help her, and I also lucked out and got a job at Elena. It was an incredible two years.

There was no plan for after Sara had her baby. During the pandemic my mental health was not great. Being in a city during the pandemic was stressful for me, and I needed a change—I needed nature. So my partner, Jon, and I moved back to Tofino.

What are some of the challenges and benefits of the pandemic?

I've learned a lot through this time. I am a seeker; I can't sit and wait. I have to do something positive and fulfilling at all times. Even in uncertain times I want to achieve and do what is best for me. The restaurant industry has been hit hard; many people have lost their jobs, had to close their restaurants, and are waiting for things to get better. It is very hard to watch and wait.

Upon your return to Tofino, you started a pandemic passion project called Pain Perdu. Tell us about that.

Pain Perdu is homemade sourdough loaves and bagels that I bake and deliver to the Tofino community. I'm a calm person, but I can't sit still, so when I got laid off, I started baking bread at home. It became an obsession, a need to perfect my techniques and recipes. There was too much bread for us to eat, so I decided to sell some and created an online bakery of sorts via social media. I loved to market it, take photos and use social media as a platform for selling the bread. It was fun to create more than food, to create a brand and a vibe. My friend Nanou (Cristina Gareau) offered to get me a stamp for my bags. I thought it would be weird to put my name on it, so Pain Perdu was the first name that came to my mind.

What has been the community's response to Pain Perdu?

I don't want to brag, but people loved my bread. I had some people ordering more than two loaves a week for months. I think it was something special for people to get something homemade in this time of being apart from one another.

Who have been your biggest supporters on your culinary journey?

I lost my dad eight years ago. I think he would have been very proud that I'm doing what I am passionate about.

My biggest supporter is my partner, Jon; he is as passionate as I am about restaurants and food. He understands why I work long days for minimal pay. He has been my best friend and sounding board since 2015. We have shared so much great food and wine.

My mother is proud of the route I'm taking, almost like she's looking up to me and that she's passed on something special. Gigi passed away a year ago, but her feelings were similar.

What would be your dream kitchen to work in?

Somewhere in Italy with a *nonna* (grandmother) who has done pasta all of her life. You don't know pasta until you have been to Italy. I've never been.

Have you thought about opening up your own place?

I think about it all the time; I'm always daydreaming, taking notes, and thinking about different concepts.

Emma
FitzGerald

Author, artist, illustrator

"I don't do a lot of archival research, relying more on what I feel, sense, hear, and what people tell me. That element of surprise is a big part of my process."

What is your first memory of drawing?
I'm sitting next to my dad, at about four years of age, in Hamilton, Ontario. We are looking at a story book based in Lesotho, in Southern Africa, where I was born. I remember us copying the drawing and my dad drawing the grass with me. As he was a busy medical doctor, that time together drawing must have stood out in my memory as special.

What are some of your memories of Lesotho?
Shortly after my parents were married in Ireland, they moved to Lesotho for two years to work at the Queen Elizabeth II Hospital in the city of Maseru, as a doctor and physio respectively, as the Irish government was focusing its aid there. I was born in South Africa and spent my first eighteen months living in Lesotho. Though I do not have memories that I can picture in my mind, I am sure the place had a big impact on me.

My mum went back to work soon after I was born, and I spent most of the day tied to the back of my caregiver, a woman named Grace. Apparently, she sang to me all day, and even after we moved to Canada, she wrote me and my parents long letters on blue paper with blue pen. The last letter I received from her was shortly after we moved to Vancouver when I was seven years old. I tried to find her when I returned to Lesotho in my twenties but did not have success.

This experience made me think of the world as being much more connected, but also full of things that are not easy to understand—like why Grace could not easily come to visit, what apartheid was (which was ongoing at the time over the border in South Africa). It also gave a lot of colour and texture to the stories of my babyhood, with stories of riding ostriches in South Africa and on mountain ponies in Lesotho.

Were you creative as a child?
I remember an early preschool drawing of a rose made of many hearts. Later, when I was ten, the first watercolour painting I did that I was proud of was a vase full of lilies. I was encouraged to express my creativity through drawing, but also dance. I began ballet classes in Ontario at age three with Betty Love, the same woman who first taught Karen Kain, which made an impression on me even then. My favourite part was pretending to be a deer and using my hoof to find grass in the snow to eat. My imagination and sense of play were certainly encouraged. In Vancouver I continued to study ballet, and in my teens I was part of the contemporary performing group at Anna Wyman School of Dance Arts on the North Shore. Anna was an important mentor.

You received a BFA in visual art from the University of British Columbia, and a master's in architecture from Dalhousie University. Can you share a bit about this?
I went into fine arts at UBC to study printmaking and drawing straight out of high school, partly because I had free tuition as my dad taught there in the medical school. I leveraged that and spent my first year in England doing a study-abroad program via UBC, and my third year was at L'École des Beaux-Arts in Paris, an exchange made

possible as Vancouver artist and former prof Ken Lum had taught there. With my Irish citizenship I was able to access funding to pay for my housing.

When I graduated from UBC I didn't see myself wanting to try to fit into the gallery system as an artist, or becoming a teacher, at least not right away. Studying architecture seemed like a way to help people more tangibly, and it satisfied an interest for working in public space. I had initially been afraid to study architecture because math was required. I was helped in that regard when I was sixteen at Crofton House School and famed architect Cornelia Oberlander visited my classroom. She said that math wasn't really that important when I asked her about it; she had such a compelling way of seeing architecture as a means to help the environment. That gave me the courage to go ahead with studying architecture, eventually.

At what point did you decide it was time for a change?
It was when I graduated with my Master of Architecture degree in 2008, when it was a time of economic recession around the world. I felt lucky to get a job at a local firm and have the chance to stay in Halifax, a place that I had come to love. However, I was not happy in my workplace, and after two years I had the chance to travel to The Gambia and teach architecture as a CIDA intern alongside former classmates from The Gambia at The Gambia Technical Training Institute. That was an amazing five months.

On my return to Canada, I had trouble finding permanent work, so when I found another contract ending, I decided to apply for the national self-employment EI benefits program, something I was eligible for as I was on EI, and begin a house portrait business, to see if illustration could become a full-time job.

In a sense, the shift to being an illustrator was out of economic necessity. Admittedly I never really felt like I was destined to be an architect, but I was still motivated to try my hardest. The process to get fully registered is long and arduous, even after school, and the lack of work opportunities at the time forced me to consider making money from my art. However, I had been making art all through my years working in architecture, whether it was drawing in my sketchbook, posters for musicians, or larger-scale installation art that I made and exhibited, addressing the denim industry in my birth country of Lesotho, where I focused on the impact textile factories had on the social and environmental landscape.

Do travel and moving around continue to be part of your life?
Yes, I have a long-time pattern of living in different places! When I was in architecture school, we had to complete two work terms. I spent four months in Calgary working for Sturgess Architects, and nine months in Johannesburg working for Peter Rich Architecture. Those experiences taught me a lot about being a professional and how to work with a client. I also had to let go of the expectation for political correctness that I am so used to in Canada, and I saw how systemic racism continues to exist in South Africa despite the ending of apartheid, while also seeing a lot of joy and vibrancy and gains for the Black community. In the office there was Rob who was British South African, Janet who was Greek, Franz who was Afrikaans, Tsleng who was Pedi, and me.

Living in many places and travelling light has affected my illustration style most directly in that I work quickly—with pen, no pencil first. Architect Peter Rich, my boss in South Africa, is a prolific sketcher, and I saw how his pen drawings tell a story; that is as important as the more technical drawings. When drawings tell a story, they connect with people on an emotional level and become a part of their world.

I have also learned how to create a sense of home and connection wherever I am, which is a source of comfort in life, and allows me to create the base wherever I may be to then go out and take risks.

What were some of the challenges and benefits as you embarked upon a new career as an artist?
I was lucky to have a lot of momentum during my first year of being self-employed. I was in the self-employment benefits program for forty weeks, with a mentor and lots of workshops, which gave me structure and people to be accountable to. I think I lucked out in that Halifax has a very supportive craft community; my art was selling in shops and at craft fairs very quickly. I learned some simple aspects of accounting that have helped me out, namely keeping business and personal expenses separate, and diligently saving for those inevitable lean times. One of the biggest benefits was creating my own schedule, which meant I could attend artist residencies for one to two months at a time without having to ask for time off work. That time became an investment in myself and my business. The flexible nature of my work—I basically just need

a pen, paper, scanner and laptop—has meant I can travel to be with family during illnesses and other important life moments.

Tell us more about your first book, *Hand Drawn Halifax*.

I had started completing a drawing once a day for a month in my North End Halifax neighbourhood during the summer of 2013. I would sketch on location with pen and paper and add the colour digitally later. It started off as market research for my house portrait business. But as I posted my drawings to my personal and business Facebook pages, I realized there was a lot more to it.

People were sharing stories with me while I was drawing, and also when I posted online, getting really excited to see local places represented in my quirky but detailed style. However, the idea for a book didn't come until my neighbour, the late Hal Forbes, an amazing carpenter who really shaped the neighbourhood, told me he was concerned about people stealing my images if I kept posting them online. He told me to listen to a CBC interview he had just heard about copyright, which was available to listen to online. The most helpful part came at the very end when the interviewer mentioned that there would be a "pitch to the publisher" event at Word on the Street, a national book festival that occurs in Halifax and cities across Canada in the fall. I quickly called and secured a spot on the waitlist. I picked ten of my favourite drawings from sketches I had completed and made an accordion-style fold-out. It included all ten images, a short elevator pitch—an illustrated book about my neighbourhood—and my new logo and website. This was something I had learned from Peter Rich in South Africa: how to make a pocket-sized document to get ideas across quickly and in an attractive manner. Luckily, I had a chance to pitch, and Formac Publishing liked the idea. The concept expanded to the whole city, not just my neighbourhood. That ended up working really well, and the book became an instant success when it was published in 2015.

It was an idea I and my editor at Formac came up with. I had noticed the colouring book craze in fall 2015 when I was in Brazil, just before the book came out. The trend hadn't made it to Halifax yet, so it took a while for my publisher to be convinced. We caught the tail end of the trend, so it did well, but it was interesting to go from lots of interest to not as much within a few short months.

Hand Drawn Vancouver came out in 2020, and *Hand Drawn Victoria* is scheduled for release in 2023. Can you share about that process?

I had more personal reasons. My dad had been ill with cancer, and I wanted to find a way to be closer to him and to family in Vancouver. Thankfully I found a publisher based in Vancouver.

It was a real gift, re-exploring the city that formed me. Even though a lot has changed, there are some things that remain the same; finding and recording them before they disappear feels important. Victoria was basically all new to me, so that was a very different process, especially as I moved to Victoria right as the pandemic began. It meant appreciating the smaller moments and all the nature that is so readily available.

What's your creative process like?

I walk a lot, and in Victoria I did a combination of walking and bike rides. I don't do a lot of archival research, relying more on what I feel, sense, hear, and what people tell me as I draw. That element of surprise is a big part of my process.

But of course, sometimes it is important to follow up with some reading and/or reaching out to individuals. When I first went to Musqueam territory to draw an exhibit at the Musqueam Cultural Centre, it was closed, so I drew the longhouse instead. Thankfully I reached out to Jim Kew, the protocol officer at the time, and he was able to tell me why that would not be appropriate due to the sacred nature of the building and current relations with Canada. He kindly and patiently taught me a lot in an hour-long meeting, and I was able to find a different way to express the Musqueam worldview in *Hand Drawn Vancouver*. That work is not made explicit in the book, but it is an important part of my process—and for any settler or newcomer to a community. I am sure I make mistakes, and I am always open to feedback.

Why is art important?

Art allows for a safe place to explore our feelings, our dreams, our fears, our wishes. It feels like medicine and allows for sharing, even from a distance, which has made it transcend so many of the barriers that the pandemic has presented. I love that people who are ill in hospital can enjoy my books, as the pictures tell a story even when there is not capacity to read words. I think that is the true magic of art.

Cristina Gareau

Photographer and creative director

"Sometimes not-so-perfect things happen, but they still have a magic to them."

What is your first memory of an image that moved you?
My older sisters had a poster of the famous kiss in Paris photographed by Robert Doisneau. I was quite young at the time, but I remember being very moved by that image but not understanding what it was about. I think it's so powerful when an image can trigger an emotion in the viewer. I'm hoping I can do the same one day with my images.

What makes you so passionate about photography and the outdoors?
My father is from California, and so at a young age we drove across the country (from Québec) to attend my uncle's wedding there. I will forever remember driving through Yosemite park and by Lake Tahoe. These wild and raw landscapes triggered something in me.

You hold a PhD in cancer research. How did the experience of doing research prepare you for being a photographer, and how did it lead you to your current path?
I think cancer research really helped me learn about photography in a unique way. I was trained in the scientific approach: understand the problem, hypothesize a solution, test and then re-test three times, and note every observation in a notebook.

I never thought that my studies in cancer research would prepare me for anything else than what they were meant for, and eventually I decided that it was time for

me to push the reset button on my life. I had the intuition that I was not on the path I was supposed to be on, but that changed when I chose to focus on photography.

I was very curious and attracted to photography but also very intimidated by it, so I decided to approach it the way I had been taught and studied for eleven years as a cancer researcher. For example, I had a notebook and recorded all my observations about the light I was shooting in. I find a lot of pleasure learning about things in this way.

The move west was a big departure from your life back east in Québec. How did that come about, and what was it like when you arrived?
It was a gradual decision. For a long time, I had been imagining what it would be like to live out west. Many of my friends who I grew up with had moved there. For a lot of us, who love the outdoors, it was like hearing about Neverland. I was also inspired to take the leap and drive west after watching the movie *Groundswell* by the Raincoast Conservation Foundation.

I began my life out west as a ski patroller in Revelstoke. It was a whole new world and a whole new adventure, but the people I met by the coast had the same deep love for the outdoors, and the same passion for living a simple life, which is what first attracted me to move out west.

What motivated the move to Tofino?
I met someone in my first year in Revelstoke. He spent all of his winters in Revelstoke and then his summers in Tofino. I had somehow never heard about Tofino; I didn't even know where this town was. He invited me to join him for the summer and I decided to go.

I remember that the journey and adventure to get to the remote town of Tofino brought up a lot of questions. Driving through winding roads, passing the many rivers, lakes, glacier mountains, and huge trees, I couldn't believe that a small coastal town could exist at the end of this road. But after a few hours of driving, we arrived in the dark at the "Welcome to Tofino" sign, and a feeling of calmness and joy overcame me. The next day we went early to the ocean, and a group of girls were laughing and going surfing. I remember thinking that I would have loved to be just like them one day. Tofino is the most magical place I have ever experienced.

Tell us about the first time you picked up a camera.

I was so scared, and I had no idea of what I was doing. I bought my first camera, a used Canon 60D. I remember the girl telling me to give it a try, and I was so embarrassed and shy as I had no idea of what to do—there were so many buttons!

Was there a first shot that made you believe that photography was your calling?

I don't think there was a time that I thought, *This is it!* I think it was more of a slow, unconscious process. But I do remember a shot that brought me to tears and made me reflect on this crazy life journey. I was with an older friend of mine who is a wildlife photographer from Tofino. He offered one evening to take me on his little boat and go see some of the eagles he often watches in the inlet. I wasn't ready, my camera wasn't set, and out of nowhere this eagle came to catch fish right in front of me. In a rush I pointed toward it with my camera and pressed the shutter. This picture is far from perfect, but its imperfection gives it motion and some sense of beautiful emotion and feeling. It still remains to this day one of my favourite photos; it means a lot to me and reminds me that no matter how hard we try to prepare for everything we can never be as ready as we would want to be—we just have to go for it. Sometimes not-so-perfect things happen, but they still have a magic to them.

Since your arrival in Tofino, you've become a sought-after photographer, known for stunning yet subtle captures of surf culture and lifestyle branding imagery. Like many creatives and entrepreneurs based in Tofino, you've become an integral part of the fabric that makes up the community. What is that like for you?

I think this town is truly what it is because of its unique and inclusive community. There are a lot of creatives here, and the support that exists for each other is pivotal. I'm not sure if it's because of the remoteness of Tofino or that this place attracts and brings people together who share a similar mentality. There are definitely common values and interests. This is something I had never experienced before—to feel literally surrounded by people who inspire me in the direction that I want to go. So yes, there is definitely a blending of my personal and professional life here. My work is my passion, and in a small community when we work together on things we love, we all benefit from each other's efforts.

How would you describe your shooting style?

It's funny to be asked this question because that was my biggest concern when I started photography—to find my style! I was so focused on trying to find it and try new things, but in the end, I realized that you can't look for it or force it; it will come to you with time. I try to capture a specific feeling—often calmness, joy, or positivity—in my images.

Who, where, or what inspires you?

Tofino is one of the most beautiful places on earth, but it is rapidly changing as more and more people are moving here—understandably so. But what has always inspired me about Tofino is its rawness and the wildness of its landscapes. The wildlife is always present and gives you a feeling of gratitude for being able to share this beautiful space. Every day, when outdoors, if you look closely on your way to the beach, you will see a bald eagle, sometimes a bear or even whales out in the bay. This place is magical, and we need to protect it. In my personal process of unlearning and relearning, I am now finally seeing and understanding that Tofino is as pristine as it is only because of the efforts that the First Nations have made to defend this land from our colonial ways of extracting resources. I am grateful and inspired by them.

You've recently started Nanou, "A creative studio which offers photography, creative concepts, direction and styling." Where did the name "Nanou" come from?
My mom named me Nanou when I was born, but I guess my parents decided to put a more conventional name on the official documents. I have always preferred that name, though, and so have always used it.

It has been a dream of mine for a while now to own a studio or a creative agency where I could have a team of creatives to work with. Freelance photography is quite rewarding, but it can sometimes feel a little lonely. I strongly believe that working with other creatives or artists can bring ideas to a whole new level. I would love to eventually work with a team of graphic designers, photographers, writers, and media managers on different projects, and hopefully Nanou Studio can facilitate this.

Does a good photographer possess both an inherent ability to see and capture moments, subjects, and messages in a unique way in combination with formal training?
I don't have any formal training. This question reminds me of this quote by Austin Kleon: "School yourself. School is one thing. Education is another. The two don't always overlap. Whether you're in school or not, it is always your job to get yourself an education. Be curious. Look things up. Go deeper than anybody else."

School can be good, but you still need the motivation to get your education in school, and if you have enough internal motivation, believe me, the internet has everything you need to learn photography on your own.

I also think that learning on your own has its advantages. As an independent learner, you are more willing to bend or break the rules as you didn't learn the rules in the first place. This can sometimes lead to completely new ideas that might bring you to invent the next big thing.

What are the benefits of mentorship in the field of photography?
Different photographers at different times have been really kind and helpful to me in my forever-learning experience. My partner, Reuben Krabbe, who is also a photographer, has been extremely helpful, always patient with my chaotic schedule and happy to answer my pricing questions. (For the people entering this field of work: Believe me, there are always pricing questions; I still have a lot of questions.) I haven't mentored anyone in particular but have been helping some people along the way; I always try to make myself available to anyone who has questions about photography.

Which photographers inspire you?
There are so many, but I'm particularly fond of the work of Kelly Brown, Judianne Grace, Catherine Bernier, Marley Anthony, and Mirae Campbell.

What is your dream location to shoot?
New Zealand.

Who are the first people you're going to visit when it's safe to do so?
My mom and dad in Québec.

Jazmin Gillespie

Health, wellness, and nutrition coach

"When I trained for my genetics and not against them, I found balance."

What is your first memory of movement?
I was four years old, and my parents put me in martial arts. I have many memories of being active growing up. I rediscovered fitness and movement after I had my first daughter. That's my most vivid memory as an adult in this journey. Meela (my first daughter) was six months old when I took her to the YMCA childcare for the first time. I started with walking on the treadmill because I didn't know how to use the equipment. Not long after that I did P90X workout videos with her at home.

I have always been an athlete because that's where I felt things just came naturally for me. I always enjoyed being in sports and PE class. Academics were hard for me, so naturally I was drawn to movement. It's my happy place. Now, as an adult fitness trainer and athlete, I find movement to be a form of therapy for me. It relaxes me; it makes me feel powerful and like there's nothing I can't overcome.

At what stage of life did you realize that your purpose and passion was in the fitness industry?
This was a process that happened over the course of a few years. Fitness became my passion after having my first daughter, Meela. That passion carried over into my second pregnancy but had limitations because of not being able to take my fitness to the next level while being pregnant. Once I was cleared for exercise after having Shania, I felt the fire of wanting to take my fitness to a new level. In 2015, I hired a personal trainer to help me lose the baby weight, and by 2016 I was in school to become a

personal trainer. That year I competed in my first bodybuilding show.

Tell us about your work as a personal trainer with a focus on "sustainable fitness."
"Sustainable fitness" means that we are making it a lifestyle. So many people go to extremes with diets, trying to get fast results; this means they often end up feeling deprived. Yes, they lose weight, but they gain more back after they fall off the program. Sustainable fitness means we focus on balance and creating healthy habits, making it something we can do for a lifetime. Fitness and movement come in all forms; it's important to find something you're passionate about and enjoy feeling in your body. We can still enjoy foods in moderation and get results, and we don't need to spend hours in the gym to see results. This works for both me and my clients because part of my job is making sure they are happy and enjoying life while still achieving their goals. No one wants to be miserable eating chicken and broccoli for the rest of their lives.

You've said, "Once my bodybuilding days were behind me, I focused on sustainable fitness. I was not hyper-focused on aesthetics."
This was a tough one. As someone who won competitions in taekwondo, it wasn't easy for me to lose the bodybuilding competitions. I won my first one, which made me keen to continue. However, after my first competition in 2016, I developed a bad relationship with food—not uncommon in the industry. I went weeks without having carbs, which took a toll on me mentally, emotionally, and physically. It took me twenty weeks of prep to lose thirty pounds. I put all that weight back on in four weeks after the show because

I binged. This happened again in 2017 when I competed, and it became a bad cycle. In 2018 I worked with a different coach, a close friend of mine, and I didn't deprive myself; this was a better approach for me. I didn't place, and both years (2017 and 2018) the feedback I received from the judges was that I was too "thick" for the category. This was pertaining to my legs. I'd stopped training my legs eight weeks before both shows and started running like crazy, trying to look the way the judges wanted me to look. It didn't work. Once I stepped off stage in 2018, I decided I wasn't going to kill myself to look the way judges wanted me to.

I've always been thick, so trying to fight my genetics for shows was exhausting and shook my confidence. Being hyper-focused on aesthetics had me being extreme in my dieting. Although I could achieve being extremely lean, I was still fat in my eyes. It was not a healthy headspace. Once I detached from this mindset, I felt free. I ate what was going to fuel my body and didn't binge post-show. When I trained for my genetics, not against them, I found balance. I walked away from competing because it was doing more damage than good. I do, however, believe this was supposed to be part of my journey. It taught me a lot, and I can better relate to and help my clients going through similar experiences.

You've also said, "Exercise and fitness are building blocks for everything else in one's life." How did you come to this realization?
This became something I thought about in 2018, while going through a lot of mental and emotional growth after stepping away from competing. Fitness and health, for most people, help them feel better, look better, increase their confidence, and give them more drive. For me, I feel like if my fitness is in check most of the time, I can literally do anything. I can open that business, save and buy that house, be on the cover of that magazine, be a strong single mom for my daughters. That comes from movement, that comes from being healthy, that comes from giving my body the nutrients it needs.

Through fitness, I totally transformed everything in my life by shifting not only my physical appearance, but also my mindset. At times, this became a gradual consistency in my life, and then at other times it felt like a lifestyle overhaul. It comes in waves. When I separated from the girls' dad in 2016, I was working at my father's restaurant, going to school, and prepping for my first show. My life completely changed that year. From there it was more gradual until I decided to stop competing in 2018 and began dating someone in Los Angeles who introduced me to a new way of life. Although that relationship ended, it still lit a fire inside me that made me feel clearer about what I wanted for myself and my daughters. My next overhaul was me taking this vision and making it into something real. I opened my own online coaching business and took my passion to a point where I could have a positive impact and make a difference in people's lives. It seems like every two years an overhaul happens.

What are some of the benefits and challenges of being a single mom?
I had my first daughter in 2012, and my second in 2013. Together, we are a single unit, a team, and they are my biggest motivation.

Being a mom is the most rewarding part of my life— being able to guide them, teach them, love them. I believe that we are already born to be who we were meant to be, and seeing my girls become who they're supposed to be is beyond wonderful. I'm grateful I get to be here to support them to be the best versions of themselves. When I look at them, I feel immeasurable pride and love. They make me proud and they make me strong.

That said, being a single mom is extremely difficult. I am the mom and the dad in our family unit. The good guy and the bad guy. The nurturer and the disciplinarian. The provider and the homemaker. Balance comes and goes, and my daughters share frequently that I work too much. In addition to my online fitness coaching, I am an executive assistant for a sawmill equipment company, and I'm an ambassador for a supplement company. I do what I can to make sure my daughters have a good life and everything they need. Some days are easier than others, but we make it through together. I have a strong support system; my family, especially my mom and my friends, all help. I don't think I could do it without these incredible people.

One of the biggest challenges is having to do everything on my own, even with a support system. At the end of the day, everything is my responsibility. I can't go on a trip for business unless I have coverage. I had Meela just after I turned twenty-one. I had to grow up fast, and I didn't have much freedom—not a bad thing, just a challenge. The benefit of being a single mom, for me, is that I have control over their surroundings and environment. I love that I get to experience and witness every single milestone with them.

You and I have talked about how you feel that lack of direction and purpose can fuel depression and anxiety. Can you share more about that?

I have struggled with both in the past. My first bout of depression happened when I was seventeen and just graduated from high school. I had no direction, and my friends were going to school in other places. I got into partying because I didn't know what I wanted to do with my life. My doctor put me on antidepressant medications, and it was a rollercoaster ride for a few years. Some meds made me worse; others made me think I was better when in fact I was acting crazy. While on the meds I felt I'd never be happy again. I felt hopeless, and I overdosed on antidepressants at age eighteen because I couldn't handle my own headspace. At nineteen I got a dog, a wolf hybrid who made me feel like I wasn't sad anymore. She was an angel sent from heaven. Shortly after that I was pregnant with Meela, and even though my hormones were all over the place, I didn't feel depressed anymore. I was, however, feeling more anxious with the thought of being a young mom and not really having my life together. I don't think depression has affected me much since—maybe some postpartum—but my girls gave me a reason to push through and find the light. Once I became a mom, I had purpose and direction. I still suffer from anxiety at times, but that's when I turn to fitness and health. My career in the fitness industry fuels my life with purpose in addition to my role as a mom. I use the gym as therapy now. I may feel anxious about how I am going to pay for the girls' college tuition, or if I'm ever going to be able to afford to buy a home, but that's nothing a good gym session can't fix.

You shared with me about being in an abusive relationship. Can you share a bit more about how you've survived and thrived in light of this experience?

It impacted me mentally and emotionally because every time there was an "episode," I would ask myself, *Why would he want to do this to me? How could he hurt me?* I felt worthless, unlovable, like I wasn't good enough. I was insecure and felt stuck in the situation. After some time, I just got tired of it. I got tired of trying to be the best woman, and tired of being disrespected. My breaking point came when the girls were getting older; I didn't want them to witness how I was being treated. I didn't want them to think it was okay for anyone to treat them this way. Working out and training is what gave me the confidence to leave. I wanted better. I knew I deserved better. Even though at the time I felt worthless, at age twenty-five I told myself I would rather be by myself for the rest of my life than to tolerate this any longer. Now my daughters only see a strong, independent woman.

Why is body positivity important?

When I first got into fitness, I wanted to be the skinny girl. I didn't want curves. I didn't want to be thick or have too much muscle. But that wasn't who I was or how my body was made. It took time to accept myself. I am thick, curvy and muscular. We are all unique in our own ways and we need to learn to accept that. Be kind to yourself, and love who and what you are.

How has the perception of fitness evolved?

This is an interesting question. Some would say fitness in social media has turned into something more sexual. It's about the sexy photoshoots, muscle fetishes, about being sexy and not necessarily healthy. As in most industries and day-to-day-life, people tend to be judgemental. I don't waste my energy on that. Everyone has their own path, and I respect everyone's choice. We all go through things. We all have phases and experiences that make us want to do things a certain way. I encourage everyone to be active, to move your body and eat healthy—no matter what the motivation.

Tell us about your philosophy of "happiness starts and ends with you."

I feel like this statement is intertwined in both my professional and personal life. At one point I depended on other people to make me happy, especially in my romantic relationships. I believed that it was their job to make me happy, and if I wasn't happy then it was their fault. I played the victim because that was easier than being accountable for my own happiness. Once I took my happiness into my own hands and knew this was an internal job, I grasped the "happiness starts and ends with you" idea. It's a decision, and I work on it every day.

What do you enjoy most about your work?

I love that I get to make a difference in people's lives. I know what it's like to feel insecure, worthless, and hopeless. I get to help people. Helping people feel good and achieve their goals feeds my soul.

Alissa Hansen

Model and content creator

"I feel like the world is crying out for us to slow down and pay attention to ourselves, so we can heal and in turn help heal the world."

While you were growing up, were you drawn to all things artistic?

I have always felt like a creative soul. I was an only child and spent a lot of time in my imagination. I loved to sing and make up stories, and I especially loved to dance. I would make up dances and preform them for my parents and also at school for talent shows. In Grade 4, I wrote a really long story about an imaginary world. My teacher thought it was great and asked me to read it out loud to the class.

How did the physicality and surroundings of your early years inspire you?

I grew up in Vancouver. I remember my mom encouraging my creative impulses. I was watching TV one day and a rhythmic gymnastics competition was on. I pointed to the TV and told my Mom, "I want to do that," and she went out and enrolled me in the sport. From the age of seven, I trained as a rhythmic gymnast and competed in that sport for ten years. My mom was always the first to make my dreams become reality, and I am deeply grateful for that. She showed me that I can do anything I feel called to.

Have you done any formal training in the arts?

My creative path has been very non-linear. After I retired from rhythmic gymnastics and graduated from high school, I tried college. However, I knew deep down that this path was not for me. I tried to stick with it because of the societal conditioning around going to school, but I ended up dropping out after a year and a half. I joined a ballet and contemporary dance intensive, which was the best decision. I have no regrets. This is where I was introduced to acting. An acting coach led an "acting for dancers" workshop with us, and I fell in love with the art form. I knew I wanted to pursue it, so I began training with her in her private studio for five years.

Eventually, the nature of the industry (which is quite challenging) and some unresolved trauma in my system caused me to not enjoy the pursuit of the career as much. Acting class is no joke. You are using your body as an instrument, so if there is any unprocessed trauma in your system it will inevitably come up in the work and can get in the way of your process as an actor. My nervous system was starting to shut down in acting class, and I didn't have access to my body instrument like I used to. I now realize that my nervous system was calling out for some much-needed relief. I didn't really listen to that call until recently.

Tell us about how you came to a place of realization, of creative purpose, through trauma.

I have always been a spiritual seeker of sorts. I've been on a path of self-discovery and healing since my early twenties, which is when I got my first oracle deck; this is also when I became interested in angels, energy healing, psychics, and spirits. I had a conspiracy theory phase too. I am very open to the idea that there is more to this experience than what we are seeing on the surface. Living my life through this lens has informed where I put my energy.

I didn't start focusing on healing trauma until after I lost my boyfriend and two friends in a tragic accident. I

was twenty-eight, and this loss completely flipped my life upside down. It took me one year before I started to do grief work and address the impact that trauma had had on my system. I came to a point where I realized the path that I was on was not great; I could either continue coping and repressing the grief by drinking, smoking, and denying, or I could choose to face it and get professional help and start the healing process. I am glad I finally decided to do the latter, as it has brought me down a helpful path where I am excavating all the past hurt in my life and alchemizing it into lessons that are moving me forward and informing my life in a positive way. Some days it feels like I am taking one step forward and then thirty steps back, but these baby steps forward are slowly paving the way to creating a new way of showing up in the world that is much more pleasure-filled and joyful than it was before.

I especially appreciate and applaud your approach in sharing your personal experience as a way to help others feel less alone on their journey. When working through grief, it forever changes the way we walk through the world. How do trauma and grief inform your work?
I agree that it changes the way we walk through the world. There was my life and who I was before the accident, and there is my life now and the woman I am becoming. There is a very significant split between the two versions of myself and my life.

All of the writing I share on social media is generally about or inspired by what I am personally going through or working through during that time. All of the photos I take tend to have a more dark, emotional vibe to them as well. It would be hard for me to create content that didn't reflect what I was going through as my work is an extension of me. I want to be honest in what I share as there is so much superficial noise out there. I think the world is starting to crave more truth.

Grief is ongoing; it doesn't have a beginning, middle, or end. How does your creative work help guide you through the range of emotions?
Grief is a non-linear journey. I had a teacher explain to me that the first three years after loss are the most important. The first year is complete chaos, the second year is still foggy, and the third year there begins to be a grounding into what is. I am in that third year, and I feel like I

finally have my feet on the ground. I am feeling much more accepting of what happened and how it has impacted me. I am aware of how my trauma has impacted my nervous system and informs the way I react or get triggered. Working through the triggers is still a process, but having this clear awareness is the first step in helping me heal. With this new awareness of how my nervous system operates, I have been spending a lot of time alone and not feeling as comfortable as I used to in social situations. I am sure this will shift eventually, but for now I am learning to be okay honouring where my system is at.

I have always had the strong belief that when someone dies, they cross over somewhere new. Their body may be gone, but their soul and essence are still alive—just not in the same place we are. I have a deep knowing that I will see them all again.

When I bring my healing process into my creative work, it helps bring some levity to it. Life doesn't feel as heavy because I am transmuting the emotional pain into something I can express. It's not so locked up in my body.

It takes immense bravery to put yourself and your pain out there. Can you share how you became willing to share your experience?
I don't remember making a conscious decision that I was going to start sharing about my grief journey publicly; it just kind of happened. I started sharing more online after the accident; I found it cathartic to write about what I was going through, and it felt nice to connect with other humans who were going through the same thing as me all over the world. What I share about is continuing to evolve, as does my grief.

What have been some of the beautiful benefits and unexpected challenges of putting yourself and your words out there?
Being creative feels like one of my needs as a human being; that said, it's challenging to have that need while figuring how to live in this world and make a living through creative ventures. Of course, it is possible, but I feel like the system we are living in doesn't make it easy to be an artist.

What is special about the collaborative process?
I love being able to connect and create with other like-minded humans; something magical happens when you combine forces. It is beautiful when you come together

with others to make something happen, as we all have so much to offer in our own way. We all have our own unique signature.

I only work with brands that I feel inspired by and that reflect my personal values. This has been the key for me to create strong work because if I believe in the product and the message, then my work will reflect this. This is very important—I always want to do my best to show up as honest and authentic as possible online.

At what age and stage of life did you start modelling?
A modelling scout first approached me when I was sixteen, but I didn't start pursuing it until I dropped out of college and began dancing and acting at the age of twenty. One of the first agents I signed with told me I needed to lose weight if I wanted to go overseas to model, and I had a strong knowing that this was not a career path I wanted. I did love being in front of the camera and creating artistic images, so I kept shooting for fun and connecting with photographers who I felt drawn to. I don't identify with being a model because I don't get paid regularly to shoot, but it is something I have and probably will always enjoy doing.

You speak openly about working through body issues. What motivates you to do so?
I think it is deeply important to show images of real bodies. There is so much pressure to look a certain way as a result of societal beauty standards. It is so damaging for both men and women. The amount of filtering, face tuning, and modified bodies that are being normalized and shown on social media is concerning and not helpful for our mental health as a society. It simply isn't real. It is not healthy to live in a society where the narrative is that women are only attractive and worthy while they are young. This is what motivates me to share the truth about my body and skin online.

Psoriasis is an autoimmune skin disorder that gets triggered for many different reasons, which will be slightly different for each person. Mine got triggered when I got very sick when I was around twenty-three; it covered eighty percent of my body at the time. Having psoriasis has been hard on my confidence, and it took me a few years after that outbreak to feel okay wearing shorts and dresses in public. It's been a long journey to cultivate self-acceptance, and I still have moments of wishing I didn't have red patches on my skin. Despite those challenging moments,

having this skin condition has confronted me with looking at where I am sourcing my worthiness. It has invited me to dig deep and cultivate my worthiness from within, which has been a huge gift in my growth as a woman.

There's a beautiful sense of stillness in the photos of you—and an evocation of nature.
That's so beautiful to hear. I have never consciously decided to invoke a sense of stillness in my images, so I love that is coming through.

I feel a strong connection to nature, especially now. I have been working with a somatic therapist for almost two years, which is helping me de-thaw my nervous system and bring more emotional regulation. As this is happening, I am feeling less drawn to the busyness and noise of the city and more drawn to be closer to nature.

Let's talk about the power of social media. What are your thoughts?
There is certainly a shadow side to it, but I think because of the massive reach of social media, it can be a very powerful tool for connection, inspiration, and sharing of ideas. It also gives us a platform to use our voice, which is so valuable when it is utilized in a helpful way. I am rooting for more truth, honesty, and transparency from everyone on social media in general.

How has the pandemic affected you?
The pandemic was the start of some deep healing work for me. As the city started to shut down and lockdown was put in place, my internal world started to get really loud. That is when I began working with a somatic therapist (online at first). My anxiety level could be measured at twelve out of ten, and with little to no distractions I realized I had to start to look at the dysregulation in my body.

The pandemic was very polarizing; it brought so much hardship but also a much needed (although forced) slowing down of everyone's lives. I feel like the world is crying out for us to slow down and pay attention to ourselves, so we can heal and in turn help heal the world.

Where do you envision yourself in ten years?
I hope I am still creating, growing, and sharing, and using all of the lessons I have learned to help others in some way. I hope to continue to cultivate deeper love and connection with my partner.

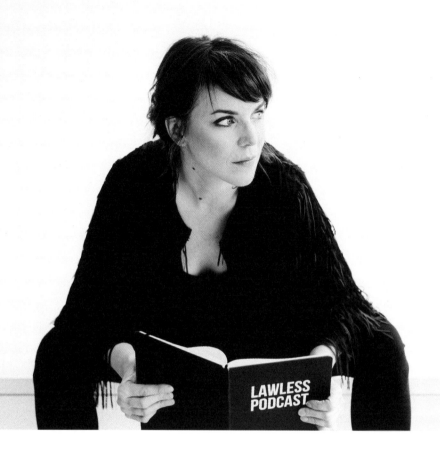

Andrea Helleman

Activist, creative, and host of *The Lawless Podcast*

"I like to acknowledge people that I see doing the good work."

How would you describe yourself?
I have a lot of energy, and I'm ruled by passion. One of my best friends says I am organized chaos, and another says I'm zero or a hundred. Both seem accurate.

Memorable moments from childhood?
I grew up in the eighties and was raised by a single, working mother. I am a middle child and a latchkey kid (which meant I wore my house key on a shoelace around my neck to grade school and got myself to and from school). I was self-sufficient, very dramatic, and spent a lot of time by myself. I loved to read; I watched a lot of TV, had an early bedtime, and loved the way my yard smelled like lilacs in the spring.

I have an older brother and a younger sister. My sister Adele has Down Syndrome, and she always served as the great equalizer in our family; she commanded preferential treatment and melted our hearts. We were all individuals, and we had no competition among us; it was more like we were three distinct entities all nurturing a different part of our mom's heart.

I don't really know how Adele shaped me because I've never known an alternative. When I was young, my parents gave me a book about Down Syndrome called *My Sister is Special* and I always just held on to that thought.

Being raised by a single mother shaped me in the sense that I saw a woman could do everything and do it with love. Her core beliefs were rooted in respect, loyalty, and responsibility, and those values became my own. When you spend a lot of time on your own you become very resourceful.

Tell us about your experience as a multi-hyphenate with several outstanding skills and professions.
One of my biggest struggles in life is boundaries, so I don't know how to compartmentalize. But if I looked at all these hyphens, I'd say they were all borne of each other, and I use them all to tell stories. Stories have always been a source of inspiration, drive, and fuel for me, especially transformational stories, the ones that make you feel like anything is possible.

I am currently in the process of putting together a documentary series about my sister and her Down Syndrome community, and we're just about to launch her YouTube channel. So maybe filmmaker might be a new hyphen soon. At least that's the dream.

I've never thought of myself as an advocate, but I do feel a certain responsibility or duty to share my sister's voice and story with the world. Because the world needs more love, laughter, acceptance, and truth. And I suppose I like to acknowledge people that I see doing the good work, and fan out on others' initiatives.

Do you feel that there's solid value in both formal training in one's profession and real-world, hands-on experience?
At one point in high school, I hatched a plan to become an accountant. So, I went to college for business, and I did two work terms in accounting, one in England and one in Banff, Alberta. It didn't take long to discover that accounting wasn't my path. During my second work term the mountains took hold of me, and I kept deferring and shortening the amount of school I was doing. I ended up leaving with a diploma in business administration and then doing a web development course.

Then I bought a camera, and my creative life was born; a series of entrepreneurial passion projects ensued. I cannot seem to turn off the business side, and luckily it seems to have married itself to the creative.

All my twenties and half of my thirties I worked in the hospitality industry; it was both my stage and my retreat from the monotony of work life, but it made me notice details, anticipate what people need, and hone some communication skills.

Which brings me to my belief in everything: All the training, the experience (good and bad) and life stuff accumulates into a work ethic, a way of thinking, and an ability to communicate and work with people.

What brought you west?
I was born in Sudbury, Ontario, grew up in Aurora, and then my mom moved us to Innisfil (just south of Barrie) when I was in Grade 6. I thought she had ruined my life. I don't think I ever got over the move. But it's a part of who I am today.

I came out west because when I was eighteen, I lived in England for the summer and everybody was always going on about how great British Columbia was. I wanted to see that for myself.

So, western Canada became my next destination. I had friends that moved to Banff for a winter in '98, and I followed them out. I still remember sitting on a bus and seeing the mountains rise from the plains; I was spellbound. Now, here I am, all these years later, and the mountains have become the foundation of my life.

I moved to the Sea-to-Sky Corridor in British Columbia three years later, and it felt like coming home. I never left.

I don't think I ever thought too far in the future; I just enjoyed living my life out here. On my twenty-fifth birthday, I was on a beach in Brazil with my boyfriend, and I had a little breakdown. I didn't know where my life was going, and I didn't feel stimulated. That's when I went back to school and started a multimedia business and life became full.

What has kept me here is the massive friend network. I often think we've hacked life when forty centimetres of fresh snow can shut down a city and we drop everything we are doing and head for the hills. Life in the mountains comes with a lot of loss, and navigating so much loss takes friendships and transforms them into family.

Since high school, I've lost friends and family members to accidents and illness, but the deepest day of loss came when my mom was diagnosed with a brain tumour, in 2011. I moved back to Ontario to care for her and my sister.

Can you share more about the loss of your mom?
I felt the pain of losing her every day for fifteen solid months, and it ripped my life apart. During that time, I got divorced and was bought out of a company; my uncle died of a heart attack, and one of my close friends died in a skiing accident. It was awful. It knocked me down, and it taught me some hard lessons I wouldn't wish on anybody.

On the day my mom died, I sat in her hospice room and watched and listened as each of her systems shut down. It was one of the most real moments in my life. I cannot even think of it without falling to pieces.

The last came when her breathing shifted; it sounded shallow and then quickened. It sounded like an engine running out of gas, sputtering as it wound down.

My sister and I were sitting across from each other crying. Then, as my mom drew her final breath, a ripple crossed her forehead. Adele and I met each other's gaze and we both smiled. It was a phenomenon—some may say an involuntary muscle spasm or release, but to me I saw my mom cross over to the other side. It was beautiful.

Our mom had given everything she had to this life and to us. I don't think I can ever express the profundity of that moment, and yet it shapes how I live every second of my life today.

You do not have control over anything aside from your reaction and how you choose to move through the world.

Life is short, so love hard and deeply. Let go, enjoy the ride, and when you get a chance, run to those hills—they are medicine.

When we lose someone, we have celebrations of life, and I love living in a place that is so beautiful that it helps me value every moment.

How does living in Squamish inspire your professional and personal life?
I moved to Squamish in 2006 out of necessity. I was ready to buy a house and couldn't afford the Whistler market. I liked that Squamish was fed on both ends—Whistler to the north and Vancouver to the south; it seemed like the perfect landing spot.

I love everything about Squamish. It's big enough and small enough to have me feeling both anonymous and connected to a community. Plus, the biking just keeps

getting better and better as does the food. We've got it all—mountains, lakes, the ocean, rivers, and forests.

There appears to be a true, heartfelt interconnectedness in everything you work on. Where does that quality come from?
I think I'm heart-centred, emotional. This ties in with my zero-or-a-hundred mindset: if I'm not feeling something, I don't continue with it. I need to really connect with people to work well with them, and I have to believe in what they are doing. As I age, I realize that our life's work is a big part of our legacy, and if it doesn't have meaning or impact, I'm not that interested.

You also host *The Lawless Podcast*, which you describe as "curated conversations with people of interest." How did this come about?
I've always been a big talker and listener. I absorb stories. When I was eighteen, a lady I worked with told me I should have a radio show, but I didn't think I had lived enough to have much to talk about at that time in my life. I wasn't interesting, but I was curious.

I wanted to start a podcast as an extension of my business because I was always getting so deep with clients and hearing about their inspiring life stories. I was getting ready to launch, and then I turned forty, and then my boyfriend broke up with me. I found myself lost—or rather dealing with the trauma I had been trying to escape for the past decade.

I didn't know what I wanted in life anymore, so I decided to go ahead with my podcast, but without any motive aside from wanting to talk to people that interested, inspired, or made me curious to know more.

I called it *Lawless* because my therapist told me I was lawless, and I wanted to own it and have no guidelines or any expectations from anybody.

When I asked my ex-husband what he thought of the podcast, he said, "You've always had a lot of questions, and now you have a platform to ask them." His answer made me laugh so hard, but what he said is true. I'm curious and fascinated by people and what motivates them or shapes them. I think having the podcast has made me a deeper listener.

Let's talk about your sister, Adele, an incredible source of positivity, inspiration, and motivation in your life.
I don't remember life before Adele. She gave me responsibility at an early age, and she gave me a different set of eyes to look at the world through. She gave me patience. And she keeps teaching me every day. She lives in the moment but thinks a lot about the future. She processes everything in real time, an eruption of passion. She gets mad, sad, happy, and ecstatic within a short timeframe. But she moves through it all quickly and doesn't linger in anything for too long to have it shape her.

You're currently at work on a documentary titled, *Can't Stop Love*. What inspired this project?
I want the world to see Adele the way I see her. I want Adele to see herself the way that I see her. I want to share stories for parents about to embark on a life with Down Syndrome. I want to share stories for people that are in the thick of life with Down Syndrome. I want to share stories for people who have lost that part of their family. I want to share stories that help inform the world about what life is like with Down Syndrome.

Have we moved forward as a culture in our understanding of Down Syndrome?
I'd say we've realized we are advocates with a duty to do what we can when we see gaps. We are a part of a greater community; I hope that sharing information, praise, and stories will fuel and shape us to be better and do better for ourselves and the world that sustains us. We can amplify the voices of those who need to be heard.

How has the pandemic affected you?
It brought me Adele. She was visiting for a few weeks at the end of February 2020 as we were filming for her documentary—and then she never left. All her programs in Ontario got shut down, and my brother and I decided BC was the best place for her. But it was rough in the beginning; Adele was having panic attacks along with the rest of the world, and I wasn't used to being a full-time caregiver. Work dried up for a while, and I was stressed. Now, as the world starts to open back up, I see a brighter horizon.

What has this time together with Adele given you?
It's united a part of my soul. It has slowed me down. I've found breath, and my house feels full of love again. I guess I stopped running away from or toward something. I found some stillness.

And I think it was me I was running from.

Clare Hodgetts

President and co-founder, InFocus Canada

"Photography has the power to evoke emotion and inspire action."

Can you tell us about the first photo that moved you?
More vivid than the memory of a first photo that moved me was the first time I realized that a photo captures a moment. Photography is extremely powerful that way. This struck me when I was looking at a picture of my mum. She passed away when I was two, and without photos there would be no visual knowledge of her for me.

What about photography inspires you?
I started enjoying photography at a young age. My dad took many photos for work, so having photos around was part of my life from an early age. I have a vivid memory of finding a small film camera in our house and pretending I was a professional photographer. I must have been eleven or twelve. I waltzed around the study taking photos of the map on the wall, the lampshade in the corner, the desk against the wall, asking them to "strike a pose." It wasn't until I couldn't click the shutter again that I realized there was film in the camera—I had thought it was empty!

Later I got an old Pentax K1000 SLR. The light metre was broken, so it forced me to learn light and what settings worked best in what conditions. I travelled with that camera everywhere. I loved taking pictures of what I was seeing: life as it was in front of me.

What inspires me about photography lies in the essence of what it is: capturing a moment in time. People come and go, things come and go, situations come and go, but a photo holds them in time. When you look at a photo that moves you, that inspires an emotional response; that is

what I love about photography. And from that, the power to motivate and inspire action. Really cool stuff.

For me, pursuing photography as a profession was about following a feeling in my gut. I had always wanted to go to the Western Academy of Photography in Victoria, BC. At the time I decided to actually apply, I was working for Environment Canada studying the effects of pesticides on wildlife. I loved that work and came to a real crossroads where I had to decide whether to continue at Environment Canada or take a leap of faith and delve into photography and photojournalism. I decided to take the plunge, and I'm so happy I made the decision I did because now I get to work in environmental conservation through photography. The best of both worlds.

Who, where, or what inspires you?
What fuels my passion is being outside taking pictures of landscapes and wildlife, as well as macro shots of plants. I love being outside. It is where I feel happiest. I feel my passion for the outdoors is reflected in my images.

My favourite sport is surfing. I have a collection of fine art surf prints. Some of these photos were part of our very first collection of scarves at InFocus Canada, the BC Collection. I love that my photos reflect my love of the outdoors and ocean.

You've travelled extensively. Which destination especially moved you?
I find each trip is so unique and special. Top of the list, though, is the Canadian High Arctic, specifically the northern tip of Ellesmere Island; then there is also Iceland, and Sri Lanka. I find the High Arctic to be so humbling. The landscape is raw and beautiful, and I'm always amazed

that wildlife can live in such an extreme environment. I have been moved on a number of occasions by the complete silence of the Arctic. I remember standing on a ridge and suddenly realizing that there was no sound at all, not one thing. All you can hear is your heart beating.

Iceland was another amazing place to visit. I've been twice. It is a magical country, beautiful landscape. I stayed with some people that my dad and mum knew in the seventies when they were doing bird migration work in Iceland. They lived in a small farm on the Snaefellsnes Peninsula. It was one of those places where you feel that there is magic in the air.

Another outstanding trip was Sri Lanka. My now-husband and I spent five months there in 2005, one year after the tsunami. We were totally taken by the kindness of the people and the beauty of the Buddhist way of life. We were both working at the time, contract positions that could be done from anywhere, and so we'd get up and surf every morning, then come back to our little house we rented and work for the rest of the day on our laptops. Simple living that was so good.

What is your dream location to shoot?
I'd love to shoot in a tropical rainforest and also go on an African safari.

Tell us more about InFocus.
When we moved to Squamish, I reconnected with an old friend, Kemp Edwards, who lived in Vancouver. I had always wanted to do something with photography on clothing, and Kemp was, and still is, in the sustainable manufacturing world. So we got together and spoke about printing some images onto fabric and what that could look like. That led to the birth of InFocus Canada, a company that raises money for charity through sustainable fashion and showcases photography of renowned professional photographers on fashion scarves made entirely from recycled plastic bottles. I now run the company; in addition, Kemp's company, Ethical Profiling, is our dedicated production partner.

As I mentioned earlier, Kemp and I are good friends and have known each other since Grade 1. My work as a photographer and Kemp's work in the field of ethically produced sustainable goods was a natural combination that led to the idea of wearable art, where photography would be shown in a new way—on a sustainably and ethically produced medium—and at the same time give back to charity. What we do is print images from professional photographers onto fashion scarves made entirely from recycled post-consumer plastic bottles. The material has a very luxurious feel and is soft and flowy. Each photographer chooses a charity to support, and we donate ten percent of the sales of their scarves to that charity

Our mission at InFocus Canada is to raise money for important charities through sustainable fashion and to spread awareness of the exceptional and beautiful work being done by professional photographers. We strive to raise awareness about sustainable fashion, environmental conservation, charities, and photographers all through ethically made scarves showcasing the work of the photographers.

I love how InFocus Canada is the evolution of my dream. We work with professional photographers—many of whom are nature and wildlife photographers—and we donate to environmental charities, in turn helping enable their important work. We also aim to provide education around what sustainable fashion is and why it matters.

Our mission statement is, "Through our work we strive to inform our collective understanding of the interconnections between ourselves, the environment and animals, and hope to inspire action and awareness in all of us toward being better stewards of our natural and social worlds." This is an ever-evolving mission of ours, and something we're achieving in different ways through different parts of the project.

The photographers' work is not only very educational but also exciting. By spreading the photographers' work and supporting the charity work, we are helping share their messages. The scarves act as a platform to spark conversations about these compelling topics, which means more people learn about them, and that can lead to action. Education is power. We want to connect with people and to make us all more aware of our impacts on this planet and the environment.

In Focus **launched its third collection, the Athena, in November 2020. What were the challenges of producing and putting out a new line during a pandemic?**
The Athena Collection is a very special collection. It consists of a powerhouse group of female photographers, hence the name. Athena was the ancient Greek goddess of heroic endeavour, wisdom, and warfare. In relation to

our Athena Collection, the women involved are warriors for the environment, nature, and wildlife.

We've been lucky our sales are online, and we're able to communicate with our photographers and charities through emails and Zoom. We did have some delays with production because of the pandemic, and shipping delays over Christmas, but it was minimal, and our business is thriving.

Where do you envision InFocus in ten years?
Our goals for the future are to raise more money for charity, to continue to promote and work with inspiring professional photographers, and to continue our environmental conservation focus. And doing all of this through sustainable fashion and the creation of beautiful wearable art.

We are excited to continue to build our community and expand our reach, and have the scarves act as a platform to share and spark conversations about key issues. By looking after and protecting nature and the environment, we are in turn looking after ourselves.

You have twin boys. Is it important to you that they're aware of your passion?
I have awesome twin boys who are ten years old. They are interested in what I do, and I feel lucky to be able to show them that it's possible to work and live your dreams and do work that is rewarding. They love to help and will assist with unpacking shipments of scarves and organize things for me. It's important to me that they're aware of my passion because it shows them that it's possible to follow your dreams in life and be successful in doing that.

How do you ensure time and energy for your passions?
I'm not a fan of the word *balance* as it conjures up a scale with family on one side and work on the other. I like to think of it more as harmony. I ski at least one day a week in the winter. We also aim to go on three local surf trips a year (in normal years when we can travel). I enjoy running and find that's an easy thing to pop out of the house to do when I have half an hour. Any physical activity clears my head and helps keep me focused.

Another big discovery for me over the past year and a half has been the power of mindset—especially keeping my mindset positive. It was an aha moment when I realized I control my thoughts and how I respond to things in the world.

What do you hope we as a global population can take away from the pandemic?
I think there's a surge in awareness about our environment and the impact we're having on the planet as a species. More and more people are speaking up and educating themselves. I see what's being taught in my kids' classrooms at school, and it gives me hope for the future. I think collectively, it is powerful to realize that our actions have consequences, and even small changes can make a huge difference if we all do them. The slogan that stands out to me from the pandemic is "We're all in this together." It's the same for improving the state of the world for ourselves, wildlife, and future generations.

Corrine Hunt

Jewelry designer and artist

"I grew up in a culture where art is a profession, and more than a profession in that I live what I do and love what I do, every single day."

What is your first memory of art?
The totems in the graveyard, in Alert Bay. Many of these were older and falling apart. I thought this was extremely beautiful.

You were born in Alert Bay and are a member of the Raven Gwa'wina clan from Ts'akis, a Kwakwa̱ka̱'-wakw village on Cormorant Island, in British Columbia. How did this environment shape you?
I grew up on a small island; the sea surrounded us, and we were exposed to the elements. This environment mirrored the stories we were told as children. The *dzunukwa*, wild woman of the woods, kept us from straying too far from home. The art in the village was alive everywhere I went; this was a big part of my early consciousness, a living, breathing art form.

What are some of your fondest memories from childhood?
I loved playing on the beach while waiting for my dad's seine boat to arrive from his week away fishing. We were, as children, allowed a certain freedom that big city kids didn't have; being on such a small island allowed us to explore the clay cliff, create fantasy worlds, feel the rain and the wind, and thrive.

The elements of nature play a pivotal role in your heritage. How does nature factor into your life choices?
I absolutely need to live by the water, to see it on a daily basis. We are made human by the power of the sea.

You come from a long line of artists. How did this inform your idea of art and pursuing this path yourself?
I am truly blessed to have had two uncles from both sides of my family to mentor me as an artist. I grew up in a culture where art is a profession—and more than a profession in that I live what I do and love what I do, every single day.

Which piece of art has moved you?
I am moved by the work of Noguchi, a Japanese artist who creates masterpieces in wood. My first piece of furniture was Noguchi inspired. Although I started in jewelry and I love it, I am totally grooving on the way wood expresses itself. The grains appear and reappear as though it is still living and breathing. Indeed, I think it is.

As a First Nations artist, how does your culture inspire and motivate you?
I am informed completely by my culture. I explore the nature of the art and how it moves and evolves. At the moment I am learning the language, and I feel with every word I understand a little more of what my ancestors were saying.

I read that you were given the name *Nugwam Gelatleg'lees*—which means "killer whale scratching her back on the beach"—by your paternal grandmother, Abusa.
Oh, how I love this name. My granny Abusa was a kind and gentle woman; to know this was also her name still gives

me chills of happiness. And to know this name is representative of the orcas and their collective journey on the coast makes me feel I am one of them.

You majored in anthropology and Latin American studies at Simon Fraser University. How do you incorporate your studies into your art?
I studied at SFU and did two semesters in Mexico. I love to travel—what better way to get an education? I suppose I see the world through a critical eye, constantly wondering what makes an object beautiful and useful.

I have no formal training. I have learned on my feet with anybody that would teach me. I've had many errors, failures, and breakthroughs.

Your uncle, Norman Brotchie, a jewelry engraver, was an early teacher and mentor. How did this mentorship help and move you forward as an artist? You've also mentored many First Nations artists. Why is mentorship important?
My uncle Norman was a mentor in many ways. I dedicated the design for the Paralympic medals to him, the totem rising. He is a paraplegic; after his accident, he managed to run a gillnetter, play basketball, and learn to make jewelry. He was a patient teacher.

Mentoring is important on many levels. It allows artists to explore their creativity, and the mentor is reinvigorated by both the questions and the answers.

Which artists/creatives do you admire?
Skeena Reece is my hero. Skeena tests boundaries and requires a response to her work. She is not at all afraid to laugh at herself—or others, for that matter.

Who, where, or what inspires you?
I love to go to art galleries in strange places. I once went to a gallery in Berlin; it was a squat of an old building that was missing some walls, but still they used the four floors for a sound studio, café, and an incredible exhibition of poetry and art from sex workers from eastern Europe. These women were scholars and deeply talented; my eyes were wide open with possibilities.

Can you please walk us through your creative process?
I worked on a piece for a client who liked stories about travel and history; I did this piece out of a round piece of cedar, separated into four unequal parts, that told the story of my great-great grandmother's journey from Tongass, Alaska to our village here in Tsakis. The first part was her in a canoe; the second and third the treasures she brought (her chilkat blankets and songs and dances); and the fourth part is the Big House she lived in. I chose colours that were vibrant and earthy.

Do you have a specific space in which you work?
I have an outdoor studio and an indoor studio. And, much to my partner's despair, I paint and chip away at cedar wherever my family is because I want to be included in the fun. I don't keep standard hours and often can't stop the feeling.

Your known for your engraved gold and silver jewelry and accessories, custom furnishings in carved stainless steel and reclaimed wood, modern totem poles, and other sculptural installations—extraordinary pieces that are both timeless and contemporary. Do you employ a similar process with each?
In some ways I have no process, so it is all the same. I sit and then I start and whatever will be will be. I do love to have several wood pieces on the go at one time and move from one to the other. I do look for inspiration; sometimes when I'm watching a movie all I see is the furniture or the art on the walls. Or when I'm out and about I see a beautiful set of earrings on a person and I find myself staring at them, the earrings and the person staring back at me wondering what the heck I'm looking at—embarrassing!

You co-created the medals for the 2010 Olympic Games in Vancouver with designer Omer Arbel. What was this experience like?
Best gig ever. Omer and I worked well together, but I would say my primary design partner was Leo Obstbaum, the creative director of VANOC (The Vancouver Organizing Committee for the 2010 Olympic and Paralympic Winter Games). Leo taught me an enormous amount about design. He was a bright mind with an encouraging affable nature. Sadly, he passed away before the medals were unveiled. The medals took eighteen months to create; it

was a very happy and, in part, stressful time—after all, the world would see my work, yikes! In the end, my mother was my guide, from heaven; if I thought she would like it, that was good enough for me.

The recognition is really overwhelming; seeing the medal on Sean White on the cover of *Rolling Stone* magazine still brings a smile to my face. Only a handful of artists have their unique art on Olympic and Paralympic medals, and me, this little girl from Alert Bay, is one of them. Weird.

You then published a book, *Olaka Iku Da Nala: It Is a Good Day*, in which you recount the adventure of designing the medals for the 2010 Olympic Winter Games.
I was inspired by the questions I was being asked, and it was such a fun time that I wanted to share the experience.

In 2011, you were awarded the National Aboriginal Achievement Award (now called the Inspired Awards) for your outstanding work and achievement and for serving as a role model for Indigenous youth. How did this feel?
Wonderful. *Ikan noke* (my heart is happy). Canadian actor Adam Beach gave me the award, and my heart was fluttering. He's so handsome, kind, and talented. What a combination!

Do you see a recurring theme in your overall body of work?
Adventure.

Is there one particular piece with which you feel a special connection?
A gold watch bracelet with a chilkat design, which I made for my dad. He wears it every day; it just makes me happy.

What or how do you think people feel when viewing and wearing your art?
I think people feel happy and curious about the inspiration behind a particular piece.

Why is art important?
Art is the unknowable; it gives us pause to breathe.

What is your dream space or gallery to exhibit your work?
The main street in my village, with all my cousins and their art. How fantastic would that be!

How, if at all, has your work been affected by the pandemic?
I've had more time to play during the pandemic, to explore the ideas that have been in the back of my mind. Oddly, I have more work than ever before. At age sixty-one, I'm only beginning to really enjoy the fruits of my labour, and the fruits are a continued inspiration to create.

What words of advice can you offer someone looking to explore a profession in the arts?
Do what you love. Don't be afraid to make mistakes or ask for advice. Laugh at yourself when you need to and remember to sharpen your blade.

Where do you see yourself and your art in ten years?
Oh, my gosh. Hopefully I'll continue on a similar path—creating, loving, breathing the fresh air, and being surprised at what I see when I'm finished chipping away at a piece of wood or metal.

Kailee Jackson

Owner, designer, and silversmith, Rauw Jewelry

"If your mind and hands want to do something artistic, you have something inherent in you to create."

What is your first memory of jewelry?

I was young, maybe five; I was looking through my oma's jewelry box as a curious five-year-old does. It was a sizable cream-coloured jewelry box, with gold accents, full of beautiful pieces, mainly gold with a few larger silver pieces. She gave this jewelry box to me a couple of years ago; it still smells like her, which I love so much.

Can you describe a favourite piece of jewelry?

I always had puka shells on, handmade anklets, and bracelets by the time I was seven. I admired my mom's beautiful gold hoops; they almost looked Western in their shape. This design is what sparked the idea to create the nautilus shell hoops that I make. I think my mind combines things I see—the inside of a nautilus shell—with what I know and connect to, like my mom's hoops.

Tell us about the first piece of jewelry you made.

I went through a phase when I was maybe seven where I made those beaded flowers. I would make chokers, anklets, bracelets, all super colourful pieces. I was also into making hemp-woven jewelry and colourful wrapped jewelry out of different threads, which I then started to wrap around a handful of strands in my hair.

At what age did you realize that designing jewelry was your passion?

In my late twenties I made a decision. I always felt pressure from others because I could never quite figure out what I wanted to do. I knew plenty of things that I didn't want to do. But I always said it would come to me, and it did.

It happened very organically. My best friend Leanne got me into wire wrapping jewelry before I left on a three-month trip with my love, Graham. While we were travelling, we stopped by this little boutique in Granada, Nicaragua. There was this beautiful gold ring that I was drawn to, but we were travelling, and we were on a budget. Graham whispered to me that I could learn how to make a ring. I had zero skills to do that; it didn't even cross my mind that I could make a ring on that level. When we arrived home, I looked into taking silversmithing courses. After many years of taking classes and practising, I decided this is what I want to do. It started to feel like a business in 2019, when I found my groove. I was doing markets, and people were buying my pieces; it felt good. And now, I'm finally able to end the juggle of serving part-time at Graham's restaurant and trying to work on Rauw. Being able to work on my business full time is a game-changer. I'm just starting to really settle into this position.

Is Rauw available exclusively online?

Currently, I have the online shop and stockists around the world. I feel like that's great for now.

"Rauw Jewelry is a conscious brand for the conscious shopper... Slow-made jewelry with purpose." Why is this important?

I've been interested in environmental studies for a long time now; intertwining it into my business was natural. Intentionally creating an environmentally conscious brand is significant to me. Feeling good knowing I'm putting effort into keeping my brand's carbon footprint low is essential. Looking at the current state of the climate, I believe every little bit counts. I stay away from mass production; time and love are poured into each piece I make. *Slow made* means I'm not going to stay up all night to meet a deadline, and if a piece takes a little longer to make, I rest easy knowing I enjoyed the process. I walk fast, but rushing my work is the worst thing for my mind and a piece. I design purpose-driven pieces, made with intention to connect you with moments in time.

Rauw is "designed to capture nostalgic moments between you, the sun, and sea." Can you share more about this?

I think about the happiest moments in my life, and it's always been when the warm sun is touching my skin, when I'm breathing in the ocean's air, when my feet are in the sand, when I'm taking a dip in the ocean, looking down at the ocean's floor and finding a seashell, gazing into the sunset gleaming on the water. I treasure all of these beautiful moments and look forward to experiencing again and again. It's like a gravitational pull toward the ocean, like the tide being pulled by the moon. It isn't just because it's beautiful; it's how it makes me feel.

Where is your favourite beach?

Oh, that's a tough one because I think every beach offers something different. If I had to choose, I would say Barbados has some incredible beaches. One side of the island has the relatively calm, clear turquoise waters of the Caribbean Sea, powder sand beneath your feet, ripples on the ocean floor, the marigold sunsets sinking into the ocean; on the other side of the island is the rougher water of the Atlantic, turquoise blue on the shoreline and deep blue as the depth increases. I especially enjoy listening to the sound of the palms blowing in the wind.

I think moments between you, the sun, and sea can feel like pure magic.

There's a stunning simplicity to your designs. Each piece has an organic aesthetic. What inspires this?

This is intentional. I always think if you found a piece of jewelry in the ocean, what would it look like, feel like? When I imagine it, the treasure would have the smoothest edges.

I wanted my brand name to reflect a bit of my background, so I decided to name my company Rauw (pronounced Ra-ow) which means *raw* in Dutch. My mom's side is from Holland, so having the brand name in half Dutch, half English felt right.

Which creatives do you admire?

I admire everyone who can make something out of nothing.

Who, where, or what inspires you?

Who: Mother Nature is the number-one inspiration in my designs. Also, I have some very talented friends, some of whom I've had the opportunity to go on creative trips with. I've discovered how important this is, to surround oneself with other creatives; this form of inspiration has helped me grow immensely.

Where: Spending time oceanside fuels both me and my designs. The ripples and waves dancing in the water, the glitter on the ocean from the sun's reflection, discovering natural movements and treasures; swimming, which energizes me and clears my mind. Spending all day at the beach until golden hour, then going into the ocean, eye level with the sun setting, and watching as it sinks down and disappears into the sea. Some of my favourite sunsets have been in Barbados, Costa Rica, and Kauai. My travels and all the experiences have unconsciously helped me develop ideas.

What: Sustainability—how to make a piece and my business as sustainable as possible. The ocean, sun, moon, and seashells all inspire. The driving emotion that I want each piece to instill is happiness, that feeling when you look at a piece and it reminds you of a time—time with a loved one, or a time spent at your happy place. Researching old jewelry also inspires me. I tend toward ancient Egyptian jewelry; I love the large gold statement rings, so simple and beautiful. A few years ago, my oma gave me a sculpture of a woman, called "Stargazer" by David Fisher, made in 1981, which has been a pivotal source of inspiration in my work.

I read this quote from William Morris: "Have nothing in your house that you do not know to be useful or believe to be beautiful." These words have stayed with me. To have something beautiful and sentimental that you cherish for yourself creates a form of everlasting happiness.

Please share with us your creative process.
I believe our mind gathers and stores visuals from our experiences over time. I'll often have a sketchbook beside my bed, I'll lay down, close my eyes, and let my mind wander. I'll conceptualize the piece, then create a quick sketch of it. To really know if I'll love the piece, I have to create it, make it. Sometimes I'll fabricate a piece by forging a piece out of silver, or carving a seashell out of a chosen metal, soldering all the pieces together like a puzzle; another way is with the process of lost-wax casting. I'll carve the piece out of wax, then have it cast by a local caster. Once a piece is done being put together, I spend time polishing the piece until you can see the sun's reflection beaming off it.

All your pieces are "mindfully made in Vancouver." Can you describe more about this?
The full process of creating a piece is so meticulously thought out, from using recycled metals, using plant-based polishing compounds, dipping the piece in a homemade salt-and-vinegar pickle solution instead of artificial chemicals, to sourcing all packaging that is made with post-consumer material. I'm always mindful of how to be a more sustainable company.

The west coast has everything in our backyard; everywhere you look there's an opportunity for new inspiration. I was born and raised in Maple Ridge, BC, which has one of my favourite spots to dive into a glacier-fed lake.

What is your studio space like?
I believe having a space where you can shut the door and be in a creative state of mind is important because it allows the physicality of producing to flow through your fingers. I just did a renovation in my workshop; it helps to have an organized area. I feel like having an organized space keeps my mind calm, and a calm mind helps with creating each piece. I coated the walls with white paint and wooden accents, along with a wooden tool wall and a wooden workshop table; I also added a large slab of wood for a desk. There's a little cactus and aloe plant on the windowsill, and a Paloma palm in the corner. I'm often either listening to Khruangbin or Hermanos Gutiérrez and getting lost in my thoughts or listening to podcasts.

I am a one-woman show, working solo in my studio. Having music or a podcast on is essential. I couldn't run my business without the help of my local caster, photographer, and all the wonderful collaborations along the way. I've met some of the sweetest people.

How has the pandemic affected you?
The pandemic has made me shift my business quite drastically; my main focus was markets, which I loved the social side of, but they are draining because I wasn't setting boundaries. I would work early mornings until late in the night. A surprising positive has been that the imposed stillness has allowed me to slow down quite a bit, to take a breath as I've fully shifted my business to online and with stockists, which is inevitably helping me grow toward having a balanced life.

Have you found new inspiration?
In this past year, I've become more comfortable being alone. Most of my days last summer were spent at the beach breathing the fresh air, taking a dip in the ocean, and doing solo hangouts in some of my favourite spots, which I've never experienced before. I find with solitude you notice and take in your surroundings so much more. I think my last collection really embodies those moments of observation.

Jewelry marks many memorable life experiences. Why do we have such strong connections with our pieces?
Jewelry is forever; we have discovered jewelry dating back over 100,000 years ago. Marking a memorable time in your life with a keepsake piece connects you with those nostalgic moments.

I feel a connection with every piece I create. Each one is a visual moment that I've captured and transformed into a piece. When someone picks out a piece of Rauw jewelry, I believe they've chosen that piece because of a nostalgic moment, or because they feel a connection to the sea.

I always want people to smile and be happy, whether wearing Rauw or not.

Gail Johnson

Co-Founder and editorial director, Stir Arts & Culture

"I'm curious about people—how they cope with life, make the best of things, and how they've ended up where they are today."

What is your first memory of words?
Wow, I love this question! The first word that comes to mind is *Glowa*. When I was four years old, I thought this was how I spelled my name. I took a black permanent marker and wrote it down on our basement floor, where it stayed forever.

At what age did you start writing?
I was always one to write notes to my parents; I would leave them on their bed at night before I turned in, just telling them about my day or how much I loved them. I loved writing letters, pages and pages long, to friends, and I had lots of pen pals. In high school I loved writing essays.

Tell us about one author, one book, and one journalist who consistently wow you with their work.
Author: Canadian physician Dr. Gabor Maté. He is a writer of non-fiction, which is where I turn to first when it comes to picking up a book. He is best known for his expertise in addiction, ADHD, and trauma, but he has also worked in palliative care and approaches medicine from a mind-body perspective. I admire his fierce intelligence and openness. And although he comes at things from a scientific point of view, he is a wonderful storyteller.

Book: *Anna Karenina*. I don't know how I missed this in high school, but when I did finally get to it years later, I was rapt. The complexity, the passion, the tension, the structure… it was the first time I remember being astonished by the skill of writing.

Journalist: Christie Blatchford. She was so sharp. Even if you didn't always agree with her, you can't argue that she was an extraordinarily fierce writer with a knack for research, clarity, and descriptive detail. I met her when I was covering child serial killer Clifford Robert Olsen's "faint-hope clause" trial for the *Province* newspaper in 1997. It was one of my first big assignments for the Vancouver daily, and reporters from all across the country were there. I felt very intimidated. She was the only reporter who bothered to talk to me, and she even complimented me on my coverage, which meant the world to me.

What brought you west?
Pretty hard not to fall in love with this place. The ocean and rain and mist were foreign to me coming from Alberta. In elementary school, I spent a week on the coast at a summer camp, and being here somehow felt like home.

At what stage of life did you realize that writing was your professional path?
I had completed a Bachelor of Arts degree with a major in French from UBC and was working as a restaurant server and travelling after that, feeling somewhat lost. I stumbled upon a pamphlet for the journalism program at Langara College. I remember reading through it, and every single class sounded appealing to me. Then I noticed that the application deadline was the day before. I dropped everything, drove up to the college that instant, got an application, filled it out, and begged them to accept it. I was accepted the next day.

The journalism program at Langara was fantastic—far more practical learning than what I experienced getting an arts degree. It included an internship, which I split between the *Georgia Straight* and BCTV. I also did an internship on my own initiative at *Western Living* magazine. Those experiences and contacts proved invaluable.

Upon graduation, you went on to work as a reporter covering daily news at the *Province* for two years while also working at the *Georgia Straight*, covering dance and health.

They were two very different experiences. The *Province* taught me how to work quickly. Every day I'd go in for 9:30, grab a coffee, get my assignment (or two or three), pair up with a photographer, and head out to gather information, interviews, and photos. Then it was back to the office by 2:00 or 3:00 p.m. Our stories were due no later than 5:00 p.m. It was such an excellent training ground. I worked on some big stories and loved it. The *Straight* was a different vibe; at the time it was under the editorial leadership of Charles Campbell. He is an outstanding journalist who made the paper into the award-winning publication it was at the time. He had extremely high standards and expectations. I learned so much from him about journalistic integrity and fact-checking. He gave me a three-word spelling test during my interview and still hired me even though I spelled "fuchsia" wrong.

You've said, "Food is culture." What does this look like, in your experience?

I started working in the restaurant industry in Grade 12 as a hostess at Earls Tin Palace in Edmonton (we called it the "Skin Palace," as the lounge was quite the scene), then became a server. The training there was fantastic. I worked at a few restaurants upon moving to BC for short stints before joining Bridges on Granville Island in 1990. I worked on that enormous dock my first summer. Newcomers were given "sunshine shifts," meaning you only worked if the patio was open. I remember having two shifts for the entire month of June. That's June in Vancouver. I eventually moved upstairs to the dining room, which at the time was a much higher level of service; that's where I really began learning about food and wine. We would spend time with the chef before every meal to go over feature dishes; I remember having never seen a fiddlehead before, and I was just fascinated to learn all about it. We learned about

food and wine pairings, and I loved all of the stories behind the products.

I always say food is culture because food is one of the best ways to learn about the history, beliefs, traditions, practices in any given place; it's such an accessible, intriguing, and fun entryway into different worlds. People who pursue cooking are proud to showcase the ingredients, recipes, culinary techniques they grew up with or that inform their roots, and there's always a cultural connection. Food brings people together, and this is vital to cultures around the world.

I love being able to tell the backstories of local food vendors and chefs; I wanted to share people's stories, and that takes time to research and to do thoughtful interviews and then compile information into a compelling article. There is so much crossover between the arts. I always loved dance in particular (both taking lessons as a kid and watching live performances). The pandemic made me realize how the arts nourish your soul; they really feed a different part of your brain and allow you to see things in a fresh light.

You and your colleagues are working hard at building Stir. What has it been like to start a new platform during a global pandemic?

It was odd to launch an online arts and culture platform mid-pandemic, but everything in the world seemed upside down, so why not go with that theme? We hit the ground running. The arts and the culinary worlds adapted extremely quickly and in very creative ways, so we had no shortage of things to write about—we were keen to share those stories of innovation, resilience, frustration, loss, hope, and community.

There's something exceptional about Stir—can you share a bit about this?

Stir was co-founded by me, Janet Smith, and Laura Moore—all of us working moms. One of the things that struck us is that there are very few media companies owned and operated exclusively by women. We feel very proud of this. In a study by the Canadian Media Concentration Research Project, it was found that 70 per cent of the media landscape was made up of four conglomerates: Bell, Rogers, Shaw, and Telus, and 100 per cent of these companies are run by male CEOs.

Why is storytelling a valuable component of our culture?

Storytelling may be the world's oldest art form. We need stories to inspire, entertain, fuel, motivate, awaken, startle, comfort, and delight us.

"The common denominator in writing about any given topic for me is that the human is at the heart of the story." Can you share more about this perspective?

Over the years I have freelanced for many publications, covering everything from personal finance for the *Globe and Mail* and Yahoo Canada to natural health for *alive* to cocktails for the *Alchemist*. No matter what the topic or idea, controversy, or question, there's always a human behind it, and so you can always learn something or at least get a new perspective.

You've shared with me that you have anxiety.

I would say it started when I was twelve. It caused me enormous anguish throughout my twenties and up until I finally got a diagnosis and, eventually, effective treatment. There is a difference between having "normal" worries and when anxiety is debilitating, limiting, and emotionally painful. To stay healthy, I take medication, exercise regularly, get into the forest or by the ocean, incorporate stress-reducing practices like deep breathing and massage, and more.

You've said, "I'm a mom of two teenage boys and married to a selfless man who's a three-time cancer survivor." Can you tell us more?

My boys are now teenagers. My family is extremely supportive, especially my husband. He is a rare find: thoughtful, giving, fiercely intelligent, knowledgeable, romantic. My most important job is that of mother and wife. I adore my family and am so thankful for them.

You've also said, "I think the world needs more humility and kindness, and I work daily to try to become a better human; I firmly believe that we can all make the world a better place in our own small way every single day." What has informed this perspective?

Great question. I am extremely, genuinely compassionate and caring. I don't fake it. Having a big heart and sincere curiosity may be why I love listening to people and beyond that, hearing them.

Where do you envision yourself and Stir in ten years?

Continuing to put out fantastic content but having a team of writers to help do it—essentially a bigger and better version of what it is today.

Kia
Kadiri

Hip hop and R&B recording artist

"Humility is a crucial aspect of being a student, and no matter how good you become, you can always learn more if you remain willing and open to feedback and constructive criticism."

What is your first memory of music?
I have two early childhood memories of music, both from when we were still in England. I was four or five years old, and I was singing as we were leaving church as my father carried me. A lady behind us told me I had a very nice voice. I'm not sure if I said, "I know," or "thank you," but from what I've been told, it was probably "I know." I wasn't very humble back then.

Tell us about music influences that inspire you.
I listened to the Beatles, and the oldies radio station with my dad, as well as James Brown, Aretha Franklin, and Etta James. As a family we listened to Michael Jackson's *Thriller*. The first CD I ever bought was Madonna's *Immaculate Collection* in 1990. The first box set I ever bought was the Led Zeppelin *Complete Collection*.

After rock came jazz, then hip hop—Public Enemy's *It Takes a Nation of Millions to Hold Us Back*, Diggable Planets *Blowout Comb*, Mos Def's *Black on Both Sides*. So many talents, not enough space to list them all.

How did your surroundings inspire and form you?
I spent my formative years growing up in Victoria. Moving to a new city as a young teenager was difficult, and I

struggled with the many adjustments needed to fit in. My high school was in a wealthy neighbourhood, and most of the students had been in school together since they were small children. The population was mostly white and privileged. My brother and I had no other family in Canada, and no real connection to a Black community. I wouldn't come to understand the traumatic effects of racism, the socio-economic environment, or the lack of cultural and family connection, until much later in my life.

I struggled with mental health issues—depression, eating disorders, suicidal ideation, sleep disorders, and dissociative events. Eventually I ended up in a children's psychiatric hospital and fell behind a year in school. My parent's marriage was falling apart. I had never felt more alone. I didn't have any friends I related to other than my first boyfriend. The one thing I gravitated toward in that time was journaling. Little did I know that those journals would become one of the biggest sources of inspiration in my life.

When I returned to school, I immersed myself in the arts. After graduation, I continued to pursue these areas of my life in the community.

I started performing with my first band DIGG. DIGG was special because the two other vocalists were two Black men. I had never had Black friends before, and they were ten years older than me, and were like family—big brothers who guided me and taught me about Black culture. They explained hip hop to me and helped me understand and appreciate it. They also explained slavery and racism to me, which wasn't something I was taught about in school. They showed me the value of my journals. They introduced "Kia Kadiri" to the world, and they protected me like a baby sister from all the pitfalls of the music industry. I learned how to be a woman and gained confidence

and self-esteem. I believed in myself and my story and better understood what it meant to be Black. Most importantly, they taught me how to turn those journals, feelings, struggles and pain into powerful stories, spoken word, and inspirational songs.

Everything that happened in the years after graduation irrevocably changed me as a person. My surroundings inspired me to grow as an individual and as a musician. I enjoyed the beauty of the water and the mountains. I loved to tour and travel the small islands for gigs. I joined multiple bands, worked with amazing musicians and deejays, and performed in almost every live music venue in Victoria. Music was my saviour. Victoria was a magical place. I felt blessed, I was grateful, and I felt loved. I had not felt that my first six years in Victoria. This period was the calm before the storm.

When the World Trade Towers fell in New York, I was hospitalized for the second time in my life, experiencing a full mental breakdown. I quit performing with the musicians in Victoria, and shortly after I moved to Vancouver. Not long after arriving in Vancouver, I met Ian Menzies, the man who became my first manager. He helped get my solo career started, and with his help I received a recording grant from SOCAN. In 2004, I recorded my debut album *Feel This*, and the next chapter in my musical career began.

Most importantly, I've learned how to love myself, to be patient with my shortcomings, and to be grateful for all the amazing people in my life. Everything that I have been through has shaped me as an artist and a human. Each path and road that I have travelled reveals a deeper side to my writing and my music.

Do you have any formal training in music?
Up until the fall of 2020 I had no formal training in music. I was self-taught and learned by listening, watching, performing and teaching myself theory. Twenty-six years after I graduated from Oak Bay High School, I returned to school at Douglas College and graduated from the Basic Musicianship program. The one-year course was an introduction to music theory, piano, aural skills, and private instruction. It was wonderful to finally learn how to read and write music, compose using music software, get a better understanding of music history, terminology, harmonies, cadences and form. I graduated with honours, receiving scholarships to continue with my studies in music. Over the next two years I will be focusing on music

production, recording and engineering, working toward my music tech diploma.

The experience of returning to school taught me valuable skills. My focus now is working as a professional with youth in a government-funded program. In my role with the Ministry of Family Development, I'm looking to improve skills and programs that are offered. I have a talent—and have developed skills—for teaching hip hop and song writing to at-risk youth, and the formal training I am now undertaking provides me with techniques to expand on the therapeutic applications of hip hop music.

What are the benefits of mentorship?
I have had a lot of mentors over the years; most of them were peers. Being a self-taught musician, I relied on lessons and direction from people working in my field. Mentorship is beneficial because in order to grow, you must remain teachable. Humility is a crucial aspect of being a student, and no matter how good you become, you can always learn more if you remain willing and open to feedback and constructive criticism.

I learn from people who I mentor, just as they learn from me. There are many young women whom I have watched grow in the hip hop community—amazing artists, intelligent business owners, teachers, grant writers, producers, musicians, writers, and poets. The fact that powerful women have stood up before me has given me the confidence to rise, and I have passed that gift on to other women.

In an industry dominated by men, it has always been important for me to be respected and recognized for my talent, intellect, communication skills, writing skills and work ethic—not just for the way I look or because I'm a woman. I encourage other women to be seen for their gifts and not only their beauty, moving away from objectification and engaging with men as equals in the conversation. I don't believe this would be possible without strong women and men mentoring each other and working together to provide safe places for these discussions.

What is unique about hip hop and R&B music?
Hip hop is like folk music. There's an underground network of shows, audiences, and groups all around the world. Hip hop artists usually aren't in it to make money or become famous; oftentimes they are people who enjoy the art form and who have a message they want to convey. The music isn't typical or overly produced (at least it wasn't in the

beginning); the music is more about the lyrics, storytelling, and sharing of a common experience. Almost every other style of music can be categorized, but hip hop breaks the mold, featuring rap in different languages and aimed at a variety of demographics.

Rap is timeless because we seem to repeat the same cycles of struggle in the world. The same themes repeat, and rap music addresses these moral complexities. Hip hop has always been the voice of poets, artists, rebels, activists and common folk. The music expresses political views, systemic racism, and poverty, and acts as a voice of the communities. If human rights issues remain present, the music remains timeless, expressing the feelings of each generation and passing them along to the next to reinvent.

Hip hop and R&B play an important role in representing the truth and opinion of the young, oppressed, and marginalized.

Let's talk about your creative process.

I'm a night owl! I like to write by myself in a quiet space, usually at my office desk, with a lamp. Sometimes I'll write to a beat, other times in silence.

If I'm composing a song, I like to listen to the music over and over. I come up with a melody, or some words sung to a melody, and record it to a voice memo so I don't forget the idea. Then I'll sit down and write the song when I have time to be alone. I love writing original lyrics in pen, on lined paper, with my clipboard. I number the bars and start with a chorus, then write an eight- or sixteen-bar verse. I keep everything that I write in binders with page protectors. I have many binders full of lyrics and ideas. It will often be re-written several times before I decide on the final version to type.

I like to diffuse essential oils like peppermint, and I have led lights. I like the environment to be clutter free. I drink Starbucks Americanos, black, in my stainless-steel coffee mug. I also love gummy chewy candy like wine gums or cola bottles and have them around when I'm in the studio or when staying up late composing. I love to be comfortable in sweatpants and hoodies, especially in the studio—no makeup, kicks, or sometimes my fuzzy slippers if it's a long session.

Once I've completed a song, I like to walk outside or drive in my car listening to the drafts and rapping the lyrics until I have them memorized to perfect the form and flow. Once I've learned a verse, I remember it for years.

Your song, "Be Brave," was released in October 2020. Can you share how this song came into being?

I worked with Johnny Tobin, an amazing keyboardist/ producer in the Famous Players Band, and knew he was producing a lot of cool music. Earlier that year, in August, I had presented a spoken-word piece at the Canadian Recovery Capital Conference that focussed on the struggles of the BIPOC community as it relates to addiction, mental health, and incarceration. The poem was heavily influenced by the George Floyd murder, the Black Lives Matter movement, and my own experience with addiction. The lyrics focus on the effects of systemic racism and the barriers we face when it comes to accessing care and justice in our communities and institutions. I decided to compose a song based on the spoken-word piece "Black Addicts Do Recover," and the result was "Be Brave." It tells the story of overcoming addiction, taking back our power, using our voices, and the courage it takes to share our experiences with these matters. Some of the lyrics are:

No longer a slave, I'm gonna be brave
I'm riding this wave, it's all that I crave.
I won't live in fear, I'm surrounded by love
As long as you're near, I'm lifted above.

The song means a great deal to me. One of the greatest accomplishments and honours was having the music video featured at the fiftieth annual conference for the ABFE (Association of Black Foundation Executives), "a philanthropic partnership for Black communities in Washington DC," in April 2021. This phenomenal organization funds many of the grassroots organizations such as BLM and supports prison reform and unlawful imprisonment cases in the USA. It was an honour to share my work for such a worthy foundation.

How has the pandemic affected you?

This time has allowed many of us to focus on family, nurture friendships, and understand what we truly value. The pandemic has taught me to love and respect others, despite differences in opinion or viewpoints. I've learned not to fight to be right, or judge others, rather to find acceptance, tolerance, and compassion for one another. I have found more peace, contentment, joy and appreciation for the simple and beautiful things in my life. I enjoy fresh air and walks outside; I value the support of my friends; I have grown closer to my family. My happiness is evident in my art.

Marie
Khouri

Sculptor

"Speaking a language is a way to understand a culture, its humour, its place, and its people. This has allowed me to be a very open human being."

What is your first memory of art?
I remember a painting of a Bambi which I did when I was seven years old.

Did you grow up in an artistic family?
I did not; my family was mostly in business. When I married my husband in Paris and had in-laws that were both architects, my eyes were opened to a new world.

Your childhood was interrupted during the Lebanese Civil War, when you relocated with your family to Spain, Italy, Canada, and then to Paris. How did these moves affect you?
I left Lebanon during the civil war. My mother, brother and I left for Spain, where my mom is from and where she had her family. We waited there until my father could join us. Sadly, my father was assassinated the week we left Lebanon. This whole path left me with a feeling of being a wandering and rootless individual, never belonging anywhere and missing everywhere I am not in. I did, however, learn to become adaptable, learning to speak five different languages. This made it easy for me to morph in; however, my soul sometimes felt hollow.

How did the above shape you?
Well, when I discovered sculpture, I felt I had found a way to express the layers of my life, to talk about it. I became my work, and my work became me.

What do you remember about when you first arrived in Canada?
I landed in Port Coquitlam, where we had family. This was in 1976. After having lived in Beirut, Madrid, and Paris, I found myself in a world I had never before encountered. It was all very different from everything I had known up until then. I could not speak English, and I wanted to go back to Lebanon to fight.

Years later, as an adult, you moved back to Canada, Vancouver specifically. You mentioned your daughter was fifteen, the same age you were when you first came to Canada. Where feels like home now?
My husband, children, and I decided where we wanted to move after my husband sold his company. He had a non-compete agreement, which impeded him from continuing to work in Paris. Too young to retire, and being an entrepreneur, we felt that a move to North America would be good for our children; it was where they could learn English and prepare to attend English universities. I wasn't too keen at first, having lived for a period in Canada during which I found it difficult after the dismantling of what my life had been prior to 1976. This sour taste had remained with me—an unfortunate link to Canada in my mind. But the kids knew Whistler, and my mother was living back here, which made it easier to move back. The first few years were difficult; I kept driving through areas that

reminded me of the challenges we had experienced upon our arrival back in 1976. We had lost everything after leaving Lebanon and had to rebuild our lives from scratch. At the same time, these painful memories reminded me of the strength I had developed, and the will to move forward.

Before pursuing art full time, you had a career in linguistics. How did your previous profession help and/or inspire your current role as a sculptor?
Let's sit and talk is a perfect image of how these two careers came together; I sculpted benches that were Arabic letters and that spelled *let's sit and talk.*

You speak five languages; how does this influence your work as a sculptor?
You know, when you speak one language you are one person; when you speak two you are two people, and so on. Thus, speaking a language is a way to understand a culture, its humour, its place and its people. This has allowed me to be a very open human being.

At age thirty-four, you decided to pursue your passion as a sculptor. How did starting your career at this stage of life shape your path? What were the benefits and challenges?
It truly happened in a most organic fashion. I took a sabbatical when we sold my husband's company. I then enrolled in an art program at the l'École du Louvre to try something completely new. As I moved through the classes, I found myself eager to touch the clay, and I completed the entire curriculum, working endlessly. This experience truly ended up defining me.

The advantage of having started later in life is that I did not need to search for what spoke to me. The forms I was attracted to, the way I wanted to express them, questioning if anyone was supportive—none of that mattered. I needed to sculpt, needed to express myself and to speak of everything I had bottled inside me for so many years.

You spend six weeks twice a year in France. What time of year do you go, and what takes you there?
The dates are decided based on the projects I'm working on in Europe, be it private or public commissions and production agendas. It is pivotal because I deal with different production teams and different materials, and there are varying ways of viewing my work. It's important for me

to have these two worlds (Vancouver and Europe) to feed from in my work.

Have you had a mentor?
Not really. I shared parts of my path with different people that each contributed in some way to my development as a sculptor. I listened, paid attention, and never once believed that I knew it all. I'm avid about different mediums and different ways of working; I think that my curiosity and strong worth ethic define me best.

Who are creatives who inspire you?
Henry Moore certainly did when I started out. I now have much appreciation for many creatives of various kinds—artists, dancers, musicians, writers and people in general. Anyone who shares their talent and takes a risk to bring their own voice.

You're known for your large-scale pieces. I imagine there's a lot of physicality involved in your process. What inspired you to create big?
My wanting to do public art came from a need to democratize art. I wanted it out of the galleries and the museums, in places where people can stumble upon it unexpectedly. I want them to not feel intimidated by art, but instead to connect with it, to touch it.

Do you have a favourite piece?
My piece *Eyes on the Street* speaks of city growth, about how communities interact and come together. In *Down from Writings of Jane Jacobs*, I wanted to speak in this area where condominiums and high urbanization is developing, to express that we are not safer behind a hedge but with neighbours that we can see and interact with.

How is it different to create public versus private pieces?
It takes a village to create public works. Being very large scale the majority of the time, and of heavy, sturdy materials, they're usually fabricated in metal shops and handled by teams. I oversee the project, after having built the model.

Walk us through your creative process.
I have a small think tank in my basement where all of my ideas and concepts come to be. I often form models out of clay by hand with a knife. For the public art, there's a lot of

reading, and site visits which happen prior to even starting to think about the work. I try to connect with the community, the history, the architecture, etc. I tend to sometimes create in response to the site. My private practice is about the way I'm feeling at a specific time, in response to societal and personal implications.

Do you have a specific space in which you work?
My home think tank, as mentioned, is in my basement. There's no natural light, however; it feels like a womb to me. It's a place where I'm able to process and digest. Most of my large works are created in external shops and foundries, depending on the medium and scale of work I'm dealing with.

Do you see a recurring theme in your overall body of work?
My curiosity is what brings me to new bodies of work. When I feel that I've expressed everything I wanted to in a medium, I move on to something else to learn and challenge myself. Challenge is what makes me grow.

Is there one particular piece with which you feel a special connection?
Let's sit and talk identifies with my past and the situation in the world, the disconnect we have because of all the tools that exist in our lives that make us forget to actually speak to each other. The pandemic has isolated the way we share. This particular piece started with a concept that spoke of the Middle East and how the wars continue because of religion. This idea and subject make sense in the society we live in today too.

What or how do you think people feel when experiencing your art?
I hope and want for people to relate to the art in their own way.

Why is art important?
Art is language, a soothing touch, and a reflection of our society.

How has your work been affected by the pandemic?
The pandemic has forced me to stay put and therefore deepen my practice and process.

What words of advice can you offer someone looking to explore a profession as a sculptor?
It is never too late to start something new.

Where do you see yourself and your work in ten years?
Ahead!

Julianna Laine

Singer/songwriter

"Writing songs and telling stories are the first things I fell in love with when deciding to become an artist."

What is your first memory of music?

My first memory of music would be driving in my parents' old car in the summer when I was younger and listening to *Graceland* by Paul Simon. My second memory of music would be when my brother and I were younger, and we would listen to "Live Like You Were Dying" by Tim McGraw and run around our backyard and make up dance routines.

Did you grow up in a musical family?

Yes! My dad is actually a musician and he taught me how to play guitar; this was a big part of how I got into music. My parents bought me my first guitar when I was about twelve years old because I wanted so badly to be Taylor Swift. My mom plays piano, my brother produces and writes, and my sister plays the drums—we're a very musical family! I took voice lessons for a short period of time, but mostly just learned by writing songs and singing them myself. While I was growing up, being creative was definitely encouraged. Aside from playing music, I took dance lessons and loved painting and drawing and writing short stories.

What is a song that moves you?

"Austin" by Blake Shelton.

What kind of music did you enjoy listening to growing up?

I listened to a lot of country music. My parents always had the radio station on. In Calgary, country music was very popular, so that was most of what I heard from a young age. It's definitely hard to narrow down the musicians who have inspired me, but here are a few: Taylor Swift, Kenney Chesney, and Chelsea Cutler.

At what age did you realize that music was your path?

I have always been drawn to music as a career, but I think the moment when I realized I wanted to pursue it full time and in a professional way was when I was selected as a Top 12 artist to participate in Project Wild, an artist development program run out of Alberta. During the six months when I was part of this program, I learned a lot about the industry and met so many different people who inspired me. I really liked the energy and the conversations that I was having and decided I wanted to be in that creative environment all the time. I haven't had much formal training. I think the music industry is so difficult because there is not one correct path to follow; each artist has their own journey, and I think that's where the magic of it comes from.

Tell us about the first time you performed live in front of an audience.

My first time performing in front of a crowd was at my middle school talent show. I sang a Taylor Swift song, of course, and I was so nervous! I guess from that point onward I started playing at outdoor events and small concerts around Calgary and really liked the feeling of sharing my own original songs with people. I haven't had a specific

aha moment, but before the pandemic, I spent six months working on my degree in Europe and was booking venues on the weekends and travelling around to different countries to play these shows. I remember feeling, *Oh, this is definitely what I want to do.*

What motivated your move to the west coast?

I have lived in a few different places before landing on the west coast. When I was eighteen, I moved to Australia on a working holiday visa and lived in Byron Bay, and then lived in Austria to work on my degree; I spent that summer working at a surf camp and playing music in Portugal. While living in Australia, I caught the surfing bug, and it has played a pivotal role in where I travel to.

I moved to Tofino in 2020; the motivation for moving out here was because international travel was banned, and I wanted to spend some time being creative through working on my music and surfing. With the restrictions of being allowed only to stay in Canada, I wanted to go somewhere I could be creative and surf. Having been to Tofino a couple times before, I was familiar with the place, and it felt like the right place for me during this time of my life. It checked all the boxes— the waves, the people, and the culture of creativity. I also love the supportive girl gang that we have out here. There are so many awesome women in Tofino. This motivates me to work hard and be supportive of my friends who are doing amazing things!

What other creative outlets currently fuel you?

Yes, we can add modelling! I love spending time in nature with my really amazing friends out here and also having fun paint nights or working on random artistic projects— one friend and I are learning how to screen print this summer. I think this environment inspires my music and writing because it allows me to live my life then come back to have stories to tell when it's time to put the pen to paper.

There's a big connection between surfing and music for me. Surfing requires you to be very present and in the moment; because it's such a dynamic environment, it's hard to think about anything else. I find that the feelings that I have on land are normally magnified when I am in the water; for example, if I am feeling nervous or anxious about something, I notice that in my surfing. If I am feeling confident and peaceful, I also notice that in my surfing. Either way, when I get out of the water I always feel better.

You have to be creative in the surf because you never know what waves are going to come, and I think this type of thinking translates to breaking writer's block when I am writing my music.

How would you describe your music?

I always have a hard time with this question! I feel like my music can fall into the singer-songwriter genre, but also from a production standpoint, I would describe myself as a "bedroom pop" artist. I tend to stay away from describing my music as one genre because I feel like it can limit my creativity.

Lyrics as storytelling: What does this mean for you as an artist?

I describe myself as a songwriter first and foremost. Writing songs and telling stories are the first things I fell in love with when deciding to become an artist. I think that stories become more powerful when there is a melody that brings them to life because this allows other people to connect with the messages, whether the song is in their native language or not. In my travels to different places around the world, I have realized how powerful music can be and have experienced feeling connected through music with people who I cannot speak with because of a language barrier. I think music simply makes people feel happy and understood.

What instruments do you play?

I play guitar and very basic piano (this mostly comes from needing to when I am working on song production). I would love to learn more piano.

Your voice is melodic and transportive in the sense that it makes me feel totally swept up in the song as I listen. What do you bring to music that is unique?

First off, thank you so much for those kind words. With my music, that is my main goal—to make people feel that they are swept up in the song and story. I place a really strong focus on my song writing, so I think something that is special about my songs is the emphasis on the storytelling aspect of it. Growing up listening to a lot of country music, I realized how important the lyrics to a song can be, so I would say my writing is something that stands out and makes my music unique.

Who, where, or what inspires you?
Who: My family, friends, and relationships that I have been in are a big part of what inspires my work.

Where: Whenever I go back home, I find I write a lot in the bedroom I grew up in because it's a good place for me to get my thoughts straight. And, of course, I'm inspired by Byron Bay, San Clemente, and Tofino—basically anywhere near the water.

What: Emotions inspire me to write, such as when I am feeling sad or confused or overthinking things. And I am inspired by the ocean and its ever-changing tides.

What do you require to be creative and productive?
I find that before bed I am my most creative. This is usually the time when I am journaling or reading. I like to write during rainy days and stormy weather. I find it hard to be inside when the sun is shining (which is not very often in Tofino), so I find myself outside surfing or enjoying the sun when it's nice outside. I write and record mostly in my bedroom; I really find myself to be most productive when I have a week set aside to work strictly on music with no distractions. While writing my last three songs, I spent a week working with my creative collaborator who lives in Vancouver; we worked fifteen-hour days together, and it felt so good!

I especially love the opening shot of you in the video for "Where Did All My Friends Go?" Do you enjoy the process of putting a song to video?
I love the process of creating a music video! I feel like once I have produced the song, I already have a visualization of how I would like it to appear on screen. For the past three music videos, I have co-directed, scouted locations, storyboarded, and did my own wardrobe and makeup. I am a very visual person, so I get excited when it comes time to film a music video for a song.

There appears to be an element of fun in your videos. Is this intentional?
Most of the time we are laughing while on set. I generally don't have much of a budget for these videos, so my friends and I find ourselves in some interesting situations. The last video I shot, "Remind You," was such a funny experience because there was this aesthetically gorgeous neighbourhood in Calgary, but it was private, so we had to create a whole plan to sneak in there and film this specific dancing scene at midnight. We had a big floodlight and were so nervous about getting caught, but we pulled it off and were so stoked about it.

Which musicians currently inspire you?
At the moment, Patrick Droney, Quinn XCII and Chelsea Cutler. I am first and foremost a songwriter, so I appreciate these artists because I feel like their songs are very strongly crafted.

What is your dream stage to perform on?
The Bowery Ballroom in New York City.

How has the pandemic affected the music industry and concert scene?
During the pandemic, the whole live music industry has basically been non-existent. At the start of the pandemic, I did lots of online concerts and livestreams, but it is not the same feeling as playing to a live, in-person audience and feeling the energy in the room. I am very certain we will experience live music again. I think now, more than ever, people want live music, and that is a very exciting feeling as an artist.

How has the pandemic affected you?
The past two years have been a lot quieter than ever before, similar for most of the world. I have found inspiration in this slower pace of life, especially living in Tofino. Here, I've found myself spending more time with people and enjoying the moment rather than rushing on to the next thing. The music industry is very fast paced, so it took a while to adjust to this and be okay with living slower. Having said that, I am ready to get back into the world, work hard, meet collaborators, and play live music again!

Music brings people together. Why do you think this is?
Music is special because it is a form of connection without judgement. People can relate to a song in a thousand different ways and feel things so unique and specific to them. I think our job as artists is to translate these experiences into songs that anyone can listen to and feel something in their soul. I think music has been very important during these tough past two years.

Dee Lippingwell

Photographer and author

"I get more confidence with every success. I thank my mom for modelling confidence and capability. She went above and beyond to show me how it can be done."

What is your first memory of photography?
My first memory is of my grandfather showing me how his camera, a big box Brownie, worked. I captured a mother cat and her newborn kitten in the viewer and took the photo. My grandfather entered my photo in the community centre's photo contest, without me knowing, and I think I was the youngest to win a smaller Brownie camera. I believe that's the camera my family used for years, but I definitely did not think that photography would be in my life or even that I would make it my career.

Were you surrounded by creativity during childhood?
My mother was the creative parent; however, my father was very creative in his chosen field of doing body work on cars. He could take a totalled car and make it brand new again, which I thought was brilliant.

My mother held so many titles. The message that she shared with me was, "Anything you want to do, you can do—all you need is the confidence in your own ability to achieve your goals." She taught the lesson by example: she was a telephone operator in the Second World War and sold enough war bonds to sink a U-boat; she was a florist who ran her own business in the early fifties; she was in the Canadian army, first in the reserves and then as an instructor in the regular forces, at which time she rose to the level of sergeant. She travelled with the Red Cross to provide aid

when Hurricane Katrina hit. She was a makeup artist, working for the Rossland Light Opera and then doing casualty simulation makeup for the Red Cross all across the country. Most of the time, she was working at more than one or two of these at the same time! She was my biggest supporter.

When I told her that I was going to be a photographer, she told me she always knew I would be something theatrical and actually thought photography was a good thing because I was always the best photographer in the family.

At what point in your life did you realize that you wanted to pursue photography as your profession?
Photography was always a hobby. I was using an Instamatic, and it was a slow evolution from that to 35 mm photography. My subjects were trees, flowers, and my kids. Then I discovered rock and roll, and things changed. By 1973, I had my first 35 mm camera, a Canon. I was still shooting flowers, trees, etc. And then Pink Floyd came to Vancouver, promoting the *Dark Side of the Moon* album.

You're a self-taught photographer. What was your learning process like?
My very first concert was shooting from the "pit." I was labelled a "groupie photographer" by the four or five male photographers from various publications, including the *Sun* and *Province*. Did they think I couldn't hear what they were saying? I simply thought, *Watch me get better photos than all you guys!* I gained more confidence with every success, so I just kept going. Again, I thank my mom for modelling confidence and capability; she went above and beyond to show me how it can be done.

When I started shooting bands for real—after the first Pink Floyd concert—I realized I couldn't shoot in colour as it

was too expensive. Black and white was extremely cheap to process if you did it yourself, so I got the series of Time-Life photography books which showed step-by-step instructions on just about everything one needed to know to develop film and print photos. I set up a darkroom in a basement bathroom, and through trials and tribulations I taught myself how to do the whole process. I did not have a mentor, although I admired Annie Leibovitz's work in *Rolling Stone*.

What it came down to was that I was motivated and intelligent enough to teach myself the whole process involved with the photography profession, everything from working in the darkroom to photo refinishing, mounting, framing. I simply forged ahead with no definite plan except for knowing I was doing exactly what I should be doing.

What are your thoughts on mentorship?
I don't really think about mentorship, but I have unintentionally mentored three incredible photographers. When they tell me, "If it wasn't for you blazing the trail, we never would have thought we could do it," this blows me away. So now, when I get questioned about photography as a career choice, I'm very supportive but also tell them about the perks and pitfalls of the business. I also tell them to make sure they keep a day job until situated. The three photographers that I unintentionally helped are now successful wedding, portrait, street scenes, music industry, and wilderness photographers.

You're known for capturing images of some of the world's greatest music icons of our time. What are some highlights that come to mind?
My first concert photo was of Glen Campbell, and I shot him with my Kodak Instamatic. At what point did I know I wanted to shoot musicians? At that Pink Floyd concert. I brought my camera along to take photos as mementoes of the concert experience. I had no idea what I was doing. I knew nothing at that point about stage lighting, correct film speed, or shutter speed use; I was flying by the seat of my pants. When I picked up my film from the Shoppers Drug Mart photo lab a few days later, there were gold stars on the envelope. *Weird*, I thought. The saleslady told me that I must have some interesting photos to get gold stars. The photos I took of Pink Floyd had miraculously turned out.

When you started shooting local musicians in the seventies, I imagine there weren't many female

photographers. **What was the response when you showed up to a gig?**
I practised with the local bands, then auditioned my work for the *Georgia Straight* and got the job. At some assignments I was met with attitude, but as always, I was nice to everyone, from the people taking tickets, to all the security and food caterers, to the lighting and stage crews; we were all there to do a job. It wasn't just fun and games, although I do admit it was a pretty interesting job, and I met a lot of wonderful people.

Has the attitude toward women photographers shifted over time?
There's been no problem for me or any other female photographer in this business for a long time. I can probably even take some of the credit for this shift.

How has concert photography changed during your time in the field?
I went from using film, and doing darkroom developing and printing, to digital photography and editing in front of a computer—a major move for me, to be sure.

Which musician stands out to you as being a truly remarkable and kind human?
Tom Petty. I don't want to give it away—the details of the story appear in my book *First Three Songs . . . No Flash!*—but I will say I quickly realized that nobody ever minds having a woman take their photo.

What qualities make for a timeless photo?
Who knows? I think everyone has their own idea of something great or wonderful in a photo. I look at lots of "famous" photographs and think, *So?*

What do you want people to take away when looking at one of your photos?
I want them to feel like they did when they actually witnessed the artist perform on stage. If I had a dollar for every time I've heard someone say, "Takes me right back to the concert," even though the concert is years past, I'd be a relatively rich photographer today. This makes me feel great!

You mentioned that you had to "do something" to get that first photo published.
As I built up my portfolio, I set up an appointment to show it to Bob Geldof who was then the music editor at the

Georgia Straight. He did reviews and gave out all the photo assignments. By this time I'd already had several "paying" jobs with some bands; however, now I needed that all-important accreditation: the legitimacy of working for an actual publication. This was important because all the bands now coming to perform in Vancouver required photographers to actually be working and getting paid for photos instead of simply being there because it was a hobby. I had to prove myself to get the job at the *Georgia Straight* by taking not just music photos but photos to go with editorial, news stories, etc. I had numerous meetings to show photos before I was actually hired. I was officially hired by the *Georgia Straight* on October 12, 1975.

Tell us about your first photo exhibition at the A&A Record Store in the Coquitlam Centre.
My roommate at the time had a boyfriend who worked at the A&A Records downtown; he introduced me to the owner in Coquitlam Centre, who set up the exhibition. We actually hung the photos from the ceiling, so they were above all the albums. For the opening, we had to cover all the albums so as not to destroy anything while people wandered around looking up at the photos.

Tell me more about your cross-Canada tour, from Vancouver to Halifax.
The cross-Canada tour was to promote the 1987 publication *Best Seat in the House*, my first book, consisting of just photos—no stories. We set up in shopping malls because Debbie Gibson had done the same thing with quite a positive response, so we just contacted the major shopping centres, and they were overjoyed to have a rock and roll exhibit they could promote. Trussing and supports were engineered to be free standing to hang giant photos in a walk-about display— quite elaborate, I must say, as the photos were on both sides of the steel supports. It was a real road show. We had to rent a five-ton truck to transport the exhibit; my son Chris was my driver, installer, and employee. We went from Vancouver to Halifax in winter; we almost killed ourselves in a snowstorm in Québec, but all in all the response was wonderful.

You've had an incredible career that has spanned decades of music. Do you have a favourite style of music?
Anything that gets my toe tapping or closes my eyes or makes me want to dance!

What does your family think of your profession?
My family thinks I'm a spoiled brat but brag about me to their friends all the time. My son is a master printer (textiles) and my grandson and granddaughter are involved in promotion/radio/marketing ventures. There can only be one photographer in the family, you know.

I remember bringing my then-teenage son, Chris, to the Elton John concert in 1975. As I watched my son's face, I knew I'd made a good decision in making this my career, to capture the excitement that made Chris's eyes light up like that.

Once you became a mother, did you have to adjust your work schedule?
I didn't become a professional photographer until my son was in his early teens; at that point he got involved in the acting profession, doing commercials, movies, etc. This happened because one of my clients in the music business came to pick up some eight-by-tens one day, and my son gave them to him. That client called me the next day and said, "Get your kid an agent! He's got the perfect look!" He's since given up that profession as he got bored waiting for things to happen.

You worked as the official photographer for the Merritt Mountain Music Festival for seventeen years. What was that like?
I was there from the beginning to the bitter end. (I'll be writing about it in the next book, tentatively called *The Rise and Fall of a Mountain*.) How did I get that job? It's not who you are, it's who you know. I can't remember how it all happened, exactly; I think I received a phone call. I wasn't a country music fan. but I figured what the hey! I went for it and now have the most iconic country artists on file, and I am almost ready to publish the book.

During tough times in history, we've seen music bring magic and lightness to our lives. What are your thoughts on this?
My simple answer is this: music is the universal language. Even the deaf hear music vibrations. Music soothes the savage beast. Music brings forth memories, both good and bad. Music makes us laugh and cry. Music makes our lives whole. I can't imagine a day without music in some shape or form. Thank goodness we have so much to choose from.

Delainy Mackie

Owner, Gluten Free Epicurean

"It takes a lot of passion and energy to run a successful business. You can know how to do something, but if you're not passionate about it you won't have the drive to keep going through the toughest times."

What is your first memory of food?

My mom making massive amounts of granola for my brother. I think I still don't like granola because she always made it on the darker side.

Did you have a favourite bakery where you grew up?

I grew up in Quesnel, BC, and there was a little bakery there: Quesnel Bakery. I made a gluten-free sprinkle sugar cookie at my own bakery because of my memories of the ones they had. I am, however, more of a savoury food eater. Crappy cheese bread was my favourite. I find that a special occasion is an opportunity to try new things. I grew up with a different style of cake every year for my birthday.

At what age did you realize you wanted to pursue a career in the culinary arts?

I was around age thirty. I was doing photography before, and after my son was born and life threw me some curveballs, I changed everything.

You run the successful Gluten Free Epicurean bakery located in East Vancouver. Tell us a bit about how it all started.

We opened the bakery in 2011. I had no idea, nor did I imagine, it would become what it has. The bakery has been steadily growing since I opened the doors. I was raising my son, so I took it slow. Many people wanted me to go big, fast. We're now in our tenth year and I'm finally expanding into the space next door that recently became vacant.

Why a gluten-free operation?

I'm celiac. My mom and aunt were both highly sensitive to gluten, and they lived a gluten-free life before I did. I was nineteen when celiac hit me like a ton of bricks. Luckily, I had my mom and aunt to help me along my gluten-free journey. I like to try new things all the time, so when I couldn't eat gluten, I had to start baking all the things I was craving because I was not thrilled with the options on the market at the time. Keeping the bakery and the kitchen gluten-free was easy—it had to be, so it is!

What inspired you to open up your own bakery?

It was a very aha moment in a time of loss. Both my mom and aunt passed away within six months of each other. I needed something to ground me, something therapeutic. I have also always wanted to find a way to give to people while still finding my passion and following my path in life. I entered into this in a daze of what I now understand was manic depression. I'm glad it wasn't regular depression, or the bakery would never have been started.

Do you have any formal training?

Ha! I knew one day this would come up. No, I don't have any formal training at all. I feel for my staff who have had to learn alongside me as we go. I would have liked to have had training, but it didn't exist for gluten-free diets and still doesn't really. It's a totally different ball game. I would go to school if I could, but the flour dust would kill me. I'd like to learn some proper techniques that I could transfer over, but I feel like the bakery is thriving and growing as it should.

What did you do for work prior to opening Gluten Free Epicurean?

As mentioned, I was a photographer. I did some food photography, and I feel that helped me a bit. It takes a lot of passion and energy to run a successful business. You can know how to do something, but if you're not passionate about it, you won't have the drive to keep going through the toughest times. I can't count the number of times I've said, "I'm done!"

There appear to be several specialty bakeries in Vancouver. What did you do differently?

I focus on making food that both I and my staff crave and want to eat. It just so happened that a lot of other people (our dedicated customers) have a similar palate and are craving the same.

Who have been your biggest sources of support during this process?

My friends and family, which includes everyone on staff. Regular counselling has helped me with feedback and the repetitive thoughts and moments of doubt that come up.

My family and I have been customers at the bakery since 2016, and we've noticed there's a strong sense of community, kindness, and pride in the products produced on site at Gluten Free Epicurean. What brings that quality to your work?

I struggled in the beginning having people tell me how to be a boss. I just can't be someone else. As a boss, I'm a genuine human. I bring who I am, which I think lets my staff be true to who they are. I encourage them to turn the music up because sometimes you just have to let it play loud. I encourage talking while working. I'm unhappy when a staff member isn't doing well. Every time someone leaves the team, it feels like losing a family member.

Who, where, or what inspires your culinary creations?

My mother and my aunt were the inspiration for the bakery. There was a huge need for a different kind of gluten-free that I feel I have brought to the market. Portland has been a big inspiration for what I make, not because of what is being made necessarily but more of what could be made. Portland has the style and vibe that I love, but again, still not enough choices for a gluten-free lifestyle. As far as bakeries go, Portland offers up an incredible list of celiac-safe options.

Did you look to any well-known bakers while building your business?

My bakery inspiration comes from road trips. I go into all of the gluten-free bakeries and love to see what people are making. I love New Cascadia Traditional bakery in Portland, Oregon. Their bread is like no other. It's all gluten free. The bakery is in an industrial area near a giant Goodwill. Thrifting and discovering gluten-free delicacies are what I enjoy discovering on a road trip.

Is it a challenge to offer up new items?

This is always difficult. As you know, we have a lot of product because anytime I try to take something away, I get emails and phone calls asking why. Sometimes I have to stop baking a certain item, but I'm always adding new ones.

The shop itself has a unique aesthetic. Very calm, clean lines. No clutter. Sparse yet inviting.

It's unintentionally intentional. I wanted the focus to be on food. We now offer kitchenware and locally made items from other culinary enthusiasts. I'm working with local designers to collaborate on items that are specific to a gluten-free lifestyle.

You and I share an understanding about loss as we both lost our mothers quite young. How do you feel this loss impacted and moved you?

The loss of my mother drastically changed my life. She was my best friend. I'm still devastated that my son never got to have his grandmother around. She would have loved him like the love I have for him. Her death got me up and running. I was stagnant, and I didn't want to die not having tried things in life other than being a parent. Before she passed away, she talked about all the things she wanted to do but never did for herself. Her death was why I became a

business owner. As for breast cancer, when I first received my diagnosis, I thought that was it for me. My son would lose his mother like my little brother lost his, right around the same age. I had some trauma to work through. Treatments have come a long way since my mom's diagnosis; I feel both very fortunate and sad at the same time.

How has your experience with breast cancer impacted your role at the bakery?
I'm right back to work because that's where I love to be. Cancer showed me that. It also taught me that I can't do it all, so lots of changes are being made after ten years. I've finally hired a general manager; I used to have baking managers while I'd pick up the rest of the day-to-day operations. I want to start teaching classes and begin working on a blog. That was the plan the year cancer and COVID-19 hit.

You've taken some time off, if we can call it that. What has this time looked like for you?
One of my dearest friends said, "You know, Delainy, if you didn't tell anyone what you're going through, no one would ever know." This was in reference to me working the entire time during my diagnosis. I often felt bad that I wasn't doing enough or giving enough support to my staff. I think my family would like me to work less, but that means more work at home. I'm terrible at domestic life. I'm a

career woman through and through. Never imagined that would happen.

How was the bakery impacted by the pandemic?
We didn't slow down; we got busier. The pandemic did, however, allow me to realize that I really like not having seating in the bakery. It was hard to let that go because I wanted a sense of community. I thought that seating inside was the only way to have that. Well, turns out we already had that sense of community in place. And it's an expansive and supportive community, which is truly wonderful.

What did you make of the trend to bake bread in the midst of the pandemic?
When looking at this from my point of view and how I started the bakery, I would say baking became a form of stress relief. I'm so happy people took that on for themselves.

What do you hope we will take away from this time in history?
To go easy on ourselves—city dwellers especially.

Where do you see yourself and the bakery in ten years?
I'd love to see it become a giant kitchen store attached to the bakery with a space dedicated for classes.

Sabina Majkrzak

Sustainable designer and owner, Green Bean Reloved

"Only buy what you need. Quality over quantity. Buy local whenever you can. Use up everything. Find different uses for things you have around the house."

What is your first memory of clothing?
I remember heading to the Salvation Army after my mom would get off work, and I would be super excited if it was a bag sale day. I was allowed to fill the bag with whatever I wanted!

When did you first become interested in upcycling materials?
I've always loved thrifting and always found joy in adjusting, repurposing, and altering clothing that I've found while thrifting. I never really liked wearing the same clothes as everyone else.

Your brand, Green Bean Reloved (GBR), focuses on using only previously worn clothing in its designs. What inspired this decision?
I always knew I wanted to have a company. My first memory of creating and selling was when I was young: I found some carpet underlay in the river and took it home and made sandals out of it. I made a stand at the end of the driveway to try to sell them. I don't think anyone bought them. I never really expected or thought this would become anything. It all started when I didn't want to buy gifts for friends and family and thought it would be fun to cut up my clothes and materials and make some as gifts. It just evolved from there.

You and your team design and produce a variety of items and styles. What are some of your bestsellers?
Honestly, I don't really plan. It depends what material I find and how much of it I find. Originally, I started making only scarves, but I couldn't just make those for the summer. From there we started making the shawls, and our list of items grew. Most of our designs have stemmed from things I like to wear and have been wanting to make for myself. Shawls were always our number one item. Currently our bestsellers are our scrap pullovers, scrap hats, overalls, and ReLoved clothing.

You've said, "Each fabric has a story." Can you share more?
It's been fun to hear stories about materials. "I had those bed sheets when I was little." Or "My grandma had those curtains." This is especially true with the scrap hats. I can often tell the purchaser where I got each scrap from.

You carry scrap masks, scrap hats, and scrap sweaters. What does "scrap" imply in the design and production of these items?
It's usually the remnants from other projects. All our materials trickle down. Say we make overalls: the scraps from those get used to make dresses or scrap hats. When the scraps get too small, we make them into pockets for our ReLoved pocket clothing. I say, try to discard as little as possible.

Do you think that consumers today are more aware of how our buying patterns affect the planet? How do we educate and make sustainable and upcycled fashions accessible to more consumers?

There are more and more companies like us emerging. You see all those refillery markets and sustainable stores popping up, and they are filled with amazing sustainable and eco products.

It seems more costly because making these items requires companies to pay decent wages to workers, all while using sustainable and, oftentimes, local materials. But in the end, you buy less because the quality is superior.

What are a few simple and affordable ways to be a more conscious consumer?

Only buy what you need. Buy quality over quantity. Buy local whenever you can.

Use up everything—find different uses for things you have around the house.

Did you do any formal training in fashion design or are you a naturally gifted seamstress?

No, I didn't get any formal training, but I wish I did. Designing and sewing was always a hobby. I just had an old machine as a kid and played around on that and have learned from there. It all came with time and trial. I have a great seamstress who does all the hard and intricate stuff.

You live in Kelowna, in the Okanagan Valley, surrounded by parks, forests, mountains, vineyards and orchards. How does the geography of Kelowna inspire you?

A lot of our collections are inspired by the beach, the outdoors, and nature. I try to make things that I would wear and want to wear on a daily basis.

Are your children involved in and/or interested in GBR?

I have a son, Kai. He's fourteen, and my daughter Neve is ten. Neve used to love playing and designing with my scraps and pinning materials together. She would come up with things she could wear. She even made some of her teachers' gifts with some of her designs. Now my children model my collections or help me thrift. My husband is an ideas guy, always feeding new ideas. It's great. I want

them to know what hard work is and that they need to work hard to play hard. That things don't need to be thrown out because they can have multiple purposes. They (mostly my daughter) love thrifting with me. Everyone sees the benefit of GBR, that we can be kind to the environment and have fun and find purpose in the treasures we find.

In addition to GBR you also work as an RN. You've been working on the COVID-19 Unit with direct patient care. Thank you for all your hard work, efforts and energy. This must be full-on for you and your family. How do you manage to run GBR and give so much of yourself to patients? What do you do for you, for self-care?

I like to keep busy. My husband is also a busy body. It's always full on. I think we function better when we're busy. My husband is a realtor, so he has some flexibility with his hours, which helps. I like the combination of nursing and the creativity of GBR. It keeps me balanced. My self-care is heading out into nature. I work hard but I also play hard. I spend as much time as I can outside either at the lake in the summer or in the mountains skiing in the winter.

Was there a connection between your experience as a nurse and starting GBR?

No. I've always enjoyed both sciences and the arts. Now I'm able to do both and not rely on one over the other and not burn out in either role. They each fulfill me in different ways.

Where do you manufacture the GBR collections?

All of the clothing items are made in Kelowna by either me, or one of our team of sewers. Everyone works from their own home. The hats we start in Kelowna by quilting the scraps, which are then sent to Vancouver to be made into hats. All materials and completed items are stored at the house in my office/studio and in our house storage space.

Who is the GBR customer demographic?

It's all over the place, from the really young to the elderly. All walks of life. I like to think that these collections bring out the creative side in people. We have a stock list of our retailers that carry us online. Each store carries various collections. Some carry all and some only select items. We're in stores and online from coast to coast and in the

United States too. It's been so exciting to see photos of the people wearing our collections and where they travel to or order from.

How do you define your role within GBR, and how do you ensure that there's an element of collaboration amongst the team?

Charlotte has been my number one. My husband found her. He went into Fabricland looking for help for me because he saw I was drowning, and Charlotte has been with me ever since. She's been super helpful with design work as well as sewing. She does all the tough stuff. All of the ladies do piecework from their own homes. I've tried to create a flexible work environment; I'm not a very regimented person myself. I've had lots of help throughout the years depending on the needs and growth at GBR.

How has the pandemic affected the operations at GBR?

Online has been great, but so have the stores that carry us. I really feel like people are trying to support local more than ever before. I hope people continue to support local and shop small and see the difference it makes in communities. Shopping small really goes a long way in building and growing communities.

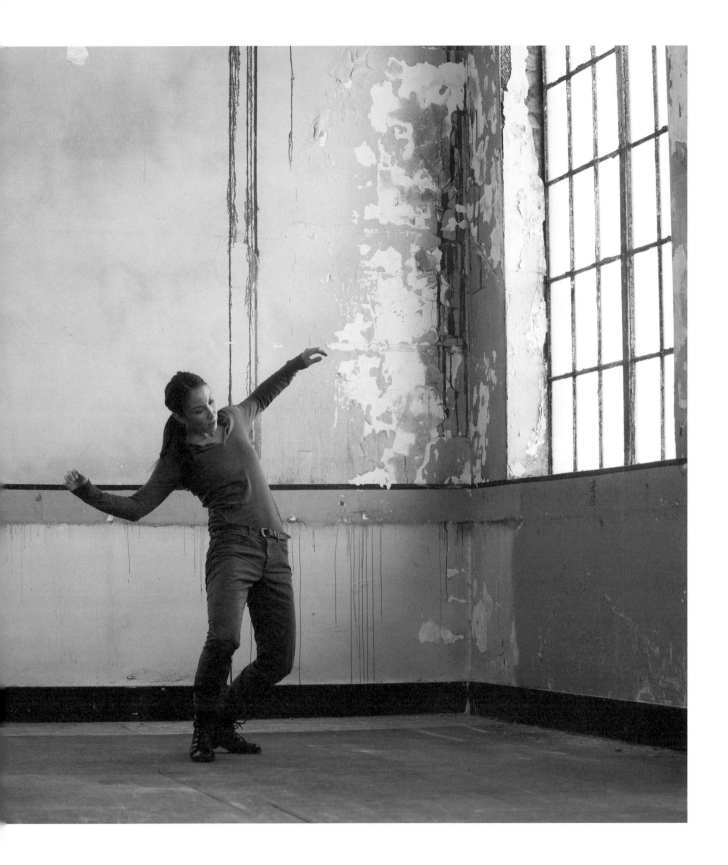

Lisa Gelley Martin

Dance artist, co-director, Company 605/Independent

"Over the last decade, where I fit within contemporary dance has shifted many times, and I like that it feels like an evolving form for me."

What's your first memory of dance?
I'm in my home, watching my father's offbeat groove and nerdy moves; I remember my brother and me performing shows, which I had choreographed in our family room, for grandparents, aunts and uncles. I remember my mom buying me my first tap shoes, and my father letting me try them out on our kitchen floor, which wrecked the linoleum (but no one was mad). My family enrolled me in my first dance classes as a way to help with my shyness, hoping that this form of physical expression would help me open up a bit.

Was your family supportive of your creative ambitions while you were growing up?
I grew up in Deep Cove, a village-like spot in North Vancouver, surrounded by water, mountains, and forest. In high school I was into drama, and I largely survived high school because of the drama group and friends I had, as well as an amazingly charismatic drama teacher, Suzanne Cooke. The drama program was run out of a portable, and I spent a lot of time there, acting in plays, and later writing and directing. Outside of school, I danced every day at my studio. My parents were very supportive of my interest in the arts; my dad had a professional football career in the CFL, so he was especially encouraging of me to follow my

dreams. Though my family had more connection to the world of athletics, they were very supportive of my connection with the arts.

At what age did you start to train formally as a dancer?
My parents enrolled me in ballet and tap lessons when I was five years old, which were taught at a small studio in North Vancouver. As a teenager I moved to a studio in Burnaby, and that is where I started training more seriously, competing, and also learning about modern and contemporary dance. When I started to chase dance as a profession, I was focused on "commercial" forms like jazz, hip hop, and urban dance. Though I enjoyed those forms, I never felt like I could really be myself in those spaces. I was always working hard to be something I was not even though I loved the dance forms themselves. In my early twenties, I went to Europe and landed an audition with Ultima Vez in Brussels. Even though I had very little experience in contemporary dance and didn't make it past the first cut, being at the audition was incredibly exciting and inspiring. I realized in that moment that contemporary dance was where I could feel at home and where I wanted to keep working.

You also trained in Europe. What was that like?
I spent a few years in Europe taking workshops and training, but I didn't train at any formal institutions. I started off in Italy where my friend and colleague, Tiffany Tregarthen. While there, I met a teacher/choreographer whose work I really enjoyed. He generously offered up his apartment in Paris while he travelled for work, so I had a home base in Paris where I took classes at studios for several months. I focused on ballet, hip hop, and contemporary during that

time, and would travel to take workshops in Belgium, Italy, France, and Austria. Through that period, I discovered that I was on the periphery of a much larger community, that I was in a transition from commercial dance to contemporary dance, and that community and network held so many things I had come to value. In some ways it felt so out of reach, that my ballet training wasn't strong enough and that I had missed the chance to pursue contemporary dance seriously, and in other ways I realized that I now had a lot of new information and inspiration. By the time I realized that I wanted to be in a big contemporary dance company, I sort of knew it was too late. But I would learn that I would still be able to find some of what I thought I was looking for in that "dream" in other ways.

What moved you to pursue contemporary dance as your focus?

When I discovered contemporary dance, I found a place where I could be myself. It's a broad genre and can mean so many things, and in part the possibility of it all felt great to me. I loved being introduced to floor work, raw physicality, dance that didn't have to be gender-specific, and I didn't have to try to be sexy. With contemporary, I didn't have to be a certain kind of beautiful with a certain body, or of a certain race to get work. Coming from commercial dance, these were the types of barriers I had experienced, and they always seemed to get in the way of the dance itself, the techniques and what I had trained for, whereas in contemporary dance, these barriers seemed to be somewhat less prevalent if one found the right niche.

You're known for your physically demanding choreography. What inspires this?

I think in all my years of training and being in an athletic family, I was drawn to dance that was challenging physically, that required rigour and focus, and had an element of virtuosity. I like the feeling of pushing past your limits, getting to the other side, and being in an exhausted state, or a place that you didn't think you could make it to until you got there. It strips away everything else and becomes raw, vulnerable, and honest. I like being in that place, and I like attempting and watching people attempt impossible tasks. There is at once immense intensity as well as humility and levity in working in this place of precariousness, where the stakes are high. You're playing with failure and living in a zone where the attempt itself holds more value than the outcome.

Tell us about Company 605.

The collective first formed around 2006 as a group of friends—Josh Martin, Shay Kuebler, Maiko Miyauchi, and Sasha Kozak, and me—who wanted to train together as a way for us to experiment with movement forms and contexts that we couldn't necessarily find elsewhere or didn't know how to find. We were all studio-trained dancers (ballet, jazz, tap, hip hop, musical theatre) with some commercial and urban dance training and professional experience, but we were searching for a way to exist inside the contemporary community. We started working on movement and choreography that helped us enter into those spaces, primarily in a work-live space that Josh and I rented, apartment 605 at the arc (artist resource centre) in East Van. Shay, Josh and I were the co-founders of the collective. We wrote the grants, applied for performances, and Maiko and Sasha were artistic collaborators. When we got our first performance invitation, we were asked what our group was called; since we were put on the spot over a phone call, we just came up with 605 Collective (the unit number of our work-live studio). From there, the group made more pieces and did some extensive Canadian touring with our first work, audible. In 2012, Shay desired his own creative outlet and left as artistic co-director to form his company. Josh and I decided to continue with 605, renaming it as Company 605, under a shared artistic leadership, but maintaining the collaborative mandate, valuing peer-to-peer development and striving for a non-hierarchical room, within all of our future work.

"Company 605 continues to push into new territories and awaken a fresh and exciting aesthetic, together building a highly athletic art form, with extreme physicality derived from the human experience." Can you share more about what this means for you?
To me, this means that we are always searching for something that excites us, as movement lovers, as creators, as people. Something we may not have seen or felt before in our bodies, yet maintains the potential for universality, as in something that other humans can relate to. Rigour, sweat, athleticism, challenging beyond our capacity, holding multiple values simultaneously, the potential of failure,

the "attempt" as the valuable thing, are all things that I feel and hope are relatable on a broader level. Things that we do every day in many ways, big and small.

What's it like to collaborate creatively with your partner, Josh Martin?
We're collaborators in all areas of life, from the moment we wake up, to the moment we fall asleep—in the studio, at home, and everywhere in between. It's really hard to separate what work and life are, but now, having two children to raise collaboratively, there's definitely a space that feels like "family time" because every time we try to talk about work in the presence of the kids, our four-year-old shuts us down.

You have two daughters, Loa and Noemi. Has becoming a mom altered the way you move and create?
At the time of my first pregnancy, our company was on an extensive tour that finished when I was thirty weeks pregnant, so it didn't make sense to be in that work. I didn't have any experience performing pregnant, though being on tour was exhausting enough! Three weeks after I had Loa, I was back creating in the studio, working on a piece we were making for Ballet BC. I was back performing on tour in Australia when she was four months old. It was really intense on my body, but also mentally exhausting. It felt like I was doing both jobs poorly at the time. I did work and tour quite a bit in her first few years, and while not impossible, it was challenging. I guess one of the biggest things I learned was that I could do more with a lot less. Less time, less preparation, less everything. When I do get to work, I need to be efficient and trust my decisions more because I just don't have the luxury of time or mental space like I used to.

My approach has had to change out of necessity since becoming a mother. I used to spend a lot of time training and dancing for other people in addition to my own company's work. I could see more art, talk and think about it, be connected to my colleagues locally and around the world. Basically, I used to be able to live, eat, and breathe dance, and with my partner being an artist I work with as well, we could be in that world at all times together. There has been a huge shift since bringing two little humans into the world. I've fortunately remained active in dance, but my time and attention, capacity, as well as desires, have had to shift. I sometimes feel worlds away from my community, especially in a pandemic and at a moment where my children are so young; it's intense to keep them both safe, healthy, and happy. I don't get to spend as much time with my colleagues and company members in the workplace; it's frustrating, but I am trying to remind myself that this level of intensity is not forever. I remember there was a shift when Loa turned eighteen months: I felt she was her own person and I could be away from her for six hours, get into work mode, and then return to family life.

You were the recipient of the 2015 Vancouver International Dance Festival Choreographic Award. Congratulations! What did this mean to you?
It meant something to be recognized independently of Company 605 and my collaborative work with Josh Martin. I had performed a short solo at the 2015 festival that originally was commissioned by Powell Street Festival in 2014. It takes a lot for me to do something solo, so the festival asking me to perform the work again allowed me to revisit the solo and forced me to put myself out there without my teammates. Being recognized with the award after the performance made the experience that much more meaningful because I can be quite shy and insecure about "Lisa Gelley" on her own. I need to continue to force myself to do choreographic work that is separate from my collaborations with Company 605.

Tell us about the benefits of mentorship.
I have had the privilege of working with so many people I would consider mentors—Amber Funk Barton, Justine Chambers, Susan Elliott, Maiko Yamamoto, Cindy Mochizuki, and Sophia Wolfe, to name a few. Mentor relationships can look like so many things to me, and I've grown and learned from everyone I have worked with, whether more or less experienced than I am. We all come from different places and hold our own priorities and perspectives, and that's what makes artistic exchange so important and vital to me.

Why is artistic expression important at this moment?
Art has the potential to initiate change, to question, and to disrupt. I think we desperately need all of these things right now. We also need healing, inspiration, open-mindedness, innovation, and creativity to move forward in a way that is hopeful.

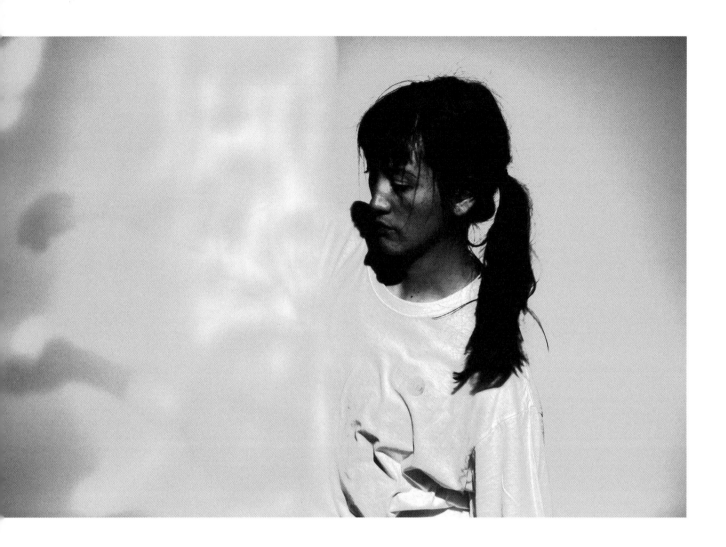

Erika Mitsuhashi

Dance artist

"Art has a role in our lives because it allows us to experience something that's outside of our day-to-day."

What's your first memory of dance?
Watching Prince, Madonna, and Michael Jackson music videos. I was enthralled by dance on screen.

Describe a performance that left a lasting impression on you.
A pivotal moment was when I watched Cloud Gate, a Taiwanese modern dance company, perform a work called *Moon Water*. I was at university and had decided to turn my initial dance minor into my major. The work was highly meditative. There was a final sequence to the work, where water magically filled the stage. The mirrored reflection of the stage, lights, and dancers, in addition to the insistent slowness of the ending, truly changed me.

Was your upbringing and family supportive of your creative ambitions?
I wouldn't describe my upbringing as immersed in the arts, but my mother was an avid museum- and gallery-goer. My parents were both supportive in activities that I wanted to try, but I mainly did sports until I was eleven. I transitioned out of gymnastics and told my parents that I just wanted to do jazz through the gymnastics club. I adored my teacher, and a year later, when the club discontinued dance classes, my parents asked me if I wanted to pursue dance somewhere else.

The following year I started classes at Vancouver Academy of Dance and spent the next six years training there. I studied classical ballet, lyrical, jazz, hip hop, modern, and a short stint of Latin ballroom. My parents were at every competition, every year-end show, and drove me to and from classes until I was old enough to drive. I was really lucky to have parents like them.

You were born and raised in Richmond to a Japanese father and a Canadian mother with Italian, Ukrainian, English, and First Nations ancestry. How does culture inspire your work?
How could it not? A theme I keep coming back to in my work is in-betweenness. Being mixed race and having a diverse cultural upbringing, I didn't necessarily fit or belong in an easily checkable box. I don't think I really felt the meaning or implications of that until I noticed that I would gravitate toward themes and concepts that were unknowable, yet to be defined.

Your mom passed away when you were nineteen. How did grief impact you?
Loss is something I experience as a non-linear cloud that passes through my life in so many different ways. Quite simply, I miss her. It was really hard and strange in the years following her passing, but even now I find myself seeking out the maternal/female role model. I have found it in dear friends, in my partners' mothers, in my stepmom, and in mentors.

I have vivid dreams where no time has passed and we are doing lovely mundane things together, like having a conversation. It feels like if multiverse theories are correct;

maybe when I'm dreaming, I'm just accessing the reality next door, where she's alive and we're just mother and daughter doing regular things. I sometimes catch myself wondering what she would have thought about something, or if she and my partner would have gotten along, or if she would have liked natural wine. Then there are stretches of time where I don't think of her, almost like I only exist in this moment until something pulls me out.

You received a BFA honours in dance from Simon Fraser University. What was that experience like?

I think the SFU program is very holistic; it exposed me to contemporary forms, modern dance techniques, dance and art history. The important thing was exploring composition and improvisation. Prior to SFU, I had very limited experience with improvising and devising as means for creating a dance or as a way to practice. Without that training I might have become a different artist. My time at SFU was the beginning of the big learning I would do in my career. I was exposed to many things through the program; then, in my final years there, I was able to do some self-directed activities for credit that allowed me to start thinking about my artistic interests. I really was searching, trying to figure out who I was. Now, almost ten years later, I am still searching, but it's slightly less painful.

What moved you to pursue contemporary dance as your focus?

Contemporary dance offers so many possibilities.

You've made mention of being a "late bloomer." Can you tell us more?

I had this moment, when thirty was approaching, when I said to myself, *Fuck it, I'm doing x, y, or z.* I started to come into my own a little more. I had a list of things that I thought were only appropriate for someone in their twenties, and I decided I didn't care—I was going to do them now. I noticed I offered my opinion more freely and spoke up more if I thought there was injustice happening. I had been shedding shyness my whole life, but around age thirty I really started putting myself out there more, not holding myself back from opportunities. And I started handling rejection better.

You mentioned that you're more willing to take risks when you feel safe, and that many of your collaborations are with friends.

Each collaboration is unique, ever evolving and deepening. When I think of risks, I think of two things: first, experimentation, and second, vulnerability. These require safety or a person or community to hold space for the potentially scary things that can come up during the process.

I try to be explicit about the invitation with new collaborators or people who I don't yet have a relationship with, and I always create an opting-out option. This is a lovely moment to mention the people that taught me what it really means to have a radically ethical process: Justine A. Chambers and Sasha Kleinplatz. I have had the pleasure of being a part of their processes in the past few years where the wellbeing of everyone involved was a priority. I felt so held in each of their processes, like I could give more and was more willing to take risks.

Can you share more about the importance of collaboration?

I love being in conversation and bouncing ideas around with collaborators. It's nice to have someone to witness you in a process, in addition to getting another perspective on things. Making work on my own can create this little insular bubble around a project, and it's so helpful to have an extra set of eyes on something, to learn more about it through another perspective.

The people I collaborate with are brilliant. I am interested in what their artistic choices are and how they might complement or contrast mine. Each one of my collaborative relationships is different. I love that I get to tap into many different forms of collaboration. Sometimes it's more conversation driven, sometimes it's bolstering other people's ideas, sometimes it's like I've mind-melded with the other person. I also really enjoy the community it creates and celebrating multiplicity. I don't always want to be the only voice in a project.

It seems a natural extension for you to expand your passion to scenography—set design, props, lighting. What is that like?

I have always been curious about how other mediums interface with dance and performance. By collaborating with people from other disciplines, things just happened gradually and naturally. I think the tipping point was when

my collaborator Francesca and I were talking about creating a monochromatic look for a piece. I was thinking a lot about materials and was intrigued by the materiality of Tim Burton films. I decided to try creating the props for the show myself and never looked back. I love getting my hands dirty.

When it comes to lighting—oof, that's a whole other love. I think light and lighting design reaches a wide audience. It's a part of the aesthetics in day-to-day life that, when utilized in artistic ways, is an approachable medium. I'm interested in using projected light and video as a way to animate a space and be the site for movement and dancing. Let's talk about this again in five years—this part of my practice is still pretty budding.

Who is your dream person to dance with, and your dream stage or space where you'd love to perform?
This list could go on forever. I would love to work with or for the Danish designer Henrik Vibskov. His shows and installations are so playful. I went to visit his studio when I went to Copenhagen and made it my immediate goal to intern for him one day. I needed to have a better handle with Adobe programs, but then things really took off with my dance career here and that dream went on the back burner. But I did take an Adobe course and am upping my skills—so Henrik, if you are reading this, I'm yours!

There are some stages and venues that I would love to perform on, but more and more I like presenting work in non-traditional spaces. I think it's a combination of working with festivals and organizations whose values I align with and also making sure the space is the right fit for the work.

How has the pandemic affected your work?
I am grateful I had a few opportunities that were postponed and some that are postponed until in-person activities or travel is permitted. A few opportunities were cancelled, and then there were some where I was invited to share something digitally.

My bubble shrank, and it made those relationships even more meaningful. I have been able to do some in-person rehearsing and creation when safe. I started thinking about scale and valuing the work I was making, even though it wasn't necessarily going to be a large-scale production.

I have had time to do various professional development activities and am currently learning a new media software called Isadora. I have been meeting digital mediums with softness and see this as a rare opportunity to potentially reach audiences that I might not otherwise.

I think performances will be for intimate audiences, and I'm really okay with that. I think live-streaming and online platforms will still be commonplace. It will be exciting to see what new mediums or hybrid forms come out of this time.

When working and thriving in a sector and community that focuses on connection, touch, and performance, what tools and techniques have you drawn on to keep that positive perspective?
It's an ebb and flow of emotions, and waves of grief and acceptance. I hope that, ultimately, there will be space for all the different ways that dance and performance can be experienced. I have been trying to meet the technologies and digital mediums with softness and curiosity. I miss my community all the time. It's the peripheral friends and colleagues that I don't have regular interactions with that really make my heart ache, but I know it's just a prolonged break.

Why is dance important?
I can speak to this only from my experience: I think art has a role in our lives because it allows us to experience something that's perhaps outside of our day-to-day. In this particular moment, we are looking to things that provide us with the space to indulge our imaginations and experience things through another lens.

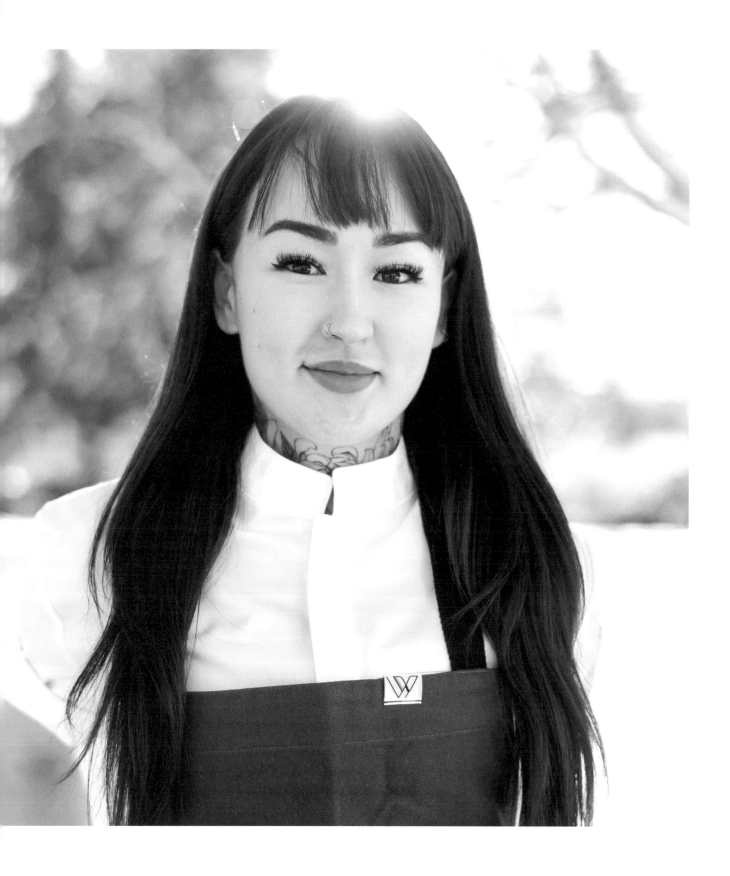

Kiko
Nakata

Pastry chef

"I build desserts that I love by incorporating flavours from my childhood and from my time living abroad; these elements come together to make some of my favourite creations, and they feel uniquely mine."

What is your first memory of food?
I'm standing on a chair next to my mum or grandma, completely mesmerized by whatever they are doing and maybe "helping" by stirring something on the stovetop. Food was a central part of my childhood.

Everyone has different love languages, especially across different cultures. But cooking for each other was something that we all understood to translate into love. Coming together around a meal was part of my daily childhood routine, which I now realize I was very lucky to experience. Far before I was able to put together an edible meal, I would sit my family down and serve them some horrible homemade creation, oftentimes Jell-O. Yet my family encouraged and nurtured my desire to cook for them, and I think now they finally see the rewards of surviving all my childhood experiments.

You spoke only Japanese until you were five.
Growing up, everyone in my household spoke Japanese. For the first four years I only spoke Japanese, until my parents gradually transitioned to speaking English to better prepare me for kindergarten. I'm grateful that I was immersed in Japanese for so many years, otherwise I'm not sure I would have held on to as much of the language

as I did. But because those pathways were already formed in my brain, it made it so much easier to pick it back up when I moved to Japan later in life.

Growing up mixed race in Vancouver, specifically being Japanese and British, I was incredibly fortunate in feeling "normal" and accepted. Many of my friends were from mixed-heritage backgrounds and families. I grew up feeling a great sense of pride for both my family's cultures. Because I spent my childhood in Vancouver, we had to create tangible ways to connect with my heritage, and cooking was the main way in which I felt connected. Flipping *takoyaki* with my grandma while she told me stories of when she ran her own stall in Osaka helped me feel closer to my roots in Japan.

Vancouver has many distinctive neighbourhoods. Where did you grow up?
I grew up in Kitsilano and spent much of my early adult years in Strathcona/Gastown, and now call Mount Pleasant home. I feel like I came full circle, starting and ending in smaller neighbourhoods. During my late teens and early twenties, I craved the hustle and bustle of downtown and gravitated toward busy, high-end restaurants. As I've gotten older, I prefer to spend my days off going to small, locally owned bakeries and shops. I love the relationships forged with my local barista and getting up early to walk to the bakery for a loaf of bread. There's a real magic to that kind of community and sense of neighbourhood.

What drew you to pursue pastry as your specialization?
Art was always an outlet for me to find peace. I went to an art-based high school, and going into pastry just seemed

like a natural progression; with its focus on presentation, beauty, and design, pastry always drew me in. As soon as I started pastry classes, I was hooked. While all types of cooking and food culture were celebrated in my family, there was a sense of magic that surrounded desserts.

How do you incorporate your heritage into the food you create?

I take bits and pieces from the countries my grandparents were born and the places I've been. Japanese ingredients are unique and reminiscent of my grandma's cooking and my time living in Japan, and they serve as equal parts culinary tools and nostalgia. Nothing is entirely from one source of inspiration, as I don't feel like I belong to any one specific place.

It feels much more authentic to infuse parts of my culture and heritage into dishes and concepts rather than making the entire plate entirely Japanese or entirely British. I build desserts that I love by incorporating flavours from my childhood and from my time living abroad; these elements come together to make some of my favourite creations, and they feel uniquely mine.

You studied at Le Cordon Bleu in London and spent three years with Vancouver chocolatier, Thomas Haas. How did these experiences influence you?

Both experiences were incredibly formative. I didn't know anything about being a professional cook when I enrolled at Le Cordon Bleu. I met people from all across the world.

As much as I learned at pastry school, it was no comparison to how much I learned in the kitchen.

Thomas is passionate about teaching young cooks and giving them the tools to go out and be the best that they can be. In a way I feel like I went to school twice, once at Le Cordon Bleu and again at Thomas Haas. Only after both those experiences did I feel like I had learned enough to go out into the world.

Tell us a bit about the value of mentorship.

My relationship with Thomas Haas is important because he saw something in me when I didn't see it in myself. He encouraged and pushed me to work smarter, harder, and with more purpose. He took me under his wing and inspired me to dream bigger. And while my mentor is a man, I have worked with and been inspired by so many

badass women as well. It truly takes a village to lift someone up, and I credit many people with helping me get to where I am now, as well as with continuing to push me to strive for more. I feel like, in a sense, I have had dozens of mentors; everyone can teach you something if you let them. The young chefs I work with teach me something new every day.

I've never thought about mentoring someone else; I simply think of it as giving the cooks on my team all the tools and support they need to succeed—on my team and beyond. I want to create an environment where they feel comfortable taking risks and asking for help, while at the same time pushing them to be better and try more. I want to foster their love for food and fuel their passion for putting out the best product they can every day. I am there to create a structured and safe workspace, push them outside their comfort zones, and hopefully inspire new concepts and ideas. I am only here to assist them on their journey, not to shape who they become; that is up to them.

You lived in Japan for a couple of years. What was that like?

I moved to Tokyo in 2016 and returned to Vancouver in 2018. It was an incredibly meaningful and difficult time for me. My two years in Tokyo were mostly consumed by work, with long stretches of solitude. I felt like I connected with inner peace and strength that I didn't know existed inside me. I came home to Vancouver with a clearer idea of what was important to me, both professionally and personally. Having now spent time living in both countries I am culturally connected to, I felt more at home in Vancouver. It was as if I had found middle ground where I felt accepted and not seen as a foreigner.

How is it for you being a young woman working in a predominantly male industry?

It's been a mixed bag of experiences. The old guard is dwindling but they're still here, usually in positions of power. "Let the men take care of it," or "Let the strong men do that for you" are among the phrases I got used to hearing. My early years in the industry were spent trying to prove that I could work harder and faster, be better, lift more than any of the boys. Now that I'm older (and a little wiser), I don't have anything to prove to anyone but myself.

No one is harder on me than myself. The toxic idea that whoever puts themselves through hell to prove that they're the toughest one in the kitchen, and that it somehow makes you the best, wasn't something I wanted to feed into or contribute to the industry. After being sexualized, laughed at, and underestimated, I learned there is much strength and power in empathy and kindness.

Creating an environment where people can feel safe and supported creates the strongest teams, not the ones where you express yourself by screaming and throwing things. At eighteen, watching the old-school chefs torture young cooks, humiliating them in front of the whole team or throwing pans across the kitchen, I thought that was what I needed to do to gain respect from my team. But I've watched time and time again how leading a team with mutual respect, kindness, and a sense of family results in the least amount of team turnover; people stay longer, work harder. When they care instead of operating out of fear, you end up with a team of cooks who want to put out the best product possible every day, out of passion and drive rather than fear.

We need to move past the idea that women can't do what men can; it's absolute bullshit. The strongest and most capable people I know, both in kitchens and in life, are women.

Tell us about your time as head pastry chef at Vancouver restaurant Miku, where you were until 2021.
I started at Miku in October 2019. It has been a great experience. I love the people who I am lucky enough to call my team, and this position gave me the opportunity to really push myself out of my comfort zone. It was a diverse team with a cool array of backgrounds, both culturally and professionally.

I worked in many lower-level positions, including pastry cook and pastry sous chef, before taking the head pastry chef position at Miku. The experience of being in lower-ranking positions is a different but necessary part of growing into higher positions. Watching and observing what works and what doesn't in kitchens and for leadership was what helped me build my own leadership style and principles.

The negative aspects of my career leading up to this point have helped me become a more understanding, empathetic boss, which I hope has made a difference for those on my team. I never want them to feel as unimportant and powerless to speak up as I have in the past.

You've openly shared that you struggle with generalized anxiety disorder and depression. Can you tell us a bit more about this?
My earliest memories are tied up with anxiety. I remember trying to put into words how my stomach felt like it had tied itself into a big knot. I'm incredibly lucky to have the best parents in the world. I can say with absolute certainty that I wouldn't still be here without their unwavering support, sense of humour, and love.

It took a long time to understand what was going on inside my head. When I finally got a diagnosis at age twenty-two, it felt like a huge piece of the puzzle clicked into place. Everything sort of came rushing back in this moment of realization. I felt so much relief realizing that I was sick, that there was an actual chemical imbalance in my brain. I had walked around for my entire life thinking I was weak, less abled, and crazy. I blamed myself for all the panic attacks and depressive episodes, thinking that I just needed to push on and snap out of it.

Once I understood my diagnosis, it felt like something I could work with, rather than simply hating myself and the way I was. It allowed me to make changes in my life—none of which happened overnight; it continues to be a constant process of learning and adjusting. I've opened up about my struggles and how I experience the day to day, allowing my friends and family to understand what I am going through and what I need. It continues to be difficult, being transparent and honest about my experience to others, as there is always that voice in my head telling me that I'm crazy and not worthy of people's time or understanding. Some people didn't stick around, but those who did have held me up at the darkest of times, and they are ones I need.

Are you having any new adventures in the culinary world?
I'm currently working with some of my favourite chefs in the city on some new projects. We'll be popping up throughout the year, so keep an eye out! I feel incredibly fortunate to have this opportunity to express and push myself and have the support of my incredible team. I have been working toward this time in my life, and I am excited to see where it takes me.

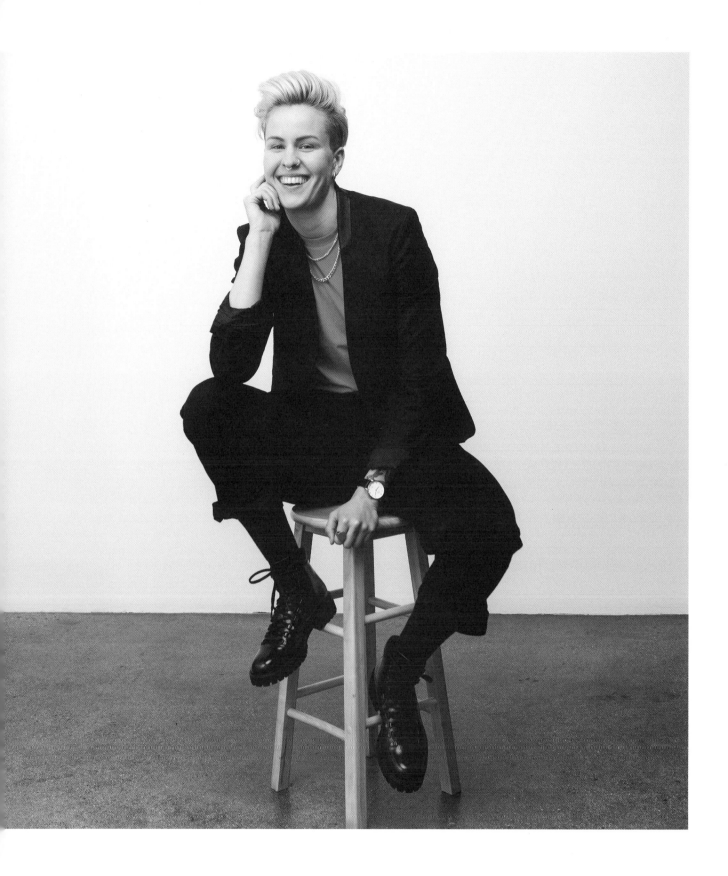

Kezia Nathe

Photographer

"I think it is beautiful and incredible what humans are capable of, and I love capturing people feeling strong and confident in whatever way that is for them."

What is your first memory of a photo that moved you?
A black-and-white photo of my brother, Aaron, that I saw when I was eight. It was a beautiful portrait my sister had taken shortly before he was diagnosed with cancer. As my older and only brother, I looked up to him a lot. He was tall, athletic, handsome, and had so much life and love in his eyes. I saw the photo in a scrapbook she made for him months before he passed away at the age of twenty-one. Perhaps it was that photo, or every photo I saw of him afterwards, that made me realize how special those captured memories are.

At what stage of life did you begin to have an interest in photography?
It wasn't until my last year of high school that I really had an interest in photography. For as long as I can remember I have always loved art and being creative, so when I started picking up a camera, some aspects of photography came easily to me.

There are so many things about photography that inspire me, but I would have to say subject and light are my top two. I love the combination of light and the absence of it; I love observing the way it hits a subject or creates patterns, the quality and colour of different light sources, the way it can shape and create depth. Light has the ability to completely change the mood of an environment or

subject. It can be manipulated to hide or highlight certain features. It has the power to do so much within an image yet is still only one of many aspects of a photo. The subject also inspires me; usually that's people for me. Humans are beautiful, and everyone is different. To be able to truly capture someone's essence in an image is one of the most beautiful, challenging, and inspiring things about portrait photography.

Do you remember the first photo you took that made you think, *Maybe this is something I want to pursue as a profession*?
Shooting sports for my high school yearbook helped me discover my love for photography and capturing humans in movement. It was the first time I had considered pursuing something as a career without even once considering how hard or possible it would be.

Do have any formal training in photography?
I took a year off after high school to continue shooting and decide if that was really what I wanted to invest my time and money in. After that, I completed a two-year photography program at Langara College. One of the things I was most excited to learn about was lighting. I saw the beauty in light and shadow but didn't understand it, and school really helped with that. The program was highly technical, and I learned so much that helped me get to where I am today. I don't think formal training is necessary, and there are so many resources out there nowadays for learning, but having an outlined course and the structure of school was great for me. I think a "good" photograph can mean so many different things and be a varied combination of elements. For example, a good image can capture the

moment and mood to evoke an emotional response in the viewer but not be as "technically" good; on the other hand, it can have beautiful light and composition, or have a lot of technical skill involved, and not be as much about the story or emotion. I love to find a balance of both in my own work.

Your photography focuses on athletics, portraits, and travel. Can you share a bit about how each of these speak to you?

Athletics, portraits, and travel are each important to me in their own ways. Travel photography is personal for me and I have never pursued making money from it. I love to travel, and I love to capture memories of where I go and the people I meet along the way. I can't image visiting a new place without my camera. Athletics has been the focus of my photography for most of my career, and I think my passion from it was born when I started shooting sports in high school. Being an athlete and very involved in sports myself gave me a greater knowledge and understanding of anticipating and capturing movement. It's challenging yet so rewarding to get that perfect shot at the perfect moment. Shooting athletics merged two of my passions and felt like a natural direction for me. Where athletics are more of a professional focus, portrait photography is equally important to me both personally and professionally. I love capturing portraits of people because there is so much beauty and uniqueness in each person, and having the opportunity to encapsulate that in an image is so special. My favourite is creating images of people doing what they love, when they are so taken with and focused on what they are doing that they forget I'm even there.

How passionate are you about sports?

I am *very* passionate about sports, and I am so grateful for the health and strength I have to be able to do them. I grew up playing as many sports as I could manage, but basketball and throwing javelin were my favourites throughout school. Since graduating high school I have only played team sports very casually but kept my passion for movement alive in new ways. I had a short but sweet love affair with boxing, during which I trained for and won a match to raise money for a good cause. To this day I think the match itself was one of the hardest things I have every physically done; it pushed me to the limit. Every round, I hit a point where I thought I had nothing left to give, but somehow I kept going. I had to stop boxing due to a development of osteoarthritis in my knuckles, and I miss it. My most recent obsession is mountain biking; I love the way it makes me feel challenged and accomplished. Being active in nature is so much fun and always leaves me with the biggest smile, and I appreciate how both boxing and mountain biking keep me present and focused—the moment you let your mind wander and get distracted is when mistakes happen. Mountain biking has been everything, this past year especially, for both my physical and mental wellbeing. While going through challenging periods in life it has been my meditation.

You've shot an impressive range of local athletes. What is that experience like for you?

I love shooting athletes because I love capturing the human body in motion. I think it is beautiful and incredible what humans are capable of, and I love capturing people feeling strong and confident in whatever way that is for them. This style of photography is unique because there are so many elements that need to align to catch that perfect shot, and oftentimes it's up to chance as far as, for example, how the hair and clothing move throughout the action. Adding movement can make a shot so much more dynamic and interesting, but also challenging.

Who, where, or what inspires you?

Who: Passionate people inspire me—people who are pursuing something they love, people who are authentically themselves, and people who have a story to tell.

Where: Anywhere with beautiful light or potential to look beautiful in different light. This could be anything from a small room to the great outdoors.

What: Passion, wonder, connection, and curiosity about something I want to know more about; travel and beauty also inspire me. Inspiration can be found in so many places, big and small; you just have to be open to it.

What are some of the challenges and some of the benefits of being your own boss?

I have been a full-time freelancer for nine years now (my entire career so far), which is wild for me to think about because it hasn't felt like that long! There are so many pros and cons to freelancing, but for the most part I love it. As a freelancer, you have to be okay with instability and inconsistency. For the most part, I love the ebb and flow of work. I choose to work hard and play hard, so I may have periods

where I'm working forty to seventy hours a week, but then I am able to take off and travel, work on other creative projects, or spend more time doing fun things with friends. I definitely struggle at times to find balance, though. It's important to know your capacity so as to not take on too much and burn out, which can be really hard when you don't know how long it will be busy for.

It also takes a lot of self-discipline and motivation to be your own boss and get shit done; some days are easier than others. Sometimes I wish I could just show up somewhere, have someone put work in front of me, and tell me what to get done and then leave at the end of the day, but in reality, I think that would kill a piece of my soul. I love the flexibility and control I have of my schedule and the variety of people I get to work with.

One of the greatest successes for me personally is the lifestyle I've created for myself. I make money doing what I love while still having time and space for all the other things I love that fill up my soul. Taxes, bookkeeping, tracking mileage and expenses, and not having extended health benefits can go to hell, though. I definitely put the dentist off longer than I should without coverage.

Who have been your biggest supporters in your journey as a photographer?
My biggest supporters have been my family, friends, and clients. I'm so grateful that my parents never questioned my decision about becoming a photographer. Since *they* never questioned if I could or should do it, *I* never questioned it; I just went for it because I loved it. I have friends who are clients and clients who are friends, and their encouragement, feedback, and acclamations over the years have meant so much to me. My friends know when I'm struggling with imposter syndrome or doubting my abilities, and they always remind me of my accomplishments. It means so much to me.

Tell us about a travel experience that left a lasting impression on you.
My first big travel experience was somewhat of a turning point for me. After finishing my photography program at age twenty-one, I set off for a month-long solo backpacking trip across Iceland. I want to note that I used to be incredibly shy, not very adventurous, and not really into hiking. (If you just got to know me now, you might not believe that.) I ended up hitchhiking around the entire

country with my camping gear and finished my trip with a seventy-eight-kilometre trek, mostly solo. It's safe to say the experience pushed me out of my comfort zone in many ways. Since then, my love for adventure, travel, and meeting new people has grown immensely, and I continue to try to push the boundaries of my comfort.

What has been one of your most memorable shoots?
It's incredibly hard to choose my most memorable shoot, but the ones that stand out the most are the ones that created the opportunity for new friendships, connections, and experiences that have meant so much to me and may not have blossomed otherwise. In saying that, one that stands out would have to be the first shoot I did with Tight Club Athletics. It wasn't the most standout as far as the photos; they were just simple portraits of each of the fitness instructors, but because I did it as a trade for a membership, I became a part of the most incredible community—a fun, inclusive fitness community that I felt so welcomed into. I had spent so much of my life feeling like I didn't quite fit in, but this was a space I felt a part of, and I built many meaningful, lifelong friendships there.

Tell us more about how important it is to make a connection with your subject.
I grew up in a conservative Christian home, and it wasn't until I came out later in life as queer that some things started to click for me. I had always felt a little out of place, like I didn't fit in that well anywhere, and I was often a little unsure of myself in certain situations. Looking back, I realized that I didn't feel very safe or confident to be myself or discover that piece of me. When I did finally come out at age twenty-five, it was challenging in many ways, but as I worked through the shame, guilt, and internalized homophobia, I began to find a new confidence in myself. It was slow at first, but once I reached a point of acceptance in myself and found new communities I loved that welcomed and celebrated who I am, things began to change, and the confidence I discovered spread to other areas of my life. It was a shift so noticeable that friends commented on it. Because of this journey, it means so much to me now to have the opportunity to hold space for people to feel safe and confident in themselves while being vulnerable and seen. This is especially true in my work and my relationship with clients. It has changed both the way I connect with people and the connections that matter most to me.

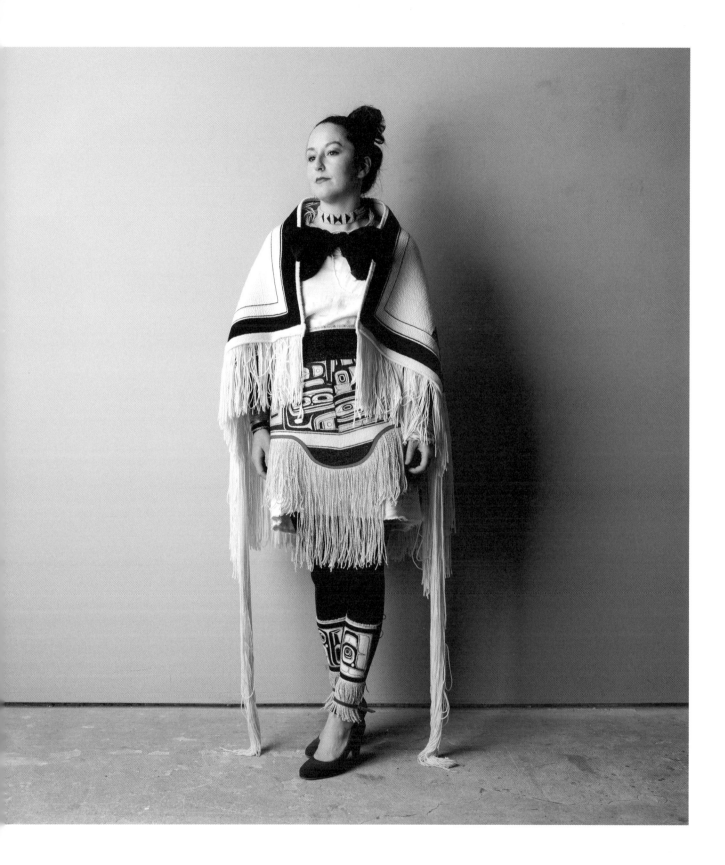

Meghann Shaun O'Brien

**Northwest Coast
textile artist**

"In the art world, I'm not just representing myself as an individual; I'm continuing a legacy established by my ancestors, and there's real value there."

What is your first memory of being in nature?
I was maybe four or five, and my dad had me up on Mount Cain in a storm. My dad loves storms, and when I wouldn't sleep, he'd bundle me up and take me on a walk. We lived on the southern part of Alert Bay and got hit with really intense wind in the fall and winter. That's one of my favourite aspects of nature that brings back a lot of nostalgia. Another early memory is playing in the forests and on the bluffs of Alert Bay with my friends.

Can you remember a favourite piece of clothing from early childhood?
I wore these grey ballet flats, waffle knit white long johns with a big cuff at the bottom, and an adult women's stretchy fuchsia workout style top that was clearly too big, as it flopped over one shoulder. I was also very into headbands. Another piece I favoured was a gold-and-black sequin women's tube top that I wore as a miniskirt.

Alert Bay is a village on Cormorant Island, off the northern coast of Vancouver Island, home to the Kwakwa̱ka̱'wakw. How did this environment shape you?
What stands out most to me was the freedom we had to go play on our own at a very young age. I don't think that kind of freedom exists in the world anymore. There was a lot of trust back then among neighbours. It was a really cool

upbringing. There were fifteen or twenty kids around the same age in our neighbourhood. Being surrounded by the ocean and having deep histories between families in the area was wonderful. My dad and mom were commercial fishers in the summers. We spent a lot of time on the boat, and I have memories of going out in our Zodiac to explore the surrounding islands.

At what age did you start snowboarding?
I started snowboarding at age thirteen or fourteen. When I was between the ages of fifteen and seventeen, my dad brought my sisters and me to competitions throughout BC. I was racing in boardercross and doing well. I moved to Whistler after school and did some travelling, so it wasn't until I was twenty-five that I moved into the sport as a pro or semi-pro.

I was twenty-nine when I decided that I wanted to devote more time to weaving. I found myself in an apprenticeship in northern BC; that was the terrain where I really wanted to be riding, so I decided to stay, but I got very little support from my sponsors on the idea and was dropped by them. It was very frustrating because most of the exposure I had as a snowboarder included my weaving, but snowboarding was incredibly narrow-minded back then. We're in a much different world now where everyone seems to be looking for diversity.

You're celebrated for your incredible weaving skills. How did you learn?
I haven't had any formal training in textiles and fashion. I was trained in strict traditional apprenticeships as a weaver by my teachers William White, Sherri Dick, and Kerri Dick. I also worked with Donna Cranmer. I grew up watching

my mom sew. She made us a lot of clothes when we were growing up. She also loved quilting. She's an amazingly creative woman and gets more eccentric and bolder in her designs, which is cool to see.

The processes of being a semi-pro snowboarder and artist are different, but there was one common thread in my experience: I did a terrible job of standing up for myself in the world of snowboarding. It was expected I'd do it for free because there are hundreds of people willing to ride for free product or simply to gain exposure. I made up my mind early on that I wouldn't let the same thing happen in the art world.

I received good advice early on from a gallery owner. I'd brought in a piece and asked him to assign a value to it, and he told me I was the only person who could do that because only the artist could decide upon the value of their work, and the time, effort, and energy put in. I wish someone told me that earlier in my time as a snowboarder because in that world I was always waiting around for someone to tell me I was worth it.

The biggest difference is that in the art world I'm not just representing myself as an individual as I did as a snowboarder; instead, I'm continuing a legacy established by my ancestors, and there's real value there.

Please tell me more about your experience as an artist-in-residence at the Institute of American Indian Arts.
I'm not a fan of art schools, even Indigenous-run ones. I had a positive experience and enjoyed the people I worked with, and I love Santa Fe; however, I'm not a big fan of institutions.

Who, where, or what inspires you?
Who: Agnes Martin, Wolfgang Laib, Ursula Le Guin, and Gertrude Stein. In the snowboarding world, I'm inspired by Tamo Campos, Victoria Jealouse, and Natasza Zurek. In my family, I'm inspired by my sisters, my dad and mom, my cats, and my husband.

Where: Alaska and the mountains in northern BC.

What: The ocean, the forest, the night sky, and plants—so many inspirations.

Tell us about a memorable design.
Sky Blanket, because it seems to gather strength through time, and because it's aimed at sharing a broad perspective.

I also don't consider it just my design, but one that was a collaborative process with the material, to express what it shared.

The design process happened over a year, with contributions from Andy Everson, Jay Simeon, Margaret and Andrew Grenier, and my mom Dixie Johnston. Together, all our ideas created the end result, and I hold that sacred.

How would you define yourself?
I like to use the term artist. I used to say weaver a lot, but I found limitations with that. I would say a thinker of sorts too. I like thinking a lot, about everything and how it is similar or distinct, how things breathe in the world, how things interact with each other. About the histories of objects, of techniques, about how they function in the world.

Which designers, artists, and creatives do you admire?
I admire the artists Agnes Martin and Wolfgang Laib because I appreciate the commitment they have to their art and to the decades-long expression of a singular vision. I could go on at length about both of these artists— Wolfgang Laib in particular because he's been collecting pollen since the seventies, and he sifts it onto the floor in these beautiful geometric forms. I like the harvesting aspect, the being-in-nature aspect, and the gentleness. I like that pollen is a source of life, an origin of life, and I like Wolfgang Laib's attentiveness to that. It's beautiful.

Agnes Martin's work and life are just a thing of complete beauty. Sometimes people can't connect with her work; it's mostly horizontal lines and grids. But when you see the work in person, it's alive; whatever she was tapping into was something real, and the paintings feel like an emotional landscape.

I admire many Native artists as well, such as Beau Dick, Phil Gray, William White, Sherri and Kerri Dick, Wayne Alfred.

In fashion, I admire Daniela Gregis, Karl Lagerfeld, Warren Steven Scott, and Rei Kawakubo from Comme des Garçons.

I admire Daniela Gregis for her respect for craft, tradition, and natural fibres. She views fabric as a religion. She used to be an herbalist. Her garments are total magic. I admire her work also for its singular vision, as a very true expression that doesn't follow trends. I love that although it isn't an Indigenous label, they're Italian, and they embody an older way of doing things in an *avant garde*

way. Absolutely nothing is thrown away; everything is used, even the scraps. Designs for new clothes are based on the cut-offs from other designs. It's incredible.

Walk me through your creative process.

I love weaving up north. I think it has something to do with the spirit of the work and where it came from. Sometimes the combination of the energy of the work itself and the weaver can create its own space, but living in a city I'm finding my work impacted in a terrible way. My impulse here is to protect myself, to make myself as small as possible, whereas with more space, in nature, I feel so expansive and like I'm a part of everything I see. Many people, snowboarders for example, talk about how being in the mountains makes them feel small and like they are so insignificant, and I can understand that in some way, but for me the feeling is the opposite. It makes me wonder how we as people have been gifted with such an incredible home and yet have managed to create such oppressive societies and city landscapes. How did we fuck it up so bad? And how can it be fixed?

How does fashion inform your art?

I have very little experience in fashion. I consider the garments I did make to be more like sketches of clothing, as they were all handsewn. I love natural fabrics. I feel like with linen you almost can't go wrong. I like working from my own body, or a mannequin, and just sewing directly on there, and kind of draping the fabric.

I wish I had the dedication or time to devote to learning more about pattern making, as it does twist my brain in interesting directions, like the geometric nature of it, taking flat surface designs and seeing how they respond to the body.

I love fashion that is just one size. Texture is important. What I do is far too expensive to ever be considered commercial clothing. I don't have a team of people working on things.

When styling an outfit, I look at thing holistically. I love working with thrift store items or seeing how smaller items that I've woven play off of or contrast certain elements in an outfit. I love building outfits. To me fashion is total freedom and so exciting to play with. I love the strictness that I worked with in learning traditional weaving, and fashion provides a nice contrast.

How do you go about incorporating elements of heritage into your designs?

I don't have to work too hard to incorporate heritage into it, as it is heritage, it is culture; it's impossible to get away from, really.

Tell us about your thoughts on beauty and nature.

I think it's important to remember that human beings are capable of creating beauty. Nature creates beauty; it created so many beautiful expressions and distinct cultures all over the world. We need to hold on to that, learn from our mistakes, and move forward while both acknowledging and promoting positive change.

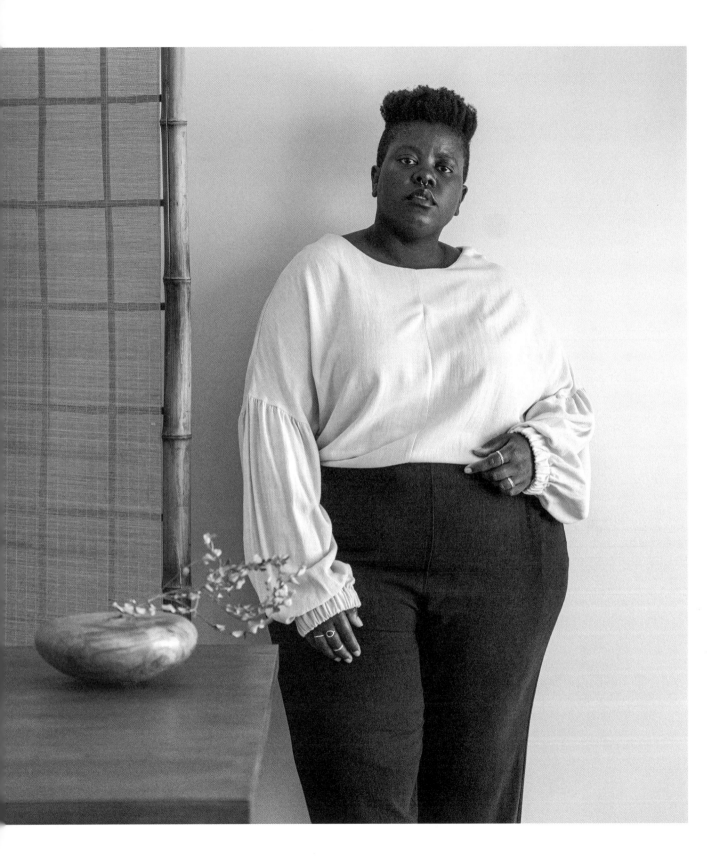

Lydia Okello

Non-binary writer, model, and content creator (they/them)

"I used to feel lucky to be invited or noticed. Now I know I deserve to be at the table, and if I'm there I'm responsible to change who's in the room."

What was your first favourite item of clothing?
My mom used to make my sister and me matching dresses with hats (very *Blossom*). I vividly remember one with big apricot-and-yellow-coloured rose print, and a little red dress with a big white overlaid collar—early memories of my emerging style.

How would you describe your childhood?
I was born in Norway—Oslo, to be exact. In the 1980s, my parents migrated there from Uganda and had me. We moved to Canada when I was almost four because my dad wanted his kids to grow up in an English-speaking country. We moved around a lot. It was tough to move so much as a kid; I was good at going with the changes, but as an adult I've realized it really affected my ability to feel safe and secure. I'm working on all that inner child shit now, ha. Safety and stability are something I really needed; as an adult I've realized I didn't feel like I had it. I suppose moving a lot affected me in that way. I also think it made me a more empathetic person. I have met so many people in my life, and I think I'm able to see the beauty in different kinds of folks.

I think I had a happy but a bit of a tumultuous childhood. I moved fourteen times before I was in the eighth grade. I am a pretty friendly person, and I was always excited to make new friends as I moved from school to school. I grew up in the suburbs of Vancouver; I'm Black (Ugandan Canadian) and lived in predominantly white spaces for most of my life. At the time, I didn't think too much about it, but I feel it really shaped the way I saw myself. My mom has always been so, so beautiful to me, but I felt like I should want to be a *Sweet Valley High* twin. That Valley Girl aesthetic had such a hold on me, probably because it felt so unattainable. Most of my friends were white. There were many microaggressions, but I didn't experience a lot of direct racism, probably because I was an earnest and "smart" kid. I did well in school, teachers liked me, I wanted to do well.

The suburbs of Vancouver are pretty… regular? I was a poor kid, and I remember wishing I could be rich so I could seem acceptable and not get made fun of when I was excited about clothes my mom found at Value Village. I think I have been interested in aesthetics and expression through adornment since a young age; my parents let me dress myself from age six. There was always a balancing act: pleasing my parents by being a good Christian Ugandan "daughter," and then also feeling like I wanted to be popular and cool at school. I think I was well liked, but I wasn't cool. And I just wanted that so badly, especially in those pre-teen and early teen years. I felt like my suburban life was so *boring,* like if I lived in a city, I would be the "cool" version of Lydia. It's humorous now, but I think because I was queer and non-binary and didn't have vocabulary or knowledge of those things, part of those wants were me trying to find people like me—my chosen family, my community.

What brought you to the west coast?

I moved to Vancouver for school. This is my eleventh year in Vancouver. It's a beautiful place to live; we have a lot of access to nature and clean air. It's a place that feels very, very white, despite having a large Asian population. The history of Vancouver has a deeply racist and racialized lens, but it's also a city that sort of *thinks* it's very accepting. I've realized that growing up here, and having my young adulthood here, I have been painfully aware of my difference as a Black person. I've been conditioned to be rubbernecked and treated differently, while at the same time I've been able to find community and like-minded folks. I suppose Vancouver is a mixed bag. I think it can be tough to live somewhere that is very micro-aggressive. In the past it has made me feel like I don't have a place or don't belong here. The feeling that my voice and my personhood and wants don't matter. But I've learned how to carve my own space; I have a strong chosen family here, and I feel safe and seen with them. I am lucky to have that soft place to land now.

I first became aware of you after reading a personal essay you penned for *Fashion* Magazine. You shared openly about being raised in a conservative, religious family and favouring feminine designs while simultaneously beginning your gender journey. What are some ways in which you've unpacked ideas and societal expectations that are considered to be limitations?

I was approached to speak about my style journey; I hadn't shared about that part of my journey, and it was exciting to dive into where my personal style expression comes from.

I think, for me, I always felt like my differences were a hindrance. My family had traditional and conservative norms about people who are assigned female at birth, and I was frustrated in those confines. But I felt like it was who I was; I didn't feel that there were any other options for me as someone who was socialized as a girl. I had to read about, listen to, and immerse myself in queer and trans media (an ongoing project) to start to learn that those ideas are a setup. That those ideals of femininity are actually a trap, set to perpetuate the patriarchy. I also had to learn about the ways that European settlers, worldwide, worked to erase the legacies of gender-divergent folks. This erasure also fed into patriarchy, particularly upholding white patriarchy. I'm constantly unlearning all of that shit, unlearning these systems that we all internalize. I think unlearning is the most important part. I also try to

find ways to remind myself of the beauty of non-binary and trans folks. Our art, our cultural impacts, and the beauty of our lives. Seeing folks thrive really brings me joy.

Do you feel that you've reached a point where you feel a hundred percent comfortable with who you are?

Ha! No. I'm becoming more comfortable, but I have accepted it's something I will likely always have to work on. I've made so many strides since being an extremely insecure sixteen-year-old, but I feel I have many imperfections and shortcomings to come to terms with.

What have been some of the biggest challenges and positives in your gender journey?

I'm still on that journey; I think my biggest challenge has been accepting where I am at. And that it doesn't look how people might assume. The biggest positive has been the acceptance from my own community and finding new friends and folks who are coming from a similar place.

You were assigned female at birth and now identify as non-binary.

This is a fairly new realization for me; I really only started exploring that part of myself in my late twenties. I'm now thirty-one. In hindsight, I can see that a lot of my discomfort and feeling alienated came from my sexuality and my gender. I didn't have words or concepts for feeling not typical. It evolved over time; I had held onto a lot of preconceived notions of what I thought I had to be to identify as non-binary. I'm not really out to my family; I don't feel like they would exactly understand, so it's something that I don't really discuss with them. It's not hidden, but it's not really a conversation. My friends have been receptive and understanding. We're all learning together.

What has been the evolution of your professional journey in fashion?

I worked in a store at my local mall, and I felt like I was the absolute coolest, which is very funny to me now. I've always been interested in clothes since I was very young, probably since I was about four or five. I started blogging in 2008; I've been documenting my outfits and talking about fashion since then. I now get to write, model, and create digital content. When I started out, I did everything for free. I definitely felt like an outsider—I was a bit nerdy, a vintage-obsessed, small-town person who loved

deep-diving fashion all through my teenagehood. I definitely found folks who had similar interests, but it wasn't until recent years that I felt like my peers noticed or appreciated my work. I'm fat, I'm Black, I'm queer. These are not characteristics of the influencers who have massive followings or access to infinite funds. I think I've become less naïve—I used to feel lucky to be invited or noticed. Now I know I deserve to be at the table, and if I'm there I'm responsible to change who's in the room. Whether that's recommending folks to work with or suggesting folks who would be better suited for jobs, I think I really appreciate the power of building one another up. The power of questioning the bare minimum and status quo and collecting resources to change the (major) issues in the industry. Fashion's elitism acts as though there is room for few. But there is room for all of us. That's where my interests lie these days. I have less concern with being noticed by the cliques, and I am more about building community.

Have you done any formal studies?

Yes! I did the fashion merchandising program at Blanche Macdonald, as well as a year working toward a Bachelor of Arts degree.

How would you describe your style?

A combination of grandparents' wardrobe, school uniform, colourful, joyful, relaxed.

We spoke at length about you being a "popular pick" in this new space of social media. How do you discern which brands and products are genuine, and how do you decide which brands to represent?

I know it's very trendy to find folks with "diverse" identities and to align your brand with them, in a tokenizing way. It's hard to navigate, and honestly sometimes you know there is a touch of that occurring. It's a matter of assessing what a job is worth to you. I have my own lines of things I would never do, and I try to research the brands I work with as well. It is a tough balance because I don't think any one brand is perfect or without room for growth. But there are major differences between say, an Amazon versus a small, independently owned clothing retailer who has transparency about where the clothes are produced, who is making the clothes, and how folks are being paid. It's all about gut reaction and research. I also ask around if I know folks who have worked with brands as well.

You made mention of feeling grateful for being "older" in this time of social and cultural history, and that you no longer feel "hungry for validation." Can you tell us more?

I think this comes from working in social media for thirteen years. I remember when I started out, I was more interested in being validated by my peers. With likes and shares and so many metrics on social, it's something that is easy to fall prey to. I've realized that what I actually take value from is mutual appreciation from my peers and feeling proud of the work that I do. That's what makes me feel happy within my work—not that specific numbers or metrics that are met.

I think it's hard to resist seeking this validation. It strokes our egos! I would say, find ways to be happy that don't involve what your output is—this remains a lesson for me. You are not your productivity or accomplishments; your worth comes from your personality and care. Find loved ones, find hobbies and activities that are rooted in pleasure. I think seeking pleasure is a perfect antidote to seeking validation. I try to remind myself of that.

How has the pandemic affected you?

Honestly, I wish I could say I've created a healthier relationship with work–life balance, but the pandemic has really skewed my workflow. I got laid off from my day job in September 2020 and started working for myself. Now that things are slowly opening up, I'm realizing I have a pretty unhealthy relationship with work. I have gotten used to working constantly; since there was no socializing occurring, I leaned into the imbalance. I definitely learned that I am lucky to be in a really great relationship; the pandemic was super hard to be newlyweds in, but we knew we had each other. There isn't another person I would want to spend twenty-four-seven time with. I'm proud of the work Hannah and I have done in our relationship during the pandemic—we got married summer 2019. It's been a time of flux, and I don't know if I will understand the full scope of the changes that happened for a long time.

Where do you see yourself in ten years?

Happy, I hope. I hope to be writing, creating work related to personal style and expression; hopefully the fashion industry will have made real strides toward inclusivity. Maybe we will have kids by then, climate crisis willing.

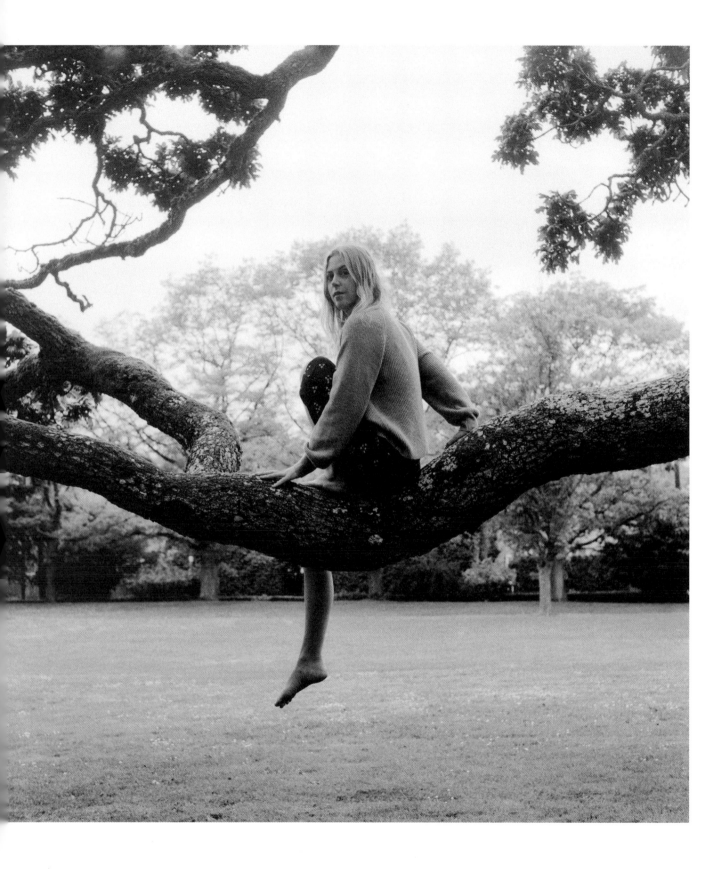

Melissa Renwick

Photographer

"I love what I do because I am in a constant state of discovery—the camera acts like an all-access pass into people's lives."

Can you tell us about a photo that moved you?
I was gifted Richard Rothman's *Redwood Saw* when I was still living in Toronto. It's a book of black-and-white images, made with a four-by-five camera, of California's redwood forests, paired with portraits of people from the neighbouring town of Crescent City. I didn't get it. I didn't understand what the book was trying to say or why the photographer included nudes, so I put it on my shelf and left it alone.

When I moved to Tofino, I left the book behind in a storage locker in Toronto. I didn't think I would miss it. But as I started making portraits of people in Tofino and the surrounding old-growth forests in black-and-white film, I was stunned at how I found myself making images similar to the ones I'd seen in *Redwood Saw*.

At what age did you begin to have an interest in photography?
I can still remember the stale smell of expired developer and the dim glow radiating from the overhanging red light in my high school darkroom. As out-of-focus images took shape, it felt like magic, and the world seemed to slip away.

It wasn't until I attended Mount Royal University when I was twenty-one that photography re-entered my life. I had spent the past several years travelling, taking loads of photos but never with any intention. As part of my journalism degree, I was required to take photojournalism classes and bought my first DSLR camera. It didn't take long for photography to outshine my love of writing, but it still felt out of reach—I didn't even register it as an option to pursue. My photo professor, Paul Coates, encouraged my interest by opening up the school's photo studio on the weekends so I could experiment with portraiture and lighting. It was pure creative joy.

We were assigned to bring in a working photojournalist to speak during one of our senior classes. Todd Korol was one of the presenters and encouraged students to follow up for portfolio reviews or with industry questions.

Six months later, I asked Todd if he needed a photo assistant and started working for him the next day. Without knowing it at the time, I had started a mentorship that continues today.

Photography inspired me to look at the world more closely, to pay attention to the details that others might pass by.

The photojournalism classes I took at university taught me about composition, lighting, and how to create visual narratives. They quickly became my favourite classes, but I stayed focused on writing. For whatever reason, photography felt more like a pipe dream.

Having that foundational knowledge of how a camera functions and how to look for moments was really helpful. It gave me the tools to go out in the world and start putting them into practice.

I know a lot of really great photographers who never received formal training, and I don't think it's needed. The learning really begins when you're out in the world making photographs.

It took years of many failures before I started to really see and understand light. As I've grown, so has my photography. It's an evolution that will continue to change as I do.

Who, where, or what inspires you?

I'm interested in making photographs that capture the complicated interrelationship between the coastal landscape and those who inhabit it. Through portraiture and visual narratives, I am most passionate about documenting the different ways people live in remote regions of the country, but mainly at home, in Tofino. I love the spacious landscapes that change minute by minute with the weather, and the wonderful people who have found peace living on the fringe of society. They've inspired me to consider the way I want to live my own life.

There is something about the stillness and mystery that lingers in the moments during the last light of day, or just as the sun is beginning to wake up. It's then that I'm most moved to create. I love the darkness during those times of day and how intimate and raw it feels, like I've got the world to myself.

I'm an over-thinker, but when it comes to photography I tend to lead with my heart. My images are usually driven by emotion and curiosity.

You've been a contributing photographer to the *New York Times*, the *Globe and Mail*, *Maclean's*, the Canadian Press, *vice*, Getty Images, and the *Toronto Star*.

I'm grateful for the relationships I've built throughout my career and the people who have pushed and elevated me along the way. I had a lot of people take a chance on me early on in my career by trusting me with photo assignments—arguably before I was ready. But that support and encouragement gave me the confidence to keep going.

Just like with every story, each life experience leads to the next. A lot of my images come from something I've already photographed. Through photographing a furniture collection, I became interested in the wood the artist used, which has led to a new series about a tree. Sometimes there are unexpected connections between people and places, other times it's more obvious.

You've also got to want to put a lot of yourself into it. The trick is to just stick with it. Practice every day, believe in yourself, and don't hold on to other people's criticisms too closely.

What makes photojournalism unique?

Photography has always just been a way for me to tell stories. I've always been curious about people and the many ways there are to live. Photojournalism was like an all-access pass into their lives. It helped me to understand the world and my place within it. It pushes me out of my comfort zone and forces me to ask intimate questions to strangers. I'm grateful to everyone who has trusted me with their stories by opening their doors and allowing me to experience their world.

Through photojournalism, I've gravitated toward environmental portraiture, which makes up a lot of my work today. I love collaborating with people in their work or home environments to capture their inner spirit. It's an intimate experience and allows me to get lost in someone else's version of reality.

Being a storyteller is a privilege because people are putting their trust in you. Occasionally, they're sharing details of their lives that they've never expressed before. I try to be sensitive to people's vulnerabilities and capture their stories in a way that is honest and resonates with them.

Photojournalism is important because it creates a historical archive of our lives. Collectively, it captures a moment in time that illustrates where we were as a society, that allows us to reflect on how to move forward.

Your plan was to stay in Tofino and Ucluelet for four months. It's been four years. How did that develop?

I was born and raised in Calgary, so I've always felt a pull to the mountains and expansive skies. When I was growing up, my parents drove my brother and me around the country in a motorhome on camping trips. We drove up to the Yukon, out to the east coast, and spent our summers vacationing in small-town Saskatchewan. I spent a lot of time staring out the RV window watching the hay bales roll by. On one trip, I reached out the window to touch the clouds. That window felt like my personal slideshow.

I've always lived in cities, so I never knew how those rural landscapes had impacted me until I moved to Tofino. Before moving west, I was living in Toronto. At the time, I wasn't quite ready to say goodbye, but I knew it was time to go. The stress of the city was starting to impact my emotional and physical health. So, I packed up my apartment, loaded my belongings into my car, and headed west.

When I got to Tofino, it took a while to shake off the stress. My mind continued to race, and my body still felt stiff and anxious. But as I eased into a slower pace of life, my body relaxed, my mind opened, and I was finally able to sit still. With close access to nature, I was able to drop my guard and connect back with myself. I couldn't imagine

living somewhere isolated from nature again. It's my main source of inspiration and the place I feel most free.

Tofino is the first place that's ever felt like home. It's got an adventurous spirit full of passionate people who seize the day. People often say that it's full of Peter Pans, and there's definitely some truth to that. I love being surrounded by people who never stop dreaming.

Has the west coast changed the way you work?
The west coast has completely changed the way I approach photography and the kinds of images I'm interested in making. When I got to Tofino, I started working with film. Like my life, I wanted to slow down the way I photographed.

When I'm working with film, everything around me fades away and time seems to stand still. The images are less spontaneous, but shooting with film forces me to practice patience and wait for the light to shift or the tide to rise. It's a slow process that allows me to consider that space between me and the landscape or the person I'm photographing. Because of that deliberate process, I find my images become more honest because people really lean into it and offer more of themselves.

Living in a small town keeps me more accountable to the people I'm photographing because oftentimes they're my neighbours. Building connections and trust is a really important part of my process. It also means that it could be months before I even start making images. By taking the time to have conversations and really getting to know the people I'm photographing, I'm better able to get to the heart of the story and what they have to say.

Because the communities around Tofino share such a deep connection to the natural world, most of my stories explore that relationship. I'm usually drawn to groups of people who are living similar lifestyles, like off-grid living, or those who share a common purpose, like the Nuu-chah-nulth people working to keep their traditional language alive.

Through my work, I've been able to develop close relationships with people from the surrounding Nuu-chah-nulth nations. They have taught me so much about their worldview and the Nuu-chah-nulth guiding principles, like *His-shuk-nish-tsa-waak*—everything is one.

I always look forward to the change in seasons on the coast. As summer comes to an end, the days become shorter, darker and stormier. It signals a time to turn inward. This past winter, I set up my bathroom to double as a darkroom. I love waking up early and heading into the stillness of my bathroom to develop film before starting the day. Seeing the images reveal themselves on negatives still feels like magic.

I was recently gifted an enlarger so that I'm able to make my own prints. The process has allowed me to develop a deeper connection to photography and given me more control over the entire process of creating an image.

How do you ensure that your subjects are comfortable?
When I first started making pictures, I was too scared to even ask people to take their photo. It took years of working myself up to get over that. Now it feels so natural that it's hard to remember ever being in that place.

People have a complicated relationship with the camera. I'm often told, "I hate having my photo taken." I really try to make it a positive experience so people walk away feeling confident.

Before I even pick up my camera, I always give people a clear sense of the story I'm trying to tell, where the images will be used, and how they'll be used. Open communication is so important. From there, I try to gauge how the other person is feeling and adapt to their needs.

There's no real guidebook. It has to come from the heart.

What do you hope we, as a global population, take away from the last few years?
If you ask me this question in a year's time, I'll likely have a much different response. I think people have become more aware of how much they need a connection to the environment. It's important for people to develop a connection with nature because you protect what you love.

I feel lucky to have lived through the pandemic in Tofino. I was still able to surf and had empty beaches and forests to escape to. Relatively speaking, Vancouver Island had low case counts, so my experience was a lot different than my friends and family in Toronto and Montréal, who had curfews and couldn't leave their homes.

Because I had so much time to myself to think, I was able to get really clear on what I need from my relationships, work, and lifestyle. In the end, though, I think the biggest take-away is that people need people.

What is your dream place, space, or subject to shoot?
I've always been fascinated by Canada's far north and Inuit culture. I would love to visit a northern community in the Northwest Territories or Nunavut and photograph traditional hunting and fishing practices.

Samantha Reynolds

**Writer, bentlily,
ECHO Storytelling Agency**

"For me, writing has always slowed life down and allowed me to see the beauty in the details."

What is your first memory of words?
Based on how devastated I was when Canadian broadcaster Peter Gzowski died—I liked him, but my grief surprised me—and the fact that my mom kept CBC Radio on all day and every day, I sometimes wonder if, aside from my mom and granny, Peter Gzowski's words were among my earliest memories.

At what age did you start writing?
I wrote all the time as a child. I used to write down the lyrics to my favourite songs and then re-write them (and sing them badly). I made stacks of stapled storybooks. One bit of foreshadowing happened in Grade 10: I made my three best friends books about our friendship over the years, one going back to when we met at age four. Each book was different, with photos and stories that captured my favourite memories with each of them. The production value was a bit sketchy (bound with a three-hole punch and yarn), but in many ways this is the heart of the storytelling and custom book publishing company I founded ten years later when I was twenty-four.

Can you share one book, one poem, one author, and one poet who consistently wow you?
Book: *Bloodletting and Miraculous Cures*, by Vincent Lam
Poem: "Good Bones," by Maggie Smith

Author: Zadie Smith
Poet: Billy Collins

Who and what inspired some of your early writing?
I read everything when I was young: Archie comics, Danielle Steele romance novels, the *Sweet Valley High* series, Stephen King thrillers. I was not picky, but I was *always* reading. My mom was an antique dealer, so she went to garage sales every Saturday looking for vintage things she could sell in her shop, and she would always bring home a box of cheap books, which I would devour until the next Saturday instalment. That early love of reading grew into a love of story and writing—and fortunately, a love of reading slightly more refined material.

You studied journalism at the University of Victoria. What was that experience like?
I didn't plan on studying journalism, but I was in my room in residence during my second year and listening to these two DJs on the radio laughing and bantering and having fun. Suddenly, it hit me: You can have fun in your job. I was raised by a single mom who always struggled to make ends meet, so I assumed that I would pick a stable career that guaranteed I could always pay the bills. But when I allowed this idea of having fun into my vision for my career, I knew I had to write. It's always what has brought me the most natural flow of joy. So, I switched paths and studied journalism. I did the co-op writing program which let me "taste-test" lots of writing jobs in a series of four-month work terms—traditional print journalism, public relations, corporate writing, book publishing. I ended up freelancing and then took a contract as head of content for a dot-com

start-up, which paid well enough that I was able to pay off my student loans and save enough money to start ECHO when I was twenty-four.

Tell us about how you started ECHO Storytelling Agency in 1999.

My granny was a big part of my life growing up, and the only grandparent I've ever known, so I had always planned to sit down with her, ask her questions about her life, and collect all that history into a book. When I left for university, she seemed so healthy, and I assumed I had more time. As it turns out, she fell and broke her hip while I was away at school. I came home in time to see her get wheeled into the operating room for a hip replacement, and when she came out the other side, she had a new hip but no memory. She just never bounced back from the anaesthetic. It was too late; I'd missed my chance. Just like that, my family history was erased. I was devasted. Ultimately, I realized I could keep wallowing in regret, or I could interview the family members I had left, so I did. I sat down with my mom and her two brothers. I was hooked. I knew right away this was what I wanted to do with my life—help people capture their histories and stories to share with the people that matter most to them.

I knew nothing about running a business. But the benefit was *also* that I knew nothing about running a business. I had no real preconceptions of how things should be done, so I made up my own rules and many of them were successful, like calling up the executive assistants of well-known people in town to tell them about what I did in case their bosses wanted to hire me, which several did. Looking back, it was so forward of me to do that, but I ran it kind of like a lemonade stand—make good lemonade and tell a lot of thirsty people about it. Another benefit is that because I was young, a few clients offered to mentor me. One mentor in particular had a huge influence on how I grew my business; my weekly coffees with him was like getting my MBA.

Our purpose at echo is to use stories to help people deepen their relationships with the people that matter most to them. Seeing that happen again and again in the work we do, both in families and in organizations, brings me so much joy. I am forever changed by a Holocaust survival story I wrote for a couple in Edmonton as one of my very first projects. It left me with an enduring faith that even after unimaginable grief, people can find hope and joy again.

ECHO has been going strong for over twenty years now. Congratulations! What would you say has influenced your success?

Storytelling has evolved from something reserved in people's minds for fiction writing to a buzzword that has almost become synonymous these days with "marketing." While we differentiate what we do at ECHO from marketing, the broad understanding of the value of storytelling in the corporate world has definitely kept our phone ringing. Because we have been doing this work since 1999, and we come at it as storytellers who understand marketing, rather than the other way around, clients tend to trust us to get their story right. These days, about fifty percent of our work at ECHO is still custom books for families and companies who want to get their history on record in a compelling and beautiful way, and the balance of the rest of our work is video, digital storytelling, brand story consulting, storytelling training, and brand museums.

Why is storytelling a valuable component of our culture?

Stories are the way we find common ground with other people so we can connect and understand one another better. Now more than ever, we need to share stories to see, in Maya Angelou's words, "how we are alike so much more than we are unalike."

In your experience, how does being a woman change the role of storyteller?

I believe women are naturally better listeners than men, which isn't to say that men can't be good listeners, but I think they need to work harder at it. Women naturally hold space for other people to share their stories, and that quality has served me so well at echo. In my work, there is no good writing or editing or storytelling until there is first good listening.

In addition to ECHO, you work on bentlily, an online platform where you share a daily poem that centers around parenthood, relationships, creativity, nature, and musings on life. How did bentlily come into being?

At a dull corporate event years ago, I was trying hard to stay awake. Then I noticed one lily bent over in the centrepiece of flowers. The awareness of that small detail lit me right up—the world around me came back into focus.

I write my daily poems under the pen name *bentlily* as a daily reminder to chase down my joy by noticing the ordinary details of my life. As for the catalyst for writing my daily poems, I started on January 1, 2011. I'd just had my first baby, and I was on a quest to find more joy in the tedious rhythm of my life as a new mother. I loved being a mom in so many ways, but I also found the routine a bit boring and was looking for ways to transform my perception of the repetitiveness of it into little moments I could cherish. For me, writing has always slowed life down and allowed me to see the beauty in the details, so I vowed to write a poem every day that year to train myself to observe the world around me. That was ten years ago, and I never stopped.

The categories are natural buckets that pretty much sum up what I observe in my life, with "musings" being a handy catch-all for what I'm reflecting on that day if it's not about motherhood, marriage, creativity, or nature. I don't decide ahead what to focus on; I just try to stay open and aware to the ordinary details of my days, and I find that when I do that, I tend to see how so much of my life is actually extraordinary, whether it's the clatter of crows on the electrical wires behind my office, a spoon I spot on its own in the sink, or something my son says to me on the way home from school.

So, you've written a poem for every day over the last ten years.

I don't keep track because I really do use this practice as a way to try my best to stay present in my life, but the math was easy recently because I celebrated ten years of writing a poem every day, which makes 3,650 poems! The unexpectedly easy part of writing a poem every day is that I don't sweat over the poems. The point isn't to write a perfect poem—the point is to be so saturated by noticing the little details of my life that by the end of each day, I squeeze my heart gently and a poem falls out. I write most of the poems in about fifteen to twenty minutes. The other advantage of writing every day is that you do become a better writer, so the poems I write now are overall better, I think, than the poems I wrote last year or the year before. Since I do share the poems in my email newsletter every week, and on social media every day, it is nice to hear that people are moved by my poems, that they're

not just a mindfulness and creativity practice that serves only me.

Please walk us through the process of writing one of your poems.

I wish I could relay a romantic picture of how it all unfolds, but I'm afraid it's rather basic. I jot down notes throughout the day on my phone. At the end of the night, once my kids are asleep, I open my laptop (not even a Mac!) and I write the poem inspired by one of the notes I jotted down that day. Oh, and I'm almost always sitting on my couch or my bed in an ergonomically shameful position.

How does writing a daily poem fulfill and fuel you?

It grounds me in the present moment, keeps me joyful and tuned into reasons to be grateful, and fulfills my need to be creative every day.

What do you hope your readers take away from your poetry?

I hope my poems inspire readers to notice the ordinary moments in their own days and find them suddenly bright with wonder.

Have you thought of compiling all of your poems into a book?

Yes! I have a book coming out called *The Little Book of Noticing*, which will be partly a book of my poems and partly my tips and tricks on how to notice and cherish the little moments in your everyday life.

What advice would you offer a young writer?

Read a lot. Notice what you love to read. Write a lot. Notice what you love to write. That's your recipe for what to focus on. Don't worry about being perfect. The more you write, the better you'll get. Ask for feedback, find mentors, hustle, don't be afraid to pitch yourself. Most of all, don't be afraid to fail. My creative and business past is peppered with some truly epic fails. I learned and got better with each of them, and I wouldn't trade them for early or easy success. As Maya Angelou said, "You may encounter many defeats, but you must not be defeated. In fact, it may be necessary to encounter the defeats, so you can know who you are, what you can rise from, how you can still come out of it."

Piya Sandhu

**Owner and chief curator,
The Handpicked Home**

"I went in with a plan and with my heart on my sleeve; this has allowed me to connect with people in a deep way."

What motivated you to open The Handpicked Home?
Opening a shop has always been a dream of mine, one that I used to think was unattainable or perhaps unrealistic; it was the answer to the question *What do you want to be when you grow up?* The idea of owning my own shop felt like such a fun, fulfilling, and creative way to spend my time in my community.

Have you always had an interest in home décor and artisan goods?
My love for artisan-made home décor comes from my parents. Our home has always been filled with unique items for as long as I can remember, and they really helped spark my love for decorating a space. However, my discovery of locally made goods happened after getting married, when I was consistently asked by my friends and family where I was finding these amazing items that decorated our new home; they hadn't realized that they could find great products handmade by local artists. In those moments, the concept for my shop became very clear.

How would you describe the shop?
The Handpicked Home is a lifestyle and gift store full of fun and inspiring goods that are naturally, artisanally, and ethically made. Every artist and brand I partner with is conscious about the environment; each item is intentionally handpicked; every piece is made with love. By choosing local, we can feel good about our purchases, supporting our local economy and investing in small businesses so they can continue to provide customers with great service and wonderful products! For The Handpicked Home, offering locally and artisanally made goods means our customers get to discover how much talent there is right in our own backyards, and learn about the maker's story and how each treasure is uniquely created.

Do you have any formal training in business studies?
I do have a business background in sales and marketing, and my commerce degree has helped immensely in building a business plan, forecasting, and planning. The advice I give someone interested in opening a brick-and-mortar business is to take some courses to become familiarized with these business concepts; at the very least, a bank won't take anyone seriously who doesn't have this knowledge. I do not, however, have any engineering or Autocad experience, so when I was building out my retail space, I was literally hand-drawing all my designs, which ended up working great for myself, my contractor, and all of my vendors. The designing of my build-out was entirely self-taught but was successful enough for others building retail spaces to ask for my consulting help in designing theirs. That is a true stamp of approval!

What kind of experience do you hope to offer anyone who walks into your shop?
I want to bring back the fun, connected, human side to shopping. The landscape of shopping has really changed over the last several years with the internet dominating how people make their purchase decisions. But as an avid shopper (and professional buyer), I still value the in-person

shopping experience: touching and feeling products; walking up and down aisles and browsing items; asking questions to people who truly want to help me. I knew there was a market for this, especially in a community like White Rock, and I wanted to connect with my customers in this way. I wanted to give our customers the same experience when they browse our website so they'd feel the same as when they walk through our shop in person—as if they're on a little treasure hunt, with lots of information and visual appeal. People pop by the shop for help in picking out gifts and learning about new products, and they value the knowledge I provide and passion I have for each item. They return day after day, week after week, and year after year for the relationship we create and the fun we have together. This is exactly what I'd hoped for when I opened The Handpicked Home; I am so grateful for this.

What has been the community response to The Handpicked Home?

Not only have our customers been wonderful and welcoming, but community builders like the Chamber of Commerce, City of White Rock, Surrey Board of Trade, our MP and local MLAs, and *Peace Arch News* have all valued the shop's presence and my voice, and it has been so rewarding. The shop has been noticed by the *Vancouver Sun* and *Province* newspapers, supported, encouraged, and shouted-out on CKNW news radio, and I hear from other businesses and customers around our neighborhood about what a great reputation The Handpicked Home has. So much of our growth has come from word-of-mouth advertising; this wouldn't be the case without the positive experiences our customers feel each time they walk through the shop door. I am honoured and humbled by this feedback and will never take it for granted. The shop speaks for itself (which is how I feel about every product inside), and that is the utmost of possible achievement for my business.

What does the word "community" mean to you?

My intention when opening The Handpicked Home was to be a valuable member of the community in a meaningful way; the bigger the footprint I created for myself, the more of a positive difference I hoped to make. Donating to local organizations; voicing my ideas, opinions and positivity; rallying for my fellow small businesses—these are all the incredible ways I've connected with people and fellow professionals, which confirm how seriously I've been taken as a businesswoman. Being a young, female professional comes with its own challenges, but I was given a strong chance from the start, regardless of being the new kid on the block. Perhaps I can attribute this to the impression The Handpicked Home has on people—I've put everything on the line for this little shop of mine and I think it shows! The last thing I'm doing is messing around in this business, and I am grateful to have been given a chance to prove this.

You have an incredibly upbeat personality. How has this helped you connect with your customers?

Thank you! It is such a treat to have something natural, like my personality, noticed like this. I often have customers spend time in the shop and tell me that they feel a positive energy and truly enjoy spending time with me while browsing. I wanted to create a safe space for customers to treasure hunt. I pay a lot of attention to detail, and these details like the shop music playlist, flow of foot traffic, and product displays all contribute to the shopping experience, which I hope is always a positive one. When it comes time to hiring new staff, I describe the patience it requires to ensure things are done with painstaking care at the shop because this quality has helped create a shop full of good vibes that keep our customers returning for more.

Who have been your biggest supporters in this journey?

My friends and family, through and through. From the beginning, I was encouraged by my support system, including my colleagues and manager from my previous workplace, to grow my dream into fruition. From there, my network has grown immensely; customers have become friends, and fabulous female leaders have become collaborators. My portfolio of work experience has been fulfilling; I am grateful to have been featured for Small Business Week by former MLA Tracy Redies; I've worked with the City of White Rock on many arts and cultural projects; and I've been asked to be part of the Peace Arch Hospital Gala's décor committee in efforts to give back and connect with our community. The City of White Rock has included The Handpicked Home in their official growth strategy plans as an exemplary business that they would like to see more of, and it is this recognition and support that drives me to work hard every day at the shop.

What have been some of the challenges and benefits of opening up The Handpicked Home?

Even with a history of working in retail from my younger years, there are some intricacies of owning a retail store that I was truly not prepared for. From the break-and-enter in 2017 to the (unsuccessful) fraud attempt on our credit card machine, there have been a few tough instances that required developing a thicker skin, or more specifically a disconnect from the shop, to cope and push through them; these are the experiences you often don't hear about. These moments were ones I wasn't sure I could move past because they were too hard on my heart, but the days got easier and I managed to learn from them through the encouragement of customers, family, and friends.

Which leads me to the benefits: Hands down, they have to be my network of supportive and amazing people that has grown since opening, along with the opportunities I've had to work with remarkable businesspeople to grow my professional capabilities. I believe my time running the shop has and will continue to open many doors for me, and this invaluable experience is a wonderful by-product of small-business life.

There's a focus on carrying mostly BC brands. Why is this important?

The premise of the shop was always to support local; the fact that I seek out products in BC before looking broader throughout Canada and other parts of the world will never change. I love knowing the story and passion behind a product—the way items are made, the opportunity to build our local economy. These are things our beautiful market cares about.

At this point, I am introduced to products on a daily basis, and while I'd love to support them all in the shop, we don't always have the capacity to (what a phenomenal challenge to have!). I consider how unique a product is, whether it is missing from our product mix, and whether I have room to fit it in. I am positive our apparel selection would be much larger if I only had the room to fit more in the store. What really works about how I've set up our selection of goods is that I can phase out products to try new ones anytime, which is what keeps things fresh for our customers and gives them a reason to keep coming back for a browse. The fact that I work with local artists and artisans allows me the flexibility to do this, and that is a wonderful gift.

How has the pandemic affected you?

Closing last year for the health and wellbeing of our patrons and my staff, without any guidance or technically being told to do so, was a hard decision. Morally, I knew I needed to be part of the solution and not the problem (which meant shutting our doors), but as a business owner, shutting our doors meant not knowing whether I would be able to open them again, which was heartbreaking. It was an emotional time during which I really had no idea what the outcome would be or whether I would make it through to re-open, but I couldn't go down quietly. I attended virtual townhall information sessions through our chamber of commerce; I had meetings with our MP, MLAs and mayor, and I sent letters to our federal government about additional assistance commercial retailers required (and would eventually receive) to stay alive; I rallied for our small-business community. I also used the power of social media to continue to spread positivity, promote curbside pickups, and guide all of our interactions through our website. The response was nothing short of amazing. I was happy to offer local, contactless door delivery, make donations where possible, and host giveaways. During such an uncertain time, I strived to do my best to carry forward the shop experience that everyone had come to love.

What makes The Handpicked Home unique?

The fact that we've always emphasized the importance of shopping local, sourcing local, supporting ethical, fairtrade goods, as well as brands who work hard to minimize their carbon footprint. I believe in sustainable, earthfriendly living, equal pay and quality products, and do my best every day to share these values with my customers. How we spend our money matters, and I believe these values encourage the longevity of the shop and continue to keep our customers feeling great about what they are investing in.

Katherine Schlattman

Owner and creative director, Foe & Dear Jewelry

"Giving back and being a part of the community has always been instilled in our brand ethos. The more we grow, the more we can offer to organizations that do better for the world."

What is your first memory of jewelry?

My first memory of jewelry brings me back to my adolescent years. My grandma on my dad's side—we called her *Ngin Ngin*, pronounced *ying ying*—had the most beautiful and graceful hands, adorned with jade and gold bracelets and rings. She wasn't in our lives for very long, and we never spoke the same language, but there was always a deep connection and communication through emotions and touch.

At what stage of life did you realize that designing jewelry was your passion?

It was a slow realization, a forever dream that I thought would never be attainable. I studied fashion design at Ryerson University in Toronto and aspired to become an apparel designer, but the start-up costs were too high for a recent grad with big student debt. Designing and making jewelry was always a hobby, and I didn't realize that it was my true passion until I moved to New York with my then-boyfriend (now my husband) and interned for an amazing inspirational designer and shop owner in Brooklyn.

Do you have any formal training?

I've taken specific courses for metalsmithing, lost wax casting, and other jewelry techniques like stone setting and illustration. But to be honest, most of what we use day to day when we're dreaming up pieces at the studio has been self-taught and learned through experience. I truly believe that you do not need to have a formal background in the field that you become passionate about; all of the nitty-gritty details can be found when you look hard enough. Many of the talented business owners that I've met through networking have not had a formal education in the successful businesses that they're running.

The "about us" page on your website says, "Our team of designers create jewelry that is eco-conscious and sustainably made. We use recycled metals, fair-trade gold, and conflict-free gemstones to create one-of-a-kind pieces." Can you share more about this approach?

These company values are at the core of our business. Everything is rooted in nature—the pieces are inspired by natural forms, elements, colours, etc. The root of our fine pieces come directly from nature; gold is a natural element, and gemstones are created in the earth. Partnering with like-minded suppliers and working with non-profits that appreciate and give back to the environment is important. All of our fine pieces are designed and made in Canada, which makes things more costly but adds value in an intangible way. Foe & Dear pieces are made with conflict-free and fair-trade materials, by real humans who make a living wage and put every ounce of care into lifetime jewelry.

Tell us about the first piece you designed and sold for Foe & Dear.

The brand has evolved a lot since I first started back in 2009. I can't recall what the first piece I designed looked like, but I can tell you that it definitely involved vintage deadstock chains and possibly some sort of crystal.

What's the inspiration behind the brand name?

The name ties back to when I lived in New York. It provokes questions and conversation, and is an antonym, which also speaks to the opposite nature of relationships sometimes. A little saying that we like using around the studio is "same but different," which could be said to describe you and your partner, or the design for your rings.

Which jewelry designers and creatives do you admire?

Jewelry designers that I admire include Rene Lalique, a French glassmaker from the late 1880s who created beautiful glass vessels and ornate art jewelry pieces. Another is Elsa Peretti, an Italian jewelry designer and fashion model who shaped my jewelry experience as a teenager; I had saved up all my money to buy her Tiffany & Co. Elsa Peretti bean necklace in my early twenties.

Creatives I admire include Dieter Rams, a German industrial designer and academic known for saying, "Good design is as little design as possible," which is always something we come back to when dreaming up fine jewelry designs. And I admire my grandma, Keiko Yamaura, fashion designer, seamstress, patternmaker extraordinaire. She basically shaped my desire to become a fashion designer as a kid. She had the coolest sewing room setup when I was growing up—trunks filled with scrap fabrics, buttons, multicoloured spools of threads. I have her industrial sewing machine in my parent's garage.

Who, where, or what inspires you?

Family and personal travels to Japan, Nicaragua, Hawaii, or our backyard. Art history, paintings, furniture, architecture, pieces of nature, falling in love with a specific stone's shape, colour, and texture.

Walk us through your creative process.

The process is messy, chaotic, and can't be held to a certain timeline. Many ideas will remain as ideas in my head because we're a small team and can only handle so much. It truly starts as a thought; I put it to paper and let it simmer.

When it's time to design the next collection, product, or ceremony piece, everything falls into place. Prototypes and samples are made; we test, we price, then we photograph and make it live.

Please describe the space where you create.

It's a dream to come to our studio every day. It's filled with natural light, dried florals, Aesop room spray or woodsy-smelling candles, soul music—sometimes the odd nineties hip hop comes out when we have no meetings. It's where dreams come true!

Your website says, "The Foe & Dear Team is one of inclusion and diversity. Our team is made up of individuals from a variety of backgrounds/ethnicities. Each valued and appreciated for the talent they bring to work every day." Can you share more about how this creates your company's culture?

We're a diverse team where everyone wears many hats. I'm proud to sit beside each and every team member that we have. We're not a team of all women anymore—we have happily introduced Matt to the crew! We're more of a friend-and-family atmosphere at Foe & Dear; everyone relies on each other, and we have a very friendly and open work relationship. We have some members who work remotely, but we all bring different skills that work together in a harmonious way.

Your website also says that you are "a community of love and connection." How does this extend to your relationships outside of the studio?

This statement perfectly sums up our relationship with anyone that we work with, whether it's a client, supply partner, photographer, or a non-profit organization. We like to get up close and personal. We're the type to use too many exclamation points in our emails and cheer every time we get updates on proposals.

You shared on social media, "As we grow, so do our hearts and the opportunities we have to give back." Please tell us more about your community outreach program, which partners with local and international organizations, and your connection to 1% for the Planet.

Giving back and being a part of the community has always been instilled in our brand ethos. The more we grow, the

more we can offer to organizations that do better for the world. The 1% for the Planet network is basically a collective of eco-conscious brands and non-profits that have to be approved. As a partner, we are committed to giving back at least one percent of our sales to environmental non-profits that are also part of the 1% for the Planet network. To choose a specific organization to donate to, we try to look at ones that may need more exposure or that relate to what we're promoting that season.

How has the pandemic affected your business?
The pandemic really threw us out of our routine, as many businesses have felt during this time. It challenged me in ways I had never encountered before, and our team who usually works together (closely together like a family) had to figure out how to work apart. As a small business owner who started from nothing, adapting and getting thrown off course isn't anything new. It just presents an opportunity to learn, grow, and flourish. And that's what we did!

Do you feel that since the pandemic began there has been an increase in people looking to adorn themselves with pieces that bring them some spark of joy?
I do see that people are looking for small things that bring them simple joy in their everyday lives. One thing I learned was that a pandemic can't stop people from loving each other. Jewelry is such a wonderful gift to get someone (or yourself) to remind you of a special moment—getting engaged, married, or finding that perfect gift for someone you care about. And that has been a driving factor in the design for the future pieces that are coming through the pipeline. Can't wait to share them.

Foe & Dear recently celebrated the ten-year mark. Congratulations! Can you tell us a bit about some highlights and challenges you've encountered?
Thank you! As I reflect on the last decade, I recognize that a lot of the challenges are also highlights. As a small business owner who went from hobby jewelry maker to full-time owner/creative director/jewelry designer, I can't let challenges get in the way; each challenge has and will

be overcome. It may take time, but each challenge will eventually turn into something that I'm really proud of.

Highlights include being able to do this as my full-time job; transitioning from sole proprietor to a corporation; growing the team with amazingly inspirational and kind-hearted humans; being able to give back and make wonderfully unique jewelry for just as wonderful and unique humans.

Challenges include being able to do this as my full-time job—I'm very much a creative-minded person, so organizing the business side of Foe & Dear took a lot of learning, guidance, and time to fully understand and appreciate. Going from sole proprietor to a corporation was also a challenge; a lot of work had to be done backwards to set up for the future (shoutout to Sean and Jacinthe for sticking with me). Knowing where to grow, and how to grow. Learning how to be a great and inspirational leader for the rest of the team. Growing the brand to the level where I could sustain it full time, have a team, and be able to give back to the community—this also took time, but I'm so happy we're at the stage now where we're able to, and we have a large enough platform to promote some good in the world! Always wanting to be better—this is a personal challenge that always fuels my desire to work with the best, to keep learning about the fashion and jewelry industry, to produce the highest quality of jewelry, to provide the best service and most beautiful pieces that people will love forever.

How do you ensure that each piece you create instills a sense of connection and timelessness for the wearer?
Jewelry is one of those special gifts that can be tied to a wonderful moment, person, or idea. Our fine collection is full of birthstones, tiny objects, items you can personalize. We use quality materials that can be worn for a lifetime, so it can be passed down or gifted to someone you have that special connection with. Every piece from our collection that I wear is tied to a specific person, moment, or memory.

How do you wish for people to feel when wearing Foe & Dear pieces?
Special and loved.

Emily Scholes

**Knitter and knitwear designer,
Olann Handmade**

"I draw on all my experiences and knowledge to make pieces that are unique to my story. By combining heritage, tradition, and place, I'm able to knit together the story of my past and present to create a future for Olann."

What was your first favourite piece of clothing?

A pair of ballet flats made from thick cotton green lace. They travelled the world with me—to South Africa, South America, trips back to Canada—and they pounded the pavement around my homes in Manchester, Derry, Nottingham, and London. I wore them well beyond their best-before date and couldn't bear to throw them away. I ended up leaving them in Ireland on a visit home, for my mum to dispose of in my absence. A couple of years later I found the shoes again, tucked in a box. My mum couldn't throw them away either! These shoes had walked so many paths with me. This was the first time I realized the value in honouring what we own.

How did the physical and cultural surroundings of Ireland inspire your creativity?

There is no place on earth more beautiful than those rolling green hills, the golden sandy beaches, the castles and tombs that pepper the landscape. You feel the history of people that came before. That beauty and heritage was incredibly inspiring to me as a child, and certainly I continue to be charmed by nature, seasonality, and culture as I pursue my design career. In school I was always much more talented in art rather than academics.

At what age did you start knitting?

My grandmother, Mabel, taught me to knit when I was eight or nine years old. She was a prolific knitter and made blankets, scarves, hats and sweaters for all her grandchildren. On a visit back to Canada one Christmas, she sat me down and showed me how to knit a scarf. I was an avid student, and I sat for hours, watching *The Secret Garden*, knitting each row until I had a multi-coloured and tasseled creation. It was pretty hideous, but the knitting wasn't bad! And I still have the scarf. I keep it in my Olann Studio. It's good to be reminded of where I started so I can stay focused on where I want to go.

You earned a fashion knitwear design degree from Nottingham Trent University. What was that experience like?

This is a unique degree, taught by inspiring and knowledgeable tutors. I was twenty-two when I started the four-year program, the oldest in my year, and I knew I didn't want to squander the opportunity to learn. I dedicated myself wholeheartedly to doing the best I could. I loved every aspect of my degree: the life-drawing classes, the work on the knitting machines, pattern cutting and computer classes, and the lectures. Hand knitting wasn't the main focus of my degree; in fact, it was an elective, but I opted for this elective every time it was offered. In the end, I was the only student in my class who used hand knitting as the main component for my fashion collection in the final year.

Nottingham is known for its lace making, and so taking my degree in the UK opened up the opportunity to see and learn about the historical importance of the many types of skilled fibre work. I remember my frequent trips to the museums in London to observe fashion installations,

taking tours around still-operational mills that continue to spin and weave yarns and fabrics, and working with Irish knitwear designers. These are unique opportunities not available everywhere in the world.

You then worked at People Tree in London.
I was an intern at People Tree for nine months after graduating from university, working as the knitwear design assistant. My main duties were to help design the knitwear collections for both People Tree, and also capsule collections that were supplied to the flagship Topshop store in London. I worked on the drawings and specs for each design and supplied that information to the hand-knitters we used in Nepal. People Tree had their own hand-knitting facility there where women earned fair wages and their children received schooling. I worked on the conception of ideas, wool types and colours, and stitch swatches, through to final design and quality control. I learned a lot during my time in London about how the fashion industry works and the effort required to make ethical and sustainable clothing decisions. It was fortuitous, in hindsight, that People Tree is focused on fair-trade, ethical, and sustainable fashion, and that now I can continue that message with Olann.

What brought you to Canada?
I was born in Canada but grew up in Ireland from age six through thirty. I stopped working for People Tree and moved back to Canada in 2010. My husband and I moved to Sooke from Victoria when we bought our first house. We wanted to move out of the city, and we both love this part of the island—it's close to beautiful beaches and hiking trails and is known as the place where the rainforest meets the sea. I'm inspired by this coastal landscape, the colours and smells of the land.

The music of rain and wind during a winter storm, or the lapping of waves on a pebbled shore, are the sounds of home, along with the smell of warming tree sap on summer hikes, and of cedar and ripe blackberries. All these are knit into the fabric of Olann as an ode to place.

What inspired you to start Olann Handmade?
I tentatively started Olann in 2015 when I was thirty-five. The first few years I lived in Victoria I didn't knit or design at all. I didn't think there was a place in Victoria for the type of work I had been doing in London and essentially abandoned my career. After a few years I began to feel

very agitated and disappointed that I was not utilizing my education or work experience to further myself. Having no creative outlet translated to feelings of worthlessness and squandered potential. I felt like starting my own company was my best option since I had already searched for knitwear design jobs available locally, which had yielded no results. And so Olann was born.

I started by doing some research online, browsing hand-knit shops on Etsy to see what people were making and what they were charging. I was starting from scratch, learning how to design and knit again, and then figuring out how to photograph items, list them online, and promote myself. In the beginning I focused on knit accessories and vended at small markets. And as I grew in knowledge and confidence, I began stocking my goods in shops and expanded the Olann repertoire by introducing new fibres and more ambitious designs.

After six years I feel like my business has evolved into something I am truly proud of. Getting to this place has taken a tremendous amount of work, with steep learning curves and hard lessons learned along the way. But I wouldn't change my path; it's part of the story of Olann.

Tell us about the name *Olann*.
Olann is the Irish Gaelic word for "wool." In choosing a name for my brand, I had a few specific criteria: I wanted the name to be simple and pronounceable; I wanted the name to speak to what I do; and I wanted to reflect myself in the brand. In choosing the word *Olann*, I felt I was tying these three threads together. I also loved that the word felt soft, quiet, and calm.

Can you share more about how a sense of place inspires your work?
Growing up in Ireland has inspired my whole life. There is a calmness and subtlety imbued in the land that stays with you; like a romance, it becomes part of your heart. The historically rich knitwear traditions of Ireland have permeated my ideas, whether through the Aran sweater, or the vision of soggy sheep in the bog, there is an intangible mark that remains despite distance.

When I moved back to Canada, I embarked on a new relationship with the landscapes and traditions of my new home. I draw on all my experiences and knowledge to make pieces that are unique to my story. I use tweed from the mill in Donegal close to where I grew up to make hats

that'll stand up to any Irish rain shower, and I use Canadian wool to make garments and accessories suitable for life on the west coast of Vancouver Island.

We have Indigenous artisans who have worked with wool for millennia, and so I take inspiration from their wool work and other artistic pursuits as I design. It's important for me to understand how we live and what we do on these lands because I want my designs to travel with my customers as they turn the pages of the story of their life.

How do you maintain a work-life balance?
Working from home means I feel like I am working all the time. It's easy for me to take my work with me, so even when I'm on holiday I invariably have knitting projects on hand.

It is a challenge to separate my personal and professional lives. It helps that I love my work and that it's achievable to engage with others in a meaningful way, even when I am knitting. It can be overwhelming at times, however—especially in the fall and winter when orders and projects are intensely scheduled. To relax I like to be in my garden, tending flowerbeds and vegetables. I love to go to the beach (of course I often have knitting with me) and watch the waves and the people meander by. I love listening to music and walking, and I find it is in these moments that my brain relaxes, and I'm able to problem solve and feel creative at the same time. The nature of my work is inherently time consuming, so I need to pick and choose what I invest my time in carefully.

There's a beautiful stillness and simplicity to your designs and in your branding.
I want Olann as a brand to embody a sense of calm, since the nature of my craft is slow, quiet, and restful by nature. I want my brand to reflect where I live, a sense of peace and elegance, and to honour the nature of my profession. Working with photographers to bring life to these ideas and concepts is paramount. A picture can speak a thousand words, and I am passionate about using photography and images that give Olann a voice. Beautiful photography makes Olann shine.

My aim is for Olann to feel timeless and ageless. I want my designs to be wearable and become part of the journey of your life. It is my desire that your Olann piece feels crafted and designed with intention, for you from me.

Is it possible for brands such as Olann to sell their pieces at an affordable price point so as to attract a wider clientele?
Price point is very challenging for a brand like Olann. I hand-knit and hand-make all of the items, so there is a finite number of products that can be made every year. The nature of knitting is that it is a slow process, and the costs involved are high, and so offering pieces at competitive prices to high street retailers is not only challenging, but also disingenuous to the craft. It is one of my missions with Olann not to undervalue the skill, time, and importance of the handmade. The nature of Olann is that it will always be small scale. Rather than fight against that truth, it is my mission to speak to why embracing slow made is important, and why investing in handicraft and women's work is vital. I want us to elevate craft and think of it as art.

How has the pandemic affected you?
In previous years I would make most of my sales through the stores that I supply inventory to, and by vending at in-person markets during the fall and winter months, with the balance of my sales coming in via my website. In 2020, everything changed. My website sales increased fourfold from the previous year, markets were cancelled, and there was great uncertainty in the retail sector. Balancing the increase in sales alongside managing other commitments was challenging at times, and it meant learning how to adapt. All the new designs and collaborations were launched online, instead of in-store, which meant focusing on great photo campaigns rather than relying on people seeing items in person. It was a massive learning curve, but I think in the end being flexible and adjusting to the changing circumstances has only served to make Olann a better brand and business in the future. I am so grateful to my customers for supporting me and my business during such an uncertain time.

How do you envision the future of fashion?
I hope to see a continued movement toward sustainable, ethical, and fair-trade fashion choices. Not only is it better for our planet, but it also sustains our economy in a meaningful way. Throw-away fast fashion has been problematic since its inception, guaranteeing low quality, high waste, and unsavoury working conditions. When you buy consciously you are deciding to buy with love and intention. When we love something, we care for it, and in so doing we prolong its useful life.

Veerpal Sidhu

Cosmetic chemist, organic skincare formulator, medical laboratory technologist, Reiki master, and aromatherapist, ЕО Healing

"Embrace your beauty. When you embrace and love who you are, only then can you help others feel confident in their skin."

What is one memory of life in India?
I have amazing memories as a child, and I loved living in India. I remember going to a rose garden with my sister and dad every Sunday. Surrounded by roses and their natural beauty made me feel beautiful.

You shared that, as a young girl in India, you questioned your sense of self regarding your skin colour.
I remember how, when I was around eight years old, elderly women in India often asked my mom if I was adopted due to my darker skin colour. I always wondered why God was so unfair to me and why he decided to make me different than others. I wanted to look fair and white because I thought, *Fair means beautiful and dark means ugly.*

When I was twelve years old, I asked my mom to buy a cream for me, called Fair & Lovely. Before leaving for school, I would apply it to my skin, and then apply talc powder on my face to give me the brighter complexion that made me feel comfortable in my own skin. I used it for well over three years. I decided to stop using it when I moved to Canada—I had brought a little stock with me, and when the stock was depleted, I realized I no longer wanted to apply that product on my face because I was starting to feel comfortable in my own skin.

When did you come to Canada?
I moved to Canada with my family at age fourteen, but I did not want to move to Canada. I did not want to leave my friends. I had no idea what to expect. I did not speak the language, so I was very uncomfortable going to the school here. I knew how to read and write English but never had a chance to speak. It was not an easy transition because to make friends at that age was difficult. I found Canadians did not want to hang around with me because I was from India. When I say, "Canadians" I mean brown people born in Canada. They used to refer us as "dippers." I did not want to be called a dipper, so I decided to not be friends with those people. I mostly hung out with Asians and Caucasians.

I did berry picking the first few summers we lived here. I would wake up at five o'clock in the morning to get ready to be picked up by the contractor; by 6:30 a.m. we had to start work, and I used to come home at 8:00 p.m. It was one of the hardest jobs I have done in my life. Working twelve hours a day as a fourteen-year-old was the last thing I wanted to do. My skin was so dark from working out in the sun, and I hated it. I felt my skin was darker than what it was when I lived in India.

Your dad was emphatic about his children finding success. How did he express this to you?
Raising four daughters in Indian culture is no easy task, and I feel my dad wanted to prove to the community that his daughters were no less than the men out there. He wanted to be proud, and he wanted his daughters to have professional careers so no one could ever point their fingers at us. He raised us like boys, and I feel therefore all of

us sisters are very independent and strong in our own ways. For my dad, success means a professional career, and for me I define success as happiness.

I feel because we were raised in a strong household environment, we were always taught to fight for our rights and to face our fears. It took me a long time to face my fears and embrace my own beauty, but that upbringing has brought to me to the point where I could feel comfortable in my skin colour.

You began your professional life as a lab technician. What moved you to expand your vision of wellness?
I graduated in 2003 from BCIT, and I worked in the field until 2018. I enjoyed working as a laboratory technologist. I worked at a smaller hospital when I first started but moved to a different city in 2006 and did not like the culture of this new place. When I was working at Surrey Memorial Hospital, some of my co-workers were very racist and would indirectly make racist comments. I worked in transfusion medicine for almost ten years out of the fifteen years I was a laboratory technologist. I enjoyed building relationships with my co-workers and was well liked by everyone except the management team. I fought for my rights, and went to the union for my rights, and won my grievances two times. Such incidents caused some conflicts between me and the management team.

In 2017, I was offered an opportunity to apply for a management role while my supervisor went on maternity leave. I was indecisive about taking on the supervisor's role because the toxic culture at the workplace was causing me a lot of anxiety. I had a male co-worker who made all the females feel like shit, and his presence at work made it very difficult for us to work. The workplace was not serving me, and I needed to walk away.

My job had become a source of anxiety, and in 2018 I decided to leave my career. I quit without a plan in place.

My husband Amar has been my biggest supporter. If it wasn't for his encouragement, I wouldn't be running EO Healing full time. EO Healing was a hobby of mine, and I had never thought of pursuing it as my career.

To grow EO Healing without a plan was not easy, but in my heart I knew I was going to take EO Healing to the next level. For the last two years, I have not looked back. I have let go of something that was not serving me. My purpose in life is to heal, and that's what I am doing.

It's important to share this message—a lot of women don't pursue their dreams because leaving their nine-to-five job involves uncertainty.

Please share with us how EO Healing was born out of personal experience.
In 2009, I gave birth to my first son; shortly after, I started to experience postpartum anxiety. I visited doctors and was prescribed medicines which triggered terrible reactions, and I ended up in the ER. It was at that point in my life that I began checking the ingredients in everything I consumed, from skincare products to the scented candles in my house.

It was a revelation to discover the amounts of chemicals and synthetic ingredients present in the products I was either consuming or surrounded by every day. I learned how harmful these synthetic ingredients and chemicals can be and the adverse effects they can have on our health and mood. I was shocked to find how these chemicals disrupt one's hormones and innately affects one's mental health. I got rid of the toxic products and turned to aromatherapy to battle my anxiety. This experience initiated my interest in natural therapies and essential oils.

I began experimenting by combining different natural ingredients and essential oils. My childhood story motivated me to ensure that all men and women feel beautiful in their own skin. This is where the idea for our EO Healing skincare line came from. I started with ten products.

Did you do any formal training before opening EO Healing?
In 2010, I attended and graduated from the aromatherapy school. Then, in 2012, I took a natural skincare diploma course online, and in 2015 I enrolled myself in a spa formulations and organic skincare diploma program in Europe. In 2018, I graduated with an advanced cosmetic training and colour cosmetic diploma from Australia, and in 2020, enrolled in cosmetic chemist training.

When did EO Healing officially open for business?
We officially opened in 2012—first in Surrey, BC, as an e-commerce shop. I opened up a Facebook page, and word of mouth is what helped me build up a clientele.

How does your heritage inspire the products you create?
I incorporate a lot of Ayurvedic ingredients into my products. My mom always used home remedies on us, and I wanted to incorporate some of those remedies into my products so others could experience the benefits.

How often do you think of the younger version of you?
Every day, because at my job I often meet people who share stories similar to my own. I would tell the younger me that true beauty comes from within and that outer beauty is temporary.

What inspires your passion for promoting self-acceptance to your clients?
In 2019, I attended a business coaching program, and it was all about mindset and how to reset your mind to start a new journey. We had to write about why we do what we do. I realized that my childhood experience had played a pivotal role in EO Healing.

Our clients are mostly women who struggle with mental health and confidence. I want everyone to have a skincare ritual that focuses on self-care.

You opened the brick-and-mortar shop in the midst of the pandemic. What was that like?
Words can't describe it. I get emotional every time I reflect on my journey and how far I have come. I am a risk taker—when I have the desire to accomplish a goal, I go for it. To open in the middle of the pandemic was exciting. I had built a loyal clientele before I decided to open the brick-and mortar-shop, so it was an easy decision. I remember my coach telling me to drop the lease and back out; I responded with, "I am going to prove you wrong." And I did. I'm so grateful to have the support of our clients.

Social media can be both a positive and negative experience for a brand. What has it been like for you?
I believe in energy healing and attract only those who want to be healed to our page. I am blessed with supportive clients who continue to encourage and send good vibes our way. I do feel our clientele is mostly South Asian, and it is because a lot of them can relate to my story.

Running a business as a South Asian woman has not been easy. The majority of the time, other businesses who I approached in the past for collaborations did not acknowledge our business. It could be because we are too small or because I am a woman of colour.

What is your vision for the future of EO Healing?
My goal is to spread the message about the benefits of switching to natural beauty and the importance of loving yourself as an individual first before you can help others. I want consumers to be more conscious about what they put on their skin.

Erica Sigurdson

Comedian and writer

"If someone has a belief that women aren't funny, it's because of some closed-mindedness they have. It has nothing to do with me or my comedy, so who am I to argue with them?"

Can you remember the first joke you told?
It was just after the first time I saw Johnny Carson, a stand-up comedian, on tv. My dad was laughing hysterically, but I didn't really get why this guy was on TV just talking, as opposed to a musician or juggler or someone with discernible talent. When the commercial break came on, my parents explained what a stand-up comic did, and that's the moment I knew it was what I wanted to do. I was seven years old. The next day I told my parents I had written my first joke. "What can a person in a wheelchair never be? A stand-up comic!" My parents kind of looked at me, slightly horrified by my very politically incorrect joke, but they were also kind of impressed that I clearly got the anatomy of writing a joke at a young age.

What were your favourite comedy shows while you were growing up?
I was a fan of *I Love Lucy*, *The Carol Burnett Show*, *Fawlty Towers*, and *Three's Company*. When I turned twelve, I got a black-and-white TV for my room and I would watch SCTV (Second City Television.) When I watched *Three's Company*, I couldn't get enough of John Ritter and the slapstick of him tripping over couches. To this day I still laugh hysterically if someone falls. It's the worst because oftentimes people are hurt or embarrassed, and I just can't help myself. It's probably karma that I also fall a lot, so I feel it's there's give and take.

Did you grow up in a funny family?
I'm not sure that anyone would describe us as funny, but wit and sarcasm were big around the table. Most people who meet comedians don't immediately think they're funny because comics are often quiet in public because they're observing everything around them. My personas on stage and off stage are very different unless you're in my inner circle. My closest friends see the closest version of "stage Erica."

Have your family and friends been supportive of your unconventional career?
For the most part, yes, they've been incredibly supportive and are proud of me. I think at first my parents were worried about the security of putting all my eggs in the comedy basket, but they never discouraged me. I was encouraged to have a backup trade in my back pocket but I decided against that.

What jobs did you hold before working full-time as a comedian?
When I started comedy, I was working as a bank teller. After a few months of doing open mic shows and driving downtown six nights a week, I moved to Kitsilano and soon after took a job managing a Starbucks.

My resumé is pretty corporate—eight years at McDonald's Restaurants. I attended Hamburger University in Chicago, Illinois, as I was working through the management ranks. My years working at McDonald's contributed

to aspects of my comedy when it came to being ready for any situation thrown at me and thinking on my feet. When you work the 3 am shift, you learn to roll with the punches and have a quick answer to drive-thru hecklers.

Tell us about your experience with mentorship.
When I started comedy, it seemed like a magical time in the Vancouver comedy scene. There was a weekly room running at the Urban Well on Tuesdays that had two shows going. The group of comics in the scene became great friends—and it's where I met my husband.

Brent Butt and Jamie Hutchinson, who were running the Urban Well shows, gave me a lot of stage time and opportunity to grow as a young comic. My husband JP Mass has always been and continues to be my biggest supporter.

There's no *Good Will Hunting* scene where a comic sits you down and gives advice. It comes out in little spurts—a tagline after a show, a chat after a particularly tough show, a word of encouragement when you have a great show. I don't think *mentorship* is an appropriate term for comedy because it's important as a comic to listen to all the advice and adhere to what you think is applicable to you. There's no magic recipe for success. If you follow one person's advice you never learn to figure things out on your own.

It's important to *support* one another, and comics do that in a lot of ways, but to say I am going to *mentor* someone seems egotistical. Finding your voice as a comic takes a lot of stage time. The one thing that makes you better is performing over and over.

You've said, "Comedy tends to be an industry over-represented by men." How have you found your way through this?
I don't know if it was my upbringing or just the time I came into comedy, but I was never intimidated by the fact that women weren't represented as much in comedy. I grew up seeing so many funny women on television—SCTV was dominated by funny women, and I loved *The Carol Burnett Show*, *I Love Lucy*, *Mary Tyler Moore*, *The Golden Girls*—so it never occurred to me that anyone questioned whether women could be funny.

Sure, it was frustrating hearing, "Oh, you're funny for a girl," or "I usually don't like female comics, but I liked you." But I never took that personally. I just kept doing shows, getting paid, and doing my thing.

We're raised in a society that often minimizes a woman's voice and the physical space she takes up in the world. As a female comedian, you're taking up space, centre stage, sharing and speaking your thoughts aloud. What is that like for you?
I think anyone who gets on stage and can not only get their thoughts out but also make people laugh is demonstrating crazy confidence. I think the last fifteen years of women in comedy, both on stage and in film and television, have been instrumental. It's important to show young girls it's okay to have a voice—and a funny voice, at that. I hope that by being a woman who speaks her mind on stage and is successful, I will inspire other women who want to do that.

As artists, we tend to shy away when it comes to talking about finances. Why is there sometimes a fear for some female creatives to state our worth?
When you're an aspiring artist, writer, musician, etc., we're taught that being a starving artist is the romantic journey you need to go on. Because there is a dream attached to your talent, it's easy to let yourself work way too long for way too little.

At a certain point I decided that it didn't matter that someone else would come along and do a gig if I passed it up because it didn't pay what I was worth. The gigs that define you are often the ones you say no to. So I started talking about money and how to manage money and pay taxes, etc. I felt very empowered over my finances.

A couple years back I decided to do a seminar about the business side of comedy because I noticed a lot of comics were so focused on what happened on stage that by the time they got opportunities for festivals and other achievements, many didn't have any idea of how to handle paying taxes, promoting themselves, and transitioning into working as a full-time comic. It took me years of mistakes and a lot of tax debt to figure out the business side. In talking with twenty-year veterans of comedy, I was amazed at how many were still struggling with getting their finances in order. The first seminar I held had thirty comics in attendance, and the second, held in Calgary at the YY Comedy festival, had twenty-five comics; we all shared our ideas and experiences on everything from negotiating fundraising events to agency fees. I'm a big believer in talking more openly about the money side of entertainment because it feels like if anyone should know how much money is on the table, it's the performer.

Can you recall that moment when being a comedian all came together for you?

Like many artists, I don't think I ever feel like I've arrived. I've done a lot in Canadian comedy; I've taken my career to a point where I make good money and have the respect of my peers, but you're only as good as your last show, so I think most of us have a feeling of *what's next?* There's no point you get to where you can just stop trying to be better.

Do you think you're funny?

I do think I'm funny—that's definitely an important first step to becoming a comedian. I don't know if there are definable qualities that make a comedian good or great. Comics have to listen more than they talk. That's one thing that the general public is always surprised about. They think comedians are loud and "on" all the time. In reality, most of us are the quiet, observant ones in the room.

Have you ever experienced stage fright?

I've never had stage fright like you see in the movies. I've been nervous before a show and certainly trepidatious going in front of certain audiences, but I've never walked out on stage and just stared at everyone and ran off dramatically.

Tell us about your experience with the Just For Laughs festival.

I've done Just For Laughs three times. It's one of the biggest festivals in the world and was at one time *the* festival to be invited to. It's a lot of fun but it's an emotional rollercoaster because there's a mix of relatively unknown and known comics and then television stars and agents and famous comics all in one hotel, and almost everyone is trying to give off the impression that they are very important. Some people are, of course, but in Canada we don't have teams of agents and managers the same way Americans do. I remember being backstage in 2019 waiting to perform for the Wanda Sykes Gala, and all the Americans had their people swirling around them while I and a British comic were sitting by ourselves. It's hilariously soul crushing to be at that festival and also really fun if you've got close friends. When I went in 2013 there were about eight of my best comedy friends there and it was amazing.

What is your favourite venue to perform?

Before it closed down, The Comedy Mix in Vancouver was the best venue. Classic comedy club design: in a basement, with pillars, and a bar in the back. There were so many amazing shows there. It's a shame it closed down.

What was your most memorable interaction with an audience member?

It's not an interaction really, but Pierce Brosnan was in the audience at a show I was emceeing. After every joke, a little voice in my head said, *I can't believe James Bond just heard that joke.*

How has the pandemic affected you?

It took me quite a while to feel like I wanted to produce anything or try to be creative. People would say, "You must be getting a lot of comedy from this pandemic," and I wanted to scream because there's nothing funny about losing your livelihood and having no idea when it may return. I felt resentful at first when people would expect me to find something funny about the pandemic.

Initially, I was optimistic that things would get back to normal in a couple months, so I wasn't panicking. I shied away from online shows for the first six months because I didn't think it would work with a comic trying to do comedy over Zoom. By the time fall rolled around and I had lost more work, I decided I should at least try to do an online show before completely dismissing it.

To my great surprise, I really enjoyed the show—both watching the comics before it was my turn to perform, but also feeling a connection to audience members. I realized that we're all dealing with this craziness in our own way, and the more we can connect with each other in a safe way, the better. I've now started producing biweekly Zoom shows, designed a logo, put up a website, and am learning a lot about digital marketing to sell shows. It's not a huge money maker, but we've been able to put a little bit of money in comics' pockets.

We're human beings, and we crave connection; I think we will return to that as soon as it's safe to do so. My hope for the future is that we fund the arts, give hourly employees paid sick time, and all stay home when we are ill.

Emma
Smith

**Owner and founder,
Zimt Chocolates**

"The personal shaped the professional."

What is your first memory of chocolate?

I have fond memories of eating the gold foil Lindt Easter bunnies and Milka bars when visiting my family in Germany. And also enjoying these little chocolate buttons, covered in sprinkles, at my oma's house over Christmastime.

You've said, "I had a great idea and wanted to share it with the world." I imagine there were a lot of steps between those first few sessions in the kitchen and starting Zimt Chocolates.

I started Zimt in the home I grew up in. I was twenty-one at the time. The idea was to share my creation with the world, which came first, long before I had ever made anything remotely edible. But the "sharing with the world" aspect has always been fundamental to Zimt because I never created chocolate as a hobby or out of an interest. Instead, the goal has always been to get the product out there and to take sales from the products and put them toward those who need it most, plain and simple. We could be making socks or bolts and the same idea would apply. I do, however, think our chocolate is tastier than socks and bolts.

Zimt means cinnamon in German, my first language. When I was younger and felt I had more accessible options, I wanted to move back to Germany. The name speaks to my heritage.

How did you get into working with chocolate in particular?

I haven't had any formal training, just a lot of hands-on experience with ingredients, along with time and much self-directed learning. You can learn a lot with patience and determination. Chocolate is tricky—it requires patience, no matter what.

Why vegan chocolate?

I've been vegan fifteen years now. I don't want to profit off the pain and suffering of helpless, sentient beings, thus it was never an option to put dairy or other animal products in the product I sell.

I went to Europe in 2010, and I saw that they were years ahead of us; vegan chocolate was readily available, in many forms and flavours, and seemed to be doing really well. I thought, *I'll make it and sell it in my own neck of the woods.*

Our café is beautiful. But today, we sold just over seventeen dollars' worth of product. I'm not kidding—success is not financial, in this case.

I had hoped that Zimt would have done much better by now. There are myriad reasons, but it ultimately comes down to what my brain has been able to accomplish. I feel frustratingly short of where my heart wants to be.

There are a handful of Zimt brands across the globe. Some are little cafés, some are hummus companies, some make granola bars, and some even make lipstick. For me, it was never about the chocolate; Zimt is a philosophy—what

do we want to achieve through our hard work, creating as few negative externalities as possible? It is work resulting in lower margins than what the market demands of a similar, watered-down, but completely acceptable product.

We'll keep prioritizing compostable packaging, eschewing cane sugar, using equitably traded cocoa and certified organic ingredients. There was very little available in terms of compostable packaging for consumer-packaged goods when I started Zimt. I was able to get one size of bag, but they did not fit our product. My oma hand cut and sealed every single bag we used, down to the proper size. I'm not sure this is the best marketing strategy, though; as my fiancé puts it (and he's right): people want a big chocolate bar for not that much money. At least, most people.

Is everything produced here in Vancouver?

Yes, we manufacture every single thing at our factory. The benefits of doing so are more flexibility, especially during production; we can take very sharp corners to change the course of action, to reach a better result. And we also have a bit of a test market for our new products, at the café.

In terms of challenges, there is nothing like having your own manufacturing space. But a lot has to be taken care of constantly, equipment maintenance being a big one. Then there's staffing, quality control, certification, raw materials management, and further inventory, massive overhead to cover—regardless of whether you have a terrible month or a great month—and trying to fulfill orders while juggling being creative. It's a bit much, to be honest.

Who have been your biggest supporters on this culinary adventure?

I'm really lucky; my mom was incredibly supportive. She always just helped, no matter how heavy, disgusting, or exhausting the task.

I have one friend who's been in it with me from the beginning. She comes by almost every weekend and buys cookies and hot chocolate. She hangs out while I do dishes. That's often when I see people. I have friends in this industry who roll up their sleeves, pick up a mop, and get to work.

My fiancé is a great support. We have conversations around strategy, trials, and triumphs. He often reminds me that I am doing a great job.

How would you describe the vibe at Zimt?

The shop is fresh and cute and beautiful—and friendly! I'm lucky to have a team. In 2020, when COVID-19 first hit, I was solo, just me in a factory. My team give life to the space and a reason for me to show up to work every day. They're an interesting, special bunch.

Who, where, or what inspire you?

I was inspired by my travels throughout Europe in 2010—however, a lot of the inspiration happened during my time in England. I don't feel much inspiration for the creative anymore; I feel more of a drive to help the greater mission.

On your site's about page, you say, "We are committed to donating at least 1% of all of our sales to helping those in need." Can you tell us more?

The personal shaped the professional. I've always wanted to make a significant difference and help save the world. We've created a real mess, us humans. I hope I am making the best use of my time because this is my heart. The idea of giving back was there long before any thought of chocolate crossed my mind.

Is there one particular flavour combination that received a thumbs-down at the taste-testing stage of development?

If I recall, the lavender didn't go over too well! Different strokes, I think. That said, our website says, *Real chocolate. No compromises.* People like putting mushrooms, algae, vegetables, you name it, into chocolate these days. Why? I say just eat the chocolate. You didn't do anything bad, and you are not a bad person for eating delicious, calorific food. Just enjoy it!

What have you taken from this time, during the pandemic?

That the end goal is a big driver. The world is broken—I knew that before any pandemic. But it is important to not give up; if you do, there's no motivation to do better or try to do better.

Where do you hope to see yourself and Zimt in ten years?

I hope Zimt is doing good things. There's still a lot of good left to do. I'd love to be healthy and happy and have a lot of love around me.

Myriam Steinberg

Author, *Catalogue Baby: A Memoir of (In)fertility*

"Once I set my sights on motherhood and experienced the challenges I did trying to conceive or maintain a pregnancy, it was a straight line toward authorship."

Do you have a fond childhood memory of reading?
When I was three or four years old, my dad would read me *Frog and Toad* and then teach me to read using that book. I remember being totally engrossed in the experience and loving that book. I was a big reader when I was a kid, mostly fiction story books and comic books like *Asterix*, *Tintin*, and *Lucky Luke*.

I would put books under my bedroom door at night so my parents couldn't see the sliver of light that would come from the bedside lamp or the final moments of daylight coming through the open curtain as I read myself to sleep.

You published your first book, *Catalogue Baby*, a graphic novel about your fertility journey as a single woman in March of 2021.
I realized I wanted to do something with my story halfway (about two and a half or three years) through my fertility journey. If you'd asked me at any point of my life up until my first miscarriage if I thought I would be writing about infertility and loss, I'd look at you funny. In the first couple weeks of my first pregnancy, all was going smoothly; my fantasy was being fulfilled and nothing out of the ordinary—certainly nothing to write about—was happening. It wasn't until well into my fertility journey that I started thinking that this was a story that needed telling.

You've had a circuitous path toward your current title as author.
I think the circuitous path was more toward being a mother. I've always been a visual artist, whether it's photography, collage, or sewing giant wall hangings. I always had the nugget of a writer in me, but I never pursued it and always lost interest in any writing projects I'd start. I think that my role as an author had to have purpose. The writing couldn't just be for me—it had to be meaningful for the rest of the world. It couldn't only be beautiful, cathartic, and artistic. Having lived through loss and infertility gave me that purpose.

I've worked a million odd jobs, including salesperson in a clothing store, cleaner at a fish plant, transcribing for documentaries, and Airbnb host. For the most part, those jobs paid the bills while I endeavoured to be an artist or festival producer. My heart careers were first in the visual arts and then, for eleven years, as producer of the In the House Festival in Vancouver. Whether it's creating the art or producing it, the mere proximity to talent, originality, wit, and ingenuity is inspiring and sits with me to this day. It's given me the ability to think outside the box, tell stories in more engaging, original ways, and understand what someone might be interested in when they are reading.

What made you decide to share your story in the genre of a graphic novel?
There were too many things that happened, emotions that I felt, and sensations that I experienced that defied words. Either there weren't the appropriate words to describe them, or it would have taken too many words to describe, and the reader would have gotten lost in them. Plus, I'm

a very visual person. There was a kind of synaesthesia as I was thinking about my story where I would get flashes of images that were often metaphorical, but which always described what I was going through in a much more effective, efficient, concise way than mere words could do. There's a different, arguably deeper intimacy with the story that is created when you see an image versus reading words. You can't fuzz out the hard bits. Instead, you are forced to enter someone's world in a very immediate and visceral way.

Was it hard to put the experience into words and pictures?

It was both easy and hard to write the book. Two things made it easier: First, it's hard to forget things that are so physically, emotionally, and spiritually challenging. Not only was everything I'd lived through still so vivid in my head, but I was actually still on my journey to children as I was writing the book! I went through at least three embryo transfers and one miscarriage as I was writing. I had no idea what the ending was going to be. Initially, I wrote an ending that was open-ended. I was hyper-conscious of not saying or implying that "And you too, if you try hard enough, will have your baby." That's just not true for so many people, and I wanted to be sensitive to that. By the time it came to the editing process of the book, I was pregnant with my twins. By the time the illustrator got to drawing the ending, the twins were born. It actually took a lot of convincing by my publishers, friends, and illustrator that it was important to make the twins' birth the ending.

The second thing that made it easy to write was that I had photographed and videotaped almost every part of my fertility journey. I transcribed all the footage and, as a result, I was about to use direct quotes for many of the characters. It lent a real authenticity to the dialogue and the interactions. It was also much easier to remember and inject the humorous aspects of the story and specific emotions when I could go off a video or photos.

The hardest part was deciding what to write when. Whenever I was pregnant, I had to be very aware of self-care. I chose not to write about miscarriage or my termination whenever I was pregnant. I didn't want to take the risk of imposing that sadness on the baby or creating high stress levels for myself that might put the pregnancy at risk. As a result, as I wrote, I jumped around

a lot in the story and wrote the book as vignettes. I put everything together afterwards so that the flow and transitions of the story were smooth, logical, and interesting.

Writing *Catalogue Baby* was cathartic. It by no means eliminated the pain of what I had gone through, but it dulled the edges of the grief.

Was there a specific memory or experience that was a challenge to recount?

Writing about my pregnancy and subsequent termination due to genetic fetal anomaly was the hardest thing to write about. After all, how could someone so deeply on the quest for a child terminate a pregnancy? I struggled with the fear of being judged and condemned for my choices. I felt like I was constantly treading the fine line between defending versus explaining my decision.

As a single woman going through this journey, whom did you lean on?

I was lucky in that my friends and family were incredibly supportive. I also ended up sharing my story on Facebook. The comments and love I received from my friends and acquaintances was astounding. It showed me that my story is not unique, and that compassion and empathy are real. When I was going through IVF, I would have those comments up on my screen cheering me on as I stuck needles into my belly. It was like having my own cheerleading squad. I was also very aware of compassion fatigue. I tried to build my network out so that I didn't have to rely on only one or two people for emotional or physical support. But fundamentally, I would not have survived this journey, or made it to my rainbow babies, without the support I had. I also want to stress that I think it's important to lean on people not only in the hard times, but also to invite them in when things are going well.

How did you find the time to finish the book while the twins, Isaac and Abegail, were babies?

I got pregnant with the twins as I was finishing up the script. I was three months pregnant when we went into the editing phase. I was four months along, and on bedrest when the illustration process started. By the time we got to the colouring phase (which I had to take on), the kids were one and a half years old, and the pandemic had hit. I was editing illustrations and colouring whenever the babies were

napping. When my boyfriend got laid off because of the pandemic, he was able to help with the babies for a couple hours a day. But basically, my life for six months was babies and book. There was no respite. I had to work efficiently and quickly to meet deadlines. I work extremely well under stress and a tight deadline—all I needed was a room away from the kids. The room would be in utter chaos because the kids were in there in between my working times and I didn't have time to tidy after them, and I would forget to eat and sleep. Sometimes I would be editing as I was pumping milk for the babies.

How long did it take to write the book?

It took about three years to write *Catalogue Baby*. It was difficult to start because I had no idea how to actually write a book, much less a graphic novel. But once I figured out how to start and how to write the book, it, in a sense, wrote itself. I don't know that I ever felt uninspired or that I wanted to stop writing and quit the project. It felt like it was too important of a story and a resource to get out into the world. There were moments of writer's block. Because *Catalogue Baby* is a graphic novel, I was not only writing the script for it, but creating stick-figure panels of the entire book (storyboarding). When I was stuck writing words, I would draw out the story. If I got stuck on how to tell it with pictures, I would go back to writing a script. I would also jump around in the story, so if I was stuck or emotionally not ready to tell a certain part of the story, instead of losing motivation, I would simply move on to another part.

Catalogue Baby was released in March 2021, a strange and unsettling time.

It both sucked and had some advantages. Because all the events were virtual, it meant I didn't have to spend a fortune on travel expenses. However, the main way to make any money with your books is to sell them directly and having in-person events is way better for that. If someone buys your book during or after a virtual event, it means you only get the royalties from the book, not the retail price, or a decent chunk of the retail price.

How has the book been received?

Catalogue Baby has received wonderful reviews, both by the press and the community. The general consensus seems to be that this book is so necessary, and the honesty and rawness of the experiences within it are sometimes emotionally hard to read, but refreshing and powerful. It seems to particularly resonate with people who have lived through miscarriage and infertility, and with Single Mothers by Choice. I've received many messages from them saying how, when they read my story, they were brought right back to their own journey.

What do you hope readers feel when reading your book and hearing your story?

If they are going through a fertility journey themselves, I hope they feel that they are not alone in their journey. I hope they find nuggets of hope, understanding, compassion (for themselves and/or for the people around them that are going through infertility and/or loss). I hope they feel compelled to keep the conversation going, and to normalize and de-stigmatize the realities of miscarriage, infertility, and the various choices a mother might make.

I've had a few memorable messages from readers. I'm blown away by the depth of emotion and gratitude they express in their messages. I expected to possibly get some "This is a great book," or "thanks for writing this book." But what I'm getting are women sharing parts of their journey and long messages of gratitude that the book exists to validate their experience, and to show the world what so many people go through.

Can we look forward to a follow-up book?

I'm starting to collect notes for a sequel! My pregnancy with the twins was anything but easy; yet again, my experience was something no one talks about—living through high-risk pregnancy, birthing premature babies, life in the NICU, and the first year as a single mother by choice to twins. The book is tentatively called either *100%* or *Stick, Stay, Grow*.

Roberta Vommaro

Founder, Salt & Spirit Collective

"We are witnessing one of the biggest mental health crises of all times. If our days are counted, what is truly important to us?"

What is your first memory of moving your mind and body in a meaningful way?

I was thirteen years old and I had injured my shoulder surfing. I had always been very active and competitive, so the forms of movement I was used to always had an end goal. The physio clinic I went to had a fitness classroom, and one day I happened to see a power yoga class through the window. I was intrigued. I saw people going upside down into headstand, and my goal-oriented mind immediately went, *I want to do this!* So I enrolled in the class, eager to stand on my head.

What happened within the first few minutes of class (we were sitting cross-legged, doing breathing exercises) was indescribable: I went to a place I had never gone before. I felt free and yet incredibly comfortable. I felt like *yes, I'm here, in my body, and this is what my body is for.* I left the class feeling blissful, bought a classic Hatha yoga book, and started doing yoga on my own the very next day. And yes, I did get to stand on my head.

Were you exposed to various forms of mindfulness and spirituality growing up?

Absolutely. My grandmother was very spiritual, as was my dad. One event that particularly struck me was when my grandmother introduced me to one of her friends, a woman who was said to have the gift of seeing the unseen.

I was seven at the time. I remember the woman placing her hands on my head and smiling while saying enthusiastically, "The light! She has the light!" Then she looked deep into my eyes and said, "You have a gift, and you will do spiritual work. You are a servant of the light. You need to serve."

What I love about this story is how she used the word *serve*, as in, these gifts are meant to help humanity, and if we have them, we should honour them by using them.

How did the physicality and culture of your homeland shape you?

I was born in Rio, one of the biggest cities in Brazil, and one of the prettiest ones too. It's a city by the ocean, surrounded by lush nature. The beaches in Rio are famous, and Rio is a very cultural city—museums, art galleries, cafés, poetry nights, live music, you can find it all in Rio.

People are warm, inclusive, and there's a depth to relationships; small talk often becomes a deep conversation, and a casual encounter can blossom into a friendship effortlessly. Perhaps this deeper connection comes from dealing with issues that most people in the world don't have to. There's also a dark side to Rio; it is unfortunately one of the most dangerous cities in the world, and inequality has always been present. I feel this contrast has taught me to understand the polarities in life, the idea of darkness being a way of showing us the light and making us remember that any day can be our last, so we'd better make it count. Rio taught me to practice what I teach: aim for deeper connections, do what you love, don't waste your time with pettiness. Be who you want to be. Today.

Prior to teaching yoga and meditation, you were a lawyer. What inspired you to switch professions?
The transition felt natural, and I had decided back at the ashram that I would teach yoga for a while and eventually open my own yoga studio. I had no clue how this would happen; I just knew this is what I wanted. I arrived in Vancouver at the end of 2010 and enrolled in a yoga class. Within a few weeks I was asked to teach, and the process unfolded.

My parents were slightly concerned, but not surprised. Before I moved to the ashram, I had ended up in the hospital with an unusual kidney infection. It took two weeks on heavy-duty antibiotics to recover. I remember at some point thinking there was a possibility I wouldn't make it. One day in bed I heard an inner voice: *Your days are counted. What do you really want to do?* This is when I started the process of transitioning from practising law to teaching yoga and meditation.

It was a period of transition because I didn't quit immediately, but this eye-opening experience was the catalyst for the shift. People ask me if it was burnout, but I'm not sure that's what I would call it. As an entrepreneur I work the same number of hours I did as a lawyer (sometimes more) without feeling burned out. I feel it was actually a misalignment with my destiny, with who I really was and am, and my body was literally signalling that.

When I quit practising law, my parents were understanding. My friends were supportive and would ask me for yoga and entrepreneurial tips, or tell me how brave I was, and how they wish they could do the same.

In 2008, you moved to an ashram in upstate New York. What inspired that choice, and how was that experience?
I met someone who had just come back from a longer stay at an ashram (a spiritual retreat site). I resonated with her experience as both of us started working quite young and both of us had a passion for yoga and meditation. She looked happy, serene, and ready to tackle the next phase of her life. It was inspiring, and when someone told me there was an opportunity to move to the ashram long term, I didn't think twice, and I applied. Like with most things I decide to do, it happened organically, manifesting itself promptly.

I stayed at the ashram for almost two years. It was an amazing experience, and I learned how to open up to love there. Most people go to an ashram to find themselves; naturally I did this too, but an interesting thing that happened was that the more I connected to myself, the more I opened up to others, attracting true, meaningful relationships. My favourite experience is that I met my beloved husband Mike at the ashram.

I knew Mike would be my husband before we actually got together. (I know, it sounds super woo-woo!) I had recently arrived at the ashram, and I was at a group meditation class with several people, including Mike. As I came out of meditation, I opened my eyes, and my gaze was directed toward a spot in the room, a few rows in front of me. Though there were several people in the room, I could only see Mike's back clearly, while the rest of the room was all sort of out of focus. I opened my eyes, saw his back, and immediately heard this inner voice that said *husband*. I was like, *What? I barely know this person!* (I actually didn't even know his name at that point.)

And then one day, out of the blue, Mike asked me out on a date. I feel we both knew when we started dating that we were meant to be together.

How did you feel upon your arrival in Vancouver?
I had been in Vancouver before, in 1998, as a teenager. I fell in love with the city and promised myself one day I would live there. Vancouver in 1998 was quite different from when I arrived in 2010, but the city still felt like home—it always does, even when I complain about the rain or the slow traffic. When I arrived, I felt immediately inspired to work; everyone seemed to be doing yoga or some form of self-improvement, so it was very fitting for me professionally to focus on my passion.

What year did Salt & Spirit Collective open its doors?
I've always wanted to open my own business, ever since I started teaching yoga. I felt I could combine my corporate skills with my passion for teaching, and this has always been part of my plan. The ten-year mark happened organically; it wasn't really on purpose. I started looking at options after about seven years of teaching in Vancouver; I was renting multiple studios by the hour to teach my classes, and I felt it made sense to bring them all to one location.

Salt & Spirit Wellness was the studio, and we rebranded it to Salt & Spirit Collective in 2020 when we closed the brick-and-mortar space. The Wellness Studio opened at the end of 2018. I had been teaching alignment-based yoga (Iyengar) for almost ten years, and my goal was to first educate my existing clients about my new wellness

offerings (which explored spirituality on a deeper level), then branch out to new clients. It was a slow process but also necessary because the concept of our studio was quite new—our services included energy healing, meditation classes, Ayurveda, sound therapy and gong baths, as well as yoga and meditation. We were not a typical yoga studio, but more of a wellness centre with a strong spiritual, non-dogmatic concept.

The challenge was that people still associated the word "wellness" with spas or health clinics, and although studios like ours were trending in California, this spiritual wellness concept was new to Vancouver. We were one of the first studios in town to offer this concept, so we had to do a lot of education in the community. I still remember people reading the "wellness" sign at the door and asking us if we were a doctor's office.

About a year later we broke into the market, our concept became clear to people, and the community grew. In 2019, I also started offering our kundalini courses online, growing our audience worldwide.

You've described your courses as offering "spirituality sprinkled with science" and "timeless practices for modern life." Can you share more about this?
From very early on I was eager to explore the concept of wellness deeper, invariably reaching the idea of Spirit. Spirit is that part of yourself which has no sensory feedback, but that you know is there. It's not the mind, as the mind is a concept in itself, which is understood by *you*. This is the you (or the spirit) I've always wanted to focus on.

This work involves yoga, meditation, and timeless practices, and I have always been one for practical results. We removed dogma from the idea of spirituality, keeping it approachable, grounded, practical. *Science* is a word I like because it describes (in part) what I mean by results, which is ultimately an experience. None of our courses, trainings, or workshops are about accumulating knowledge, but more about having a unique, uplifting experience.

What we do at Salt & Spirit is distill some of these concepts (spirituality, meditation, energy) into a practical science, something you can practice and experience every day to live a better life. The goal is not outside yourself (not some "woo-woo state" that will remove you from your current reality), but to go deeper into yourself, and from there live your most authentic and expanded life.

Since the pandemic hit, you've closed the studio in Vancouver. Can you share how this came about and how it's been for you?
Gosh, what made me decide? It was pure, one-hundred-percent intuition. I was set to teach a retreat in Italy in July 2020 and was in close communication with a friend who was organizing the retreat in Lake Como. On March 3, 2020, she sent me a message saying the situation in Italy was really bad and that we should cancel the retreat. By March 10 things started to get really messy there and I had a feeling we would be hit as well. The closure order in Vancouver came on March 16 and I was ready for it. The initial order was indicating it would be for two weeks, but deep down I knew it would be for much longer.

There is a concept in yoga and spirituality that is referred to as the Golden Age, or the Age of Aquarius. When the pandemic hit us—actually, shortly before that—I felt a shift. I knew in my being that we had begun this transition into the new era and that the transition in itself wasn't going to be easy, though in the end we would be fine. My intuition told me to trust this process and close the studio. This industry has been changed forever. Not to get into details here, but online yoga is here to stay.

I had already been offering online courses, as well as business coaching. I expanded the online courses and created a new business—Salt & Spirit Collective—bringing our courses worldwide. It felt like an expansion, in spite of the difficult situation we were facing as a small, independent business. The closure was hard both on a practical level as well as emotional, but it felt like the right move. What I love about being online is that I get to connect with people from all over the world. We have clients in Australia, China, so many countries in Europe, South America, and of course Canada and the US. I have always felt like a citizen of the world myself, so this concept feels right to me.

What are some simple ways we can incorporate mindfulness into our daily lives?
I like the idea of mini meditations. Deepening the breath is another great tool, as well as looking at a beautiful natural landscape.

Cassy Vantriet

**Founder and CEO,
WOASH Wellness**

"The only way to be in the driver seat of your own wellness rituals is to listen to your body; be guided by your inner voice, and implement practices, products, or foods that align with those needs of your body."

Do you have an early memory of tea?
I first drank tea with my oma when I was eight years old, a lightly steeped orange pekoe tea with half milk and a lot of sugar. I'd drag this green stool over to the kitchen counter and watch the tea steep and help her prepare it. We'd get a Dutch cookie too, something I still do when I'm craving something sweet. Teatime with her and my sister always made me feel a little more grown-up as we sat around sipping tea and chatting.

Have you always been interested in the idea of wellness?
I grew up in a household with very active parents and a pantry filled with whole wheat bread, fibre cereals, and no junk food. It was the only lifestyle I knew. I don't think it was deemed "wellness" yet, but my mom always made us take our vitamins and use natural remedies for seasonal colds and flu. I even joined my mom's gym aerobic classes at a young age and running with her on the weekends because I enjoyed it.

This way of life has stuck with me; I'm the type of person who craves clean and healthy food. I seek it out on menus and fill my pantry as an adult with foods to support my body. I've had many friends ask me what I eat, and when, and what I do for exercise; it always makes

me laugh because I never really thought of it—it's always been innate.

What does wellness mean for you now?
Listen to your body. It is constantly communicating with us, and our needs are always changing; all we have to do is create the space to feel it, listen to it, and give it what it's asking for. We are constantly being bombarded by the latest wellness trends, and the majority of time those may not work for you as we are all unique.

I believe that everything our bodies and minds need to feel well surrounds us in nature, and implementing the endless benefits of nature into our day-to-day can have substantial benefits on our overall wellbeing, whether that is from food, tea, the outdoors, or creating practices around being in nature.

Depending on the day, the season, or period in my life, my wellness rituals change; I crave different foods, herbs, movement, and practices.

Our bodies are made up of a variety of chemicals that are signalled by things we do, such as the food we eat, type of physical activity we engage in, when we sit in the sun, are surrounded by people we love, when we are passionately talking about something, when we are participating in something we love—all of these and many more signal different chemicals in the body, for positive and negative. This is why listening to your inner voice and doing the things that bring you joy will have a significant impact on your wellness.

What inspired you to start WOASH?
WOASH was a concept that grew unconsciously over time. During my time spent in Southeast Asia and Central and South America, I felt many seeds were planted throughout

my experiences as I explored nature, communities, markets, ceremonies and tea plantations. As I look back now and try to put all the pieces together in how the idea for WOASH came about, there is no clear roadmap but a few key places, people, and experiences that led to me believing enough in myself to bring this concept to life.

Why tea, I'm not sure. I had always enjoyed it from a young age, trying all the flavours, but I think it was all the ceremonies I had the honour of being a part of during my travels where a cup of tea signalled the beginning of something much bigger, much more healing than words could describe or the eye could see.

How would you describe what you do at WOASH?
WOASH creates unique herbal formulations to enhance everyday wellbeing. We encourage our community to create space for themselves, to listen to their body's cues, and to give their body what it needs by utilizing nature and its benefits. We create unique products that give permission to take control back over how one feels each day. All our products are intended to be easily implemented within one's daily rituals.

You've said that, prior to starting WOASH, "I was struggling to shed feelings of shame and some of society's expectations that I had internalized."
My personal journey has directly shaped my business journey, each playing a crucial role in my new commitment and vision for WOASH.

Prior to starting WOASH, I felt like I was on this endless search for my purpose. I knew it was much bigger than the "traditional path." I felt lost and confused, like I was being pulled between what I thought I "should" be doing and what I knew in my gut I needed to do for myself. This sparked my overseas travels. I was on the hunt for clarity, hoping to discover who I was and my professional path.

The one thing that felt true to me was that I wanted to work for myself. This ten-year journey did not go without failures: I dropped out of college courses and lasted all of two days working as a secretary. Being conscious of the fact I was not yet ready to decide what I wanted to study or do as a career, I continued to say yes to things that didn't feel right only to appease those around me.

One of the scariest moments was emailing my family to share with them my big idea. My fears were quieted when I received only encouraging responses.

WOASH has given me the space and freedom to discover myself. The process of starting WOASH was messy as I was trying to navigate everything that goes into starting a business, setting work hours for myself all while continuing to work as a server at a restaurant. What I took away from this stage was that it was key to step outside my comfort zone and push my limits, and to fully trust my skills and ability to create the brand and life I know was meant for me.

In spite of my determination, there was a real fear of failure and moments of crying because I didn't think it was going to work. I overcame these fears through self-growth, while working on myself. By investing in myself, the business grew in a positive direction. I was building it (and myself) up simultaneously.

When did WOASH officially open?
September 28, 2018.

WOASH is currently an online brand only. Will it always be this way?
We have no plans to open our own space. We have an online store and partner with other aligned online brick-and-mortar spaces to carry our product. WOASH was birthed from my travels, and I have always wanted the freedom to travel whenever I want and to be able to work from anywhere, so for now it will remain online—but you never know!

You've mentioned the process of "finding my voice within a saturated market." Can you share more about this?
I spent the first two years of business struggling to find the right voice and message for WOASH—how to articulate our "why" to the world and carve out our niche in a market with a unique voice. I also spent the past few years trying to figure out my own voice within the company, which has led to imposter syndrome as I'm not an herbalist, doctor, or nutritionist.

I have a business background and an enthusiasm for wellness and a love of tea. I have often felt like a fake when it came to talking about the benefits of herbs, what a specific tea could do for your wellbeing, etc. It has taken some personal growth to own my voice within the company and to accept that I don't have to be a specialist to talk about the products or brand.

There was a point where I compared myself too often to other brands. I took a break from social media to quiet the

noise and discover what my voice was. I also had to surrender to the journey of a young brand, as things change daily when you're just starting out, so utilizing those opportunities to try new things, to experiment with and discover the brand's voice, was crucial to gain clarity on what WOASH is within the market.

I spent the first year at WOASH absorbing information other successful entrepreneurs shared with me. The hope was to speed up my success. After months of doing this and following the footsteps of others, I realized that I had completely misled myself, taken the wrong path and somehow lost the initial vision and values I had for WOASH. Around the one-year mark I gave my head a shake and muted everyone I had been trying to emulate and decided to be quiet so I could rediscover my intentions for both myself and my business.

Why is authenticity key when building a brand?
It's the only thing you have that will make you stand out alongside the other brands on the market. At the end of the day, the founder is what makes the brand unique; the more we can lean into what makes us *us* (our innate skills), the more unique the brand will be.

Tell us about the importance of laying down a firm foundation for WOASH.
I'm not one to do things twice. I had a big vision for WOASH and its future, therefore I spent a lot of time and money building a solid foundation for my business to grow from. I like to be organized and prepared. A firm foundation, I learned, is key.

This idea looked like outsourcing, where I would bring in experts to consult on different products, strategies, marketing, SEO, copywriting, etc. It was also about building a solid market in Vancouver and surrounding areas. Once I established the foundation and a steady stream of income, WOASH was growing by word of mouth and exposure. I was able to focus my energy and investments on growing beyond Vancouver to other provinces and eventually into the US because of the firm foundation I put in place.

Can you share more about the process of "learning to identify and trust my strengths"?
It's no shock that I learned so much about myself along this journey. I discovered skills I never knew I had. It took some self-growth to get to a place of being authentic as

a business owner. This translated to a lot of outsourcing, learning from past mistakes, and finding compassion for myself as I learned who I was.

It always makes me laugh how much we overlook our strengths, yet we spend our whole life trying to improve upon our perceived weaknesses. I believe in leaning into what comes easy to you (your innate skills) and outsourcing the rest (to someone else who has those innate skills).

The process can be tough at times, but staying curious and looking for patterns will help you find your path and discover where your true purpose lies.

What are your thoughts on the importance of learning to say no?
I spent the first year of my business being a "yes" woman. I'd collaborate, participate, facilitate anything that came across my inbox. It allowed me to establish a strong Vancouver-based community quickly; however, it also made WOASH very hard to distinguish and understand as we were trying to be everywhere. I learned to say no a year and a half in when I began feeling resentful. I felt like people were taking advantage of me as a new business. Again, I had to give my head a shake as I was the one who created this mess. I had to take responsibility and shift the narrative. I learned to say no to be in better alignment with my business and carve out our unique niche within the market.

How do you embrace "owning what I don't know"?
There's no rule that says I have to be an expert in every aspect of my business; I put this expectation on myself. Once I allowed myself to focus on my strengths, it opened up space to bring in experts—copywriters, brand designers, naturopathic doctors, holistic health nutritionists, herbalists and practitioners to assist in bringing my vision of WOASH to life.

Wellness is a hot topic, especially now.
Yes. We saw a spike in interest and sales during the beginning of the pandemic as the products and lifestyle we curate aligned well with the needs of our community during this difficult time. We have been dedicated to always questioning how we can serve our community better depending on what is going on in the world, how can we support them during this time of need. This has helped us maintain that growth and truly support our community as we are all in this together.

Jessica Wilson

Owner, SALT Pure Goods

"If we approach each negative experience with willingness to learn and dig deep into what it can teach us, it can create some of our greatest moments."

What is one of your early memories of the ocean?
I don't have many visual memories; it's more about feelings. Today, when I am near the ocean, I am transported back to the grounding, warm, safe emotional place that I felt when we were on our childhood family adventures. An early memory for me is the feeling of a life jacket—big, bulky, hot and sweaty; that feeling always meant the ocean was close. I can remember sitting on the fibreglass decks on our family sailboat, stuffed into a life jacket, coated in sunscreen.

When growing up, were you exposed to environmentalism as both an ideology and way of life?
The island I grew up on has many environmentalists, so maybe through some form of osmosis I absorbed this ideology. But I didn't really clue in to the fact that we as humans had the power to evoke environmental change through our choices until I was in my twenties. I always cared about human impact, as this was a key issue growing up, and I was taught the values of kindness, inclusion, and treating people with respect. When I began working at the Salt Spring Saturday Market, I started to witness how environmental impacts and business can be tied together.

I was raised by the sea; I was born in North Saanich and moved to Salt Spring when I was two. My dad is an avid adventurer, and the older I get the more I realize we are kindred spirits in that way. My dad decided to buy a boat with his brother shortly before I was born. This choice shaped our families' lives. It stirred a sense of adventure, and we would take turns using the boat every other weekend. We explored the coast on that sailboat. One boat led to the next as the families grew; we all have our own boats, as the ocean has been our weekend home for as long as we can all remember.

How does nature inspire your brand, SALT?
I think the power of nature is to reflect on how it exists in the first place. We wander around with so much inward energy these days. There are countless thoughts about timelines, tasks, and to-do lists. I think the real power of nature is that when you're in it, it reminds you that it exists. "Hey human, I'm here, always and forever." Nature is like a subtle truth that then demands respect. I believe that if we could all just escape the race of life and spend more time in nature, we will be reminded that our problems are not that big. Nature exists alongside us, with us, not for us, and it needs our care so we can continue to coexist. The memories from my childhood motivate me to educate and preserve what I can for future generations.

You opened the first flagship SALT shop on Salt Spring Island in April 2016.
Well, truth is, my journey to this place has been a bit of a rollercoaster, like all good business and life stories. SALT is an evolution of my business journey. I had two different brands before SALT. I started a small screen-printing company in high school, selling at the local Saturday market in the summer. This evolved after a few years into a

brick-and-mortar retail shop in 2012. I had a partner in this shop. We were one of the first sustainable shops in our area adhering to a strong set of values and guidelines. I had this company for five years and left the partnership in 2016 to pursue my own brand. I wanted to run a company that made me feel excited to wake up every day, one that really represented me to my core; this led to SALT, and I came up with the concept for SALT in thirty days. In some ways it was not much different than what I had been doing for the past ten years, and in other ways it was a hundred percent different. SALT was formed on the basis of ocean awareness and sustainable fashion; I wanted to create a community of people that could rally together around the same passion, the sea.

On your website you describe your brand as "born from the ocean. Canadian made and designed to last."

I always say I could float before I could walk. In some ways, most of who I am today is "born from the ocean." I look to the ocean for guidance and grounding; in turn I make sure that every choice made respects the sea, expands people's love for it, and keeps it healthy. This is the SALT philosophy—to be one with the sea, and to respect and love it.

Canadian made is a fact. We ensure that all SALT products are made in Canada; we will never compromise on this. Designed to last is also a truth—ask anyone who has a SALT tee. They are comfortable, durable, and last longer than any shirt they have ever owned. In a sense, this is our mission statement.

How does your passion for ocean conservation figure into the brand?

We have a no-plastic approach to doing business, as well as being sure not to carry any plastics in the shop. This is only one part of what it means to take care of the ocean. We are building an awareness within the community that wants to protect the planet, specifically the oceans. This is where we thrive. We bring items to the market that can teach people how to live an ocean-friendly lifestyle. Outside of the products, we also donate portions of our sales to ocean conservation initiatives. As well, we host events that build awareness around connecting to the sea. In 2021, we had events such as Yoga for the Ocean, polar bear swims, and beach nights planned. If we can get humans to connect, we can change the world.

You have no formal training in design or business. You do, however, have passion, a strong sense of purpose, solid skills—and, in your own words, you are a big dreamer. How has this played out for you?

I tell every entrepreneur I meet, "You must have a purpose bigger than yourself, and bigger than what your business actually does." Yes, we make clothing, but we do it to build a community that cares about ocean awareness and conservation. Business will challenge you in ways that no school can prepare you for. To keep going, you have to possess the drive to keep going. I believe this comes from finding a purpose that expands beyond the business. Being a dreamer is a hundred percent required to run a business.

My hands-on journey has taught me to be tough, ask for what I need, assert myself, and evolve to a place of knowing that I can do it. The key is to articulate what you need with compassion. If you do that, you will never go wrong.

Who have been your biggest supporters as you grow SALT?

My mom and my staff. They always show up for SALT and for me. I have been very fortunate to hire really great women who love the brand and what it stands for. I think if you show up for your people, they will show up for you.

Who, where, or what inspires you?

I am often inspired by women living their true selves with compassion and bravery. It's tough being human. When I see people putting themselves out there, this encourages me to keep going. I'm especially inspired by poet Rupi Kaur. I also have a lot of strong women in my family that remind me to show up for myself daily.

The ocean inspires me always. My freediving suit inspires, too; it's all about boundaries, setting goals, and respecting your limits at the same time. It's a really cool sport. I am inspired by good design, whether that be branding, architecture, interiors, or lifestyles.

My boat inspires me to be creative with my hands and create a grounding space. Salt Spring Island grounds me, as it will forever feel like home, a haven.

You currently live in Victoria, where you've opened a second SALT shop.

I always knew when I started this brand that I would have to expand. Manufacturing comes with minimums, and it was often a lot for what the little Salt Spring Island shop would

sell in a season. Being able to sell to more people was a must. Having a shop in a second larger city meant that we would turn over our inventory quicker, be able to make more at once, and help keeps the cost affordable for our customers.

Victoria was a natural fit as it's also a city surrounded by the sea. We opened our Victoria shop in 2018, two years after we opened our first location on Salt Spring. I never thought I would leave Salt Spring, but after meeting my partner it felt right to be here with him. In turn this has been a great change and has enabled us to grow the SALT community in ways that wouldn't be possible on a tiny island.

Which brands and/or designers do you admire?

I would say I am deeply in love with the British surf lifestyle brand Finnisterre. They inspire me in business. They are my vibe but on the other side of the world. They do good things. For me, this brand ticks all the boxes for inspiration: style, environmental standards, design, message. I love it.

Please share with me your creative process.

My creative process is a mixture of living and space. I find if I get bogged down with work, I lack inspiration. I need to step away to get inspired. I often do woodworking projects as my mind floats there. I'll fix my boat or build something of use. I design out of a place of need most of the time. I have firm rules that if I need something, I should bring it to the market. Once I have an idea, I start the process. It involves a lot of emails and collaboration. I would say my action space is very clean—minimal, bright, full of caffeine and good tunes.

How has the business of building the brand contributed to your personal growth?

I've been running my own business for fifteen-plus years now, since I was sixteen, so it has been a journey of constantly evolving. I often joke that I am better at business than relationships. When I reflect on why, it's because I've been in a relationship with business for much longer than I have been in actual relationships with partners.

I use my confidence in business as a reminder of the growth I have achieved and what I can do if I simply show up. Being present and choosing growth in the difficult times have been my biggest lesson today. Every contract negotiation, manufacturing hurdle, co-worker relationship and many other business daily tasks build confidence in myself that I transfer into my personal life.

My daily routine is never the same. My work is dynamic, collaborative, and challenging, and I wouldn't have it any other way. I am motivated by growth, almost to a fault. If things are not moving in a direction of personal evolution, and if my dreams aren't becoming a reality, I simply won't accept it. I have let go of friendships, partnerships, collaborations and more if there is no forward growth.

How has the pandemic affected the brand?

I can't say anything bad about the pandemic other than it's been really hard. But hard stuff makes us grow, and my life has grown so much. My mindset changed, my business grew, my heart expanded, my awareness grew. We've grown, but not without a lot of struggle and hardship at first. But that reality has made me ask myself how I and the brand could move toward growth.

Do you have words of advice to others looking to embark upon entrepreneurship?

Entrepreneurship is a lifestyle before it's a business. If you can sign up for that, you will do well. You have to be doing it for a reason bigger than money and bigger than yourself—otherwise you will lose interest when things get tough.

I learned during this time of imposed-upon stillness and isolation that sometimes what seems like an obstacle is, in fact, an opportunity.

Acknowledgements

TO EACH PERSON featured in *Bloom*: The passion you bring to what you do is pivotal to bringing your stories to life on the pages in this book. The heart with which you walk the journey and give to others through your work is everything. Thank you for the endless messages of support throughout the process, and your belief in this project. The book is here because of you.

Former *Fashion* and *Elle Canada* editor-in-chief, Noreen Flanagan, who published my first personal essay in 2013 and whose belief in my words made me believe in myself.

Publisher/editor/founder of *Women's Surf Style Magazine* Sandra Olson, for the opportunity to start somewhere.

Editor-in-chief of *Fashion,* Bernadette Morra, whose professional enthusiasm and patience with the pitches I send motivate me to continue to seek out stories that move.

Former fashion news director at *Fashion,* Odessa Paloma Parker, for the opportunity to experience positive collaboration. Her innate artistic flair and passion for the arts and fashion continue to inspire.

My editor at *LUXE* and *Ottawa Wedding,* Pam Dillon. Working with her expanded my skills and gave me the confidence to keep going.

Former digital editor at bust.com, Lydia Wang, for her enthusiasm to publish the first set of female-focused profiles I sent her on the regular during the early days of the pandemic. Wherever you land Lydia, you will achieve great things.

To every editor who took the time to read through a pitch I sent, and to every editor who rejected a pitch: your feedback was invaluable in making me want to work harder and write better.

Lara Kordic, who saw the potential and importance of sharing the stories on these pages. And to the incredible team at Heritage House Publishing for bringing this book to life.

My health and wellness team of wonderful women consisting of: Dr. Rachel Stewart, Alexandra Howard, Susy Tucker, and Marion Sahlmann. All of you have formed a crucial part of my healing journey. Your individual dedication to your calling has moved me to a place I never thought attainable.

My friends and family near and far. Over the past twenty-plus years, I've had the great fortune of encountering a wonderfully eclectic group of people around the world, from my days working at Club Med Resorts to my time living in Japan, Boston, and the Philippines, and all the travels in between. There are many incredible people with whom I crossed paths. I'm thankful that we've kept in touch. Your ongoing love and support through all the layers of life means the world to me.

Daena, my best friend of nearly twenty-five years. We met at the Sassy Bead Shop back in 2000. Our connection to and love for Australia sparked a forever connection that I'm grateful for every day. You are my sister in this lifetime and hopefully beyond. Thank you for always believing in me and listening to my endless list of story ideas over the years.

Aunt Janice, my earliest and fondest memories of you are from the long, sweet summers I'd spend in Pennsylvania as a young child. Your unwavering love and support continue to carry me through what has oftentimes been a seemingly solo mission since the passing of my mom. Thank you for being a beautiful soul.

My husband, Christian. Over the years, you've softened and warmed to the idea of this unpredictable yet totally fulfilling gig I've chosen. Your protective nature and aptitude

for numbers and diplomacy has helped me navigate this creative journey. I think we've done reasonably well working in such close quarters these past two years. Thank you for your love and encouragement—and for supporting my costly chocolate addiction.

My daughters, Cali and Elle. You continue to be the motivation and inspiration behind so much of what I do. When I became a mother, both my heart and creativity grew immeasurably. Your excitement at seeing my name in print never gets old. Your sassy and sweet natures make me smile big. This book is for you.

And my mom, Ruth, who would have loved this book. There were many times throughout the writing process where I wanted to call you and share with you the excitement I was feeling, sometimes after an especially moving phone call or the discovery of a woman and her brand that I knew you would like. I miss your enthusiasm. I miss the unconditional love. I especially miss hearing your voice fill with pride every time you'd congratulate me on a piece of mine you had recently read. I'm sad that you won't be able to hold this book in your hands and show it to your friends over brunch. This book wouldn't be here without you. Because it was you who showed me that all was possible and that following one's heart was the way to walk through this world. I hope that wherever your spirit roams, you feel the love I poured into these pages.

There are many people I wish to thank, some from my past, others from my present, and likely a few in my future. This book has been a journey of connection and a creative collaboration beyond anything I would have ever dreamed possible during what began as a challenging summer. This book saved me in many ways; it was a safe space in which I could be all of me.

As a writer, I've grown accustomed to spending a lot of time alone. As much as I value and need that quiet time to create, I thrive on connection with others. The pandemic, like for so many people, threw a wrench in my plans to expand my world to include a more social aspect to my work. But like many, I learned during this time of imposed-upon stillness and isolation that sometimes what seems like an obstacle is, in fact, an opportunity. And that's what happened with this book.

Image Credits

VICTORIA ASHLEY Photography by Rachel Saunders

TRACEY AYTON Photography by Jasalyn Thorne

ATHENA BAX Photography by Gaetano Fasciana

LAÏLA BÉDARD-POTVIN Photography by Christi Kyprianou

LEAH BELFORD Photography by Nicole Robertson (www.marcymedia.com)

LAURIE BOUDREAULT Photography by Cristina Gareau

ERIN BRILLON Photography by Kimberly Kufaas @Westcoastlife

GABRIELLE BURKE Photography by Jamie-Lee Fuocco

NDIDI CASCADE Photography by Nandini Thaker

ELLEN CASTILLOUX Photography by The Near and Dear

JUSTINE CHAMBERS Photography by Four Eyes Portraits

ALICE DE CROM Photography by The Godard's Photography

SARAH DELANEY Photography by Sarah Delaney

TANYA DROEGE Photography by Cristina Gareau

CHARLOTTE ELIZABETH Photography by Alomia Photography

LIVONA ELLIS Photography by Carson Gallagher

LAURENCE FISETTE Photography by Cristina Gareau

EMMA FITZGERALD Photography by Scott Munn

CRISTINA GAREAU Photography by Sabrina Girard

JAZMIN GILLESPIE Photography by Rommel Ramirez

ALLISA HANSEN Photography by Lauren Cryder

ANDREA HELLEMAN Photography by Anastasia Chomlack

CLARE HODGETTS Photography by Clare Hodgetts

CORRINE HUNT Photography by Sandra Bars

KAILEE JACKSON Photography by Olivia Vandyke

GAIL JOHNSON Photography by Kia Porter Photography

KIA KADIRI Photography by Emmanuel Letti

MARIE KHOURI Photography by Alexandra Khouri

JULIANNA LAINE Photography by Cristina Gareau

DEE LIPPINGWELL Photography by Paul Shaw

DELAINY MACKIE Photography by Jiyoo Shin

SABINA MAJKRZAK Photography by Sabina Majkrzak

LISA GELLEY MARTIN Photography by David Cooper

ERIKA MITSUHASHI Tender Engine Performance, at vivo Media Arts Centre, 2019. Photography by Cara Tench

KIKO NAKATA Photography by CatMonkey Photography

KEZIA NATHE Photography by Krystal Calver

MEGHANN SHAUN O'BRIEN Photography by David Koppe, courtesy of the Douglas Reynolds Gallery

LYDIA OKELLO Photography by Vestige Story, shot by Aileen Lee

MELISSA RENWICK Photography by Jessie LaFleur

SAMANTHA REYNOLDS Photography by Anastasia Chomlack

PIYA SANDHU Photography by Akane Kondo Photography

KATHERINE SCHLATTMAN Photography by Kelly Heurtier

EMILY SCHOLES Photography by Sarah Stein, Fragment of Light Photography

VEERPAL SIDHU Photography by Ally Matos

ERICA SIGURDSON Photography by Mark Halliday @moonriderpro

EMMA SMITH Photography by Sean Lande

MYRIAM STEINBERG Photography by Diane Smithers

ROBERTA VOMMARO Photography by Roberta Vommaro

CASSY VANTRIET Photography by Kezia Nathe

JESSICA WILSON Photography by Sweet Heirloom Photography

BEKA SHANE DENTER Photography by Christian Denter

About the Author

BEKA SHANE DENTER is a Canadian features and content writer, who has used her knowledge, passion, and nomadic lifestyle to fuel her writing career. Her work has appeared in *Elle Canada*, *Fashion*, NUVO, *Montecristo*, LUXE, *Ottawa Wedding*, BUST, *Women's Surf Style Magazine*, *Today's Parent*, and *The Inertia*. She holds a bachelor of arts in English, a master's in education, and a certificate in web writing and social media communication. She is forever in search of the perfect pair of jeans.